Carrara™ 1 Bible

Carrara™ 1 Bible

Doug Sahlin

IDG Books Worldwide, Inc.
An International Data Group Company

Foster City, CA ✦ Chicago, IL ✦ Indianapolis, IN ✦ New York, NY

Carrara™ 1 Bible

Copyright © 2000 IDG Books Worldwide, Inc. All rights reserved. No part of this book, including interior design, cover design, and icons, may be reproduced or transmitted in any form, by any means (electronic, photocopying, recording, or otherwise) without the prior written permission of the publisher.

ISBN: 0-7645-3375-4

Printed in the United States of America

10 9 8 7 6 5 4 3 2 1

1B/RR/QU/QQ/FC

Distributed in the United States by IDG Books Worldwide, Inc.

Distributed by CDG Books Canada Inc. for Canada; by Transworld Publishers Limited in the United Kingdom; by IDG Norge Books for Norway; by IDG Sweden Books for Sweden; by IDG Books Australia Publishing Corporation Pty. Ltd. for Australia and New Zealand; by TransQuest Publishers Pte Ltd. for Singapore, Malaysia, Thailand, Indonesia, and Hong Kong; by Gotop Information Inc. for Taiwan; by ICG Muse, Inc. for Japan; by Intersoft for South Africa; by Eyrolles for France; by International Thomson Publishing for Germany, Austria and Switzerland; by Distribuidora Cuspide for Argentina; by LR International for Brazil; by Galileo Libros for Chile; by Ediciones ZETA S.C.R. Ltda. for Peru; by WS Computer Publishing Corporation, Inc., for the Philippines; by Contemporanea de Ediciones for Venezuela; by Express Computer Distributors for the Caribbean and West Indies; by Micronesia Media Distributor, Inc. for Micronesia; by Chips Computadoras S.A. de C.V. for Mexico; by Editorial Norma de Panama S.A. for Panama; by American Bookshops for Finland.

For general information on IDG Books Worldwide's books in the U.S., please call our Consumer Customer Service department at 800-762-2974. For reseller information, including discounts and premium sales, please call our Reseller Customer Service department at 800-434-3422.

For information on where to purchase IDG Books Worldwide's books outside the U.S., please contact our International Sales department at 317-596-5530 or fax 317-572-4002.

For consumer information on foreign language translations, please contact our Customer Service department at 800-434-3422, fax 317-572-4002, or e-mail rights@idgbooks.com.

For information on licensing foreign or domestic rights, please phone +1-650-653-7098.

For sales inquiries and special prices for bulk quantities, please contact our Order Services department at 800-434-3422 or write to the address above.

For information on using IDG Books Worldwide's books in the classroom or for ordering examination copies, please contact our Educational Sales department at 800-434-2086 or fax 317-572-4005.

For press review copies, author interviews, or other publicity information, please contact our Public Relations department at 650-653-7000 or fax 650-653-7500.

For authorization to photocopy items for corporate, personal, or educational use, please contact Copyright Clearance Center, 222 Rosewood Drive, Danvers, MA 01923, or fax 978-750-4470.

Library of Congress Cataloging-in-Publication Data

Sahlin, Doug.
 Carrara 1.0 Bible / Doug Sahlin.
 p. cm.
 ISBN 0-7645-3375-4 (alk. paper)
 1. Computer animation. 2. Carrara (Computer file)
 I. Title.

TR897.7. S33 2000
006.6'96--dc 21 00-023795

ABOUT IDG BOOKS WORLDWIDE

Welcome to the world of IDG Books Worldwide.

IDG Books Worldwide, Inc., is a subsidiary of International Data Group, the world's largest publisher of computer-related information and the leading global provider of information services on information technology. IDG was founded more than 30 years ago by Patrick J. McGovern and now employs more than 9,000 people worldwide. IDG publishes more than 290 computer publications in over 75 countries. More than 90 million people read one or more IDG publications each month.

Launched in 1990, IDG Books Worldwide is today the #1 publisher of best-selling computer books in the United States. We are proud to have received eight awards from the Computer Press Association in recognition of editorial excellence and three from Computer Currents' First Annual Readers' Choice Awards. Our best-selling ...For Dummies® series has more than 50 million copies in print with translations in 31 languages. IDG Books Worldwide, through a joint venture with IDG's Hi-Tech Beijing, became the first U.S. publisher to publish a computer book in the People's Republic of China. In record time, IDG Books Worldwide has become the first choice for millions of readers around the world who want to learn how to better manage their businesses.

Our mission is simple: Every one of our books is designed to bring extra value and skill-building instructions to the reader. Our books are written by experts who understand and care about our readers. The knowledge base of our editorial staff comes from years of experience in publishing, education, and journalism — experience we use to produce books to carry us into the new millennium. In short, we care about books, so we attract the best people. We devote special attention to details such as audience, interior design, use of icons, and illustrations. And because we use an efficient process of authoring, editing, and desktop publishing our books electronically, we can spend more time ensuring superior content and less time on the technicalities of making books.

You can count on our commitment to deliver high-quality books at competitive prices on topics you want to read about. At IDG Books Worldwide, we continue in the IDG tradition of delivering quality for more than 30 years. You'll find no better book on a subject than one from IDG Books Worldwide.

John J. Kilcullen
John Kilcullen
Chairman and CEO
IDG Books Worldwide, Inc.

Eighth Annual Computer Press Awards ≥1992

Ninth Annual Computer Press Awards ≥1993

Tenth Annual Computer Press Awards ≥1994

Eleventh Annual Computer Press Awards ≥1995

Credits

Acquisitions Editor
Kathy Yankton

Development Editors
Sara Salzmann
Michael Christopher

Technical Editor
John Duggan

Copy Editor
Ami Knox

Project Coordinator
Linda Marousek
Marcos Vergara

Book Designer
Drew R. Moore

Quality Control Specialist
Laura Taflinger

Proofreading and Indexing
York Production Services

Graphics and Production Specialists
Robert Bihlmayer
Michael Lewis
Jude Levinson
Ramses Ramirez
Victor Perez-Varela
Dina F Quan

Illustrators
Mary Jo Richards
Clint Lahnen

Cover Illustration
Peter Kowaleszyn

Cover Illustration Contributor
Jeff Alu, AnimAlu Productions

Media Development Specialist
Jake Mason

Permissions Editor
Lenora Chin Sell

Media Development Manager
Stephen Noetzel

About the Author

Doug Sahlin is a writer, digital artist, and Web site designer living in Central Florida. He has published numerous product reviews, articles, and tutorials about 2D and 3D graphics software in national magazines as well as on the Internet. Doug has used Ray Dream Studio, Bryce, Painter, CorelDRAW and Corel PHOTO-PAINT to create images and animations that have been incorporated in Web sites he has designed. Digital images created by him have been featured at many Internet art galleries.

To the memory of my beloved mother, Inez, one of the kindest souls to ever walk the face of the earth.

Foreword

For years I have listened to graphic designers complain about the complexity and slowness of 3D software. Truth is, they were right! But now, thanks to the brand new Carrara, and Doug Sahlin's *Carrara 1 Bible*, this is history. The unique Carrara user interface, combined with the clarity of Doug's book, introduces the first easy-to-use, totally productive 3D solution for graphic designers and serious hobbyists.

The current tendency in the 3D software industry is toward more complexity. This leads to software that looks more like a 747 cockpit than creative software. With Carrara we have tried to do exactly the reverse. Carrara is the first 3D software to be task-oriented.

To achieve this, Carrara introduces the next generation interface — SmartFlow, the intuitive, progressive, compartmentalized workflow that uses a series of production steps. Each step features the tools required to complete a specific task, such as modeling, assembling, texturing, storyboarding, and rendering. In this way, Carrara provides an uncluttered and intuitive user interface.

However, Carrara is a general-purpose 3D software with so many features that it can seem intimidating to try to apprehend such a huge array of possibilities. 3D is just like the art of cooking. Thousands of ingredients are available. The difficulty is to learn how to select and combine them to create a tasty entrée.

This is where Chef Doug Sahlin can help you.

In his Carrara Bible, he reveals to us all his savoir faire in 3D. You will find complete coverage of the feature set of Carrara. Doug employs the same "room" paradigm used in Carrara and guides you through the series of steps needed to complete a project.

You will learn how to create 3D objects, combine them in the Assemble room, design their material, build an animation with Carrara's interactive Storyboard, and generate the final output in the Rendering Room.

This book presents step-by-step instructions to let you be productive from day one. But as in every serious cookbook, you will find much more than just theory and recipes in *Carrara 1 Bible*. Doug has packed his book with tips and tricks that will help you solve real world problems.

This book has been written both for the advanced user discovering this new software and for the 2D artist taking his or her first halting steps into the 3D world. Beginners will love the easy to follow, step-by-step approach, while advanced 3D artists will benefit from the extensive coverage of Carrara's feature set.

So, no matter your level of expertise, thanks to Doug Sahlin's *Carrara 1 Bible*, you will soon become a master chef in 3D.

Antoine Clappier
Senior Manager of 3D Technologies
MetaCreations, Corp.

Preface

Carrara the 3D program shares its name with a city in Northern Italy that is famous for the fine marble quarried nearby. Michelangelo the sculptor favored Carrara marble. And when you think about it, the analogy of the 3D artist as a sculptor is pretty close to the mark. A 3D artist begins with a basic idea for a scene or image, and then uses the software to chisel and hone that idea into a finished work of art.

When this project first began in January 1999, the book was all about Ray Dream Studio, the venerable 3D workhorse that had been around since nearly the turn of the decade. One phone call to MetaCreations changed all that. After repeating several ancient oaths, swearing on a stack of bibles (not the IDG kind) and signing a Non Disclosure Agreement, I received the exciting news that MetaCreations had already begun to create a new 3D program that would replace both Ray Dream Studio and Infini-D. As I pondered this news, I couldn't help but think of my initial foray into the world of 3D graphics

When I took my first timid steps, I was armed with a creative mind, a 3D program, and the program's user manual. Like most program manuals, this one covered the basics and a bit more, but only rarely did it dig deeply into the program and give me real-world, hands-on experience with the software. Adding insult to injury, the text was often peppered with confusing techno-talk that left me scratching my head instead of answering a question.

Needless to say, reading well-written tutorials and attending the school of hard knocks is responsible for most of my 3D knowledge. My goal throughout the writing of this book has been to present information about Carrara in a logical, task-oriented, hands-on manner with a minimum of technical jargon.

Who Should Read This Book

The designers of Carrara set out to give 3D artists and illustrators a user-friendly working environment packed with tools and features. These tools and features run the gamut from "Oh look honey, I just made a sphere!" to "Wow, I didn't know you could do that in 3D!"

On a basic level, many users will be able to get up and running quickly with Carrara and create simple scenes with colored spheres, cones, and triangles. But when they

try to harness the true power of Carrara and delve into matters such as the physics method of motion, particle generators, and vertex modeling, the learning curve gets incredibly steep very quickly. That's where this book comes in.

For 3D beginners, this book will give you the confidence and knowledge needed to quickly come to terms with the Carrara basics before delving into more complex matters. Even if you don't know a pixel from a polygon, by following the tutorials and examples presented in this book you'll be creating complex scenes in no time.

For the 3D veteran, this book delves into all the subtle nuances of Carrara. Learn how to streamline your work and harness all of Carrara's advanced animation features, such as motion paths and physics. Learn subtle little tricks to create photo-realistic surface textures. Take your animations to the next level by learning how to incorporate Carrara's sophisticated Particle Emitters and special lighting effects. Learn how to create stunning images by using soft shadows and 3D light auras.

For the rest of us, this book will serve as a desktop reference to answer questions about how a certain feature is implemented. This book will tell you everything you need to know about Carrara, and then some. The information is presented in a manner designed to inform, not intimidate.

What You'll Find in This Book

This book is presented in four parts. The following is a thumbnail sketch of what you'll find in each part and appendix, and on the CD ROM.

Part I: Getting to Know Carrara

The book starts out with the basics. In the first chapter, you'll get a busman's tour of Carrara's rooms and interfaces, along with a practical idea of what you can create with the software. The next two chapters are designed to get you up and running quickly by having you create first a 3D scene and then an animation. The rest of this part brings you up to speed with the Assemble room (the heart of Carrara) and Carrara's lights and cameras.

Part II: Building 3D Models in Carrara

In this part, you learn how to create actual 3D items for your scenes and animations. You begin by learning how to modify "primitive" shapes with Carrara's toolbox full of modifiers. The pace picks up in the next four chapters as you learn how to harness the power of Carrara's native modelers to create man-made, organic, and landscape objects. The last chapter in this section is a graduate course in advanced modeling techniques.

Part III: Texturing Your Finished Models

This part of the book teaches you how to texture your 3D models. You begin with very basic shading techniques and quickly learn how to harness the power of Carrara's Shader Tree Editor by creating your own shaders. Next, you learn to mimic reality by applying layer shapes over an object's basic shader. Last but not least, you learn to apply advanced shading techniques that will separate your 3D images and illustrations from those made by the masses.

Part IV: Putting It All Together

Everything you've learned in the first three parts has been leading you to the famous final scene where all your hard-earned knowledge will come into play when you render a scene to create an image or animation. In this part, you learn how to apply dazzling special effects that will put a stamp of originality on your scenes. You learn how to use sophisticated techniques, such as physical forces and behaviors, to create complex animations. The last chapter teaches you how to use Carrara with other 2D and 3D programs.

Appendixes

Appendixes A, B, and C at the back of this book deal with keyboard shortcuts and the companion CD ROM. There's also a comprehensive reference to Internet resources for 3D artists and illustrators.

CD ROM

The CD ROM that accompanies this book is packed with demo software, shareware, and other goodies. You'll find scene files to dissect, texture maps, backgrounds, and a batch of custom shaders to use with your Carrara scenes and animations.

Conventions Used in This Book

This book is designed to be a comprehensive user guide and desktop companion. At the beginning of each chapter, you'll find a brief description of what is covered. Throughout the book, you'll find icons that highlight key points you should be aware of.

This symbol alerts you to a technique or shortcut that can be used to add pizzazz to your work or streamline it. Many of the tips presented are things they never tell you about in the manual.

Note

This symbol calls your attention to an interesting Carrara fact or tells you another way to accomplish the same outcome.

Caution

This symbol gives you a heads-up warning of a potential pitfall. These comments range from computer memory issues to words of wisdom warning you not to venture down a path that has already caused considerable grief for other 3D artists.

Cross-Reference

Whenever you see this icon you are referred to another chapter for additional information on the topic being covered.

On the CD-ROM

This icon alerts you to search for needed tutorial material on the CD-ROM.

Whenever you see the ⇨ symbol in this book, it designates a path to a menu command or shortcut. For example, Insert ⇨ Sphere shows the path to the menu command to insert a sphere.

A few last words before we begin

You'll get the most from each chapter if you have Carrara launched on your computer and follow along. Therefore, we assume that you own a copy of Carrara or are considering purchasing one.

Carrara is cross-platform. The conventions and commands dealt with in this book are for the Windows based version of the software.

The path of least resistance to 3D knowledge is practice, practice, practice.

The path of least resistance to 3D excellence is practice, persistence, and imagination.

The path of least resistance to 3D mastery is persistence, imagination, and experimentation.

No pixels or polygons were destroyed during the making of this book.

Acknowledgments

Acknowledgments!!! What a daunting task to ask an author to undertake. So many people to thank, so little time.

Special thanks to Kathy Yankton, acquisitions editor at IDG Books Worldwide, Inc., for discovering me and making this book possible.

Thanks to Sara Salzmann, development editor at IDG Books Worldwide, Inc., for her guidance, encouragement, and wisdom.

Special thanks to Michael Christopher, a man of wit and intelligence and a consummate late-innings, pinch-hit development editor.

Thanks to Ami Knox for meticulous attention to detail while grooming this work for final presentation.

Thanks to Margot Maley of Waterside Productions, Inc., for ironing out the fine points when the cast of characters changed.

Kudos to Steve Yatson, Greg Mitchell, Joe Grover, Antoine Clappier, Dorothy Eckel, and all the other fine folks at MetaCreations for putting up with my persistence and seemingly never ending barrage of questions. This book would not be possible without your help.

Special thanks to Karen Sahlin and Colin Hughes, for their support and encouragement.

Thanks to the Tedster for being there throughout the years.

Thanks to the software vendors who contributed to this book, and to Jack Mason, the CD master who pulled it all together.

Special thanks to 3D artists extraordinaire Wayne Kilgore, Dan Mancuso, Steve McArdle, and Cecilia Ziemer, whose wonderful images grace the color plate section of this book.

Thanks to all the special people in the 3D community who offered encouragement and assistance while I was earning my 3D wings.

Special thanks to all of the people in my life who have been friends, mentors, or role models.

Contents at a Glance

Contents

Part II: Building 3D Models in Carrara 193

Part III: Texturing Your Finished Models **411**

Chapter 14: Introducing the Carrara Shader Browser413

Chapter 15: Creating Custom Shaders ..429

Getting to Know Carrara

Introducing Carrara

If you look up *Carrara* in your dictionary, you'll find it listed as a city in Northern Italy, east of Genoa, near the Ligurian Sea. The city is famous for the fine white marble, quarried near there, favored by Michelangelo, and it's rumored that Carrara marble may have been used for his sculpture of David. The fact that you have this book in your hands means that to you, Carrara signifies a powerful 3D program used to create photo-realistic 3D images and animations.

Carrara the 3D program is the offspring of Ray Dream Designer and Infini-D. Both Ray Dream and Infini-D included the tools to create interesting 3D images and animations. Both programs had a loyal user base that learned to love the features and hate the quirks and idiosyncrasies associated with the software. Both programs featured a fairly gentle learning curve, which enabled beginners to get up and running reasonably quickly. But as time wore on and 3D technology advanced, both programs suffered with antiquated interfaces and slow rendering times.

With Carrara, you have the best of both programs, and then some. Carrara features an intuitive interface and the SmartFlow workflow concept. Every Carrara project is streamlined into a logical workflow where individual steps are accomplished within a single interface in a unique room devoted to the task at hand. Menus and toolbars are laid out logically and are fully customizable to your working habits. Several tasks you perform in Carrara are made even more intuitive by Ghost Menus, which are convenient toolbars that remain hidden until you need them.

What You Can Create with Carrara

Carrara is a full-featured 3D package you can use to create realistic scenes and animations. You can populate scenes with preset objects or create objects of your own with three different modelers. You can create anything from an animated logo for a client to a sci-fi scene complete with lunar landscapes and alien atmospheres. Special lighting effects and motion blur add to the realism.

Creating 3D models with Carrara

You use Carrara's three modelers to create intricate 3D models. Each modeler has its own specialty. Use them to model man-made objects with smooth flowing surfaces, organic models with asymmetrical surfaces, and smooth-surfaced symmetrical organic models.

Finished models can be used in Carrara scenes or exported for use with other 3D programs. Exported models can be saved in most popular 3D formats.

You can import and edit 3D models created in other programs for inclusion in a current Carrara scene. Or you can save the edited import to the Objects Browser for use in future Carrara scenes.

Creating realistic 3D scenes

Carrara has all the tools needed to create a 3D scene, including adjustable lights, movable cameras, and a host of built-in primitive objects that you use to populate scenes.

Carrara works just like a photographic studio. Assemble the scene by creating models, importing models, or using the preset models that ship with Carrara. Once the models are added to a scene, they can be precisely positioned and aligned.

Once a model or object is added to a scene, a shader must be created to texture the model's surface. Choose from a variety of preset shaders, or create your own in the Texture room. By filling shader channels with different components and functions, you can apply realistic surface textures to 3D objects.

Lighting is one of the most important components in a 3D scene. The proper application of lighting shows off a 3D scene by gently washing it in shadows and light. Intelligent use of lighting highlights an object's surface colors and textures. Carrara gives you a wide array of lights to choose from, and these lights can be precisely aimed and adjusted for output, range, and falloff. Photographic lighting effects can be added to liven up your finished images.

You can add as many cameras as needed to Carrara's 3D studio. Cameras feature adjustable focal lengths and can be precisely aimed and positioned by dragging their direct manipulation handles. Carrara's cameras act just like photographic

cameras, introducing realistic perspective and visual distortion. Special effect filters can be added to cameras to simulate depth of field and motion blur.

Rendering scenes with Carrara

Carrara has three different rendering engines capable of creating images that range from proof sketches to high-quality images for use in printed publications. Carrara's speedy rendering engines can be optimized for particular scenes and produce images in a wide range of popular formats. Images can be rendered with G-Buffers, which are channels that store information about the scene. These G-Buffers channels are used for post-render editing in photo-paint programs.

Creating animations with Carrara

Animation may seem like a fairly daunting process to a 3D novice. In fact, it can be intimidating even to 3D veterans. 3D animations are just like cartoons. A single animation can comprise hundreds of individual images or frames. In each frame, a change occurs. When these frames are sequenced and played as a group, smooth motion occurs. But unlike the cartoon artist, the 3D artist doesn't have to create each frame.

Carrara simplifies the process of creating animations by using a sophisticated timeline. Objects are animated by adding key frames (also known to some as key events) to a specific point in time along the timeline. Major animation changes such as motion, lighting, or camera movement are applied at these key frames. When the animation is rendered, Carrara fills in the blanks from one key frame to the next, creating smooth flowing motion. Motion transitions between key frames are editable.

Animations can also be created by using sophisticated techniques such as physics and motion paths. Explicit (key frame), physics, and motion paths can all be combined in a single animation.

Virtually anything in Carrara can be animated. Objects can move, rotate, and morph during the course of an animation. Lights can brighten, dim, and travel across a scene. Cameras can be made to track an object. Cameras can move and bank to create impressive fly-by animations. Realistic motion can be emulated by setting up a hierarchy and using inverse kinematics to control motion between linked objects.

Creating VRML scenes with Carrara

Carrara has the capability to export completed scenes in .wrl (VRML) file format. (VRML is short for Virtual Reality Modeling Language.) With the proper VRML plug-in loaded in a Web browser, a VRML scene can be navigated as if the viewer were actually walking through it. On the Internet, VRML has been used to create virtual museums and virtual tours through cities. Carrara exports in VRML 2 format.

Creating Web site content with Carrara

With the increasing popularity of the Internet, there is a tremendous demand for images and animations. Displaying images on the Internet does involve a bit of work, though. Images must be saved in Internet-friendly file formats that load quickly when downloaded into a user's browser. Carrara provides image-saving options that handle most of the work in creating an image for the Web.

Rendered animations pose a separate set of problems for the Internet. They must be compressed so they will download quickly into a site visitor's Web browser. Carrara takes care of this for you by giving you a wide variety of file formats and popular compression codes to choose from. In addition, Carrara can export animations as animated .gif files, a long-time favorite of Web designers needing quick-loading animations for Internet sites.

Working with Carrara's Rooms

Carrara's SmartFlow uses a room concept for creating 3D scenes and animations. Specific rooms are reserved for assembling, modeling, storyboarding, texturing, and rendering. At the top-right corner of every Carrara room are five icons (see Figure 1-1). Clicking an icon opens a room in which you can perform a certain task. When you're done, click another icon to open another room. Navigating between different rooms enables you to work with an uncluttered interface. If you've ever used a 3D program in which every task is performed within a single interface, you'll recognize what a saving grace Carrara's room concept is.

As you read the rest of this chapter, keep Carrara up and running on your computer and follow along to explore Carrara's rooms and gain some firsthand experience with the program.

Introducing the Assemble room

The Assemble room (see Figure 1-2) is the first thing you see after Carrara loads. This room is the core of Carrara. Scenes are created and assembled here. At the core of the room is a large workspace known as the *working box*. The working box appears every time you launch a new document by selecting File ➪ New (Ctrl+N). This is your view of the 3D scene as you build it. The working box can be viewed as a single window, or split into multiple panes. To the right of the working box are four white rectangular icons. Click each of them to view the different working box arrangements.

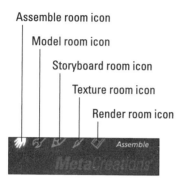

Assemble room icon

Model room icon

Storyboard room icon

Texture room icon

Render room icon

Figure 1-1: Use these icons to navigate through Carrara's rooms.

Figure 1-2: Carrara's Assemble room

Surrounding the workspace on the sides and bottom are three ridged blue buttons that open the Browser tray, the Sequencer tray, and the Properties tray. Click the blue button and drag to open each tray. From this point forward in the book, the phrase "drag open" will be used to refer to the action of clicking and dragging one of these blue buttons to open a tray. To the left of the working box is the Browser tray. To the right of the working box is the Properties tray. Directly below the working box is the Sequencer tray.

Think of the Browser tray, shown in Figure 1-3, as a place for all your 3D stuff. The Browser tray is a catalog of objects you can add to a scene. It is also a catalog of textures and effects that you can apply to objects to transform them. Drag open the Browser tray and click the different buttons to see the wide variety of preset items stored here. The Browser is also used to store objects, textures, and effects that you create.

Figure 1-3: The Browser tray

The Sequencer tray is a list of all the objects in your scene. Use it to keep your scenes organized. The Sequencer tray can also be used to duplicate items in your scene and apply surface textures to objects in your scene. In addition, you can select items through this tray.

The Sequencer tray plays a large part in animations (see Figure 1-4). This is where you create key frames, which are points in the animation where a key event such as a motion change or object transformation takes place. Drag open the Sequencer tray, and you'll see some controls that look similar to the remote control for your VCR. These controls are used to preview the animation within the working box. Below the VCR controls are four lists that will fill up as you add items to a scene. The large area to the right of the lists is the animation timeline. Each object added to a scene has its own timeline.

Figure 1-4: The Sequencer tray

The Properties tray stores information about your scene and every object in it. Drag open the Properties tray and click the small blue button with the downward-facing double arrow at the top-right corner of the tray (see Figure 1-5). You should see a drop-down list of objects in the scene plus a listing for the actual scene itself. This list can be used to select individual items. Once an item is selected, the Properties tray can be used to name, move, rotate, resize, or apply special effects to that item. The Properties tray displays different parameters and options depending on the item selected.

The Properties tray also enables you to apply scene settings. Use it to apply atmospheric settings, control ambient light, and apply backdrops or backgrounds.

To the left of the working box are tools that are used to move, rotate, and resize scene objects. Also included are camera controls, which you use to change your viewpoint. Click the big round button with two double-ended arrows to the left of the working box. Drag across it and watch what happens to the working box.

Note The angled arrow to the left of the interface is the Move/Selection tool. It is used to move objects within the working space. It is also used to select objects within the interface. Whenever you are instructed to click to select an object within any Carrara working space, the Move/Selection tool must first be selected.

At the top of the interface are a series of menus. Most of these menus are specific to the Assemble room. When you enter another room, a new set of menu choices appears.

Directly atop the working box is the toolbar you use to insert scene objects. Depending on the tool selected, an object is either inserted directly into the scene, or you're transported to a room where you can create an object. This toolbar is also used to add lights and cameras to a scene.

Figure 1-5: The Properties tray

Click the first button on the toolbar (displaying a sphere by default) to select it. The tool becomes highlighted in yellow. Click and drag it into the working box. A sphere is added to the scene.

Below and to the left of the working box are a set of tools used to zoom and pan the working box. At the bottom-right corner of the working box resides a toolbar for controlling how your scene is previewed.

Introducing the Model room

From the top toolbar, click the button that looks like a wine glass and drag it into the working box. The Model room opens (see Figure 1-6). Use the Model room to create 3D objects from scratch. Three modelers are housed here: the Spline modeler, the Vertex modeler, and the Metaball modeler.

The set of menus and toolbars displayed in the Model room differ depending on the type of object you insert in the scene. The large modeling box in the center of the room is common to all modelers except the Metaball modeler, which has a slightly different configuration. Use this box to manipulate the 3D model as it takes shape. The modeling box can be viewed as a single window or split into multiple panes (except in the Metaball modeler).

Scale tool

Move/Selection tool

Point tool fly-out

Rotate tool　Primitive drawing tools fly-out

Pen tool　Text tool

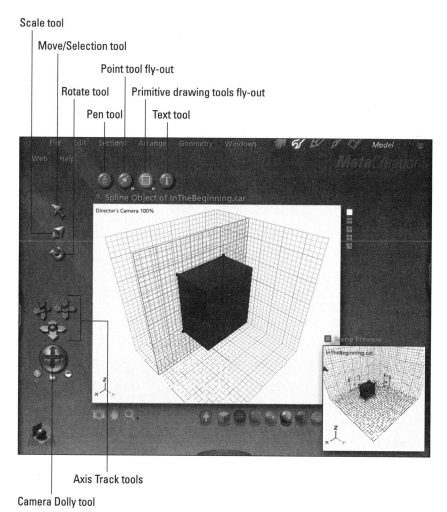

Axis Track tools

Camera Dolly tool

Figure 1-6: The Model room

Click the third button on the toolbar atop the modeling box to select it. The tool becomes highlighted in yellow. Click inside the modeling box and drag. A 3D object forms inside the modeling box. This simple 3D object can now be converted into a complex 3D model by using the available tools and menu commands.

The Scene Preview window is located at the bottom-right corner of the modeling box. When you create a 3D object, it also appears in this window. This preview gives you an idea of how the object you're modeling will look in the scene. Don't let the small size of the Scene Preview window fool you; this is a powerful feature. You make the Scene Preview window active by clicking it. The window can now be changed to a different viewpoint by using the camera control tools located to the lower-left of the modeling box. You can also move scene objects in the Scene Preview window.

Click the Scene Preview window to make it active. Click the big round button with two double-ended arrows to the left of the modeling box. Drag it and watch what happens to the Scene Preview window.

In the Model room, the Browser tray and Sequencer tray serve little purpose. However, the Properties tray is quite useful here. When you drag open the Properties tray in the Model room, it displays information about the individual parts used to create the 3D object (except in the Metaball modeler). The Properties tray is also used to edit points and shapes in the Model room (except in the Metaball modeler).

To exit the Model room, click the Assemble icon (which resembles a hand).

Introducing the Storyboard room

To enter the Storyboard room, click the icon that looks like a pencil at the top-right corner of the interface. The Storyboard room breaks the scene down into individual movie frames (see Figure 1-7). Each frame represents a point in time. This room can be used to create or fine-tune animations. Individual scene objects can be selected and moved inside the Storyboard room. But the changes you make inside the Storyboard room are not global changes. They only apply to the frame that was selected when the change was made and all subsequent frames.

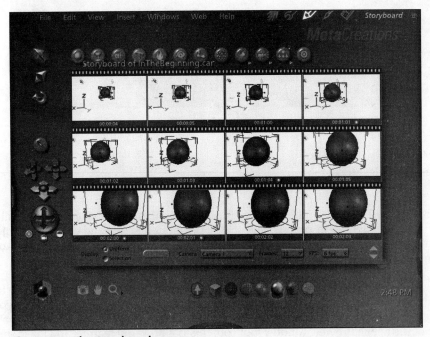

Figure 1-7: The Storyboard room

In the Storyboard room, you can insert objects and effects into your scene by using menu commands, dragging a tool into the scene, or inserting an object or effect from the Browser tray. You also have full benefit of the Sequencer tray and Properties tray. In short, the Storyboard room functions like the Assemble room but on a frame-to-frame basis.

Click the first button (a sphere by default) on the toolbar above the Storyboard room working box to select it. Drag it into the first frame. A sphere appears. Click the tool that looks like an angled arrow (the Move/Selection tool) to the left of the working box. Click the third frame to make it active and then click and drag the sphere to move it. The sphere moves in the third frame and all subsequent frames. Click any frame past the third frame, move the sphere again, and watch what happens. This is how the Storyboard room is used to create animations.

To exit the Storyboard room, click the Assemble icon (which resembles a hand).

Introducing the Texture room

To enter the Texture room, select an object and then click the icon in the top-right corner of the interface that looks like a paintbrush. The Texture room (see Figure 1-8) is where you apply a surface color and texture to objects in your scene. The Texture room is also used to edit existing textures. In Carrara, textures are referred to as *shaders*. Shaders are edited by adding components to different channels of the Shader Tree Editor.

Figure 1-8: The Texture room

The Texture room consists of a large dialog box in the center of the room known as the *Shader Tree Editor*. The reason it's referred to as a tree is the fact that you can literally branch each channel infinitely. By adding components and splitting channels, you add complexity to a shader. Close observation of natural objects will confirm the fact that shader complexity is the key to achieving realism.

At the right side of the room are two preview windows. The top preview window is the Shader preview. This window provides a thumbnail view of the object being textured. The window updates in real time as you edit the shader. Below the Shader preview is the Scene Preview window. This window is also updated as you edit the shader.

The Sequencer tray and Properties tray have no function in the Texture room. The Browser tray can be used to create new shaders by dragging existing shaders into the Shader Tree Editor using a specialized shading feature known as a *Multi Channel Mixer*.

When you're through exploring the Texture room, click the Assemble icon to return to the Assemble room.

Introducing the Render room

To enter the Render room, click the icon that looks like a piece of film in the upper-right corner of the interface. The Render room is where the result of all your creative work comes to fruition. The Render room consists of a large open space where the image forms once a rendering has been started (see Figure 1-9).

Figure 1-9: The Render room

In the Render room, the Browser tray has no function. The Properties tray is used to set up the rendering. Use it to specify image size and format. You also use it to choose a render engine and set render parameters.

In the Render room, the Sequencer tray becomes the Render tray, which is used to launch a rendering. It can also be used to abort a rendering if you're not happy with the way the rendered image is shaping up. Perhaps one of the most powerful features of the Render tray is the Batch Queue. Use it to automate the rendering of several scenes while you do something more important, like cleaning out your cat's litter box.

Setting Carrara Preferences

Well, there you have it — your first tour of Carrara's rooms. The rooms and workspaces have been laid out in a logical manner based on the vast experience of the programmers. Of course, the vast experience of the programmers may not coincide with your view of the world as it relates to 3D programs. Fortunately, most everything in Carrara can be customized to suit your personal preferences.

If you've been following along, you've noticed the difference between the light background of the working box in the book's figures and the dark background of Carrara's working boxes. Preference settings have been changed to make the figures show up better in the book. You can use these preference settings to customize Carrara to your preferences.

Setting Carrara preferences

There are 12 categories of preferences. Certain categories pertain to specific rooms or modelers. Setting preferences will help you customize Carrara to suit your working habits.

To set general preferences:

1. Select File ➪ Preference (Ctrl+Shift+P) ➪ General (see Figure 1-10). The General settings dialog box appears.

2. Enable the New Document at Launch option to have Carrara open a blank document every time you launch the application.

3. Enable the Show Clock option if you want a clock displayed in the lower-right corner of the interface.

4. Enable the Show ToolTips option to have ToolTips (labels) display on mouse-over.

5. Enable the Toolbar Hot Keys are Sticky option to keep the currently selected toolbar hot key active. Disable this option to immediately revert to the last tool used after releasing a toolbar's hot key.

Figure 1-10: Selecting a category of preferences

6. Enter a value for Maximum Undo Levels. The default is 16. You can specify up to 64 levels of Undo.

Caution

Specifying high Undo levels puts a strain on your computer's memory resources. Your computer's memory stores previously executed actions up to the number of Undo levels specified.

7. If applicable, edit Multiple Monitor Settings. If your system has a single monitor, this option is blacked out.

8. Click OK to apply.

UI effects preferences are used to adjust the Carrara user interface to your liking.

To set UI effects preferences:

1. Select File ⇨ Preference (Ctrl+Shift+P) ⇨ UI Effects. The UI Effects settings dialog box appears (see Figure 1-11).

Figure 1-11: Setting UI effects preferences

2. Enable Live Window Resize and Drag to have the window displayed as you resize it. Disabling this option is advisable if you are working with a slower computer.

3. Drop shadows appear around all windows when the Window Shadows option is enabled. Disabling this option makes the window appear as if it were lying directly on the desktop instead of above it.

4. UI Animations affects the way trays appear open. Disable UI Animations if you are working with a slower computer.

5. Show Logo is used to toggle the MetaCreations logo on or off.

6. Desktop Pattern and Gradient displays a pattern and gradient on the desktop. Disable this option to show the desktop as a solid color. You can adjust the background color used in the UI Colors preferences menu.

7. Dim Desktop for Dialogs dims the desktop when a dialog box is displayed. Disable this option, and the desktop will not dim when a dialog box is displayed.

Imaging and scratch disk preferences adjust Carrara to your system. If you're using color correction to adjust your system's colors for a specific output device, you can instruct Carrara to apply these settings. A scratch disk is an empty section of your computer's hard drive. Carrara uses the scratch disk to store information when your computer's memory resources are taxed.

To set imaging and scratch disk preferences:

1. Select File ⇨ Preferences (Ctrl+Shift+P) ⇨ Imaging, Scratch Disk. The Imaging, Scratch Disk dialog box appears (see Figure 1-12).

2. Click the blue Scratch Disk button with the downward-facing double arrow to select a directory for the scratch disk.

Figure 1-12: Setting imaging and scratch disk preferences

Note The scratch disk is where Carrara stores information when available memory resources have been exhausted. The scratch disk is your hard drive. Drive C is the default scratch disk directory. If you have multiple directories or hard drives, choose the one with the most available space for the scratch disk.

3. Enable the Color Correction option if you have color correction software installed on your computer.

4. Click OK to apply.

The Units setting you choose is largely a matter of preference. When you select a different unit of measure, grid measurements in all rooms are resized accordingly.

To set units preferences:

1. Select File ➪ Preferences (Ctrl+Shift+P) ➪ Units. The Units dialog box appears (see Figure 1-13).

Figure 1-13: Setting units preferences

2. Click the 3D Units button and choose from the following options:

- pixel (pixels)
- pt (points)
- pica (picas)
- in (inches)
- ft (feet)
- mi (miles)
- mm (millimeters)
- cm (centimeters)
- m (meters)

Caution You are strongly advised not to select mi (miles).

3. Click the Time Units button and choose either SMPTE or Frames to display the animation timeline in units of time (seconds) or individual frames.

The program's engineers chose user interface (UI) colors based on aesthetics and viewing contrast. Adjust the colors to suit your personal preferences and room lighting. If after changing the colors you decide you like the original colors better, shut down Carrara and use your computer's file management system to open up the directory where you installed Carrara. Select the file Carrara.ini and delete it. The next time you launch Carrara, the original factory settings will be restored.

Tip If you delete the Carrara.ini file, all other preferences will be lost. Once you have Carrara set up the way you want it, make a copy of the Carrara.ini file and store it in a separate folder. That way if the settings ever get out of kilter, you can restore your preferred settings by deleting the current Carrara.ini file and then copying your original and pasting it into the Carrara folder.

To set UI colors:

1. Select File ⇨ Preferences (Ctrl+Shift+P) ⇨ UI Colors. The UI Colors dialog box appears (see Figure 1-14).

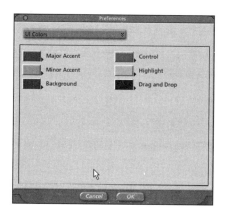

Figure 1-14: Setting UI colors

2. Click the color swatch to the right of each category. The Color Picker appears, displaying the currently selected color for the UI object. Select a new color for the object and click OK to apply.

3. After selecting all UI colors, click OK to apply the new preferences.

Note You can also click the small arrow to the right of the color swatch to reveal a rect-angular Color Picker. Drag inside the Color Picker to select a new color. By clicking this small arrow, you can also drag anywhere inside the interface to select a color.

Changing 3D view colors affects the working box only. If you prefer the light background used in this book, change the background color to white in the 3D View Colors Preference menu and choose darker colors for the working box, working box grid, camera name, selected object, silhouette on walls, and primary wireframes. Select colors that are pleasing to you and at the same time conducive to good viewing in your working environment.

To set 3D view colors:

1. Select File ➪ Preferences (Ctrl+Shift+P) ➪ 3D View Colors. The 3D View Colors dialog box appears (see Figure 1-15).

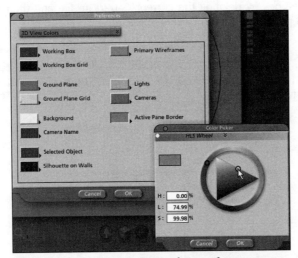

Figure 1-15: Setting 3D view colors preferences

2. Click each item's color swatch. The Color Picker appears, displaying the currently selected color for the object. Select a new color for the object and click OK to apply.

3. After selecting all 3D view colors, click OK to apply the new preferences.

The other preference dialog boxes are not general settings and refer to specific rooms within Carrara.

Setting Interactive Renderer preferences

The Preview Display options are located on a toolbar at the bottom of the working box. These tools are used to switch from one preview quality mode to another. The preview quality you choose determines the speed at which your computer redraws the scene as you edit it. Setting interactive render preferences changes the look of the working box.

To set interactive render preferences:

1. Click the Interactive Renderer Preferences button (see Figure 1-16) on the Preview Quality toolbar. The Interactive Renderer Settings dialog box appears, as shown in Figure 1-17.

2. Click the large blue Renderer button and choose from MetaCreations Software, Open GL Hardware, or Direct 3D Hardware.

Figure 1-16: Click this button to adjust interactive render preferences.

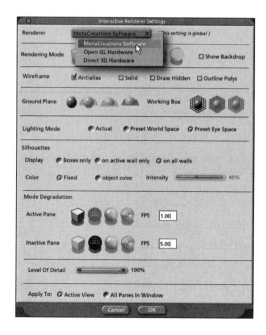

Figure 1-17: Setting interactive renderer preferences

Note Open GL and Direct 3D are enhancements to your computer system's architecture that improve the drawing of 3D objects on screen. Before selecting one of these options, make sure you have Open GL or Direct 3D software installed. Also check to be sure your hardware supports it.

3. In the Rendering Mode section, select a preview mode by clicking one of the buttons. This setting can also be adjusting by selecting a preview mode from the Preview Quality toolbar. Enable the Show Backdrop option if you want a scene backdrop displayed as you work.

Note Show Backdrop only has an effect when you have a backdrop in your scene.

4. Select options for the wireframe. You can enable more than one of the following selections:

 • **Antialias:** Creates a better looking wireframe that's easier to see

 • **Solid:** Draws the wireframe as a solid mesh instead of a see-through mesh

 • **Draw Hidden:** Reveals all facets that make up an object's mesh

 • **Outline Polys:** Draws an outline around individual polygons

5. Choose a setting for the ground plane by clicking one of the buttons. The options are None, Wires, Opaque, or Solid.

6. Choose a setting for working box by clicking one of the buttons. The options are Wires, Solid, or Transparent.

7. Choose a lighting mode:

 • **Actual:** Uses actual scene lighting to display objects in the working box

 • **Preset World Space:** Uses a generic setup where the scene is lit from above

 • **Preset Eye Space:** Lights the scene as if the light source were emanating from the viewing camera

8. Choose an option for the silhouette display:

 • **Boxes only:** Displays the object's bounding box on the silhouette wall

 • **On active walls only:** Displays a silhouette of the object's shape on the active plane's wall

 • **On all walls:** Displays a silhouette of the object's shape on all three plane walls

9. Choose an option for silhouette color. Choose from Fixed (the Silhouette on Walls color chosen from the Preferences menu's 3D view colors dialog box) or Object Color. If you choose Object Color, drag the Intensity slider to adjust the intensity of the silhouette's color.

10. Choose mode degradation settings for the active pane. Click a button to choose from Bounding Box, Wire, Gouraud, or No Degrade. Enter a value for FPS (frames per second).

11. Choose mode degradation settings for the inactive pane. Click a button to choose from Bounding Box, Wire, Gouraud, or No Degrade. Enter a value for FPS (frames per second).

Note Mode degradation is a fail-safe mode that Carrara drops back to when the scene redraw can't keep up with your edits. For example, if you have a scene with a lot of objects displayed in a high-quality preview mode, your hardware may not be able redraw the scene when you edit it. When this happens, preview quality will degrade to the mode selected until you stop editing.

12. Drag the Level of Detail slider to set the display characteristics of objects as they are drawn in the working box. Lower settings produce less detail and faster redraws.

13. Choose whether to apply the settings to the active view or all panes in window.

14. Click OK to apply.

Summary

Carrara is a full-featured 3D studio for creating 3D scenes and animations. Carrara features the SmartFlow concept of workflow. Every task in Carrara is performed in a unique room with unique menus. The workspace is fully customizable.

✦ The Assemble room is the core of Carrara.

✦ Use the Model room to create 3D models.

✦ Animate a scene in the Storyboard room.

✦ Apply surface color and texture to 3D objects in the Texture.

✦ Use the Render room to create still images and animations of completed 3D scenes.

✦ The Browser tray is a catalog of 3D items, surface textures, and special effects that can be added to a scene.

✦ The Sequencer tray contains a list of all scene objects.

✦ The Properties tray displays information about scene objects and is also used to set up the scene.

✦ ✦ ✦

Creating Your
First Scene

In This Chapter

Setting up the scene

Populating the scene

Lighting the scene

Viewing the scene

Rendering the scene

A 3D scene comprises many elements: 3D objects, lights, cameras, special effects, composition, artistic vision. In order to create an interesting 3D scene with visual impact, the 3D artist must successfully integrate all these things. Most 3D programs differ in the way the individual elements of a scene are created and implemented. Whether you're a seasoned 3D veteran or this is your initial foray into 3D, the tutorial presented here shows you how to use the basic components of Carrara and apply them to a 3D scene.

Thinking in 3D

Artists accustomed to working with imaging programs that generate two-dimensional images tend to view each creation as a single piece. They strive to get the color and lighting right for the image they are creating. They work hard to create visual centers of interest that guide the viewer's attention to specific points in the image.

With a 3D program, every object in the scene is three-dimensional. A 3D scene can be viewed from the top, bottom, right, left, or any viewpoint in between. In other words, a 3D scene has an infinite number of viewpoints from which the final image can be rendered. Consider this when placing and aligning objects and lights in a scene. If you've ever watched a professional photographer at work, you know they're not content with a single shot of the scene. They move around it, taking images from many different viewpoints. After a scene is set up, you can create different images by setting up different rendering viewpoints.

Another good habit to get into is breaking objects down into their component pieces. For example, if you want to model a watch, don't create the watch as a single unit. Instead, model individual pieces and then assemble them. It simplifies the modeling process if you can view the watch as a collection of shapes. The crown (the part you use to wind a watch) is a cylinder with ridges. The watch straps are long flattened rectangles with holes in them. The face of the watch is a domed cylinder, and so on. Once you break an object down into simple shapes, use Carrara's modelers to refine the shapes into actual objects.

Creating a Scene in Carrara

Carrara does not load a document when it launches unless you specify otherwise in the Preferences menu. Every Carrara scene or animation you create is a separate document that is saved with all the scene occupants and setup information. Scene documents should always be saved with unique names, as this makes them easier to identify later. Carrara documents are saved with a .car extension.

To create a new document in Carrara:

1. Select File ⇨ New (Ctrl+N).

2. A new Carrara document is launched and the working box appears.

Creating your first Carrara scene

Chapter 1 briefly introduced you to Carrara and the various rooms used to create scenes. Before plunging headlong into the thick and thin of Carrara, you're going to create a small scene that should give you a better idea of how the program works.

The text that follows takes you through the steps for creating an underwater scene. You model the base for an underwater habitat, attach a dome to it, and create an undersea environment complete with an ocean floor and reef material.

If you're new to 3D modeling, allow yourself plenty of time to complete the tutorial. If you're a 3D-program veteran, some of this may seem like old hat, but the tutorial still has plenty of useful information about Carrara.

On the CD-ROM Before starting the tutorial, you need to load two folders into your Browser: Tutorial Shaders and Tutorial Objects. Load the CD-ROM that came with this book, locate the Chapter 2 folder in the Contents section, and follow the subsequent steps for adding a folder to the Browser tray.

To add a folder to the Browser tray:

1. Drag open the Browser tray.

2. Click the Browser: Objects button.

3. Click the Folder button in the upper-right corner of the Browser and select Add Folder from the drop-down menu (see Figure 2-1). The Browse for Folder dialog box opens.

Figure 2-1: Adding a folder to the Browser

4. Locate the Tutorial Objects folder on the CD-ROM and click OK to add the folder.

5. Click the Browser: Shader button and repeat steps 3 and 4 to add the Tutorial Shaders folder to the Browser.

Note

The Properties tray is used extensively in this tutorial and throughout Carrara. The Properties tray has four sections: General, Motion/Transform, Modifiers, and Effects. Use the four round buttons at the top of the Properties tray to navigate through the different sections. Each Properties tray section is broken down into individual named panels that differ depending on the type of object selected when the Properties tray is opened. Click the triangle to the left of a panel to expand it. To the right of the panel's name is a drop-down menu that can be accessed by selecting the current item or clicking the double downward-pointing arrows on the right side of the panel.

Setting up the scene

Whenever you create a 3D scene, it's a good idea to do some preliminary planning; at the very least, think about what you'll need to create the scene. Many scene settings can be changed as you progress, but if the basic concept is flawed, you end up wasting precious time instead of enjoying the creative process.

Underwater scenes pose a unique challenge: How do you model water? You don't. Instead, you create the illusion of being underwater by adjusting scene settings. If you've ever been underwater, you know that even the clearest water fades in the distance. Your job as a 3D artist is to create this illusion of decreasing visibility by setting up the scene properly.

To set up an underwater scene:

1. Drag open the Properties tray.

2. Click the small blue button with the downward-facing double arrow and select Scene. The General settings section of the Properties tray opens.

3. Underwater scenes have little or no ambient light. In the Ambient panel, drag the Ambient Brightness slider to 0.

4. To simulate the fading visibility in an underwater environment, select Distant Fog in the Atmosphere panel and apply the following settings:

 - Enter 25.00 for Start Radius.

 - Enter 35.00 for Extent Radius.

 - Click the color swatch to open the Color Picker and choose a dark blue.

5. In the Background panel, select Color.

6. Click the small arrow to the right of the color swatch, drag it to the Distant Fog color swatch, and release to perfectly match the background color to the fog color.

Tip By clicking and dragging the small arrow to the right of any Carrara color swatch, you can sample a color from anywhere in the interface. Clicking this arrow also opens an alternative rectangular color picker.

Now that the scene is set up, it's time to start populating it. Begin by creating the underwater habitat, as outlined in the next section.

Creating the underwater habitat

The underwater habitat consists of a base and a dome. The following steps show you how to create the base in the Spline modeler and how to make the dome from a flattened sphere.

To create the base:

1. Select Insert ➪ Spline Object. The Spline modeler opens.

2. Click the name Director's Camera in the upper-left corner of the modeling box to reveal a drop-down menu of camera positions. Click Front to switch to the Front view.

3. Click the small arrow to the right of the Magnifying Glass icon, which is located below the lower-left corner of the modeling box. A drop-down menu of magnification settings appears. Click 300%.

4. Select Geometry ➪ Grid (Ctrl+J). The Grid dialog box appears. Enable the Snap to option. Click OK to apply

5. To the left and on top of the working box is a toolbar with four tools on it. Click the small arrow to the right of the third tool to reveal a drop-down menu of drawing tools. Click the one with a circle in its center to select the Draw Oval tool, shown in Figure 2-2.

Figure 2-2: Use the Draw Oval tool to create the habitat's base.

6. Hold down the Shift Key and drag inside the modeling box to create a small circle that fills four grid spaces.

7. Select Sections ➪ Center.

8. Select Edit ➪ Copy (Ctrl+C). A copy of the circle is placed on the system's clipboard.

9. Select Edit ➪ Paste (Ctrl+V). The copied circle is pasted directly atop the original circle.

10. Select the Move/Selection tool (the one-sided arrow button to the left of the modeling box), click the circle, and drag it up six grid spaces from the center.

11. Select Edit ➪ Paste (Ctrl+V). Another circle is pasted atop the original circle.

12. Select the Move/Selection tool and drag this circle right six grid spaces from the center.

13. Select Edit ➪ Paste (Ctrl+V). Another circle is pasted atop the original circle.

14. Select the Move/Selection tool and drag this circle left six grid spaces from the center.

15. Click the original circle to select it. Drag it down six grid spaces from the center.

16. Click the current camera's name (Front) in the left corner of the modeling box and select Director's Camera to change to the Director's Camera view. Your partially constructed base should resemble Figure 2-3.

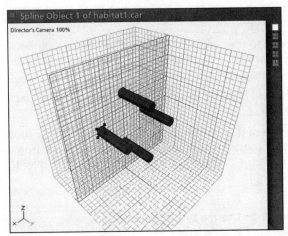

Figure 2-3: The partially constructed base

To complete modeling of the base, you apply an extrusion envelope. Extrusion envelopes consist of four envelope description lines that are manipulated to create the final shape. For the purposes of this exercise, you want the base to be symmetrical, so you need to use a symmetrical extrusion envelope.

17. Select Geometry ➪ Extrusion Envelope ➪ Symmetrical. Four description lines extend from the shapes.

18. Using the Move/Selection tool, click the pink line (the sweep path) on the bottom of the modeling box. Two unfilled black dots appear at the start and end of the sweep path.

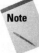

Note Points along a sweep path appear as unfilled dots or circles. When selected, the points become solid black.

19. Click the last dot on the sweep path to select it and drag it six grid spaces to lengthen the shape.

20. Select Sections ➪ Create. This creates a cross section at the end of the sweep path.

21. Select Sections ➪ Create Multiple. The Create Multiple Cross-Sections dialog box appears. Accept the default value of 1 and click OK to apply. A second cross section is created in the middle of the sweep path. If you click the sweep

path, you'll see an additional dot, which designates the new cross section. The individual shapes used to create the cross section are also outlined.

22. Using the Move/Selection tool, click the top blue line on the right plane. This is one of the envelope description lines. Three dots appear, one for each cross section. Select the last dot and drag it inward a few grid spaces. Because a symmetrical extrusion envelope is applied, the other description lines move inward by an equal amount. The partially constructed base should now resemble Figure 2-4.

Figure 2-4: Moving the outer supports of the base inward

The base could support the underwater habitat as is. However, the base will look better if its four legs curve gently inward. To apply a curve to the legs, you need to convert the middle point of the envelope description line, which is currently a corner point, to a curve point. This requires the Convert Point tool, which is on the second tool's fly-out on the top toolbar (see Figure 2-5).

23. Click the small arrow to the right of the second button on the toolbar and click the Convert Point tool to select it.

24. Click the middle point on the top envelope description line and drag outward to convert the corner point to the curve point shown in Figure 2-5.

25. Click the Assemble icon to return the modeled base to the Assemble room.

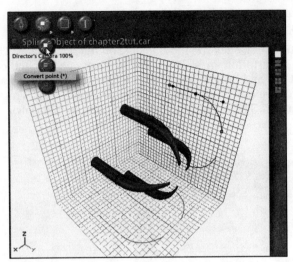

Figure 2-5: Curving the legs of the base with the
Convert Point tool

When the base is returned to the Assemble room, it appears in the same position
that it occupied in the Model room. There are several ways to right the base; here,
you learn how to do so using the Properties tray.

26. Drag open the Properties tray and click the Motion/Transform button. Enter
 the following values in the Transform panel (see Figure 2-6).

 - Center X = 0.00

 - Center Y = 0.00

 - Center Z = 3.50

 - Roll = 90.00

27. Select Edit ➪ Center Hot Point (Ctrl+Alt+H).

Now it's time to put a habitat on top of the base. A sphere is a sturdy structure,
capable of withstanding the pressures of the deep, and therefore an excellent
choice for the habitat.

28. Select Insert ➪ Sphere. A sphere is inserted in the scene, right on top of
 the base.

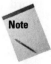

Note You could also insert the sphere by dragging the Sphere tool into the workspace.
Using this method, the sphere is left where you drop it. By using the Insert menu
command, the sphere is aligned in the center of the X and Y axes.

Figure 2-6: Using the Properties tray to right the base

29. Drag open the Properties tray and click the Motion/Transform button. In the Transform panel, change the Size X and Size Y values to 12.00 and change the Center Z value to 4.00. Your completed undersea habitat should resemble Figure 2-7.

Now that the habitat is modeled, it needs a surface texture that is more interesting than its current gunmetal gray.

To apply a surface texture to the model:

1. Drag open the Browser tray and click the Browser: Shaders Button.

2. Click the triangle to the left of the folder named Tutorial Shaders. The folder opens and reveals the tutorial shaders.

3. Click the shader named Habitat, and drag and drop it onto the sphere you just created, as shown in Figure 2-8. Now drag and drop the Habitat shader onto the base to add texture to it.

Tip

To see the components that make up any shader, double-click its thumbnail in the Browser tray to open up the Shader Tree Editor in the Texture room.

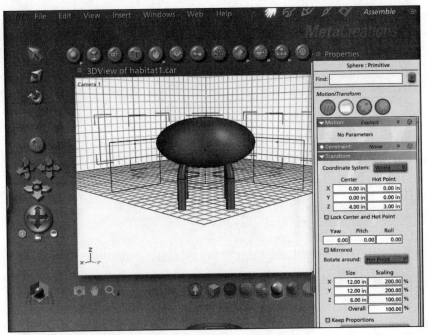

Figure 2-7: The completed undersea habitat

Figure 2-8: Applying a surface texture to the undersea habitat

To finish off the habitat model, display a name on the dome. The technique used to apply the name is similar to the way that decals are applied to a model car or airplane. Carrara's equivalent of a decal is achieved by using a layer shape to apply a texture map.

To name the habitat using a layer shape:

1. Click the dome to select it.

2. Click the Texture icon to open the Texture room. The Edit Shader Habitat Warning dialog box appears. Accept the default option, Create a new master, by clicking OK.

3. The Texture room opens and the Shader Tree Editor appears.

4. Four round buttons appear directly above the Shader Tree Editor. Click the second button to select the Rectangle Layer tool.

5. To the right of the Shader Tree Editor is a small window named Preview: Habitat. The window shows a preview of the shader as it appears on the habitat's dome. Drag the Rectangle Layer tool across the surface of the sphere. A bounding box surrounds the shape as you drag. Make the shape long and narrow (see Figure 2-9).

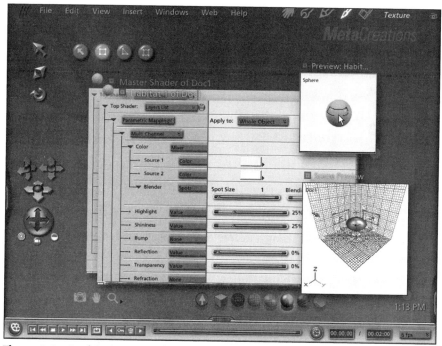

Figure 2-9: Applying a rectangle layer to the habitat's dome

After you add a layer to a shader, it converts to a layer list. The layer just added appears at the bottom of the layer list.

6. Drag the blue scroll bar on the right side of the Shader Tree Editor and find the rectangular layer just added.

7. Click the blue Shader button and choose Texture Map. The Texture Map dialog box appears to the right of the channel.

8. Click the Folder icon. The Open dialog box appears. Find the habitatdecal.tif file from the Chapter 2 folder on the CD-ROM that accompanies this book. Click Open to apply the file to the layer. The Choose File Format dialog box opens. Click OK. In the Filtering panel, select Summed Area Table. Enable the White is Invisible option (see Figure 2-10).

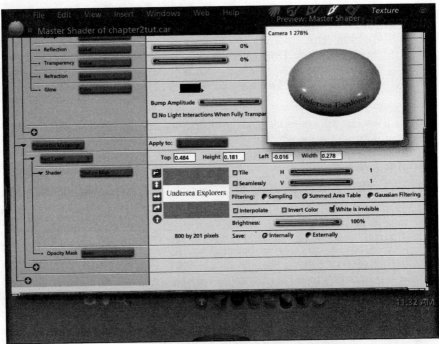

Figure 2-10: Applying a texture map decal to the dome's surface

9. The Preview: Habitat window updates to reveal the texture map as applied to the layer. If the layer looks distorted, click the first button above the Shader Tree Editor to bring up the Select Layer tool.

10. Click the layer inside the Preview: Habitat window to select it. Drag any of the corner handles to resize the layer. To move the layer lower on the sphere, click the center of the layer and drag.

11. Click the Assemble icon to return to the Assemble room.

The habitat consists of two parts, yet in the scene you want to treat it as a unit. Group the sphere and base so that the habitat behaves as a single unit.

To group the sphere and base:

1. Using the Move/Selection tool, select the base.
2. With the base still selected, Shift+click the sphere to select it.
3. Select Edit ➪ Group. The sphere and base are now grouped and behave as one unit.

Click the habitat group you just created and drag it up to move it out of the way. It's time to create the ocean floor for the habitat to rest on and some terrain to surround it.

The ocean floor will be an infinite plane. Although it looks anything but infinite when first introduced into a scene, it will appear to be infinite when rendered. To add the ocean floor, simply select Insert ➪ Infinite plane. The next step is to add texture to the ocean floor.

To apply a texture to the infinite plane:

1. Drag open the Browser tray.
2. Click the Browser: Shaders button.
3. Click the Tutorial Shaders panel to open it.
4. Click the thumbnail preview of the Ocean Bottom shader to select it.
5. Drag and drop the shader on the infinite plane.

Now that the ocean floor is textured and in place, it's time to position the habitat.

To position the habitat:

1. Using the Move/Selection tool, click the habitat group to select it.
2. Drag open the Properties tray and click the Motion/Transform button.
3. In the Transform panel, enter the following values:
 - Center X = 0.00
 - Center Y = 0.00
 - Center Z = 5.25
4. The habitat is placed in the center of the scene on top of the infinite plane.

Terrain objects will be used to create some reef material around the habitat. Carrara terrain objects can be used to simulate anything from sand dunes to mountain peaks.

To add a terrain to the scene:

1. Select Insert ⇨ Terrain. The Terrain dialog box appears.

2. Accept the default terrain size of 20 × 20 × 8 and select the following options:

 - Enable the Smooth Normals option.
 - Click the Rendered Mesh Density button and choose 512 × 512 (see Figure 2-11).
 - Click the Edit button. The Mesh Save dialog box appears. Accept the default name for the mesh and click Save.

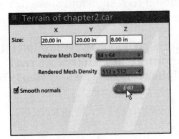

Figure 2-11: Setting mesh options for a terrain

3. The Four Elements: Earth modeler opens. Click the Generate tab and select Real terrain. A terrain is generated, as shown in Figure 2-12.

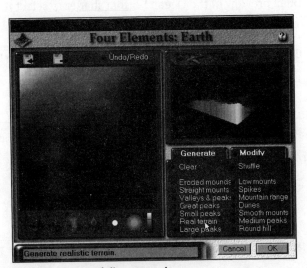

Figure 2-12: Modeling a terrain

4. Click the Modify tab and select Zero edges.

5. Click OK to generate the terrain.

6. Click the Assemble icon to return to the Assemble room.

7. Click the Camera 1 title in the left corner of the working box to reveal the drop-down camera list.

8. Select Top.

9. Using the Move/Selection tool, drag the terrain behind the habitat.

10. Apply the Ocean Bottom shader to the terrain using the same method that you used to shade the infinite plane.

11. Select Edit ➪ Duplicate to create another terrain.

12. Using the Move/Selection tool, drag the new terrain to the right.

13. Select Edit ➪ Duplicate to create another terrain.

14. Using the Move/Selection tool, move the new terrain to the right and forward. Use Figure 2-13 as a guide for positioning the terrains.

15. Click the current Camera's name (Top) to reveal the drop-down camera list. Click Camera 1 to return to the rendering viewpoint.

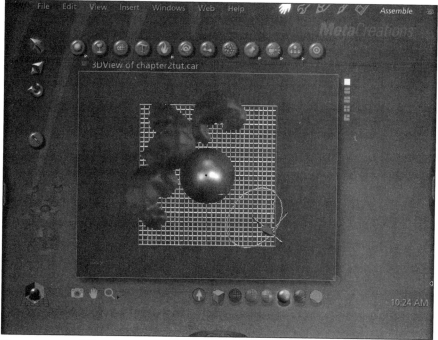

Figure 2-13: Adding three terrains to the underwater scene

In the Objects Tutorial folder you added to the Browser, you'll find a model of a miniature sub and some fish models that you will use to finish off the scene. The minisub model is completely textured and ready to add to the scene.

To add the minisub to the scene, select Browser: Objects ➪ Tutorial Objects. Click the thumbnail preview of the minisub and drag it into the working box. Drag open the Properties tray, click the Motion/Transform button, and in the Transform panel enter the following coordinates for the minisub's position:

✦ Center X = 0.00

✦ Center Y = 0.00

✦ Center Z = 2.00

✦ Yaw = -50.00

The minisub should appear directly underneath the habitat.

Drag one of the fish models from the Tutorial Objects folder in the Browser tray into the scene and position it directly over the habitat using the Move/Selection tool. You'll need to switch to different camera viewpoints to accurately place the fish. Instead of latching directly onto the fish model, click its silhouette on one of the plane walls. This enables you to accurately place the model within the selected plane's axis. If you have difficulty placing the fish, drag open the Properties tray, click the Motion/Transform button, and in the Transform panel enter the following coordinates:

✦ Center X = 4.00

✦ Center Y = 3.00

✦ Center Z = 11.00

✦ Roll = 12.00

Caution If you're not careful as you drop an item into the scene, it can wind up beyond the bounds of the working box. If this happens, drag open the Properties tray, click the Motion/Transform tab, and change the object's X, Y, and Z coordinates to 0. Alternatively, you can select Edit ➪ Send to Origin (Ctrl+Shift+O). This returns the object in the center of the scene.

Once the scene objects are in place, it's time to address scene lighting. The default lighting option in a new document is Distant light. For the underwater scene, you'll be using the Properties tray to convert the Distant light to a Spot light.

To set up scene lighting:

1. Drag open the Properties tray.

2. Click the small blue button with the downward-facing double arrow and select Light 1. Click the General button.

3. In the Light panel, select Spot. The Distant light is converted to a Spot light.

4. Drag the Brightness slider to 140 percent. Leave the rest of the settings at their default values.

5. Click the Motion/Transform button and enter the following values (see Figure 2-14):

 - Center X = 12.00
 - Center Y = 14.00
 - Center Z = 25.00
 - Yaw = 140.00
 - Roll = 42.00

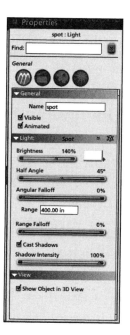

Figure 2-14: Adjusting the light's settings with the Properties tray

Cross-Reference

For more information on setting up scene lights, refer to Chapter 7.

To simulate sunlight filtering down through the ocean waves, apply a gel to the light. A gel is similar to a slide. It projects a pattern as the light filters through it. The brightness of the light projected depends on the areas of dark and light in the gel.

To add a gel to the light:

1. In the Properties tray, click the Effects button that resembles a starburst.

2. In the Gel panel, select Gel ⇨ Map. A dialog box appears in the panel.

3. Click the Folder icon. The Open dialog box appears. Locate the file named water4.tif from the Chapter 2 folder in the Contents section of the CD-ROM. Click Open to apply the image as a gel. The File Format dialog box appears. Click OK.

4. While you're in the Effects section, set shadow options for the light. From the Shadows panel, select Soft Shadows. The Soft Shadows dialog box opens in the bottom of the Spot: Light panel. Accept the default settings (see Figure 2-15).

Note The Soft Shadows effect produces shadows that blend gradually between areas of light and shadow, as opposed to the harsh transitions a ray-traced shadow provides. Soft shadows produce pleasing results but take longer to render.

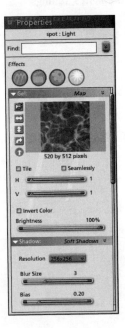

Figure 2-15: Adding a gel to the light and adjusting shadow settings

The last scene item to add is a Spot light to illuminate the stationary minisub. To simulate the effect of light bouncing off particles in the water, use the Light Cone effect.

To add the Spot light to a scene:

1. Select Insert ⇨ Spot. The Spot light appears directly beneath the habitat.
2. Drag open the Properties tray, click the Motion/Transform button, and adjust the Center Z position of the light to 6.20 inches.
3. Click the General button.
4. In the Light panel, drag the Brightness slider to 55 percent.
5. Drag the Half Angle slider to 25.
6. Drag the Angular Falloff slider to 30 percent.
7. Enter a value of 30 for Range.
8. Drag the Range Falloff slider to 25 percent.
9. Click the Effects button, select Soft Shadows in the Shadows panel, and accept the default settings.
10. In the Light Cone panel, click Enable to select the Light Cone option, and then click the Edit button. The Light Cone dialog box appears. To the right of the dialog box, a thumbnail preview of your scene appears (see Figure 2-16). This may take a few seconds depending on the speed of your computer.

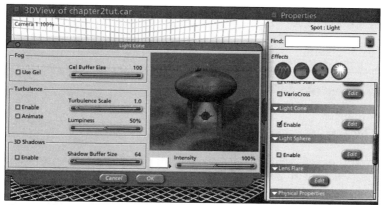

Figure 2-16: Adding the Light Cone effect to a Spot light

11. Accept the default settings and click OK to apply.

Now all that's left to do is adjust the camera viewpoint, set up the rendering, and render the image. Use a Production Frame as a viewfinder to frame the scene in the way you want it to be rendered. Normally, you'd use the Dolly and Track tools to adjust camera position. For the purpose of this tutorial, you use the Properties tray to precisely adjust the rendering camera's position.

To adjust rendering camera position:

1. Click the current camera's name to reveal the camera list. Click Camera 1 to select it.

2. Select View ⇨ Show Production Frame. A Production Frame surrounds part of the scene.

3. Drag open the Properties tray.

4. Click the small blue button with the downward-facing double arrow in the top-right corner of the tray.

5. Click Camera 1. Camera 1's properties appear.

6. Click the Motion/Transform button.

7. In the Transform panel, enter the following values to adjust the camera's position. Enter the Yaw and Roll values first.

 - Yaw = 138.00
 - Roll = 80.00
 - Center X = 22.00
 - Center Y = 29.00
 - Center Z = 13.25

8. Click the General button.

9. In the Camera panel, click Zoom and drag the slider to 60.

Notice how the viewpoint changes as you enter new values. The framed scene should look like Figure 2-17.

After rendering the scene, you're encouraged to experiment on your own using the Dolly and Axis Track tools to adjust camera viewpoint.

Cross-Reference For more information on aiming cameras and adjusting viewpoints, refer to Chapter 6.

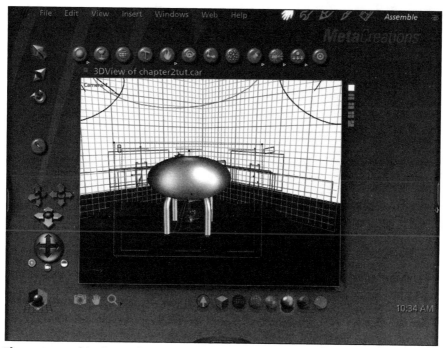

Figure 2-17: This shows the rendering viewpoint after adjusting the camera. Notice the Production Frame that surrounds the area to be rendered.

Rendering your first scene

Now comes the moment you've been waiting for: rendering the scene. In a few minutes, you'll be able to view a photo-realistic rendering of your first Carrara scene.

To set up the rendering:

1. Click the Render icon to open the Render room.

2. Drag open the Properties tray and click the Renderer Settings button.

Note

In the Render room, the Properties tray has three sections: Renderer Settings, Output Settings, and Progress/Statistics. Use the three round buttons at the top of the Properties tray to navigate between sections.

3. In the Renderer panel, select Ray Tracer. The Ray Tracer is Carrara's best renderer (see Figure 2-18).

Figure 2-18: Adjusting Renderer settings

4. In the Adaptive Oversampling panel, select Best.

5. Drag the Maximum Ray Depth slider to 25. This setting gives the best image quality when objects have reflective surfaces.

6. Click the Output Settings button.

7. The default output settings are good for general monitor viewing. If you have a large monitor, you may want to adjust the settings to render a larger image. In the Image Size panel, enable the Keep Proportions box before changing any of the settings to keep the rendered image at the same proportions you framed in the Assemble room. If you intend to print the image on an output device such as an inkjet printer, adjust the Resolution setting to match your output device (see Figure 2-19).

8. Drag open the Render tray (the Sequencer tray is referred to as the Render tray in the Render room).

9. Click the Render button and watch the scene render before your eyes (see Figure 2-20).

Figure 2-19: Adjusting output settings for the rendered image

Figure 2-20: Rendering the scene

Saving the rendered image

After rendering a scene, the image should be saved for future use. Specify the filename, file location, and file format prior to saving.

To save a rendered image:

1. After the image has rendered, select File ⇨ Save as. The Save as dialog box appears.

2. Enter a name for the file.

3. Choose a file format from the drop-down menu in the Save as type field.

4. Select a directory to save the file in.

5. Click Save to save the image.

Figure 2-21 shows the final, saved rendering of the underwater scene.

Figure 2-21: The rendered image of the underwater scene

Tip Many 3D artists render a scene in progress and use it as system wallpaper. When their computer is first turned on, they can study the image and think of possible enhancements before going back to work on the scene.

Congratulations! Completing the undersea tutorial is the first step toward mastering Carrara. Before reading on, take a look at the rendered image. Notice how the gel you placed over the light created the dappled wave shadow pattern on the sandy bottom. Notice how the Distant Fog effect you added to the scene's atmosphere tricks you into believing the rendering is an actual picture taken underwater.

Saving the scene

After scenes are created in Carrara, they can be saved for future use. When a scene is saved, all scene objects and settings are stored in a single file. When the file is reopened, everything is where it was when the file was saved. The scene you just worked so diligently on will be used to create an animation in Chapter 3, so follow the steps presented here to save your file.

To save a scene:

1. Click the Assemble icon to return to the Assemble room.
2. Select File ⇨ Save as. The Save As dialog box opens (see Figure 2-22).
3. Enter a name for the file and choose a directory to save it in.

Figure 2-22: The Save As dialog box

4. Click Save to save the file. The Carrara Export dialog box opens (see Figure 2-23).

5. In the Texture Map panel, choose from the following options:

- **Save all internally:** This option keeps the texture map file as a part of the scene file. If you ever move the texture map file on your hard drive or remove it, a copy of the original file is still stored with the scene file.

- **Use local settings:** This option uses the settings in effect when the file was last saved. In the event that this is the first time you've saved the file, Carrara will use the settings specified wherever you added a texture map to the scene.

- **Save all externally:** The option records the location on your hard drive where scene texture maps are stored. If you choose this option and a texture map file is moved after saving the scene, a dialog box appears prompting you to locate the file next time you open the scene.

6. Add any comments you'd like to save with the file.

7. Click OK to save the file.

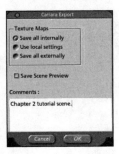

Figure 2-23: Specifying file export options

Summary

Carrara's 3D studio has all the tools you need to create a complete scene. Populate a scene with preset objects or objects created in one of Carrara's three modelers. Scene objects can be textured using preset options from the Browser or with custom shaders created in the Texture room. Lights can be added and positioned as needed to highlight scene objects.

✦ Objects inserted into a scene using menu commands are positioned in the center of the scene.

✦ Texture maps can be used as decals to apply labels or names to scene objects.

✦ The Properties tray is used to add special effects to scene lighting.

✦ The Browser tray is used to insert saved objects into a scene.

✦ Preset objects such as spheres and cubes can be added to modeled objects to create scene objects.

✦ Grouped objects behave as a single unit.

✦ Scene settings can be used to simulate different environments.

✦ Cameras are precisely aimed to frame the scene before rendering.

✦ ✦ ✦

Creating Your First Animation

Animations are everywhere. You see them on Internet Web pages, as part of client presentations, in television commercials, and in movie blockbusters such as *Antz* and *Toy Story*. Animations are often the most misunderstood part of the 3D process. Coordinating motion, lighting, and scene characters can be a daunting task, even for an experienced 3D artist. This chapter introduces you to the basics of creating an animation. You finish the chapter off by bringing the underwater scene you created in the last chapter to life.

How Animation Works

3D animation is the process of creating and recording action through time. To animate a 3D scene, objects are moved or changed during the length of the animation. This motion is recorded frame by frame. When the rendered frames are sequenced and played back, action occurs.

Carrara has four different motion methods: Explicit, Motion Path, Physics, and Still. Explicit uses key frames to designate major changes in an object's animatable characteristics. Motion Path also uses key frames, but the object moves along a user-drawn path. Physics animates an object by applying the laws of physics to the particular force applied. The Physics motion method does not use key frames. When the Still motion method is applied to an object, the object does not move during the animation.

The Explicit motion uses a technique known as *key frame animation* (also known as *key event animation*). Every time a major change occurs, a key frame is created.

To discover how key frame animation works:

1. Launch Carrara and create a new document.

2. Insert a sphere into the scene.

3. Drag open the Sequencer tray.

The sphere's name is highlighted in a part of the Sequencer tray known as the *Universe list*. To the right of the sphere's place in the Universe list is its timeline. Take a look at Figure 3-1 to familiarize yourself with the animation timeline. This is where all of the sphere's animatable characteristics are recorded as they change during the course of an animation.

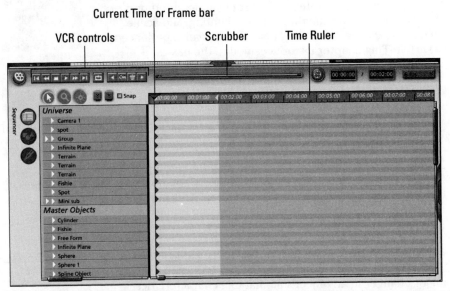

Figure 3-1: The animation timeline

The long line with the downward-facing triangle that runs from the timeline's top to bottom is known as the *Current Time or Frame bar*. The line with hash marks at the top of the timeline is called the *Time Ruler*. Each small hash mark indicates an individual frame. You'll find the time markers immediately above the Time Ruler's large hash marks. The default length for a Carrara animation is two seconds. Notice that two seconds of the Time Ruler are highlighted in yellow. There are six hash marks between the start of the animation and the one-second mark on the Time Ruler, which indicates the frame rate for a default animation is six frames per second.

To learn how an animation is made:

1. Drag the Current Time bar to the one-second mark on the Time Ruler.
2. Using the Move/Selection tool, drag the sphere anywhere within the working box.
3. Drag the Current Time bar to the two-second mark on the Time Ruler.
4. Drag the sphere to another spot in the working box.

Examine the timeline a bit closer (see Figure 3-2), and you'll notice that the sphere's timeline is now a darker color. This indicates that animation has taken place. The upright arrows located at the one- and two-second marks on the timeline indicate the points in the animation when you moved the sphere. These arrows are known as *key frame markers*. Between each key frame is a slanted white line, known as a *Tweener*. A Tweener controls the transition between key frames. Tweeners can be edited to provide smooth transitions or abrupt transitions. They can also be used to repeat motion between key frames.

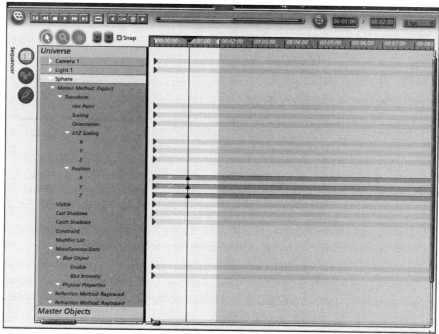

Figure 3-2: Expanding the sphere's hierarchy to show all its animatable properties.

To the left of the sphere's place on the Universe list is a triangle. Click it to expand the sphere's hierarchy. The hierarchy shows all of the sphere's properties that are subject to animation.

At the upper middle of the Sequencer tray, you'll see a slider called the *Scrubber*. Drag the Scrubber to advance the animation. Drag it to the left, and the sphere returns to its original position. Drag it to the right, and you'll see the sphere move through the scene. The blue buttons to the left of the Scrubber are VCR controls. These are used to preview the animation in the working box.

Animating Your First Scene

For your introduction into the world of 3D animation, you animate the underwater scene that you created in the previous chapter. As the animation begins, the fish on top of the habitat swims out of frame. After the fish is out of view, the light underneath the habitat comes on. The minisub then starts moving toward the camera and continues past it.

Setting up the animation

Before a scene can be animated, it needs to be set up. This involves setting up the timeline by specifying the length and frame rate of the animation.

To set up your first animation:

1. Select File ➪ Open. The Open dialog box appears. Locate the scene file you saved in the last chapter and click Open to load it.

2. After the file loads, drag open the Sequencer tray.

3. Notice that two seconds of the Time Ruler are highlighted in yellow. That is the current length or render range of the animation. Your first animation will last three seconds. To set the time of the animation, drag the yellow triangle on the right to the three-second mark on the Time Ruler. The highlighted area on the Time Ruler now extends to three seconds.

4. Enable the Snap option by clicking the box located to the left of the Time Ruler. This option snaps key frame markers to the borders of frame markers as you drag them. Enabling this option makes it easier to coordinate events between different objects at the same key frame in the animation.

5. The frame rate for your animation will be 15 frames per second (fps). To set the frame rate, click the blue button in the upper-right corner of the Sequencer tray and select 15 fps from the drop-down list shown in Figure 3-3.

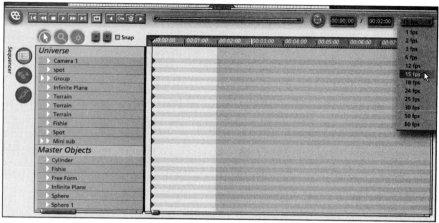

Figure 3-3: Setting up the animation

After setting up the basic animation, it's time to add some motion to the scene. If you saved the Chapter 2 tutorial scene right after rendering, you'll be viewing the scene through the rendering viewpoint for Camera 1. If not, select Camera 1 by clicking its name in the Universe list. Drag open the Properties tray, click the Motion/Transform button, and adjust the camera's settings as follows. Enter the Yaw and Roll values first.

✦ Yaw = 138.00

✦ Roll = 80.00

✦ Center X = 22.00

✦ Center Y = 29.00

✦ Center Z = 13.25

After switching to Camera 1, select View ➪ Show Production Frame (Ctrl+Alt+F). The Production Frame viewfinder surrounds the scene as it will be framed for animation. Begin the animation by having the fish swim out of frame. To animate the fish:

1. Drag open the Sequencer tray.

2. Click the fish's name from the Universe list to select it.

3. Drag the Current Time bar to the one-second mark.

4. Click the Move/Selection tool to select it.

5. Click the fish's silhouette on the right wall and drag until the 3D fish moves beyond the Production Frame. If you reach the end of the working box before dragging the fish beyond the Production Frame, press the spacebar and hold while dragging left to pan the view. After panning, release the spacebar and continue moving the fish. A key frame marker occurs at the one-second mark on the fish's timeline (see Figure 3-4).

6. After moving the fish, drag the Scrubber backwards to reset the timeline to frame zero.

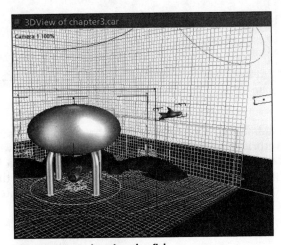

Figure 3-4: Animating the fish

Refining an animation

Click the play button on the VCR control to preview the animation so far. The fish should move smoothly out of frame. The only problem with this motion is that the fish is moving but doesn't appear to be swimming. Use a modifier to simulate a fish's swimming motion. In this case, you apply the Wave modifier to the fish and change the modifier's parameters while the fish moves out of frame. Before applying the modifier to the fish, drag the Scrubber backwards to reset the animation to frame zero.

To apply the Wave modifier to the fish:

1. With the fish still selected, drag open the Properties tray.

2. Click the Modifiers button to open the Modifiers list.

3. Click the + button and select Waves ⇨ Wave. The Wave modifier dialog box opens, as shown in Figure 3-5.

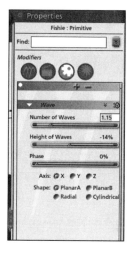

Figure 3-5: Applying the Wave modifier to make the fish swim

 4. Select the X Axis and leave the other settings at their default values.

 5. Drag open the Sequencer tray.

 6. Click the Current Time bar and drag it to the one-second mark.

 7. In the Properties tray, drag the Number of Waves slider to 1.15 and the Height of Waves slider to -14. Close the Properties tray.

Drag the Scrubber backwards to reset to frame zero. Click the VCR control Play button to preview the fish's motion. This is an improvement, but it's still not right. The fish only undulates once as it swims out of frame. You need to apply the Oscillate Tweener to make the fish swim. The Oscillate Tweener cycles through the changes applied from one key frame to the next. By setting the number of oscillations, you can control how many times the cycle repeats itself.

To apply the Oscillate Tweener to the Wave modifier:

 1. Drag open the Sequencer tray.

 2. Click the fish's name in the Universe list to select it.

 3. Click the triangle to the left of the name to expand the fish's hierarchy of animatable events, as shown in Figure 3-6.

 4. Click the triangle to the left of the Modifier list to expand it. You'll see the Wave modifier listed with a key frame at the one-second mark. Between frame zero and the one-second mark is a white slanted line that indicates the modifier's Tweener.

 5. Click the Tweener to select it. It becomes highlighted in yellow.

 6. Drag open the Properties tray. The default Tweener, Linear, is displayed.

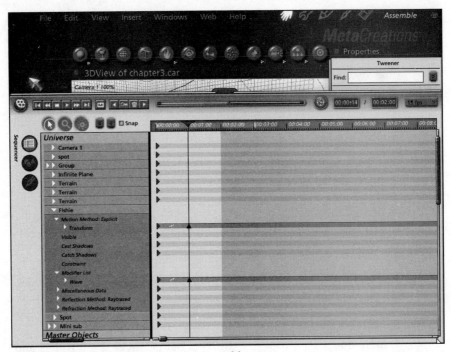

Figure 3-6: The fish's hierarchy of animatable events

7. Select Tweener ➪ Oscillate. The Oscillate Tweener dialog box opens (see Figure 3-7).

8. Drag the Number of Oscillations slider to 3.

9. The Oscillate Tweener is applied to the Wave modifier. Notice that the Tweener symbol changed from a slanted line to a squiggly line. Each Tweener uses a slightly different symbol to make them easier to differentiate.

10. Click the triangle to the left of the fish's name to collapse the hierarchy.

Drag the Scrubber backwards to reset the animation and click the VCR Play button. The fish swims smoothly out of frame.

Animating a light

The next item you're going to animate is the light. After the fish swims out of frame, draw the viewer's attention back to the minisub by turning on the light. The first step in animating the light is to turn it off at frame zero. To turn the light on at the one-second mark, you create a key frame. The default Tweener would have the light gradually brighten between frame zero and the one-second mark. Use the Discrete Tweener to turn the light on instantly.

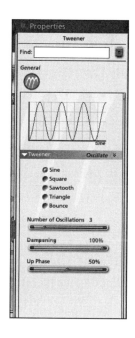

Figure 3-7: Applying the Oscillate Tweener to make the fish swim smoothly

To animate the light:

1. Drag open the Sequencer tray and click the last item named Spot on the Universe list.

2. Drag open the Properties tray.

3. In the Light panel, drag the Brightness slider to 0.

4. In the Sequencer tray, drag the Current Time bar to the one-second mark.

5. In the Properties tray, drag the Brightness slider to 55. The light is now animated to change from 0 percent brightness at frame zero to 55 percent brightness at the one second mark.

6. In the Sequencer tray, click the Spot light's Tweener. The Tweener panel opens in the Properties tray.

7. In the Properties tray, select Tweener ➪ Discrete. The Discrete Tweener panel opens (see Figure 3-8).

8. Accept the default setting and the light will turn on instantly at the one-second mark.

Observe the Discrete Tweener's symbol on the timeline. Notice how it differs from the Oscillate Tweener's symbol.

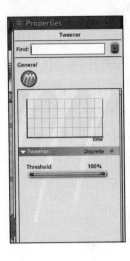

Figure 3-8: Using the Discrete Tweener to turn on a light instantly

You may be wondering why you didn't have to expand the Spot light's hierarchy as you did with the fish. The reason for this is only one property of the Spot light was animated: brightness. In the case of the fish, two properties were animated: the fish's position in the scene and the modifier applied to the fish. If the Oscillate Tweener had been applied to the entire fish instead of just the Wave modifier, the fish would have moved in and out of frame three times in addition to undulating from side to side.

Setting additional objects in motion

The next step is to set the minisub in motion. The minisub needs to remain stationary while the fish swims out of frame. Between second one and second three of the animation, the sub will approach the camera. To keep the minisub docked while the fish swims away, you need to create a key frame at the one-second mark.

To create the minisub's key frame at the one-second mark:

1. Click the minisub's name in the Universe list.

2. Drag the Current Time bar to the one-second mark.

3. Click the Create Key Frame tool (the button with the key icon to the right of the VCR controls) to create a key frame. Notice the upright arrow that appeared after you created the key frame. This is called a *key frame marker* (see Figure 3-9).

To animate the minisub, you create a motion path. Before you can create the motion path, you need to change the sub's motion method to Motion Path.

Key frame markers

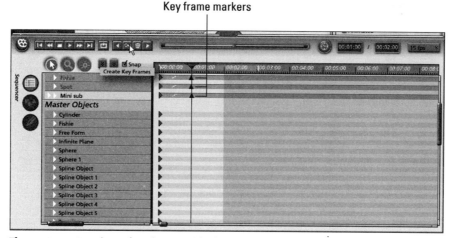

Figure 3-9: Creating a key frame with the Key Frame tool

To change the minisub's motion method:

1. Click the minisub's name in the Universe list.

2. Drag open the Properties tray.

3. Click the Motion/Transform button and select Motion ➪ Motion Path. The Convert Animation Method dialog box appears. Accept the default setting and click OK. The Motion Path panel appears, as shown in Figure 3-10.

4. Select the Align and Bank option.

After transforming an object's motion method to Motion Path, four tools appear in the left-hand corner of the interface. These tools are used to create and edit a motion path.

Switch to the top view by clicking the current camera's name (Camera 1) in the upper-left corner of the working box and selecting Top. Now you can't see the sub because of all the other objects in the working box. However, you're going to hide some of the objects from view to make it easier to create a motion path for the sub.

To hide an object from view:

1. Using the Move/Selection tool, click the object to select it.

2. Select Edit ➪ Hide/Show in 3D View. The selected object disappears.

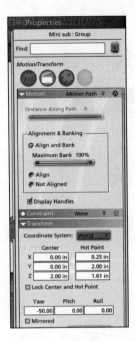

Figure 3-10: Changing an object's method of motion

Use the preceding steps to hide all objects from 3D view except the minisub and Camera 1. If an object is difficult to select, click its name in the Universe list and then apply the Hide/Show in 3D View command. Click the Pan tool (the hand icon below the working space) and drag inside the working box until both the minisub and camera are in view. When you're finished, the working box should resemble Figure 3-11.

Figure 3-11: Hide scene objects from 3D view to make it easier to draw the motion path.

Now you're going to draw a motion path from the minisub to the camera.

To create the minisub's motion path:

1. Using the Move/Selection tool, click the sub to select it. The drawing tools appear on the left-hand side of the interface.

2. Click the Extend tool (the tool that resembles a pen) to select it.

3. Click inside the working box just beyond the sub to create the first point of the motion path.

4. Create another point to extend the motion path towards the camera. The partially constructed motion path should resemble Figure 3-12.

Figure 3-12: Laying out the motion path with the Extend tool

The motion path will lead the sub right towards the camera, but the points must be converted to curve points to smooth the path. To accomplish this, use the Convert Point tool. The Convert Point tool is located above the Extend tool on the motion path drawing toolbar.

To smooth out the minisub's motion path:

1. Click the Convert Point tool to select it.

2. Click and drag the first point to smooth the motion path (see Figure 3-13).

That aligns the motion path from the top view. If the motion path is left as is, the sub will drop and move parallel to the ocean floor. To have it rise up towards the camera, it has to be edited from another viewpoint.

Figure 3-13: Use the Convert Point tool to smooth the motion path.

To align the minisub's motion path from the Left view:

1. Click the current camera's name and select Left from the drop-down menu to switch to the Left view.

2. Click the Pan tool and drag inside the working box until both the minisub and camera are visible.

3. Click the Move/Selection tool to select it and drag each of the motion path's points so the minisub rises toward the camera.

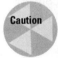

Caution

Be sure to select the center point as one or both of the point's handles may be visible. If you latch onto one of the handles instead of the actual point, you'll change the curve of the motion path instead of its trajectory.

4. With the Move/Selection tool still selected, drag each point's handles to smooth out the motion path. The edited motion path should resemble Figure 3-14.

The next step is to create key frames and move the minisub along the motion path. Before creating new key frames, click the current camera's name and select Camera 1 from the drop-down menu to view the scene from the rendering position.

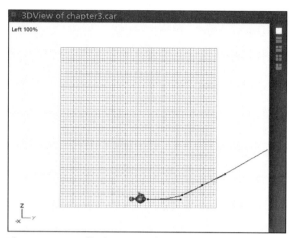

Figure 3-14: Edit the minisub's motion path so it rises towards the camera.

To apply the minisub's motion path to key frames:

1. Drag open the Sequencer tray.

2. If it's not already selected, click the minisub's name in the Universe list.

3. Drag the Current Time bar to the two-second mark.

4. Drag open the Properties tray.

5. Click the Motion/Transform button.

6. Drag the Distance Along Path slider to move the minisub along the motion path. A key frame is automatically created at the two-second mark (see Figure 3-15).

7. In the Sequencer tray, drag the Current Time bar just past the three-second mark.

8. In the Properties tray, drag the Distance Along Path slider to move the minisub beyond the Production Frame. A key frame is automatically created just beyond the three-second mark.

Tip Always create the last motion change just past the end of the animation. This allows the object to complete all motion within the render range of the animation. If the final motion is created at the end of the animation, you risk losing the last motion sequence. This technique is known as *follow-through*.

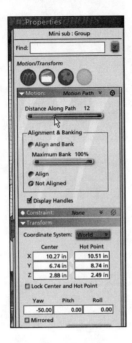

Figure 3-15: To put the minisub in motion, drag the Distance Along Path slider.

Drag the Scrubber to reset the animation to frame zero. Click the VCR Play button to preview the minisub's motion. If the sub doesn't move and rise smoothly, drag the Scrubber to reset the animation to frame zero and select Edit ➪ Center Hot Point to center the sub's hot point. Remember that all motion revolves around the object's hot point. Any time you encounter erratic motion in an animation, an object's hot point may not be properly aligned.

Rendering the animation

If the sub's motion isn't to your liking, edit the motion path by switching back and forth between the Top and Left views. When you're satisfied with the minisub's motion, it's time to reveal all the objects in the scene and render the animation. To unhide the objects, select their names from the Universe list and select Edit ➪ Hide/Show in 3DView. The objects become visible again.

 Tip To select more than one item from the Universe list, click to select the first item and then Shift+click to add items to the selection.

To render the scene:

1. Click the Render icon to open the Render room.

2. Drag open the Properties tray. The Renderer Settings section of the Properties tray should be displayed. Accept the default values.

3. Click the Output Settings button (the second round button at the top of the Properties tray).

4. Click the triangle to the left of Image Size to expand the panel.

5. Enter a value of 320 for Width and 240 for Height.

6. Click the triangle to the left of File Format to expand the panel. Your output settings for File Format should resemble those shown in Figure 3-16. If not, enter values to match the ones in the figure.

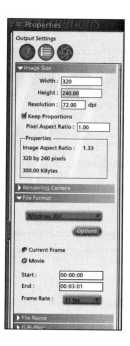

Figure 3-16: Adjusting output settings prior to rendering the animation

7. Drag open the Sequencer tray.

Note

The Sequencer tray is known as the Render tray in the Render room.

8. Click the Render button. The animation starts to render frame by frame (see Figure 3-17). Depending on the speed of your computer, this could take some time.

Figure 3-17: Rendering the scene

9. When the file has finished rendering, you can play it by clicking the play button in the lower-left corner of the rendered animation window. To stop the animation, click the stop (solid rectangle) button. To preview the animation as a continuous loop, click the loop button. If the animation is to your liking, save it by selecting File ➪ Save As. The Save As dialog box appears.

10. Select a directory to save the animation in and name it. Click OK to save the animation.

11. Click the Assemble icon to return to the Assemble room.

12. To save the animation scene file, select File ➪ Save As. The Save As dialog box appears.

13. Select a directory to save the scene file in and name it. Click OK to save the scene file.

Congratulations! By completing the undersea animation, you've learned how to use two of Carrara's motion methods. The rendered animation looks good, but you've just skimmed the surface of Carrara's animation capabilities. Stay tuned to learn more about animation in upcoming chapters.

Summary

Carrara generates animations by creating key frames where major changes in an object's animatable properties occur. The transition between key frames is interpolated to create motion. The type of Tweener applied determines how the transition occurs. Animations can also be created by using the Motion Path or Physics method of motion.

✦ Animations are sequenced scene frames that when compiled and played exhibit action.

✦ Key frames are automatically created at the point on an object's timeline where an animatable property is changed.

✦ An object's hierarchy reveals all of its animatable properties.

✦ A Discrete Tweener creates an abrupt change from one key frame to the next.

✦ An Oscillate Tweener cycles between two key frame values a specified number of times.

✦ Objects can be hidden from 3D view to reduce screen clutter when editing individual objects.

✦ Motion paths can be created with drawing tools.

✦ ✦ ✦

Getting Started in the Assemble Room

The Assemble room is where a project begins when you create a new document, and most of your work in Carrara is done there. In the Assemble room, you introduce objects into the working box and align objects after applying surface textures in the Texture room.

The building blocks of a Carrara scene are all available in the Assemble room. All the commands and tools needed to create and assemble scenes are conveniently laid out for you. And if you don't like the way the workspace is laid out, it's fully customizable to your work habits.

Scene objects are cataloged in the Sequencer tray, which is accessed by clicking and dragging the blue button at the bottom of the interface. Information about an object's size and position are conveniently stored for easy retrieval in the Properties tray, which is accessed by clicking and dragging the button on the right-hand side of the interface. Within the Browser tray are catalogs of objects, modifiers, effects, shaders, and constraints, which can be added to a scene. Access the Browser tray by clicking and dragging the blue button on the left-hand side of the interface.

Exploring the Workspace

Each time you launch a new document in Carrara, the Assemble room opens up (see Figure 4-1). The largest component of the Assemble room is the 3D working box. The working box is composed of a ground plane and one plane each for the X, Y, and Z axes. In order to find your way around the working box,

it's important to know that the X axis goes from left to right, the Y axis goes from front to back, and the Z axis goes up and down. In case you lose your way, there's a convenient little icon in the lower-left corner of the working box with the direction of each axis mapped out. Each of the Assemble room's tools is covered in detail when the need arises. The purpose of this section is to orient you to where things are located in the Assemble room.

Figure 4-1: The Carrara Assemble room

The row of menus displayed across the top of the Assemble room will help you insert objects into your scene and perform other tasks. Use the set of icons located to the right of the menus to navigate from room to room. The title of the current room is displayed next. The icon on the far right, resembling an eye, is used to minimize Carrara.

You use the row of buttons located right above the working box to insert objects into the working box.

The three tools you use to scale, rotate, move, and select items can be found to the left of the working box. The tool represented by a double-headed arrow is used to

scale objects. The tool displayed as a curved arrow enables you to rotate objects. Use the tool represented by an arrow to move and select objects.

The Eyedropper tool is used to capture an object's texture and transfer it to another object. The set of tools below the Eyedropper tool are used to change your view in 3D space by moving the current camera, the one through which the scene is being viewed. The three tools that look like four-headed arrows are the Track tools. These tools are used to move the camera along the horizontal, vertical, and depth tracks. The large sphere with four arrows embedded in its face functions as a Dolly, Pan, or Bank tool.

Below the Track and Dolly tools, you should see a miniature version of the working box, called the Working Box Control. Click any plane to make it the active plane. This tool has more significance in other rooms; for now, just remember where it is.

Note the clock located at the bottom-right corner of the Assemble room. It is carried over into every other Carrara room and helps you monitor the time you've spent in 3D land.

The bottom row of tools is covered later in this chapter.

Customizing the workspace

As nice as the workspace is, it is not perfect for everyone's working habits. Luckily, you can move everything except the menus and the icons across the top of the Assemble room to suit your working habits. To move a toolbar, press Alt and drag it to a new position. The toolbar directly atop the working space can be rotated 90 degrees by holding down Ctrl+Shift+Alt and dragging the toolbar left or right. Use the same technique to rotate the Move, Scale, Rotate, and Preview Mode toolbars 90 degrees.

The Browser, Sequencer, and Properties trays can be undocked and moved anywhere within the workspace. To undock a tray, click the tray to select it, and then press Ctrl while dragging the tray to a new position. After undocking a tray, a circular white tab appears at the bottom-right corner of the tray. Click and drag the tab to resize the tray. To dock a tray, click to select it, and then press Ctrl and drag the tray to a workspace edge.

Note You cannot dock a tray to the top edge of the workspace. This is reserved for menu items. You can switch the docking positions of the Browser and Properties trays, but you cannot assign a new docking position to the Sequencer tray.

Whenever you drag open a tray, you'll notice a white button to the immediate left of the tray's name. Click this button to close the tray. In fact, you can click this button any place you see it displayed to close an open document or window.

Adding Primitive Objects to Your Scene

Now that you know your way around the Assemble room, it's time to explore some of the toolbars lurking about the perimeter of the working box. Carrara has many primitive objects that are anything but primitive and can be used to good effect when creating a scene. For example, a textured sphere primitive can be used to simulate a planet. Click the small arrow to the lower right of the Sphere tool button (the first tool on the toolbar just above the working box) to expand the Geometric Primitives toolbar (see Figure 4-2).

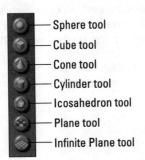

— Sphere tool
— Cube tool
— Cone tool
— Cylinder tool
— Icosahedron tool
— Plane tool
— Infinite Plane tool

Figure 4-2: The Geometric Primitives toolbar

With the exception of the icosahedron, geometric primitives may seem fairly mundane. Think of these shapes as building blocks that can be combined to create interesting models. You use these shapes in conjunction with models you build from scratch in Carrara's modelers. For example, a cone and a cylinder can be combined to create a convincing spire for a castle.

Geometric primitives can be created by using menu commands or by using the tools for those particular shapes. In the following sections, you are instructed on how to select a geometric primitive tool to insert an object into a scene. Please note that all geometric primitives are available from the first toolbar's fly-out. Click the small arrow to the right of the toolbar (a sphere by default) to expand the fly-out and then select the desired tool.

Creating a sphere

Use one of the following three methods to insert a sphere into your scene:

✦ Select Insert ➪ Sphere to place a sphere in the center of your scene.

✦ Click the Sphere tool, drag it into the working box, and release to place a sphere in your scene.

✦ Click the Sphere tool and drag it into the Sequencer tray's Universe list to place it in the middle of the 3D working box.

Note The Sequencer tray must be open before you can drag an object into it.

Creating a cube

Use one of the following three methods to insert a cube into your scene:

✦ Select Insert ⇨ Cube to place a cube in the center of your scene.

✦ Click the Cube tool, drag it into the working box, and release to place a cube in your scene.

✦ Click the Cube tool and drag it into the Sequencer tray's Universe list to place it in the middle of the 3D working box.

Creating a cone

Use one of the following three methods to insert a cone into your scene:

✦ Select Insert ⇨ Cone to place a cone in the center of your scene.

✦ Click the Cone tool, drag it into the working box, and then release to place a cone in your scene.

✦ Click the Cone tool and drag it into the Sequencer tray's Universe list to place it in the middle of the 3D working box.

Creating a cylinder

Use one of the following three methods to insert a cylinder into your scene:

✦ Select Insert ⇨ Cylinder to place a cylinder in the center of your scene.

✦ Click the Cylinder tool, drag it into the working box, and then release to place a cylinder in your scene.

✦ Click the Cylinder tool and drag it into the Sequencer tray's Universe list to place it in the middle of the 3D working box.

Creating an icosahedron

Use one of the following three methods to insert an icosahedron into your scene:

✦ Select Insert ⇨ Icosahedron to place an icosahedron in the center of your scene.

✦ Click the Icosahedron tool, drag it into the working box, and release to place an icosahedron in your scene.

✦ Click the Icosahedron tool and drag it into the Sequencer tray's Universe list to place it in the middle of the 3D working box.

Creating a plane

Use one of the following three methods to insert a plane into your scene:

✦ Select Insert ⇨ Plane to place a plane in the center of your scene.

✦ Click the Plane tool, drag it into the working box, and then release to place a plane in your scene.

✦ Click the Plane tool and drag it into the Sequencer tray's Universe list to place it in the middle of the 3D working box.

Creating an infinite plane

Use one of the following three methods to insert an infinite plane into your scene:

✦ Select Insert ⇨ Infinite Plane to place an infinite plane in the center of your scene.

✦ Click the Infinite Plane tool, drag it into the working box, and then release to place a plane in your scene.

✦ Click the Infinite Plane tool and drag it into the Sequencer tray's Universe list to place it in the middle of the 3D working box.

Note Infinite planes need to have tile UV mapping applied for a shader to map correctly across its surface. To apply tile UV mapping to an infinite plane, double-click it to open the Infinite Plane window in the Model room. Enable the Mirror UV in the X Axis option or the Mirror UV in the Y Axis option or both. Click the Assemble icon to return the correctly mapped infinite plane to the Assemble room.

Adding text to a scene

3D text is a highly desirable item to add to a scene. Text can be used to decorate billboards, theatre marquees, and buildings. Of course, text also plays an important part when designing a 3D logo. Carrara's text can be configured to any font type currently loaded in your computer. Font size and alignment can be adjusted to suit the scene. The text can also be beveled.

To add 3D text to a scene:

1. Select Insert ⇨ Text or drag the Text tool (the fourth button on the top toolbar) into the scene. The Text panel opens in the Model room (see Figure 4-3).

Figure 4-3: Creating 3D text

2. Adjust the following Bevel options:
 - Enable Front Face to bevel the front face of the text.
 - Enable Back Face to bevel the back face of the text.
 - Enter values for the bevel's Depth and Height.

3. Click one of the Type buttons to select the desired bevel.

4. Click the top blue button to set font type.

5. Click the bottom blue button and choose from the following formatting options:
 - Plain
 - Bold
 - Italic
 - Bold Italic

6. Enter a value for Font Size.

7. Enter a value for Font Scaling. Scaling increases the width of the text without affecting the height.

8. Click an alignment button to left justify, center, or right justify the text.

9. Enter a value for Leading. Leading adjusts the spacing between words.

10. Enter a value for Word Spacing. This sets the spacing between words in points.

11. Enter a value for Letter Spacing. This sets the spacing between individual letters in points.

12. Click the Assemble icon to return the modeled text to the Assemble room.

Note To edit the modeled text, double-click it to return the text to the Model room.

Importing objects

In addition to adding geometric primitives to a scene, 3D objects can be imported into Carrara. Carrara imports the following 3D formats:

✦ **Ray Dream Studio (.rds):** Carrara can import objects and complete scenes created in Ray Dream Studio. When you import a Ray Dream Studio file, you may have to adjust scene lighting by turning down the amount of ambient light that was present in the Ray Dream scene. You also have to adjust the default color of the lights in the Ray Dream scene from gray to white.

Note Ray Dream Studio files earlier than version 5.0 may not import correctly. It is recommended that you open them in Ray Dream 5.0 and save them before opening them in Carrara.

✦ **3D DXF (.dxf):** Carrara imports only 3D faces.

✦ **3DMF (.b3d, .t3d, .3mf)**

✦ **Infini-D 3.0–4.5 (.id4, .ids, .ido)**

✦ **WaveFront OBJ (.obj)**

✦ **3D Studio (.3ds)**

To import a file into Carrara:

1. Select File ➪ Import. The Import dialog box opens.

2. Locate the file to import. Click Open to apply. The 3D object imports into the scene.

Hiding an object from view

Working in 3D can become confusing, even for seasoned veterans. This is especially true when a scene has many objects. It is often desirable to temporarily hide objects from view while editing a scene. Hidden objects can be made visible before rendering a scene or as needed.

To hide or show an object in 3D view:

1. Select the object.

2. Select Edit ➪ Hide/Show in 3DView.

Alternatively, follow these steps:

1. Drag open the Properties tray.

2. Click the General button.

3. In the View panel, disable Show Object in 3D View.

Note After hiding an object from 3D View, its name is grayed out in the Sequencer tray's Universe list. To make the object appear again, click its name in the Universe list and use either the menu command or Properties tray to show the object in 3D View again.

Using Carrara's Trays

Before proceeding further in your exploration of the Assemble room, it is important to understand a few more components that are used throughout Carrara. On the right, left, and bottom of the Assemble room appear ridged blue buttons. These buttons open trays that store items, scene object lists, and information about scene objects. These trays are also used to set up scenes and add certain effects to scene objects. Open the trays by clicking and dragging their blue buttons.

Discovering the Sequencer tray

The Sequencer tray, which resides at the bottom of the Carrara interface, serves many functions. The Sequencer tray is used for animation and scene organization. Animation controls are located across the top of the Sequencer tray. The large panel that dominates the right side of the Sequencer tray is known as the *animation timeline*.

Cross-Reference Refer to Chapter 19 for information about using the Sequencer tray for animations.

The long vertical blue bar to the tray's right is used to scroll down the Sequencer list when the list overflows the Sequencer tray's vertical boundary. The short horizontal blue bar at the lower left of the tray is used to scroll through the Sequencer list from left to right. When an animation timeline extends beyond the horizontal boundary of the Sequencer tray, an additional horizontal scroll bar appears.

The Sequencer tray has three main areas: the Sequencer list, the Master Objects preview, and the Master Shaders preview.

When the Sequencer tray is first opened, the scene's Sequencer list is displayed (see Figure 4-4). Veteran 3D artists may want to refer to the Sequencer list as the scene hierarchy. The Sequencer list is broken down into four areas: Universe, Master Objects, Master Shaders, and Scene Effects.

Figure 4-4: The Carrara Sequencer tray

The Universe list contains the name of every object in your scene, including cameras and lights. The white triangle located to the left of an object's panel expands its hierarchy and lists various characteristics and information about the object used in the scene. Figure 4-5 shows a scene's Universe list with an object's hierarchy expanded.

Figure 4-5: A scene's Universe list

The Master Objects list contains information about every master object in a scene. Every time you introduce an object into a scene, it is derived from a master object. One master object can be the basis for hundreds of scene objects. For example, if

you create a sphere, it is listed in the Universe list as Sphere. It is also listed in the Master Objects list as Sphere. If you duplicate the sphere object instead of creating a new sphere, additional instances of the sphere appear in the Universe list but not on the Master Objects list. Figure 4-6 shows multiple instances of a sphere in the Universe list but only one listing on the Master Objects list.

Figure 4-6: The Master Objects list

The Master Shaders list shows all the master shaders that have been used in the scene. Click the arrow to the left of a master shader's panel to reveal information about the various components used to create the shader (see Figure 4-7).

Figure 4-7: The Master Shaders list

The Scene Effects list (shown in Figure 4-8) shows all the various attributes used to create the scene. Here you'll find information about ambient light, backgrounds, filters, and miscellaneous data used to create the scene.

Figure 4-8: The Scene Effects list

Notice how each line item on the Sequencer list extends into the timeline portion of the Sequencer tray. You use the timeline portion of the Sequencer tray to apply changes to an object's shape or behavior during the course of an animation.

Click the Master Objects button (the second blue button down the left side of the Sequencer tray) to reveal an area where thumbnail previews of each master object used in the scene are generated. This thumbnail catalog can be used to add items to a scene, modify existing items, or save items in the Browser for future use (see Figure 4-9).

Figure 4-9: The Master Objects preview

Click the Master Shaders button (the third blue button down the left side of the Sequencer tray) to reveal an area where thumbnail previews of each master shader used in the scene are generated. This thumbnail catalog can be used to apply shaders to scene objects or to save shaders in the Browser for future uses (see Figure 4-10).

Figure 4-10: The Master Shaders preview

The Sequencer tray is a powerful tool that can be used to make global changes within a scene. It can also be used to add new objects to a scene or apply a shader to objects in the scene.

When masters are edited, the changes are applied globally to all instances where the master has been used in a scene. For example, imagine that you have a scene with a flotilla of small sailboats. During the course of editing, you decide to make some changes to the hull design. If you were to select each instance of the sailboat and edit it, the task would become rather arduous. Editing the sailboat's master will apply any change you make to the entire fleet.

To edit a master (object or shader) using the Sequencer List:

1. Drag open the Sequencer tray.
2. Double-click the master's name from the appropriate Master list. A window opens up in the room where the master was created.
3. Edit the master as desired. The changes are applied globally to all instances of the master.
4. After editing the master, click the Assemble icon to return to the Assemble room.

You can also edit a master object or shader by clicking its thumbnail preview.

To edit a master (object or shader):

1. Click either the Master Objects or Master Shaders button.
2. Double-click the thumbnail preview of the master. A window opens up in the room where the master was created.
3. Edit the master as desired. The changes are applied globally to all instances of the master.
4. After editing the master, click the Assemble icon to return to the Assemble room.

Master objects can also be added to a scene directly from the Sequencer tray.

To add a master object to your scene:

1. Drag open the Sequencer tray.

2. Click the Master Objects button. Thumbnails of all master objects used in the scene are now displayed.

3. Click to select the master object you want to add to the scene.

4. Drag and drop the selected master object into the working box. The master object is added to the scene, and another instance of it shows up on the Universe list.

Master shaders can be applied directly from the Sequencer tray.

To apply a master shader to a scene object:

1. Drag open the Sequencer tray.

2. Click the Master Shaders button. Thumbnails of all master shaders used in the scene are now displayed.

3. Click the desired master shader to select it.

4. Drag and drop the selected master shader on the object you want to shade. The master shader is applied to the desired object.

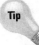

Tip If you drop the shader on the wrong object, select Edit ⇨ Undo Change Master Shader (Ctrl+Z) and then reapply the master shader to the intended object.

The Sequencer tray can also be used to find objects within the working box. To locate an object, click its name in the Universe list. The name becomes highlighted in yellow and a bounding box surrounds the object within the scene. You can now drag open the Properties tray to gain information about the selected object or use one of the tools to edit it in the working box.

The Sequencer tray works hand-in-hand with the Properties tray and is also used in conjunction with the Browser tray.

Discovering the Properties tray

The Sequencer tray stores some information about all the objects in your scene. The Properties tray contains all the information about every object in the Sequencer tray including its shader.

Displaying an object's characteristics with the Properties tray

The Properties tray is divided into four sections: General, Motion/Transform, Modifiers, and Effects (see Figure 4-11). Across the top of the Properties tray are four buttons that link to each section. Each section of the Properties tray contains relevant information about a scene object:

✦ **General:** Click the General button to gain information about an object's name, the name of the master object from which it is derived, and the object's 3D and view characteristics.

✦ **Motion/Transform:** This section of the Properties tray, accessed by clicking the Motion/Transform button, provides information about an object's motion characteristics, constraints, position and orientation in 3D space, and size.

✦ **Modifiers:** Click the Modifiers button to apply or remove object modifiers.

✦ **Effects:** This section of the Properties tray enables you to add effects to an object or edit existing ones. Click the Effects button to access the options in this section.

Note

The type of information and options in each of these sections will vary depending on the object selected. The Properties tray displays only general information when master objects are selected.

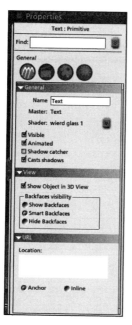

Figure 4-11: Use the Properties tray to gain information about scene objects.

Setting scene effects with the Properties tray

The Properties tray also contains information about your scene. Use the Properties tray to adjust the parameters for the following scene effects: Ambient, Atmosphere, Background, Backdrop, and Psychics.

Ambient light is a unidirectional shadowless light that shines uniformly throughout the scene. Ambient light can be used to model an object's shape and fill areas of deep shadow. However, Distant lights are more appropriate for filling areas of deep shadow.

Cross-Reference For more information on scene lighting, refer to Chapter 7.

To set Ambient light using the Properties tray:

1. Drag open the Properties tray.
2. Click the small blue button with the double downward-facing arrow to reveal a drop-down menu of scene objects.
3. Select Scene.
4. In the Ambient panel, drag the Brightness slider to set the intensity of Ambient light.
5. Click the color swatch to open the Color Picker and select the Ambient light color.

Atmosphere can be added to a scene through the Properties tray. The default atmosphere option is None. The following atmospheres can be added to a scene: Cloudy Fog, Distant Fog, and Wind.

The Cloudy Fog option produces an effect that looks like clumping clouds.

To add the Cloudy Fog atmosphere to a scene:

1. Drag open the Properties tray.
2. Click the blue button with the double downward-facing arrow at the top-right corner of the Properties tray to reveal a drop-down menu of scene objects.
3. Select Scene.
4. In the Atmosphere panel, select Cloudy Fog (see Figure 4-12).
5. Enter a value for Top. Top represents the fog's upper level along the Z axis.
6. Enter a value for Bottom. Bottom represents the fog's lower level along the Z axis.
7. Click the color swatch to open the Color Picker and select a color for the fog.
8. Drag the Density slider to adjust the thickness of the fog.

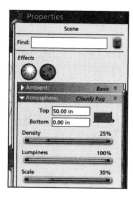

Figure 4-12: Adding the Cloudy Fog atmosphere to a scene

9. Drag the Lumpiness slider to adjust how the wisps of fog clump together.

10. Drag the Scale slider to determine the spacing between the wisps of fog.

Note If you see a slider with a corresponding value listed above it, you can click the value to open a box. You are now free to enter a value in the box instead of dragging the slider. This option comes in handy when you need to precisely match the value of a parameter that is shared by several scene objects.

The Distance Fog option adds a uniform layer of hazy fog to the scene. The fog is more apparent at greater distances from the rendering camera.

To add the Distance Fog atmosphere to a scene:

1. Drag open the Properties tray.

2. Click the blue button with the double downward-facing arrow in the top-right corner of the Properties tray to reveal a drop-down menu of scene objects.

3. Select Scene.

4. In the Atmosphere panel, select Distance Fog (see Figure 4-13).

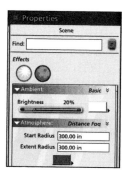

Figure 4-13: Adding the Distance Fog atmosphere to a scene

5. Enter a value for Start Radius. Start Radius determines the distance from the camera at which the fog starts.

6. Enter a value for Extent Radius. Extent Radius determines the distance beyond the start of the fog where visibility drops to zero.

7. Click the color swatch to open the Color Picker and select a color for the fog.

The Wind atmosphere simulates natural atmospheres. It is used in conjunction with the terrain primitives to create realistic landscape scenes.

To add the Wind atmosphere to a scene:

1. Drag open the Properties tray.

2. Click the blue button with the double downward-facing arrow at the top right-hand corner of the Properties tray to reveal a drop-down menu of scene objects.

3. Select Scene.

4. In the Atmosphere panel, select Wind. The Wind dialog box opens.

5. Accept the Default atmosphere, or click the blue button with the downward-facing double arrow to open the drop-down menu and select one of the preset atmospheres (see Figure 4-14).

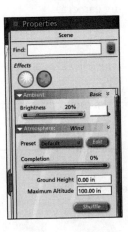

Figure 4-14: Adding the Wind atmosphere to a scene

6. To create a custom atmosphere, click Edit to open the Four Elements: Wind editor (see Figure 4-15).

Cross-Reference The Four Elements: Wind editor is covered in detail in the section "Adding Atmosphere to Your Carrara Landscape" in Chapter 12.

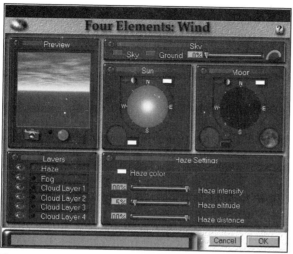

Figure 4-15: The Four Elements: Wind editor

By default, Carrara scenes have neither a background nor a backdrop. When a scene is rendered with default background and backdrop settings, areas with no objects render as black. Adding a background or a backdrop fills in the blanks when Carrara renders a scene. Backgrounds and backdrops have the same options but create different effects.

When a scene with an applied background is rendered, the background appears to have been projected onto a giant sphere surrounding the scene. Objects with reflective surfaces pick up reflections just as if the background were an actual environment. Backgrounds interact with scene lighting.

When a backdrop is applied to a scene, a 2D image is projected behind the scene. Backdrops align perpendicular to the rendering camera. Backdrops don't cause reflections or interact with scene lighting.

Backgrounds and backdrops can appear in the same scene. When you mix a background and backdrop, the background creates a reflective environment for the scene, whereas the backdrop is placed behind scene objects.

Backgrounds and backdrops have the same options:

✦ **Bi Gradient:** Creates a background or backdrop that combines two gradients to produce the illusion of sky and ground

✦ **Color:** Uses a solid color for the background or backdrop

✦ **Formula:** Creates a background or backdrop based on a mathematical formula

✦ **Map:** Uses an image or texture map for the background or backdrop

To apply a bi-gradient background or backdrop to a scene:

1. Drag open the Properties tray.

2. Click the blue button with the double downward-facing arrow at the top-right corner of the Properties tray to reveal a drop-down menu of scene objects.

3. Select Scene.

4. In the Background or Backdrop panel, select Bi Gradient.

5. Click the color swatches to open the Color Picker and select colors for Start Sky, End Sky, Start Ground, and End Ground.

6. Drag the Horizon slider to determine where the horizon appears. The default value, 0, is the ground plane (see Figure 4-16).

Figure 4-16: Applying a bi-gradient background or backdrop to a scene

To apply a color background or backdrop to a scene:

1. Drag open the Properties tray.

2. Click the blue button with the double downward-facing arrow at the top-right corner of the Properties tray to reveal a drop-down menu of scene objects.

3. Select Scene.

4. In the Background or Backdrop panel, select Color.

5. Click the color swatch to open the Color Picker and select the color (see Figure 4-17).

Figure 4-17: Applying a color background or backdrop to a scene

To apply a formula background or backdrop to a scene:

1. Drag open the Properties tray.

2. Click the blue button with the double downward-facing arrow at the top-right corner of the Properties tray to reveal a drop-down menu of scene objects.

3. Select Scene.

4. In the Background or Backdrop panel, select Formula.

5. Drag the P1 or P2 sliders to change P1 and P2 parameters (see Figure 4-18).

Figure 4-18: Applying a formula background or backdrop to a scene

6. Click the More button to edit the formula or create one of your own. This option adds P3 and P4 sliders in order to change P3 and P4 parameters (see Figure 4-19).

Figure 4-19: Use this window to enter a formula of your own.

7. Click the Parse button to apply the formula to the background or backdrop.

Cross-Reference

The Formula editor is used throughout Carrara. The editor has its own special protocol. For more information on formulas, refer to the section "Modeling with Formulas" in Chapter 13.

To apply a map background or backdrop to a scene:

1. Drag open the Properties tray.

2. Click the blue button with the double downward-facing arrow at the top-right corner of the Properties tray to reveal a drop-down menu of scene objects.

3. Select Scene.

4. In the Background or Backdrop panel, select Map. The Texture Map panel appears, as shown in Figure 4-20.

5. Click the Folder button. The Open dialog box appears. Locate the file to use as a background map and click Open to apply. The Choose File Format dialog box appears. Click OK to apply the background map.

6. Click the direction buttons to flip or rotate the map to the desired orientation.

7. Enable the Tile option to create a tiled pattern.

8. Enable Seamlessly, and Carrara will flip and rotate neighboring tiles for a seamless transition.

9. Drag the H slider to set the number of Horizontal repetitions.

10. Drag the V slider to set the number of Vertical repetitions.

11. Enable the Interpolate option to create a sharper render of the map.

12. Enable the Invert Color option to invert the map's colors.

Figure 4-20: Applying a map background or backdrop to a scene

13. Drag the Brightness slider to adjust the map's brightness.

14. Select desired Filtering option:

 • **Sampling:** Produces the quickest render and the poorest quality

 • **Summed Area Table:** Takes longer to render, but produces better results

 • **Gaussian:** Produces the best results by blending and blurring neighboring pixels but produces the slowest render of the three

Creating shadow catcher objects

Backgrounds and backdrops have one problem: They don't accept cast shadows. Creating a shadow catcher object enables scene objects to cast shadows against backgrounds of backdrops. A shadow catcher is a null object that doesn't show up in a render but makes a background or backdrop appear as if it were a scene object by accepting cast shadows from other scene objects.

To create a shadow catcher object:

1. Create a plane by selecting Insert ⇨ Plane. In a large scene with many objects, you may need to use an infinite plane.

2. Align the plane so it is in a position to catch shadows cast by scene objects.

3. Drag open the Properties tray.

4. Click the General button.

5. Enable the Shadow catcher option. When you render the scene, shadows now show up on the background or backdrop.

Tip You have to adjust the Color channel of the shadow catcher object's shader to match the color of other cast shadows in the scene. This can be done in the Texture room. Use the Area Render tool to perform a spot render of your scene in the Scene Preview window. Click the arrow to the right of the Color channel's color swatch and drag it into the Scene Preview window to sample the color of an object's shadow area.

Adding an aura to glowing objects

Adding an aura to a scene creates a visible aura around objects with a glow shader. A glow shader is any shader that causes an object to create its own luminosity. The aura emitted interacts with fog and smoke. The effect shows up better with a darker background.

When you apply the Aura effect to a scene, glowing objects are automatically detected. Aura can create impressive effects such as glowing dashboards, neon lights, and bolts of lightning.

To add a 3D aura to a scene:

1. Drag open the Properties tray.

2. Click the blue button with the downward-facing double arrow at the top-right corner of the Properties tray to reveal a drop-down menu of scene objects.

3. Select Scene.

4. Click the Filters button.

5. Click the + button and select 3D Aura.

6. Click the Edit button. The 3D Aura panel opens, as shown in Figure 4-21.

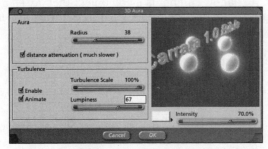

Figure 4-21: Adding a 3D aura to a scene

7. Set the following Aura options:

- Drag the Radius slider to set the aura's radius.

- Enable the distance attenuation option if desired. Distance attenuation causes larger radius auras to look more realistic by creating an aura that is more spherical. This option takes longer to render.

8. Set the following Turbulence options:

- Check the Enable option to create swirling fog within the aura.

- Check the Animate option to animate the swirling fog.

- Drag the Turbulence Scale slider to set the size of the fog wreath.

- Drag the Lumpiness slider to adjust the contrast of the fog.

- Click the color swatch to open the Color Picker and select a color for the aura.

- Drag the Intensity slider to adjust the intensity of the effect.

9. Click OK to apply.

Locating scene objects with the Properties tray

The Properties tray is used for much more than setting scene effects. This versatile tool can be used to find objects in a scene. There are two methods for finding objects with the Properties tray. You can search for them by name if you know the object's name, or you can select the object from a list in the Properties tray.

To locate an object by name:

1. Drag open the Properties tray and click the General button.

2. Enter the name of the object you want to find in the Find text field and press Enter. The object's information is displayed in the Properties tray.

Note If you accept Carrara's default name for an object and find an object by entering its name, only the master object is displayed in the Properties tray. If you assign a unique name for an object, information about the actual object is displayed. As an added bonus, the object is selected in the working box.

To find an item by selecting it from the Properties tray:

1. Drag open the Properties tray and click the General button.

2. Click the blue button with the double downward-facing arrow. A list of scene occupants is displayed, as seen in Figure 4-22.

Figure 4-22: Selecting a scene object from the Properties tray

3. Click the desired item to select it.

4. The object's information is displayed in the Properties tray. If the object you selected is not a master object, it is selected in the working box.

Naming scene objects with the Properties tray

As you gain experience in 3D modeling, you'll use Carrara to create complex scenes with many objects. Locating individual objects can become a problem if you accept Carrara's default names for objects. For example, if you have a scene with ten spheres in it, Carrara names them Sphere 1, Sphere 2, Sphere 3, and so on. When it comes time to locate a specific sphere, which one do you pick?

It's a good idea to get in the habit of naming every object you introduce into a scene, no matter how complex or simple the scene is. After a while, this habit becomes rote. It can and will save you frustration when you create complex scenes.

To name an object using the Properties tray:

1. After creating a new object, drag open the Properties tray and click the General button.

2. The new object's default name is displayed in the General panel's Name field.

3. Drag to select the default name. The default name is now highlighted in yellow.

4. Enter a new name for the object and press Enter (see Figure 4-23).

5. The object is now referred to by the new name in both the Properties tray and in the Sequencer tray's Universe list.

Figure 4-23: Renaming a scene object to make it easier to identify

You may also find it helpful to get in the habit of giving master objects a unique name. This helps when you're trying to identify a specific master object in a heavily populated scene.

To rename a master object:

1. Drag open the Sequencer tray.

2. Click to select the object from the Master Object list.

 Alternatively, click the Master Objects button and then click the thumbnail view of the object to select it.

3. Drag open the Properties tray. The master object's default name is displayed in the General panel's Name field.

4. Drag to select the default name. The default name is now highlighted in yellow.

5. Enter a new name for the master object and press Enter.

6. The master object is now referred to by the new name in both the Properties tray and in the Sequencer tray's Master Objects list.

Shading objects with the Properties tray

As you add objects to a scene, they are assigned a default shader. A shader is what gives an object its surface characteristics. The default color for a Carrara shader is gray. As you build a scene, you either assign preset shaders to an object or create your own in the Texture room. By now, it should come as no surprise that the versatile Properties tray also has a record of the shaders used in a scene. In fact, you can use the Properties tray to assign a shader to an object.

To shade an object using the Properties tray:

1. Select the object you want to shade.

2. Drag open the Properties tray and click the General button.

3. In the General panel, notice a field that reads Shader and lists the name of the shader currently used by the object. To the right of the shader's name is a small blue button with downward-facing double arrows. Click it to reveal a drop-down menu that lists all shaders currently used in the scene.

4. Click the desired shader to apply it to the object (see Figure 4-24).

Figure 4-24: Applying a shader to an object with the Properties tray

Discovering the Browser tray

The Browser tray, which resides on the left side of the interface, contains catalogs that are conveniently organized in separate sections of the Browser. Access the catalog categories by clicking buttons at the top of the Browser tray. The six Browser categories are Objects, Modifiers, Effects, Shaders, Constraints, and Artwork. Each of these categories can be further subdivided into folders. Think of the Browser tray as a place to store your Carrara stuff.

To access the Browser tray:

1. Drag open the Properties tray.

2. Click a button to open a Browser category (see Figure 4-25).

Once the Browser tray is open, you have access to all the items stored in the individual categories. Objects stored in the Browser have three preview modes: Small Preview, Large Preview, and Name Only. When files are previewed in the Small Preview or Large Preview mode, named thumbnail previews of the files populate the Browser. The three round buttons located to the left of the Folder icon are used to switch from one preview mode to another. To change preview modes, click the appropriate button.

Figure 4-25: The Carrara Browser tray

Whichever preview mode you choose, adding an item to your scene is as simple as selecting it from the Browser and then dragging it into the scene.

To insert an object from the Browser into your scene:

1. Drag open the Browser tray.

2. Click the Browser: Objects button to open the Objects Browser.

3. Click the item's thumbnail to select it.

4. Drag and drop the item into the working box or drag and drop it into the Sequencer tray's Universe list (see Figure 4-26). The object appears in the scene.

Note

When you drag and drop an object into the Sequencer tray's Universe list, it appears in the center of the scene. This is a more precise method of placement than simply dragging and dropping the item into a scene.

Caution

When dragging an object into the Sequencer tray's Universe list, be careful not to drop it directly atop another object. This will cause the new object to become a child of the object on which it was dropped. If this happens, you'll see the object you inserted listed below and to the right of the object you inadvertently dropped it on. A right-angled line connects the parent and child. To guard against this happening, always drop Browser objects at the very top of the Universe list. You learn more about the parent-child relationship in Chapter 19.

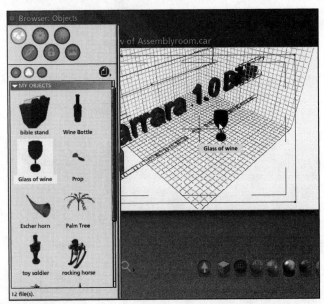

Figure 4-26: Inserting an object into a scene from the Browser tray

To apply a modifier, constraint, or effect from the Browser tray to a scene object:

1. Drag open the Browser tray.

2. Click a button to open the appropriate Browser category.

3. Drag and drop to apply the desired modifier, constraint, or effect to an object.

To apply a shader from the Brower to a scene object:

1. Click the object to select it.

2. Drag open the Browser tray.

3. Click the Browser: Shaders button.

4. Click the folder the shader is stored in.

5. Click the shader's thumbnail to select it, and then drag and drop it onto the desired object.

Cross-Reference For more information on the Shader Browser, refer to Chapter 14. For more information on shaders, refer to Chapters 15, 16, and 17.

As your skill level increases, you'll create objects, effects, and shaders that you'll want to save for use in other 3D scenes. The Browser makes it easy for you to store and organize files for future use.

To organize files in the Browser, it may become necessary to create new folders. Use your computer's operating system to create and name a folder for the objects or items you want to organize in the Browser. Add the folder to the proper Browser category and use it to store items or effects that you create.

To add a folder to the Browser:

1. Drag open the Browser tray.

2. Click the button for the Browser category to which you want to add the folder.

3. Click the Folder icon and select Add Folder from the drop-down menu. The Browse for Folder dialog box opens.

4. Locate the folder to add to the Browser and click OK to apply. The folder is added to the Browser, ready for use.

The Browser is a convenient way to catalog and organize frequently used items. This luxury comes with a cost, however. Every file and folder you add to the Browser loads a thumbnail reference of the file into your computer's memory. If you are working with minimal memory, an overloaded Browser will slow your machine down. The solution is to remove folders you use infrequently from the Browser. The folder is still stored on your computer's hard drive should you decide to add it in the future.

To remove a folder from the Browser:

1. Drag open the Browser tray.

2. Click the Browser category button you want to remove the folder from.

3. Click the target folder's panel to select it. Click the Folder icon and then select Remove Folder.

 Alternatively, right-click the target folder's panel and select Remove Folder from the drop-down menu.

Once you have folders organized in the Browser, you can begin saving your own creations.

To save an object in the Browser tray:

1. Drag open the Browser tray.

2. Click the Browser: Objects button to open the Objects Browser.

3. Drag open the Sequencer tray. Click the Sequencer button.

4. Click the name of the object you want to save from either the Universe list or the Master Objects list. Alternatively, click the Master Objects button and click the thumbnail of the object you want to save.

5. Drag and drop the object onto the My Objects panel. The File Info dialog box opens.

6. Enter a name and comments about the object before saving. Click OK to save the object to the Browser (see Figure 4-27). A thumbnail preview of the item appears in the My Objects folder.

Note Carrara creates a My Objects folder when you install the program. If you've inadvertently deleted the My Objects folder, use your computer's operating system to create one and then add it to the Objects Browser.

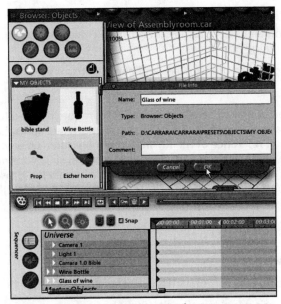

Figure 4-27: Saving an object in the Browser tray

Carrara has a wide variety of preset shaders that provide interesting patterns and surface textures for 3D objects. As you gain experience with Carrara, you'll create shaders that you'll want to save for future scenes.

To save a shader in the Browser tray:

1. Drag open the Browser tray.

2. Click the Browser: Shaders button to open the Shader Browser.

3. Drag open the Sequencer tray.

4. Click the Master Shaders button.

5. Click the master shader you want to save to the Browser, and drag and drop it onto the Browser folder in which you want to save the file. The File Info dialog box opens.

6. Enter a name and comments for the shader you're saving. Click OK to save the shader to the Browser. A thumbnail preview of the shader appears in the folder.

To save a modifier, constraint, or effect to the Browser:

1. In the working box, select the object to which you have applied the modifier, constraint, or effect.

2. Drag open the Browser tray.

3. Click the Browser: (Modifier, Constraint, or Effect) button to open the appropriate browser.

4. Drag open the Properties tray.

5. Click the Motion/Transform button (to save a constraint), Modifiers button (to save a modifier), or Effects button (to save an effect).

6. To select the constraint, modifier, or effect, click just below its name, drag it to the Browser tray, and drop it onto the folder you want to save it in. The File Info dialog box appears (see Figure 4-28).

7. Enter a name and comments for the constraint, modifier, or effect you're saving.

8. Click OK to apply.

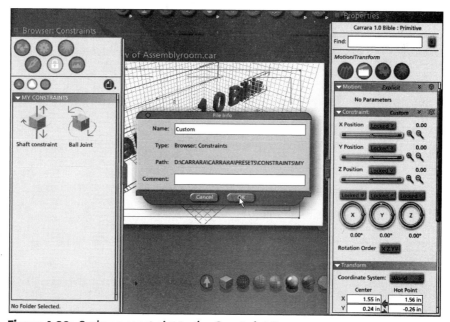

Figure 4-28: Saving a constraint to the Constraint Browser

Summary

Every Carrara scene or animation revolves around the Assemble room. The working box is the center of the Assemble room. Here is where you add objects to your scene. You use the Sequencer and Properties trays to organize your scene.

✦ Geometric primitives are often the building blocks for a scene.

✦ The Properties tray stores information about every object in a scene.

✦ The Properties tray is used to set up certain scene effects such as atmosphere and ambient lighting.

✦ The Browser tray is used to catalog objects, shaders, and effects for use in future scenes.

✦ The Sequencer tray lists every object and master used to create a scene.

✦ Master objects and shaders stored in the Sequencer tray can be added to a scene at any time.

✦ Shadow catchers are null objects that don't show up in the final rendering but catch cast shadows that wouldn't otherwise be visible on a background or backdrop.

✦ ✦ ✦

Organizing Your Scene in the Assemble Room

The Assemble room is a busy place in Carrara. As you learned in the previous chapter, the Assemble room is where a scene begins. In addition to introducing and aligning scene objects, you also use the Assemble room to organize and manage your scene. The Sequencer tray and Properties tray both play a pivotal part in this process. The information contained in both trays enables you to keep track of scene objects and effects. They are also used to move objects and create new objects. Mastering the features of the Assemble room will ensure your experience in Carrara is a pleasant one.

Changing Your Viewpoint in 3D Space

As you begin to populate a scene, it becomes difficult to perform operations on objects that become hidden behind other objects. To properly align objects in 3D space, it becomes necessary to change viewpoints.

When you launch a new Carrara document, the working box is aligned to Camera 1's reference position (see Figure 5-1). This position gives a good overall view of your scene. However, there will be times when you'll need to view the scene from one of the isometric (2D) positions, and still other times when you'll need to rotate the camera's viewpoint to a custom 3D position to gain the perspective you need.

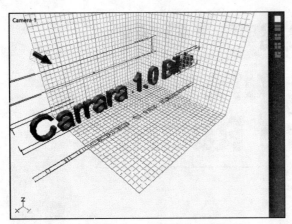

Figure 5-1: The default working box position

To change viewpoints to one of the default positions:

1. Click the current position's name (Camera 1 is the default setting) in the upper-left corner of the working box to reveal a pull-down menu of position presets (see Figure 5-2).

2. Select the desired position to change viewpoints.

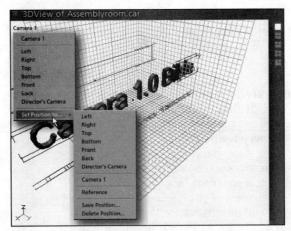

Figure 5-2: Changing from one preset position to another

To create a custom vantage point of the working box, use the Dolly tool and the Axis Track tools. These tools are shown in Figure 5-3.

Track YZ tool

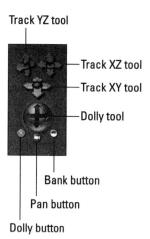

Track XZ tool

Track XY tool

Dolly tool

Bank button

Pan button

Dolly button

Figure 5-3: Use these tools to change the orientation of the working box.

Rotating your viewpoint with the Dolly tool

The Dolly tool freely rotates the camera around a central point in the working box. If an object is selected, its hot point is the center of rotation. If no object is selected, the center of the working box is the center of rotation.

To rotate the viewpoint using the Dolly tool:

1. Click the Dolly tool to select it.

2. Drag across the tool to change the working box's orientation.

 Alternatively, you can drag inside the working box to change your viewpoint.

The Dolly tool can also bank and pan. The three small buttons below the Dolly tool switch from one mode to the next.

The Pan tool changes your viewpoint by constraining camera movement from side to side or up and down. Think of a camera mounted on a tripod, and you'll have a good idea of how the Pan tool works.

To pan using the Dolly tool:

1. Click the Dolly tool to select it.

2. Click the small Pan button. The Dolly tool becomes the Pan tool (see Figure 5-4).

3. Drag across the tool to change your viewpoint of the working box.

Alternatively, you can drag inside the working box to change your viewpoint.

 Figure 5-4: The Pan tool

The Bank tool rolls your viewpoint from side to side, in effect changing the angle of the scene horizon.

To bank using the Dolly tool:

1. Click the Dolly tool to select it.

2. Click the small Bank button. The Dolly tool becomes the Bank tool (see Figure 5-5).

3. Drag across the tool to change your viewpoint of the working box.

Alternatively, you can drag inside the working box to change your viewpoint.

 Figure 5-5: The Bank tool

Changing your viewpoint with the Axis Track tools

The Axis Track tools (see Figure 5-6) make it possible to track the viewpoint camera along the horizontal (left to right), vertical (up and down), or depth (front to back) track. Each tool controls camera movement within two tracks. Click the desired Track tool to select it and drag the mouse left and right or forward and backward to adjust the viewpoint. To the left and below the Eyedropper tool is the Track YZ tool. Use this tool to move the camera forwards and backwards or up and down. To the right of the Track YZ tool is the Track XY tool. Use this tool to move the camera from left to right or up and down. Centered and immediately below these two tools is the Track XZ tool. Use this tool to move the camera forwards and backwards or from left to right. You can also change your viewpoint by selecting any of the Track tools and dragging inside the working box.

 Cross-Reference For more information on cameras and viewpoints, refer to Chapter 6.

Track YZ tool

Track XY tool

Track XZ tool

Figure 5-6: The Track tools adjust the camera's viewpoint along two tracks.

Below the bottom-left corner of the working box are three more tools you'll use frequently in the Assemble room: the Area Render tool, the 2D Pan tool, and the 2D Zoom tool (see Figure 5-7). The 2D Zoom tool can be used interactively in the working box to zoom, or you can choose from a drop-down menu of preset magnifications.

Area Render tool

2D Pan tool

Zoom tool

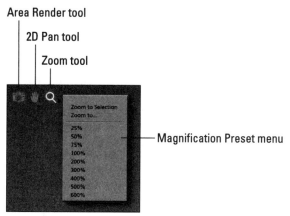

Magnification Preset menu

Figure 5-7: Use these tools to perform spot renderings, 2D pans, and 2D zooms.

Modifying the working box

The design and layout of the working box makes it easy to create complex 3D scenes and animations. As you've already learned, you can alter your viewpoint to simplify the process of modeling and scene creation. Other options are available to make your life as a 3D artist easier.

Modifying the grid

The designers of Carrara selected the grid spacing based on their experience with previous 3D programs. However, there may be times when you need to adjust the grid spacing to suit a particular scene or project you're working on.

To modify grid spacing:

1. Select View ➪ Grid (Ctrl+J). The Grid dialog box appears.

2. Enter a new value for Spacing.

3. If desired, enter a new value for Draw a line every. This value determines the frequency of grid lines within the working box. The default value, 1, draws a line for every grid space. Entering a higher number will result in a working box with wide grid spaces. Entering a lower number will result in a working box with a tightly spaced grid.

4. Enable the Snap To Grid option to have objects snap to grid points.

5. Click OK to apply the new Grid settings.

The default positioning for the working box aligns it to the center of the scene universe. There may be times, however, when you'll want to align the working box to an actual group or object in the scene. This option comes in handy when a scene object or group is jammed up against one of the corners of the working box. Aligning the working box to an object or group moves the working box to a position where the area surrounding the object or group is equal on all sides, thus making it easier for you to edit. To align the working box to an object, select the object and then select View ➪ Send Working Box To Object (Ctrl+Alt+Shift+B). When you're finished editing, return the working box to its origin by selecting View ➪ Send Working Box To Origin (Ctrl+Alt+B).

The default working box setup shows all three planes. However, you may at times want to make one of the planes invisible. To hide a plane from view, you use the Working Box Control, which is located to the lower left of the working box. The Working Box Control looks like a miniature working box with a sphere in the middle. To hide a plane from view, Alt+click its miniature in the Working Box Control. To make the plane visible again, Alt+click its representation in the Working Box Control.

Using the Area Render tool

The Area Render tool is used to perform a quick spot rendering over a portion of a scene. This time-saving tool comes in handy when you need to see how a change affects a portion of a scene without committing to a full-blown rendering. Click the tool to select it and then drag it around an area of the scene to perform a spot rendering.

Panning with the 2D Pan tool

The 2D Pan tool is used to change scene perspective without affecting camera settings. To change viewpoint with the 2D Pan tool, click to select the tool and then drag inside the working box.

Tip

To activate the 2D Pan tool while using another tool, press the keyboard spacebar. The 2D Pan tool is automatically selected.

Magnifying with the Zoom tool

The 2D Zoom tool is used to zoom in or out on parts of a scene.

To zoom in on an object:

1. Select the 2D Zoom tool.

2. Drag it to select an area of the scene you need to magnify.

To zoom out:

1. Select the 2D Zoom tool.

2. Alt+click inside the working box the zoom out.

The 2D Zoom tool also has preset magnifications to choose from:

✦ **Zoom to Selection:** Zooms to the currently selected object

✦ **Zoom to:** Zooms to a value you specify in a dialog box that appears when this option is selected

✦ **25%:** Zooms out to 25 percent magnification

✦ **50%:** Zooms to 50 percent magnification

✦ **75%:** Zooms to 75 percent magnification

✦ **100%:** Zooms to 100 percent magnification

✦ **200%:** Zooms to 200 percent magnification

♦ **300%:** Zooms to 300 percent magnification

♦ **400%:** Zooms to 400 percent magnification

♦ **500%:** Zooms to 500 percent magnification

♦ **600%:** Zooms to 600 percent magnification

To zoom to a preset magnification:

1. Click the arrow to the tool's right to reveal a pop-up menu with preset zoom magnifications.

2. Select Zoom to Selection to zoom to the currently selected object.

 Alternatively, select Zoom, enter the desired magnification in the Zoom Factor dialog box, and click OK to apply your specified value.

 Alternatively, select one of the magnification presets from the pop-up menu.

Note You can also access Carrara's zoom options by selecting View ➪ Zoom. The same magnifications and options the Zoom tool has are available in this command's submenu.

Changing preview quality

Several modes are available for previewing a scene in the working box. Preview quality is a matter of personal preference and computer speed. Switching to a lesser preview mode is advisable when you have a busy scene. Choosing a lower quality preview mode speeds up redraw times and makes it easier to move and edit scene objects.

Choose from seven available preview modes:

♦ **Bounding Box:** Displays an object's bounding box only.

♦ **Wire:** Displays scene objects as a mesh of wires.

♦ **Lit Wire:** Displays scene objects as a mesh of wires. This mode gives you a rough idea of the effect scene lighting is having on an object. Areas of light are illuminated, whereas areas of shadow show up as darker colored wires.

♦ **Flat:** Displays the objects with a low number of facets and minimal surface colors.

♦ **Gouraud:** Displays shaded objects with a low level of detail.

♦ **Textured (Phong):** Creates detailed displays of scene objects with texture maps and layers.

♦ **Sketch:** Displays scene objects as shaded sketches.

To change preview quality mode, click a Preview Quality tool from the toolbar shown in Figure 5-8.

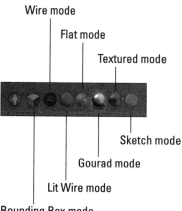

Wire mode

Flat mode

Textured mode

Sketch mode

Gourad mode

Lit Wire mode

Bounding Box mode

Figure 5-8: Use this toolbar to change preview quality mode.

Working with multiple views

When you initially launch a new Carrara document, the working box appears as a 3D studio with planes for each axis. As you've already learned, you can change to any of the preset viewpoints or create your own viewpoint. Carrara presents you with another way of working in 3D: multiple viewpoints.

Outside the upper-right corner of the working box are five square icons (see Figure 5-9). These represent the different multiple viewing configurations available for the working box. You can choose from a single-window mode, a two-window split mode, a three-window split mode, a four-window split mode, and a single window with thumbnail mode where one thumbnail window resides in the upper-right corner of the main window.

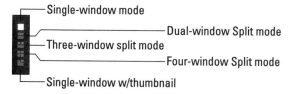

Single-window mode

Dual-window Split mode

Three-window split mode

Four-window Split mode

Single-window w/thumbnail

Figure 5-9: Click one of these icons to switch to a different working box setup.

When you work in multiple window mode, the working box is split into sections, or windows. Each window can have a different viewpoint. Individual windows can be changed to any of the preset viewpoints. If a window has a 3D viewpoint, use the Dolly and Track tools to change its viewpoint. Each window can use a different preview quality mode.

Editing a scene in multiwindow mode is a very efficient way to work. When you edit a scene in one window, the others update almost immediately to reveal the applied changes. The capability to flip back and forth between isometric (2D) views and 3D camera views saves time. Use top, left, and right viewing presets to fine-tune object positioning, and refer to the Camera 1 window to see how the changes look in 3D view.

To change the working box to multiple window mode:

1. Click one of the five icons to select the desired working box layout.
2. Click inside a window to make it active for editing.
3. Change Preview Mode, if desired, by selecting one of the buttons from the Preview Quality toolbar directly below the lower-right corner of the working box.
4. Click the name of the window's current camera and select a new viewpoint from the camera list.
5. Repeat steps 2 through 4 as need with the other windows to arrange the working box to your liking.

Figure 5-10 shows the Carrara working box in four-window split mode.

Getting Your Scene in Order

Once objects are added to a scene, they need to be positioned and aligned. Carrara provides several tools and menu options to accomplish these tasks.

Moving objects in your scene

When objects are introduced into a scene by inserting them via a menu command or by dragging them into the Sequencer tray, they are aligned to the center of the scene. When you insert an object by selecting its tool and dragging it into the working box, the object appears wherever you drop it. Either way, a bounding box surrounds the object, and a silhouette of the bounding box appears on each plane's wall. An object can be moved or rotated by selecting it inside the working box or selecting the object's bounding box on a plane's wall. Selecting the bounding box on a plane wall allows movement within two planes. For example, if you select an object's bounding box from the right (Y) plane, you can move the object back and forth (along the Y axis) or up and down (along the Z axis).

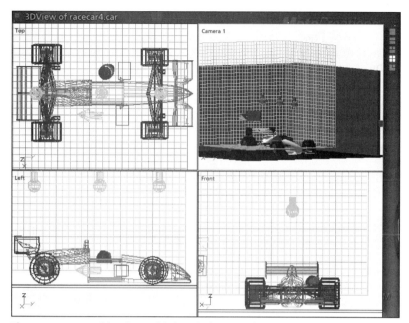

Figure 5-10: Working in multiple-window mode

Selecting the object itself from the working box enables you to freely move the object in two planes, depending on which plane is the active plane. To change the active plane, use the Working Box Control (see Figure 5-11). To make a plane active, click its representation on the Working Box Control.

Figure 5-11: The Working Box Control

The Move, Rotate, and Scale tools do the yeoman's share of the work when it comes to arranging scene objects. Figure 5-12 shows the three tools.

—Move tool
—Scale tool
—Rotate tool

Figure 5-12: Use these tools to move, rotate, and scale objects.

Selecting and moving objects

Previously you learned how to use the Sequencer tray and Properties tray to select items. You can also use the Move/Selection tool to select items. It can be used to select one object or many.

To select an object using the Move/Selection tool:

1. Click the Move/Selection tool to select it.

2. In the working box, click the desired object to select it.

To select multiple objects using the Move/Selection tool:

1. Click the Move/Selection tool to select it.

2. Click the first object to select it.

3. Shift+click additional objects to add them to the selection.

Two powerful keyboard commands enable you to select multiple objects. To select all objects, use the keyboard command Edit ➪ Select All (Ctrl+A). To select all primitive objects, use the keyboard command Edit ➪ Select Primitives (Ctrl+Alt+A).

To move an object using the Move/Selection tool:

1. Click the Move/Selection tool to select it.

2. In the working box, click the desired object to select it.

3. Drag the selected object to a new location.

Alternatively, you can follow these steps:

1. Click the Move/Selection tool to select it.

2. In the working box, click the desired object's silhouette on a plane wall to select it.

3. Drag the silhouette to a new location to reposition the object.

After you're finished using the Move/Selection tool, click anywhere inside the working box to deselect selected items.

Selecting an object in a crowded scene

As your skill in 3D artistry increases, you'll tackle complex scenes populated by many objects. It is often quite difficult to successfully select one object in a scene of many. You've already learned how to select objects by using the Properties and Sequencer trays. However, there's also a method you can use in the working box to select individual scene objects.

To select an individual object in a complex scene:

1. Select the Move/Selection tool and position your cursor over the area that contains the object you want to select.

2. Click and hold until a drop-down menu appears. This menu lists all the objects within the proximity of your cursor.

3. Drag down the list until the desired object's name is highlighted and release to select the object. The selected object is now surrounded by a bounding box.

Moving objects numerically

The Properties tray contains all pertinent information about an object, including its location in 3D space. To manually change an object's location, simply enter new coordinates in the Properties tray.

To move an object using the Properties tray:

1. Click the Move/Selection tool to select it.

2. In the working box, click the desired object to select it.

3. Drag open the Properties tray, as shown in Figure 5-13.

Figure 5-13: Using the Properties tray to reposition an object

4. Click the Motion/Transform button.

5. Enter new X, Y, and Z coordinates for the object in the Transform panel. Enable the Lock Center and Hot Point options, if desired. When you lock the center and hot point, changing the value of one automatically updates the other by an relative amount.

Understanding world coordinates and local coordinates

As you explore an object's properties in Motion/Transform section of the Properties tray, in the Transform panel you'll notice a blue button to the right of the heading Coordinate. This button is used to switch between world coordinate and local coordinate systems. World coordinates are used to specify an object's arrangement relative to the universe (the 3D workspace as shown in the Perspective window). Use world coordinates for positioning, scaling, and rotating operations. Local coordinates are used to specify an object's arrangement relative to the center of the object or group's bounding box. Use local coordinates to adjust an object's hot point relative to a particular axis.

Rotating objects

The Rotate tool functions as both a virtual trackball and a 2D rotation tool. A virtual trackball rotates an object freely 360 degrees, whereas a 2D rotation tool is limited to a specific plane.

To use the Rotate tool as a virtual trackball:

1. Click the Rotate tool to select it.

2. In the working box, click the desired object to select it. Three rings (one for each plane) now surround the object (see Figure 5-14).

Figure 5-14: Using the Rotate tool to rotate an object freely 360 degrees

3. Drag the object to rotate it freely 360 degrees, or select one of dots along an axis ring and drag to constrain rotation to that axis.

To use the Rotate tool as a 2D Rotation tool:

1. Click the Rotate tool to select it.

2. Click the desired object's silhouette on a plane wall to select it.

3. Drag to rotate the object 360 degrees parallel to that plane.

Tip

Hold down the Shift key while rotating to constrain motion to the constrain rotation increments of the rotation angle. The default rotation angle is 45 degrees. To change the rotation angle, select File Preferences ⇨ 3D View. Enter a new value in the Constraint Rotation Angle box.

Rotating objects numerically

You can also rotate an object by changing its Yaw, Pitch, and Roll values in the versatile Properties tray. An object's Yaw value is a measurement of its upright rotation parallel to the ground plane. An object's Roll value is a measurement of its side-to-side rotation. An object's Pitch value is a measurement of its front-to-back rotation. It may help to think of the Yaw, Pitch, and Roll values as they relate to the motion of an airplane. When an airplane changes its heading, its Yaw value is changing. When an airplane climbs or dives, its Pitch values are changing. When an airplane banks from side to side, its Roll values are changing. When an object's Roll value is changed, the object's hot point along the X axis is used as the center of rotation. When an object's Pitch value is changed, the object's hot point along the Y axis is used as the center of rotation. When an object's Yaw value is changed, the object's hot point along the Z axis is used as the center of rotation. Yaw, Pitch, and Roll values are measured in degrees.

To rotate an object using the Properties tray:

1. In the working box, select the object.

2. Drag open the Properties tray.

3. Click the Motion/Transform button.

4. Enter new Yaw, Pitch, and Roll values for the object in the Transform panel (see Figure 5-15).

All rotation takes place around an object's hot point. The hot point is covered in detail shortly.

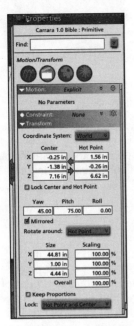

Figure 5-15: Rotating an object using the Properties tray

Resizing objects in your scene

Another duty that befalls the 3D artist is sizing the objects in a scene. Objects created in one of Carrara's modelers may be out of proportion to the rest of the objects when inserted in a scene. Imported objects may also need to be resized. As usual, there is more than one way to tackle this task.

Resizing objects with the Scale tool

The Scale tool, located on a toolbar to the left of the working box, is used to resize an object proportionately, along two axes or along a single axis. Figure 5-16 shows the Scale tool

To resize an object proportionately using the Scale tool:

1. Click the Scale tool to select it.

2. In the working box, click the object you want to resize.

3. Shift+drag to resize the object proportionately. Drag right or up to increase an object's size, left or down to decrease it.

 Alternatively, click one of the edges of the object's bounding box and drag right up to increase the object's size, left or down to decrease it.

Scale tool

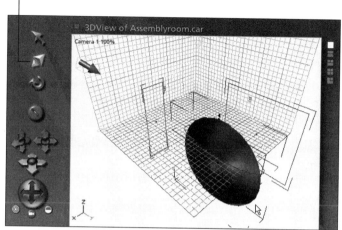

Figure 5-16: Resizing an object with the Scale tool

To resize an object along two axes:

 1. Click the Scale tool to select it.

 2. In the working box, click the object you want to resize.

 3. Click an edge and drag to resize the object along two axes. Drag up to increase size along the selected side, down to decrease it. It is sometimes easier to select the side from the object's silhouette on a plane wall.

To resize an object along a single axis:

 1. Click the Scale tool to select it.

 2. Click the object you want to resize.

 3. Click a side (in the case of a nonrectangular object, the side of its bounding box) and drag to resize the object along one axis.

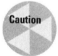

Caution This tool sometimes gets a mind of its own and acts erratically. If the tool does the opposite of what you expected, select Edit ➪ Undo Resize (Ctrl+Z) and repeat the operation to get the desired results or resize the object numerically as described in the following section.

Resizing objects numerically

Use our old friend the Properties tray when you want to precisely resize an object to specific dimensions.

To resize an object using the Properties tray:

1. In the working box, select the object you want to resize.

2. Drag open the Properties tray.

3. Click the Motion/Transform button.

4. In the Transform panel, enter new values in the Size or Scaling boxes for the object's X, and/or Y, and/or Z dimensions (see Figure 5-17).

Figure 5-17: Resizing an object with precision through the Properties tray

To resize an object proportionately using the Properties tray:

1. In the working box, select the object you want to resize.

2. Drag open the Properties tray.

3. Click the Motion/Transform button.

4. Enable the Keep Proportions option and enter a new Size or Scaling value for either the X, Y, or Z dimension in the Transform panel. The object resizes proportionately along the other two axes.

Note You can resize an object proportionately by entering a new value in the Overall field. Enter a higher percentage to proportionately increase the object's size, a lower percentage to decrease.

Working with the hot point

An object's hot point identifies that object's center of rotation (see Figure 5-18). The default location for an object's hot point is the center of its bounding box. The hot point can be repositioned anywhere within the scene.

Figure 5-18: By default, an object's hot point is in the center of its bounding box.

Where you choose to place the hot point depends on the type of rotation you want to achieve. To have an object spin in place, leave the hot point in the center of the bounding box. To have an object rotate around a stationary object, align the rotating object's hot point to the stationary object's hot point.

The Move/Selection tool can be used to reposition an object's hot point by dragging. However, using the Properties tray to enter new values for the hot point is the preferred method because of its accuracy.

To move an object's hot point using the Properties tray:

1. In the working box, select the object.
2. Drag open the Properties tray.

3. Click the Motion/Transform button.

4. Enter new values for the object's hot point in the Transform panel (see Figure 5-19).

Figure 5-19: Using the Properties tray to reposition an object's hot point

5. Enable the Lock Center and Hot Point option to maintain the relative relationship between the center and the hot point's values.

Occasionally, the hot point will move away from an object's physical center while an operation is being performed. You could use the Properties tray to realign the hot point, but there's an easier way.

To send the hot point to an object's center:

1. In the working box, select the object.

2. Select Edit ⇨ Center Hot Point (Ctrl+Alt+H). The hot point realigns to the center of the object's bounding box.

Tip

Turn on the keyboard's Caps Lock to lock the object to its hot point. If you inadvertently select the hot point while trying to move the object, the object moves with it.

When you click the General button in the Properties tray and examine an object's center and hot point in the Transform panel, you should see two arrows, one pointing from the object's center coordinates to its hot point coordinates, and vice-versa. The uppermost arrow is used to align an object's center to its hot point coordinates. The lower arrow is used to align an object's hot point to its center coordinates. These arrows can be used to quickly realign an object's hot point or center coordinates.

Duplicating objects

Duplicating objects is an efficient way to build a scene. When you duplicate an object, a clone of the original object is placed at the same position with the same orientation. Just reposition and resize the duplicate as needed. Duplicating objects is much simpler than creating new ones.

To duplicate an object:

1. Select the original object.

2. Select Edit ➪ Duplicate. A carbon copy of the original is created.

3. Perform any number of position, orientation, or resizing operations on the duplicate without deselecting it.

4. Duplicate the new object. Another duplicate is created that receives the same operations that the last duplicate did.

To experience the power of the duplicate command, follow along with this exercise to create the spokes of a wagon wheel:

1. Select Insert ➪ Cylinder.

2. Drag open the Properties tray and click the Motion/Transform button. In the Transform panel make sure that the Lock Center and Hot Point option is disabled. Then adjust the following parameters:

- Size X = 2.00
- Size Y = 2.00
- Size Z = 10.00
- Center Z = 5.00
- Hot Point Z = 0.00

3. With the cylinder still selected, select Edit ➪ Duplicate. A duplicate cylinder is created at the same position as the original.

The next steps demonstrate how to create the wagon wheel's spokes by spinning duplicate cylinders around the hot point. Reposition the cylinder's hot point to the

center of the working box to make that the center of rotation instead of the object's actual center. The wagon wheel will have twelve spokes. To create twelve spokes, you need to rotate each duplicate cylinder 30 degrees (360/12).

4. With the duplicate cylinder still selected, in the Properties tray enter a Pitch value of 30. The cylinder rotates 30 degrees.

5. Select Edit ➪ Duplicate (Ctrl+D). The new cylinder rotates another 30 degrees. Whenever Carrara duplicates a duplicated object, it remembers the operations applied to the original duplicate and applies them to all additional instances until a duplicate is deselected.

6. To complete the spokes for the wagon wheel, simply repeat the Duplicate command nine more times. Alternatively, use the keyboard shortcut Ctrl+D, which is much quicker. The spokes for the wagon wheel should resemble the example in Figure 5-20.

Figure 5-20: Duplicating a cylinder to create wheel spokes

Flipping an object

Flipping an object causes it to rotate 180 degrees and align itself on the opposite side of its axis of symmetry. The axis of symmetry for a given axis is its center, a value of 0. For example, if you flip an object located at X = 3.00. along the X axis, the object rotates 180 degrees and is repositioned at X = -3.00.

To flip an object:

1. Select the object.

2. Select Edit ➪ Flip. The Flip dialog box appears (see Figure 5-21).

Figure 5-21: The Flip dialog box

3. Click one of the axis indicators to specify the axis the object will be flipped across.

4. If needed, enter a value for Plane Offset. If you specify a plane offset, the specified value is added to the distance the object is flipped along the axis.

5. Click OK to apply. The object is flipped across the specified axis.

Duplicating objects with symmetry

When an object is duplicated through the Duplicate with Symmetry command, a duplicate of the object is created and flipped along the specified axis to form a mirror image of the original object. The axis of symmetry for a given axis is its center, a value of 0. Duplicating with symmetry is a great way to create a mirror image of such objects as airplane wings. The Duplicate with Symmetry command lets you specify a plane offset. If you were using the Duplicate with Symmetry command on an airplane wing that is already attached to a fuselage, you would specify a plane offset that is half the fuselage's dimension on the axis you're duplicating across. When you then apply the Duplicate with Symmetry command, the new wing is perfectly aligned on the opposite side of the fuselage.

To duplicate an object with symmetry:

1. Select the object.

2. Select Edit ➪ Duplicate with Symmetry (Ctrl+Alt+D). The Duplicate With Symmetry dialog box opens.

3. Click one of the axis indicators to specify the axis the object duplicates across.

4. If needed, enter a value for Plane Offset.

5. Click OK to apply. A mirror image of the original object is duplicated with symmetry across the specified axis. Figure 5-22 shows the Duplicate with Symmetry command in action.

Figure 5-22: Using the Duplicate with Symmetry command to create a mirrored duplicate

Using the Ghost Menu

Carrara presents another option for working in the Assemble room. A right-click anywhere in the working box reveals a handy hidden menu aptly named the Ghost Menu (see Figure 5-23). The Ghost Menu contains the following tools:

✦ Scale

✦ Zoom

✦ Move

✦ Pan XY (Track XY tool)

✦ Pan XZ (Track XZ tool)

✦ Pan YZ (Track YZ tool)

✦ Rotate

✦ Dolly

✦ Bank

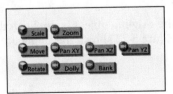

Figure 5-23: The Assemble room Ghost Menu

These Ghost Menu tools function identically to their counterparts, but they don't require you to divert your attention from modeling by searching for the tool on a toolbar.

To perform a task using the Ghost Menu:

1. Right-click to select the Ghost Menu.
2. Click to select the desired tool.

Aligning objects in your scene

Proper alignment and spacing of objects in a scene are important to the overall success of the finished rendering. There's nothing more frustrating than spending hours to create a scene only to discover objects floating when they should be touching. Fortunately, there are ways to prevent this scenario from occurring.

Using collision detection

Collision detection prevents one object from infringing on another object's space. When you enable collision detection and drag one object into another, the object stops when the two surfaces meet. If you continue to drag, collision detection is disabled and the object can be dragged to the other side but cannot be embedded.

Collision detection can be a tremendous aid when aligning objects in a scene. Use collision detection to perform tasks such as aligning tools on a workbench. To enable collision detection, select View ➪ Use Collision Detection.

Using object silhouettes to align objects

Object silhouettes are another way to align objects. Used in conjunction with collision detection, you can move an object's silhouette on a plane and align it with another scene object. Collision detection will stop the object when it touches another.

Using the Align command

For precise alignment, rely on the Align menu command. The Align command enables you to align, space, and distribute objects, and bring objects into contact.

To align two objects:

1. Select the Move/Selection tool.
2. Click to select the first object and Shift+click to select the second object.

Note The second object selected is always aligned to the first.

3. Select Edit ➪ Align (Ctrl+K). The Align dialog box opens (see Figure 5-24).

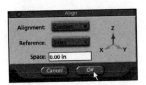

Figure 5-24: The Align command dialog box and tool

4. Click the axis indicators to specify the axis or axes of constraint. If you don't want a selected axis to be constrained, you must manually deselect it by clicking its indicator.

Note If you select all three axes, the one object will be imbedded in the other.

5. Click the Alignment button to reveal a drop-down menu and select the desired alignment command (see Figure 5-25):

- **Align:** Uses the specified reference method to align the second object to the first object's axis or axes of constraint.

- **Contact:** Brings a second object in contact with the first using the specified reference method along the specified axes.

- **Space:** Puts the specified distance between two objects along the axis of constraint. Enter the desired spacing value in the Space field.

- **Distribute:** Distributes selected objects equally across the axis or axes of constraint using the specified reference method. Requires you to have three or more objects selected.

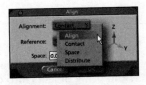

Figure 5-25: The Align Commands menu

Note You'll often need to use different alignment commands for different axes. For example, you may want to align an object to another object's center along the X and Y axes, but have that object also come in contact with yet another object's sides along the Z axis.

6. Select the reference method (see Figure 5-26).

- **Hot Point:** Specifies each object's hot point as the reference

- **Min:** Specifies the side of an object's bounding box with the lowest (minimum) coordinate value along the specified axis of constraint as the reference

- **Center:** Specifies the center of each object's bounding box as the reference

- **Max:** Specifies the side of an object's bounding box with the highest (maximum) coordinate value along the specified axis of constraint as the reference

- **Sides:** Specifies the sides of an object's bounding box as the reference

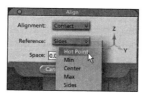

Figure 5-26: The Align Reference menu

7. Click OK to complete the alignment.

Tip

The Align command is a powerful tool that enables you to precisely align objects in a scene. At first the various options and references may seem confusing. To fully harness the power of this command, experiment with the various options and reference methods on two objects. When you're comfortable using the Align command on two objects, use it on three or more objects.

Managing Your Scene

Successful 3D modeling requires a combination of imagination, a good eye for composition, and patience. Patience can wear thin when you have problems finding and editing objects in a scene, however. Scene management will prevent headaches, frustration, and, for you more experienced 3D artists, unwanted gray hairs.

Organizing scene objects with the Sequencer tray

As you've already learned, any object you create is added to the Sequencer's Universe list, and the first instance (the master) of an object is added to the Master Objects list. Naming each object in a scene makes it easier to find and keep track of specific ones as you add more objects to a scene. Clicking an object's name from the Universe list selects it in the scene and calls up its information in the Properties tray. Once an object is selected, it's a simple matter to edit it in the Property tray or edit the object in another of Carrara's rooms.

Grouping objects

As you continue adding items to a scene, the Universe list grows longer and longer. When you go to find an object that's part of a big scene, scrolling through the Universe list wastes valuable modeling time. Grouping objects shortens the Universe list and makes it more manageable.

To group two or more objects, select them and then select Edit ⇨ Group (Ctrl+G). Grouped objects act as one unit. Any tool or command applied to a group affects all the objects in that group. Duplicating a group results in duplication of the individual objects in the group as well as their alignment to each other.

When objects are grouped, they are listed in the Universe as Group. If another group is created, it is listed in the Universe as Group 1. You can see the potential for confusion if you create a large scene with a number of groups. Whenever a group is created, drag open the Properties tray and assign a unique name to the group.

As an example of the benefits of grouping objects, let's take a look at how you might approach modeling a race car. First, create a tire and wheel, and then group these objects together and name them Tire Assembly. Next, create a suspension assembly to mount the Tire Assembly to the car itself. After the suspension pieces are aligned, group them together and name them Suspension. After that, align the Tire Assembly group to the Suspension group. These two groups could be grouped further and named Right Front Tire and Suspension Assembly. You could continue the process by using the Duplicate with Symmetry command to create the Left Front Tire and Suspension Assembly group. As you can see, grouping items greatly simplifies the modeling process. Why build something more than once if you don't have to?

To select and edit individual items within a group, drag open the Sequencer tray and select the group from the Universe list. Next, click the triangle to the left of the group's name to expand it. You're now free to select any member of the group and edit it. When the editing is complete, click the triangle to compress the group.

Editing a group in another window

Modeling in 3D can get very tricky when you have a large scene. The Universe list is filled with groups, and the working box is littered with objects, albeit neatly grouped objects. You can alleviate a great amount of frustration by editing a group in another window.

Take the example of the previously mentioned race car. Everything is neatly grouped but difficult to edit in the crowded working box. After meticulously assembling all the pieces, you notice a piece of the rear wing assembly is improperly aligned. Editing the wing in the working box can be risky business, especially if you inadvertently select the wrong part. Hours of work can be lost with one slip of the cursor. To prevent this from happening, double-click the

grouped wing assembly to open up another working box. The new working box has all the Assemble room's menus and tools, plus all the trays. However, the only scene objects in the new working box are those from the rear wing assembly. As an added bonus, the only objects listed in the Sequencer tray's Universe list are those contained in the rear wing group. Now it's a simple matter of dragging open the Sequencer tray, clicking the misaligned part to select it, and performing the alignment. After fine-tuning the alignment, click the Jump Out button to return the edited wing assembly to the main working box.

Understanding the Universe

The Sequencer tray's Universe list is a complete list of all scene objects and groups. Items are listed in the order in which they were created. Items within the Universe list can be selected and grouped. To group items from the Universe list, select them and then select Edit ⇨ Group (Ctrl+G).

Items can be added to or removed from groups in the Universe list. To add an object to an existing group, select it and then drag and drop it on the group's name. To remove an object from a group, click the triangle to the left of the group's name to expand it, click the object you want to remove to select it, and drag the selected object to the right to remove it from the group. The object now appears at the bottom of the Universe list.

Figure 5-27 shows the Universe list for a model of a race car. Seventy-four individual objects were used to construct the model. The objects were organized in eleven groups, which were then combined as one group for the entire model.

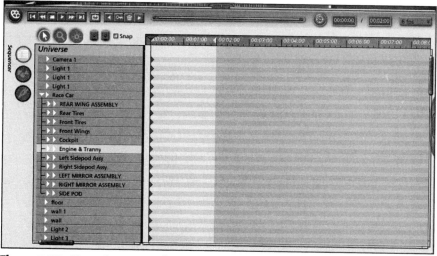

Figure 5-27: Managing a complex scene with the Sequencer tray

Eliminating screen clutter with the Single Window Mode option

Whenever an object or shader is created in Carrara, a document is created. This document takes the form of either a window in the Model room or a Shader Tree Editor document in the Texture room. After the object or shader is created, the document or window is left open in the room. When you create a new item or shader and are transported to the appropriate room, the old window remains and the new one cascades in front of the old, the idea being that this makes all documents available for easy access when editing in a room. However, in a crowded scene, the additional windows only make matters worse by cluttering the screen, not to mention taking a toll on your computer's memory.

To eliminate this clutter, you have two options. The first is to close the window before leaving the room. To close the window, click the white rectangular button with a circle inside that is next to the window's name. The second option is to select Windows ⇨ Single Window Mode. When Carrara operates in single-window mode, the active window is closed as soon as you exit the room. When you create a new object and reenter the room, the only window open is the one that pertains to the current object.

Summary

The Assemble room's Sequencer tray is used to manage and organize a scene. Scene objects are aligned and moved to their final positions in the Assemble room. After objects are aligned, they are grouped to make a scene easier to manage.

 ✦ The Move, Scale, and Rotate tools are used to position and resize scene objects.

 ✦ The Duplicate and Duplicate with Symmetry commands save time by using existing objects to create new objects.

 ✦ The Align command is used to precisely position one object in relation to another.

 ✦ An object's hot point determines its center of rotation.

 ✦ An object's center and hot point need not have the same values.

 ✦ Opening a group in another window simplifies the editing process.

 ✦ Grouping objects helps to organize a scene.

✦ ✦ ✦

Using Carrara's Cameras

Carrara uses cameras for a multitude of purposes. They are used to view a scene while it's under construction and render it as a still image or animation when it's completed.

Working with Carrara's Cameras

You can add as many cameras as needed to a scene. As cameras are added to a scene, they are also added to the camera list, which is located in the upper-left corner of the working box. This list displays all current scene cameras along with preset views and any saved views.

Carrara has two available camera types: conical and isometric. Each camera has its own distinct characteristics. Isometric cameras are used to align and position objects, whereas conical cameras are used to check perspective and render a scene. Insert a camera into a scene by using menu commands or dragging a camera tool into the working box or Sequencer tray. The Camera tool fly-out (see Figure 6-1) is the tenth button from the left on the top toolbar.

— Conical camera tool

— Isometric camera tool

Figure 6-1: The camera tool fly-out

When you add a camera to a scene, it is facing down towards the ground plane. Like other scene objects, it casts a silhouette on the plane walls. To align and position the new camera, use

the Move and Rotate tools or enter specific values for the camera's position in the Properties tray.

The default scene camera (Camera 1) is a conical camera. There will be times when you need to add additional conical cameras to render a scene from different viewpoints.

To add a conical camera to a scene:

1. Select Insert ➪ Conical.

 Alternatively, drag the Conical camera button (refer again to Figure 6-1) into the working box or the Sequencer tray's Universe list.

Note The Sequencer tray must be open with the Universe list visible before you can use it to add an object to a scene.

2. The conical camera is inserted in the scene and added to the camera list.

To add an isometric camera to a scene:

1. Select Insert ➪ Isometric.

 Alternatively, drag the Isometric camera button (see Figure 6-1) into the working box or the Sequencer tray's Universe list.

2. The isometric camera is inserted in the scene and added the to camera list.

As new cameras are added to a scene, they are also added to the Sequencer tray's Universe list. It's a good idea to get into the habit of naming any camera you add to a scene. This makes it easier to select a specific camera when changing viewpoints or rendering. Give the camera a meaningful name such as Render Camera 1 to identify exactly what purpose the camera serves in the scene.

To name a camera:

1. Select the camera.

2. Drag open the Properties tray.

3. Click the General button.

4. Enter a new name for the camera in the Name text field.

Working with the Director's Camera

To get an idea of how the Director's Camera works, think of a movie director, sitting in his or her director's chair, telling the actors where to stand, directing the

positioning of the props, and telling the gaffer where to set the lights and cameras. The Director's Camera sees all. To access the Director's Camera, click the current camera's name in the upper-left corner of the working box to expand the camera list. Click Director's Camera to select it. Use the Director's Camera to view all scene occupants, including cameras. By moving the Director's Camera to different preset positions, you can fine-tune the positions of all cameras in the scene. The Director's Camera is also invaluable when it comes to animation. You can move the Director's Camera as often as needed to align scene objects, but the camera's movements are not recorded as part of the animation. If you use the rendering camera to align scene objects, every time you moved the camera, its position is recorded as part of the animation.

Working with conical cameras

A conical camera functions just like a photographer's camera. It views the scene from a single vantage point that gets wider as the camera's distance from the scene increases. This creates a realistic perspective. Objects appear smaller as the distance from the camera increases. Conical cameras are useful for visualizing how perspective affects a scene or model. They are also used for rendering, because conical cameras view depth and perspective similarly to the way that our eyes do.

Conical cameras have the same lens choices as conventional 35mm cameras do: Wide, Normal, Telephoto, and Zoom.

✦ **Wide:** Has a focal length of 25mm. This produces a wide angle of view. Objects appear small when viewed through wide-angle lenses.

✦ **Normal:** Has a focal length of 50mm, which closely approximates the field of vision of the human eye. The default lens for the Reference viewpoint is 50mm.

✦ **Telephoto:** Has a focal length of 200mm. A telephoto lens magnifies objects and produces a narrow field of view.

✦ **Zoom:** Is adjustable for any focal length from 6mm to 500mm. A shorter focal length produces a wider angle of view and makes scene objects appear smaller. This camera option has a slider that is used to adjust the focal length.

To change a camera's focal length:

1. Select the camera.

2. Drag open the Properties tray.

3. Click the General button.

4. From the Camera panel, select the desired focal length (see Figure 6-2).

To get an idea of how different focal lengths affect a camera's viewpoint of a scene, select Insert ⇨ Sphere to insert a sphere in the center of the working box. If it's not already selected, select Camera 1 from the camera list. Follow the preceding steps to change focal lengths and view the scene through each of the available focal lengths. When you select the Zoom lens, drag the slider to zoom in and out on the sphere. As you switch to different focal lengths, watch what happens to the size and perspective of the sphere.

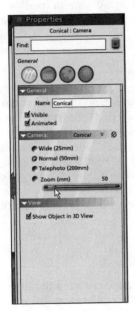

Figure 6-2: Adjusting a camera's focal length

Tip To see how the focal length change affects the viewpoint, view the scene through the camera whose focal length you're changing.

Camera lenses produce visual distortions at various focal lengths. Conical cameras reproduce most of these visual distortions.

When a conical camera is aimed at a scene, the sides appear to bend inward, causing a visual distortion. Objects near the center of the frame appear smaller, whereas those at the edge of the frame appear to expand (see Figure 6-3).

To minimize this distortion, move the camera farther from the scene and increase the focal length (zoom in using the telephoto lens), as shown in Figure 6-4.

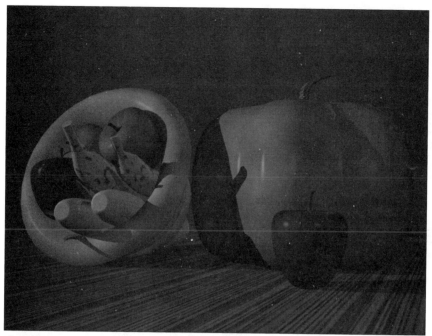

Figure 6-3: A scene viewed at 50mm through a conical lens

Figure 6-4: The scene in Figure 6-3 as viewed through a telephoto lens

To increase visual distortion, move the camera closer to the scene and decrease the focal length (zoom out using the wide-angle lens), as shown in Figure 6-5.

Figure 6-5: The scene in Figure 6-3 as viewed through a wide-angle lens

On the CD-ROM
The Scene Files folder of the Goodies section of this book's CD ROM contains a file named holidayfeast.car. This file was used to render Figures 6-3 through 6-5. You are encouraged to open this file in Carrara and experiment with different cameras to see how various focal lengths affect the rendered image.

A true telephoto lens can produce a limited depth of field, blurring objects close to and far away from the camera. Carrara's lenses are accurate to a fault. No matter how close or far an object is from the camera's lens, it is in perfect focus. The Depth of Field effect can be used to mimic a telephoto lens's limited range of focus by blurring foreground and/or background objects.

Note The Depth of Field effect is applied post rendering. It does not change the camera. See Chapter 20 for more information on rendering.

To apply the Depth of Field effect:

1. Select the camera you want to apply the effect to.

2. Drag open the Properties tray.

3. Click the Effects button.

4. Check the Enable box in the Depth of Field section.

5. Click the Edit button. The Depth of Field dialog box opens (see Figure 6-6).

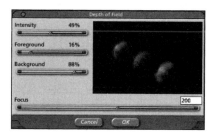

Figure 6-6: The Depth of Field dialog box

6. Adjust the settings as desired:

 • Drag the Intensity slider to adjust the intensity of the blur.

 • Drag the Foreground slider to adjust the degree of blur in the foreground.

 • Drag the Background slider to adjust the degree of blur in the background.

 • Drag the Focus slider to adjust the distance from the rendering camera to the focal point of the scene.

7. View how the different settings affect the scene through the Depth of Field preview window. When satisfied, click OK to apply. Figure 6-7 shows the Depth of Field effect applied to a scene.

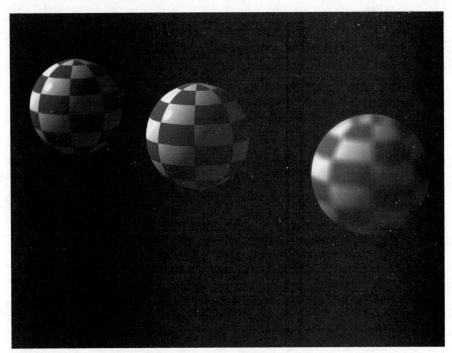

Figure 6-7: The Depth of Field effect as applied to a scene

Working with isometric cameras

Isometric cameras view a scene from a single plane. The view from an isometric camera is orthogonal, or two-dimensional. Isometric cameras offer no perspective at all. An isometric camera creates a view where parallel lines are truly parallel instead of converging as they rush off to meet the vanishing point, as they do when viewed through a conical camera. Isometric cameras are useful when it comes to creating models and aligning objects. Use an isometric camera to view a scene while placing and aligning objects. Switch to a conical camera when you want an idea of how the finished scene will appear. It's often advisable to work in multiwindow split mode, viewing one or more windows from an isometric (2D) camera's viewpoint and one window from a conical camera's viewpoint.

An isometric camera's lens has an adjustable focal length. Adjusting an isometric camera's focal length simply scales a viewpoint.

To adjust an isometric camera's focal length:

 1. Select the camera.

2. Drag open the Properties tray.

3. Click the General button.

4. In the Camera section, drag the Zoom slider to adjust the camera's focal length (see Figure 6-8).

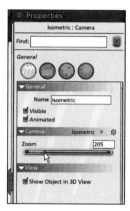

Figure 6-8: Changing an isometric camera's focal length

Changing the camera's viewpoint

The camera list is a menu of preset camera positions and cameras currently used in the scene. Use the list to save and delete camera positions. The camera list resides in the upper-left corner of the working box. To expand the camera list drop-down menu, click the current camera's name.

The camera list is divided into two menus. The top menu lists the cameras used in the scene, preset 2D viewpoints, and the Director's Camera. The second camera list menu is used to send a camera to a preset or saved position.

To select a camera or preset 2D viewpoint:

1. Click the current camera's name to open the camera drop-down list.

2. Click to select a scene camera, the Director's Camera, or 2D preset viewpoint (see Figure 6-9). The scene is now viewed through the selected camera or 2D preset viewpoint.

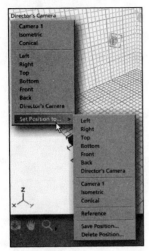

Figure 6-9: The camera list

To send a camera to a preset or saved position:

1. Click the current camera name to open the camera list.

2. From the camera list, select Set Position To, and then select a position. Figure 6-9 shows the camera list. You can select any listed saved position to send the camera to that saved position on the list, or choose one of the following preset options:

 • **Front, Back, Left, Right, Top,** and **Bottom:** These are preset views. If the current camera is a conical camera, the selected view will show a 3D perspective.

 • **Director's Camera:** This option sends the selected camera to the current position of the Director's Camera.

 • **Reference:** This option sends the camera to the default view of the scene window.

 The current scene camera is sent to the selected position.

It's also possible to send the camera to a custom viewpoint by using the Dolly, Pan, Bank, and Track tools. Use these tools to gain a better vantage point or to set up a camera for the final rendering. Any position you set can be saved for future use. Saved positions are added to the camera list.

To the left of the working box is a large round button with three smaller buttons beneath it (see Figure 6-10). This tool is used to change the viewpoint by dollying, panning, or banking the camera.

Positioning a camera with the Dolly tool

The Dolly tool changes a camera's position by rotating it around a selected object or central scene point. The camera stays pointed at the selected object as it rotates around it. If an object isn't selected, the camera rotates around the center of the scene.

To position a camera with the Dolly tool:

1. Click the Dolly button to select it (see Figure 6-10).

2. Drag the cursor across the button to dolly the camera.

Note

You can also dolly the camera by selecting the Dolly tool and dragging inside the working box. Alternatively, you can right-click anywhere inside the working box and select the Dolly tool from the Ghost menu.

The Dolly tool can also be used to bank and pan the camera. The three small buttons below the tool switch it from one mode to the next.

Figure 6-10: The Dolly tool

Positioning a camera with the Pan tool

When a camera is panned, it moves relative to two axes. A camera pans from side to side or up and down, just like a camera on a photographer's tripod.

To position a camera using the Pan tool:

1. Click the Dolly button to select it.

2. Click the small Pan button beneath it. The Dolly tool then becomes the Pan tool, as shown in Figure 6-11.

3. Drag the cursor across the tool to pan the camera.

Figure 6-11: The Pan tool

Note

You can also pan the camera by selecting the Pan tool and dragging inside the working box.

Rotating a camera with the Bank tool

The Bank tool changes the camera's orientation by rotating it from side to side. Banking a camera creates a tilted horizon effect. Bank the camera during animations to simulate the view from an airplane's cockpit.

To rotate a camera with the Bank tool:

1. Click the Dolly button to select it.
2. Click the small Bank button beneath it. The Dolly tool then becomes the Bank tool, as shown in Figure 6-12.
3. Drag the cursor across the tool to bank the camera.

 Figure 6-12: The Bank tool

 Note You can also bank the camera by selecting the Bank tool and dragging inside the working box. Alternatively, you can right-click anywhere inside the working box and select the Bank tool from the Ghost Menu.

Changing your viewpoint with the Axis Track tools

The Track tools are used to move a camera along a vertical, horizontal, or depth track (see Figure 6-13). Depending on the desired tracking, click the appropriate tool to select it and drag the mouse left or right and/or up or down to adjust the camera's position. Use the Track YZ tool to move the camera forwards and backwards or up and down. To the right of the Track YZ tool is the Track XY tool. Use this tool to move the camera from left to right or up and down. Centered and immediately below these two tools is the Track XZ tool. Use this tool to move the camera forwards and backwards or from left to right. You can also change your viewpoint by selecting any of the Track tools and dragging inside the working box. Alternatively, you can right-click anywhere inside the working box to select a Track tool from the Ghost menu. To save space when designing the Ghost menu, Carrara's designers named these tools Pan XY, Pan XZ, and Pan YZ.

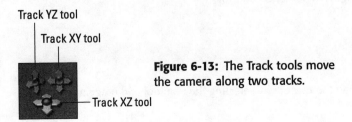

Track YZ tool

Track XY tool

Figure 6-13: The Track tools move the camera along two tracks.

Track XZ tool

Saving a camera's settings

Desirable camera positions can be saved to the camera list for future use. When a camera position is saved, the camera position and orientation are saved, but camera focal lengths are not saved. The current focal length in effect is applied when you return to a saved position.

Tip

Consider adding the camera's focal length to the name you assign for the saved position. An example of this would be to save a position as "Render #1 75mm".

To save a camera position:

1. From the camera list, select Set Position To ⇨ Save Position. The Save Camera Position dialog box appears (see Figure 6-14).

2. Enter a name for the new position and click OK to apply. The new position is saved on the camera list.

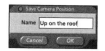

Figure 6-14: Saving a camera position

To delete a saved camera position:

1. From the camera list, select Set Position To ⇨ Delete Position. The Remove Position dialog box opens (see Figure 6-15).

2. Click the position you want to delete.

3. Click OK to delete the position from the camera list.

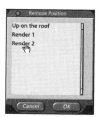

Figure 6-15: Deleting a saved camera position

Positioning a camera manually

By switching to the Director's Camera, you can use the Move and Rotate tools to position any other camera in the scene. Select either the camera itself or its silhouette from one of the plane walls, and use the Move and/or Rotate tools to reposition the camera.

Note As long as there is more than one scene camera (excluding the Director's Camera), you can use one scene camera to view another and then position it.

Aiming and positioning a camera by direct manipulation

Direct manipulation is a convenient way to manually aim and position a camera. If the camera has a zoom lens, its focal length can also be adjusted manually. To aim a camera manually, you must first turn on the camera's direct manipulation handles.

To turn on a camera's direct manipulation handles:

1. Select the camera.

2. Drag open the Properties tray.

3. From the Camera panel, click the Direct Manipulation button (see Figure 6-16) to display the camera's direct manipulation handles.

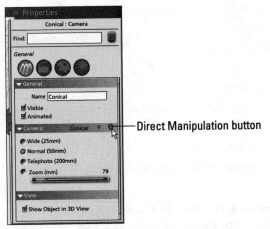

Figure 6-16: Click this button to display a camera's direct manipulation handles.

Use the direct manipulation handles that protrude from the actual camera to move and aim the camera. Alternatively, you can use the handles that protrude from the camera's silhouette on a plane wall.

To aim a camera using direct manipulation:

1. Select the Camera Aim control (shown in Figure 6-17) directly from the camera and drag it toward the object you want to aim at.

2. Select and drag the Camera Aim control from the camera's silhouette on a plane wall to fine-tune the aim.

3. Switch to other views as needed to finish aiming the camera.

Camera Aim control

Camera Position control Zoom Level control

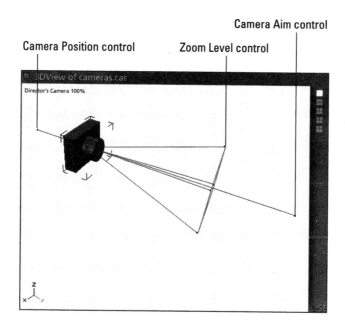

Figure 6-17: A camera with its direct manipulation handles turned on

To move a camera using direct manipulation:

1. Drag the Camera Position control (refer to Figure 6-17) directly from the camera to move it.

2. Drag the Camera Position control from a camera's silhouette on a plane wall to fine-tune the aim.

3. Switch to other views as needed.

Aim the camera first, and it will stay aimed at the target as you drag the camera to a new position with the Camera Position control.

To adjust a camera's focal length using direct manipulation:

1. Drag the Zoom Control (shown in Figure 6-17) towards an object to zoom in.

2. Drag the Zoom Control towards the camera to zoom out.

Dragging the camera's direct manipulation Zoom Control changes the camera's zoom value. For the new setting to have an effect, the Zoom option must be enabled from the Properties tray.

Aiming the camera at a specific object

Direct manipulation does a good job of aiming the camera in most instances. However, the Point At command will aim the camera precisely at an object's hot point. After using the Point At command, you can move the camera using the direct manipulation Camera Position control without affecting the aim.

To aim a camera using the Point At command:

1. Select the object at which you want to aim the camera.

2. Shift+click to add the camera to the selection.

3. Select Edit ➪ Point At (Ctrl+M). The camera aligns itself to point at the object's hot point.

Alternatively, follow these steps:

1. Drag open the Sequencer tray.

2. From the Universe list, select the object at which you want to aim the camera.

3. Shift+click to add the camera to the selection.

4. Select Edit ➪ Point At (Ctrl+M). The camera aligns itself to point at the object's hot point.

Using the Sequencer tray simplifies the selection process when you have a scene with many objects.

Tip To have the camera point where there are no objects, insert a sphere or Target Helper Object and position it where you want the camera to point. Use the Point At command to aim the camera at the sphere or Target Helper Object. After aiming the camera, delete the sphere. The Target Helper Object can be left in the scene, as it is not visible to the camera. For more information on Target Helper Objects, refer to Chapter 19.

Tracking an object with a camera

The Point At command is good for a one-time alignment. As soon as the target object is moved, the alignment is lost. In order to have a camera track an object, apply the Point At modifier. After applying the modifier, if either the camera or the object moves, the camera will reorient itself to point at the object. In animations, this modifier is useful if you want to have a camera track an object. It can also be used to have a camera track a point of interest, no matter how many times it's moved while setting up a scene.

To track an object with a camera:

1. Select the camera.

2. Drag open the Properties tray.

3. Click the Modifiers button.

4. Click the + button to reveal the camera drop-down menu of modifiers and select Point at.

5. In the Towards text field, enter the name of the object you want the camera to point at. This field is case sensitive.

6. The Axis option sets the axis of the camera that points at the object. Leave this option as is, set at Z.

Note When a camera is added to a scene, it is initially oriented with its lens pointing at the ground plane, or the Z orientation.

7. Check the Enabled box to apply the modifier.

Tip To have a camera stop tracking an object during an animation, uncheck the Enabled box at the time when you want the camera to stop tracking. For more information on animation, refer to Chapter 19.

Working with multiple cameras

Multiple cameras are useful when arranging scenes. Working in a multiwindow mode, you can use different cameras in different windows. In single-window mode, you can switch from one camera to another while editing a scene. Mixing isometric cameras and conical cameras is an excellent way to work efficiently in multiwindow mode. Switch between different isometric viewpoint windows to align and arrange your scene while viewing the results from a 3D perspective in the conical camera's window.

Multiple cameras can also be used to set up different rendering viewpoints. Be sure that each rendering camera has a unique name so that you can easily identify it in the Render room. If you have a scene with multiple rendering cameras, you can use the Batch Queue to automate rendering different views of a scene while you do something else.

Cross-Reference For more information on the Batch Queue and rendering, refer to Chapter 20.

Working with the Production Frame

The Production Frame acts just like the viewfinder on a camera. Use it to frame the portion of a scene that you want to show in the rendered image.

To view the Production Frame:

1. Select View ➪ Show Production Frame (Ctrl+Alt+F).

2. The Production Frame surrounds a portion of your scene.

The Production Frame has an inner and outer rectangle with a cross hair in the middle. The inner rectangle is called the *Title Safe Margin*. This margin acts as a "out of bounds" guide. Objects that appear between the Title Safe Margin and the edge of the Production Frame are at the outer limit of what will show in a rendering.

The default setting for the Title Safe Margin is 90 percent. You may have to adjust this setting to compensate for your equipment.

To adjust the Title Safe Margin:

1. Select File ➪ Preferences ➪ 3D View.
2. Drag the Production Frame Safe Area slider to adjust the setting.

Small dots found at the corners of the Production Frame act as handles. Drag one of these handles to resize the Production Frame. Resizing the Production Frame does not affect the Camera Position — it merely changes its view. Click and drag the cross hair at the center of the Production Frame to fine-tune its positioning.

The proportions of the Production Frame match the proportions of the image size specified in the Render room. If you intend to render at a different size than the Carrara default (640 × 480 pixels), specify the new image size in the Render room before using the Production Frame to set the scene.

Creating a Fish-Eye Lens Effect

Carrara doesn't have a true fish-eye lens amongst its inventory of lenses. However, by using a little 3D sleight of hand, there is a way to simulate a fish-eye lens.

To create a fish eye lens effect:

1. Launch Carrara and select File ➪ New to create a new document.
2. Drag open the Properties tray. Click the blue button with the downward-facing double arrow and click Camera 1 to select it.
3. In the Camera panel, select Wide to change the camera's focal length to 25mm.
4. Populate the scene with objects of your choice and set up scene lighting. If you like, place a patterned wall behind the scene to accentuate the fish-eye effect. Be sure to place the camera fairly close to the scene objects.
5. After the scene is set up, create a large sphere and place it directly behind the camera.

The sphere is what pulls off the fish-eye effect. After applying a mirror finish to it, you aim the camera directly at it. The camera will render the distorted reflection of the scene produced by the sphere.

6. With the sphere selected, click the Texture room icon.
7. Apply a mirror finish shader to the sphere by choosing pure black for the Color channel and a value of 100 for the Reflection channel.
8. Click the Assemble icon to return to the Assemble room.
9. Rotate the camera 180 degrees or use the Point At command to aim it at the sphere.

10. Align the camera until it is almost touching the sphere.

11. Select View ➪ Show Production Frame (Ctrl+Alt+F). You won't be able to see your scene in the Production Frame. The camera will render a distorted reflection of the scene from the surface of the sphere.

12. Drag the Area Render tool across the Production Frame to determine where the reflection of your scene is located in relation to the Production Frame.

13. Drag the outer handles of the Production Frame to size it.

14. Click the cross hair and drag to move the Production Frame to properly frame the scene.

Figure 6-18 shows the set-up for the fish-eye effect. Figure 6-19 shows an image created with the fish-eye effect.

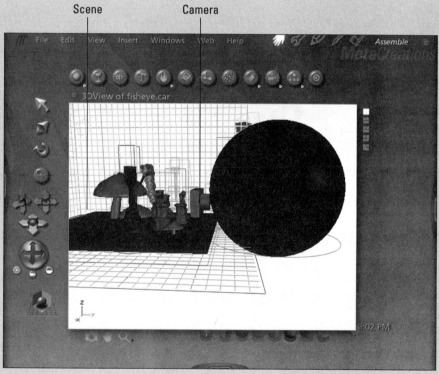

Figure 6-18: Creating a fish-eye lens effect by aiming a camera at a reflective sphere

Continued

Continued

Figure 6-19: An image created with the fish-eye effect

In the Content section of the book's CD ROM, open up the Chapter 6 folder and locate the scene called fisheye.car. Open this file in Carrara to see how the fish-eye effect is produced.

Summary

Carrara's cameras are your eyes when you set up a 3D scene. By using a combination of isometric and conical cameras in multiwindow mode, you can create an efficient working environment. Carrara's conical camera acts just like a photographer's 35mm camera, introducing a realistic perspective in a scene that looks right to the human eye.

✦ Isometric cameras offer 2D orthogonal views that are useful for aligning and positioning scene objects.

✦ Conical cameras add perspective to a scene.

✦ The Depth of Field effect blurs objects in the foreground and background, providing a limited area of focus like that of a telephoto lens.

✦ Direct manipulation controls enable you to manually aim and move a camera.

✦ The Point At command aims a camera at an object's hot point.

✦ The Point At modifier can be used to have a camera track an object.

✦ The Production Frame acts like a viewfinder to frame a scene.

✦ ✦ ✦

Lighting Your Scene

For a 3D scene to be successful, a number of factors must be considered. You should populate the scene with interesting objects of varying sizes. The objects should be decorated with appealing surface colors and textures that accentuate the scene's center of interest. Scene composition should be set up in a way that draws a viewer's attention from one center of interest to the next. One of the final and perhaps most important factors in a successful scene is lighting.

The effective use of light and shadow will draw your viewer to the scene's center of interest and guide them through the scene. Effective placement of lighting can accentuate a 3D object's form and surface texture by gently bathing it in pools of shadow and light. Carrara makes it possible to achieve dazzling lighting effects with a combination of spotlights, bulb lights, and distant lights.

Adjusting Scene Lighting

Scene lighting determines the overall success of a 3D scene once it is rendered. Carefully engineered lighting can take a scene from "blah" to "ah."

Adjusting ambient lighting

The most basic form of lighting in Carrara is ambient lighting. Ambient lighting is uniform and nondirectional. Ambient light washes evenly over a scene and casts no shadows.

Ambient lighting can be useful when creating a scene. It can give you an idea of an object's shape and surface appearance. It is best to keep ambient lighting at low levels or turn it off completely, as it tends to wash out shadows and highlights.

Ambient lighting can be adjusted for brightness and color. To adjust ambient lighting:

1. Drag open the Properties tray and click the small blue button with the downward-facing double arrow.

2. Select Scene from the drop-down menu.

3. If it's not already selected, click the Effects button.

4. Click the triangle to the left of the Ambient panel to expand it.

5. Drag the Brightness slider to increase or decrease ambient brightness (see Figure 7-1).

Figure 7-1: Adjusting ambient light settings

6. Click the color swatch to open the Color Picker and select a color for ambient lighting.

Selecting Carrara's scene lights

Scene lights give you the greatest amount of control over lighting. Scene lights are completely adjustable for a number of properties, including brightness and color. They can be precisely aligned and aimed at specific objects.

The proper choice of lighting lets you set a scene's mood. Carrara gives you three scene lights (Spot, Bulb, and Distant) and two atmospheric lights (Sun and Moon) to choose from. Figure 7-2 shows the expanded light toolbar.

Figure 7-2: Use this toolbar to introduce lights into your scene.

Introducing the Spot light

In Carrara, the Spot light emanates from a single source and sends a beam of light in a specific direction. This light acts like a stage spotlight and can be directly aimed at an object to make it a point of interest in your scene. Spot lights cast shadows by default.

To add a Spot light to your scene, use one of the following methods:

✦ Select Insert ➪ Spot.

✦ Drag the Spot tool directly into the working box.

✦ Drag the Spot tool into the Sequencer tray's Universe list.

Introducing the Bulb light

The Bulb light emanates from a single source and casts light evenly in all directions. To get an idea of a Bulb light's characteristics, remove the lamp shade from one of your home or office lamps and observe the light's behavior. Bulb lights cast shadows by default.

To add a Bulb light to your scene, use one of the following methods:

✦ Select Insert ➪ Bulb.

✦ Drag the Bulb tool directly into the working box.

✦ Drag the Bulb tool into the Sequencer tray's Universe list.

Introducing the Distant light

The Distant light is the default light when you create a new scene. The Distant light casts parallel rays of light that affect all objects in a scene. This light behaves much like the sun casting beams of light upon the earth. The light's source of origin is outside of the working box no matter where you place it in the scene. Distant lights cast shadows by default.

To add a Distant light to your scene, use one of the following methods:

✦ Select Insert ➪ Distant.

✦ Drag the Distant tool directly into the working box.

✦ Drag the Distant tool into the Sequencer tray's Universe list.

Note

As with other Carrara scene objects, when you use a menu command to insert a light into a scene, it is placed exactly in the center of the working box. When you select a light tool and drag it into the working box, it is left where you drop it.

Using Carrara's Sun light

Carrara's Sun light is used in conjunction with the Four Elements: Wind editor.

To add a Sun light to your scene, use one of the following methods:

✦ Select Insert ➪ Sun Light.

✦ Drag the Sun Light tool directly into the working box.

✦ Drag the Sun Light tool into the Sequencer tray's Universe list.

Drag the Brightness slider to adjust the intensity of the Sun light.

Using Carrara's Moon light

Carrara's Moon light is used in conjunction with the Four Elements: Wind editor.

To add a Moon light to your scene, use one of the following methods:

✦ Select Insert ➪ Moon Light.

✦ Drag the Moon Light tool directly into the working box.

✦ Drag the Moon Light tool into the Sequencer tray's Universe list.

Drag the Brightness slider to adjust the intensity of the Moon light.

Cross-Reference For more information on the Four Elements: Wind editor, refer to Chapter 12.

Aiming Lights in Your Scene

Once a light is added to a scene, it needs to be precisely placed and aimed if it is to be effective. Carrara gives you a couple of options for aligning and aiming scene lights. You can use the Move and Rotate tools to position a light. You can use a light's direct manipulation handles to move and aim it. You can numerically position a light by adjusting its properties in the Properties tray. Last but not least, you can use a menu command to aim a light directly at a specific object in your scene.

Manually aiming a light

To manually aim a light with the Move and Rotate tools:

1. Select the light.

2. Using either the Move or Rotate tool, select the object's silhouette on a plane wall and move or rotate the light in the desired direction.

Another way to aim a light is by using its direct manipulation handles. Only Spot lights have direct manipulation handles for aiming. Aim Bulb and Distant lights using the Move and Rotate tools.

To manually aim a Spot light using the direct manipulation handles:

1. Click the Spot light to select it.

2. Drag open the Properties tray and click the General button.

3. Click the Direct Manipulation button in the Light panel to display the light's direct manipulation handles.

Note

There are three Direct Manipulation buttons. The default Direct Manipulation button has a diagonal slash through it. This button turns direct manipulation off. The Direct Manipulation button with the bold border displays a light's direct manipulation handles whenever it is visible in a scene. The Direct Manipulation button with the light border displays a light's direct manipulation handles only when it is selected.

4. Drag the Light Position control to move the light.

5. Drag the Light Aim control to aim the light at a specific object in your scene (see Figure 7-3). By dragging the Light Aim control, you can extend it to the object you want to aim at. You can also use the direct manipulation handles that are silhouetted on the plane walls to fine-tune the adjustment in all planes.

Light Position control Light Aim control **Figure 7-3:** Aiming a Spot light with its direct manipulation handles

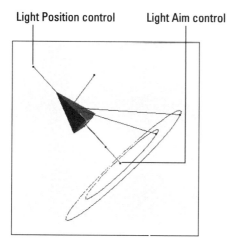

You can do a good job of aiming and positioning a light with direct manipulation handles. However, if a light needs to be placed at a specific point in a scene, you're better off positioning it numerically. A good example of this would be when you need to shine a light on an object, but not on objects beneath it. Numerically position the light a specific distance above the object. Then adjust the light's range so it is longer than the distance from the light to the object, but less than the distance to the underlying objects.

To numerically aim a light:

1. Select the light.

2. Drag open the Properties tray.

3. Click the Motion/Transform button.

4. Enter the desired X, Y, and Z coordinates to move the light.

5. Enter the desired Yaw, Roll, and Pitch values to rotate the light (see Figure 7-4).

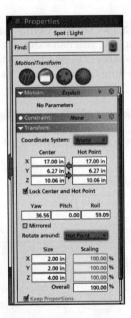

Figure 7-4: Numerically positioning a Spot light

Pointing a light at an object

Carrara's Point At command can be used to aim a light at a specific object in your scene.

To point a light at an object:

1. Click to select the object you want the light to point at.

2. With the object still selected, Shift+click to add the light to the selection.

3. Select Edit ➪ Point At (Ctrl+M). The light now points at the object, as shown in Figure 7-5.

Figure 7-5: Using the Point At command to aim a light at an object

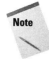

Note You can also select multiple lights to aim at an object. Continue holding down the Shift key and click to select additional lights. After adding the desired lights to the selection, invoke the Point At command to have all the lights point at the object.

The Point At command is useful when you're creating scenes that will render as still images. Pointing a light at a moving object during the course of an animation requires a different operation. To set a light to track an object during an animation, add the Point At modifier to the light's parameters.

To have a light track an object during an animation:

1. Click to select the light.

2. Drag open the Properties tray.

3. Click the Modifiers button.

4. Click the + sign and select Point At.

5. Adjust the settings as required:

- **Towards:** Enter the name of the target object exactly as it appears in the Sequencer tray. (Note that this field is case sensitive.)

- **Axis:** This option selects which axis of the light should point at the target object. As the light emits from the Z axis, leave this setting at its default value of Z.

- **Enabled:** Check this box to turn the modifier on.

Tip To have the light stop tracking an object during the course of an animation, create a key frame where you want the light to stop tracking and uncheck the modifier's Enabled option.

Adjusting the Properties of Lights in Your Scene

After adding a light to the scene and aiming it, you'll need to adjust other parameters such as brightness, color, range, falloff, and shadow intensity. Each light type has its own set of adjustable parameters.

Adjusting a light's properties with the Properties tray

The Properties tray can be used to adjust all the parameters of a light. You can also use the Properties tray to change the type of light. In the following section, you learn to change the properties of Bulb lights, Spot lights, and Distant lights.

To adjust a Bulb light's properties:

1. Select the light.

2. Drag open the Properties tray and click the General button. The selected light's adjustable parameters are displayed, as shown in Figure 7-6.

3. Drag the Brightness slider to increase or decrease the light's intensity.

4. Click the color swatch to open the Color Picker and select a color for the light.

5. Enter a value to adjust the light's range. This value determines how far the light's rays will shine.

6. Drag the Range Falloff slider to adjust the light's range falloff — that is, how strong the light is as it diminishes across its range. A range falloff of 20 percent creates a light that has full intensity for 80 percent of its range.

7. Enable the Cast Shadows option if you want the light to cast shadows.

8. Drag the Shadow Intensity slider to increase or decrease the intensity of shadows cast by the light. Low settings cast weak shadows.

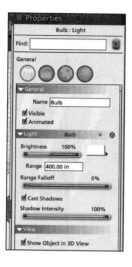

Figure 7-6: Adjusting a Bulb light's properties

 Tip

To view how lighting changes affect the objects in your scene, click the Area Render tool (the camera icon to the lower-left of the working box) and drag it over a portion of your scene to do a quick spot rendering.

To adjust a Spot light's properties:

1. Select the light.

2. Drag open the Properties tray and click the General button. The selected light's adjustable parameters are displayed, as shown in Figure 7-7.

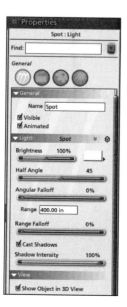

Figure 7-7: Adjusting a Spot light's properties

3. Drag the Brightness slider to increase or decrease the light's intensity.

4. Click the color swatch to open the Color Picker, and select a color for the light.

5. Drag the Half Angle slider to increase or decrease the Spot light's half-angle. The half-angle is the angle from the light's center line to its cone. Use a narrow half-angle to create flashlight beams and a wide half-angle for bright floodlights.

6. Drag the Angular Falloff slider to set the Spot light's angular falloff. Angular falloff determines how the Spot light's brightness diminishes as it reaches the end of its cone. A falloff of 50 percent creates a light that has 100 percent intensity through 50 percent of its light cone and diminishes linearly to the edge of the cone.

7. Enter a value for the Range. This value determines how far the Spot light's rays will shine.

8. Drag the Range Falloff slider to adjust the light's range falloff. Range falloff determines how strong the Spot light is as it diminishes across its range, just as it affects Bulb lights. A range falloff of 20 percent creates a light that has full intensity for 80 percent of its range.

9. Enable the Cast Shadows option if you want the Spot light to cast shadows.

10. Drag the Shadow Intensity slider to increase or decrease the intensity of shadows cast by the Spot light. Low settings cause the light to cast weak shadows.

To adjust a Distant light's properties:

1. Select the light.

2. Drag open the Properties tray and click the General button. The selected light's adjustable parameters are displayed, as shown in Figure 7-8.

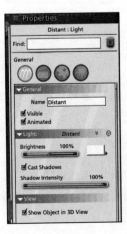

Figure 7-8: Adjusting a Distant light's properties

3. Drag the Brightness slider to increase or decrease the light's intensity.

4. Click the color swatch to open the Color Picker and select a color for the light.

5. Enable the Cast Shadows option if you want the Distant light to cast shadows.

6. Drag the Shadow Intensity slider to increase or decrease the intensity of shadows cast by the Distant light. Low settings cause the light to cast weak shadows.

Tip Add a Distant light to your scene to soften shadows cast by other lights. Position the Distant light above and out of camera range. Adjust the light's brightness characteristics to achieve desired results.

The Properties tray can also be used to change light types. This feature comes in handy when you've already set and aimed a light but decide to use a different type of light to illuminate a particular part of the scene.

To change light types using the Properties tray:

1. Select the light you want to change.

2. Drag open the Properties tray and click the General button. The name of the current light type is listed in the Light panel.

3. Click the current light type to reveal a drop-down menu.

4. Select the desired light type to complete the transformation.

Manually adjusting a light's properties

The Spot light and Bulb light have properties that can be adjusted with direct manipulation handles.

Manually adjusting a Bulb light's properties

A Bulb light has only one direct manipulation handle, which is used to adjust the light's brightness.

To manually adjust a Bulb light's properties:

1. Select the Bulb light.

2. Drag open the Properties tray and click the General button.

3. Click the Direct Manipulation button to display the light's direct manipulation handles.

4. Drag the light's Brightness control (shown in Figure 7-9) away from the light to increase intensity or towards the light to decrease intensity.

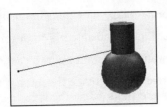

Figure 7-9: Manually adjusting a Bulb light's brightness

Note If you have the Properties tray open, you can view the changes to a light's properties as you drag the direct manipulation handles.

Manually adjusting a Spot light's properties

As mentioned earlier in the discussion on aiming lights, a Spot light can be positioned and aimed by using its direct manipulation handles. In addition, you can adjust a Spot light's brightness, half-angle, and angular falloff with direct manipulation.

To manually adjust a Spot light's properties:

1. Select the Spot light.

2. Drag open the Properties tray and click the General button.

3. Click the Direct Manipulation button to display the light's direct manipulation handles.

4. Drag the Brightness control away from the light to increase intensity or towards the light to decrease intensity.

5. Drag the Half Angle control towards the light to decrease the Spot light's half-angle and away from the light to increase it.

6. To change the angular falloff, press Ctrl and drag the Half Angle control towards the center of the cone, as shown in Figure 7-10.

Tip You can check a Spot light's half-angle cone diameter by dragging the light's Cross Section control. Notice how the cone expands as it gets farther away from the light's source.

Setting shadow options

If a scene light has the Cast Shadows option enabled, a shadow is cast whenever the light is obscured by an object. When you create a shadow-casting light, you have two shadow options to choose from: Ray Traced and Soft Shadows.

Ray Traced is the default setting for shadows. Ray-traced shadows produce harsh abrupt edges with no transition between shadow and light.

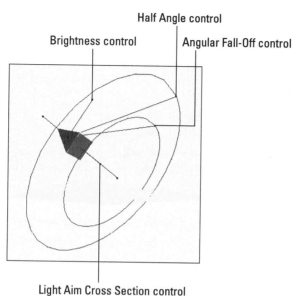

Figure 7-10: Manually adjusting a Spot light's brightness, half-angle, and angular falloff

The Soft Shadows setting produces a soft natural transition between shadow and light.

To set a light's shadow options:

1. Select the light.

2. Drag the Properties tray open.

3. Click the Effects button. Notice the current shadow type is listed on the Shadow panel.

4. Click the current shadow type to reveal a drop-down menu.

5. Select the desired shadow type to apply from the menu (see Figure 7-11).

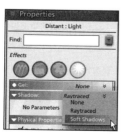

Figure 7-11: Selecting a light's shadow option

7. Shadows created through the Ray Traced option have no parameters that need to be set. If you choose Soft Shadows (see Figure 7-12), adjust the following settings:

- **Resolution:** Sets shadow quality. Click the blue Resolution button to change resolution settings from the drop-down menu. A higher resolution uses more memory.

- **Blur Size:** Drag this slider to determine the area of softness. Increase the setting if you opted for higher resolution.

- **Bias:** Drag this slider to control shadow placement. Increase this setting for objects that cast their own shadows. Decrease this setting if shadows appear far away from objects.

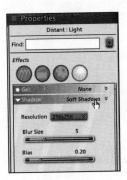

Figure 7-12: Adjusting Soft Shadow settings

Creating Special Lighting Effects

Controlling a light's color, brightness, and intensity are merely the starting points for creating spectacular lighting effects. Carrara has a treasure trove full of lighting effects to add visual impact to your scene.

Creating special effects with gels

Gels are images placed in front of a light that projects patterns or images into your scene. Gels can be full-color images or black-and-white masks. Gels are most effective with Spot lights, but can also be used with Bulb lights. Gels have no effect on Distant lights.

When used as gels, color or grayscale images act like transparent slides in a projector. The light pattern created by the gel depends on the image's opacity and the light's intensity. Color gels can be used to create effects such as sunlight filtering through a colorful storefront window.

Black-and-white (1-bit) gels create masks when placed in front of lights. White regions of the gel let light pass through, whereas black areas block light. This sort of gel can be used to create effects such as light shining through prison bars.

Movies can also be used as gels. A black-and-white movie gel can be used to simulate effects such as cast shadows from a tree swaying in a gentle breeze.

To apply a texture map or movie as a gel:

1. Select the light.

2. Drag open the Properties tray.

3. Click the Effects button.

4. In the Gel panel, select Map. The Texture Map window appears in the Gel panel.

5. Click the Folder icon. The Open dialog box appears.

6. Locate the image or movie file you want to use as a gel and click Open to apply. The Choose File Format dialog box appears. Click OK. A thumbnail of the image appears in the Texture Map window (see Figure 7-13).

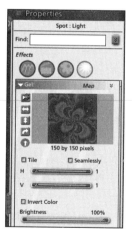

Figure 7-13: Applying a texture map as a gel

7. Click any of the direction buttons to flip or rotate the texture map.

8. Enable Tile to create multiple tiles of the image.

9. Enable Seamlessly to have Carrara flip and rotate neighboring tiles for a seamless match.

10. Drag the H slider to set the number of horizontal repetitions.

11. Drag the V slider to set the number of vertical repetitions.

12. Enable the Invert Color option to invert the texture map's colors.

13. Drag the Brightness slider to adjust the texture map's brightness.

Tip To view the effect the applied light gel is having on your scene, click the Area Render tool (the camera icon at the bottom of the working box) and drag it over a portion of your scene to do a quick spot rendering.

Carrara also has some preset gels for you to use, including Blinds, Formula, and Gradient gels.

The Blinds gel creates an effect that simulates light passing through a window covered by partially opened blinds. This gel can be used to simulate a dimly lit office with cast shadows of light passing through blinds.

To apply the Blinds gel to a light:

1. Select the light.

2. Drag open the Properties tray.

3. Click the Effects button.

4. In the Gel panel, select Blinds. The Blinds dialog box appears, as shown in Figure 7-14.

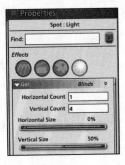

Figure 7-14: Setting Blind gel options

5. Set the following Blind gel options:

 • Enter a value for Horizontal Count to set the number of horizontal blinds.

 • Enter a value for Vertical Count to set the number of vertical blinds.

 • Drag the Horizontal Size slider to set the width of the horizontal blinds. This setting is an expressed percentage of the gel frame.

 • Drag the Vertical Size slider to set the height of the vertical blinds. This setting is an expressed percentage of the gel frame.

The Formula gel creates a pattern based on a mathematical formula. You can use the preset formula or create your own.

To apply the Formula gel to a light:

1. Select the light.

2. Drag open the Properties tray.

3. Click the Effects button.

4. In the Gel panel, select Formula. The Formula dialog box appears (see Figure 7-15).

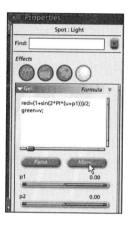

Figure 7-15: Setting Formula gel options

5. Click the More button to edit the existing formula or create one of your own. A new window opens, and P3 and P4 sliders are added to the formula, as shown in Figure 7-16.

6. Drag the sliders to adjust the P1 through P4 values.

7. After editing the formula, click the Parse button to apply the formula to the gel.

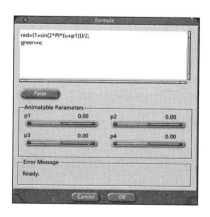

Figure 7-16: Use this window to enter a formula of your own.

The Formula editor is used throughout Carrara. This editor has its own special protocol. For more information on formulas, refer to the section "Modeling with Formulas" in Chapter 13.

The Gradient gel blends two colors to create a pattern. A Gradient gel can be circular or rectangular.

To apply the Gradient gel to a light:

1. Select the light.
2. Drag open the Properties tray.
3. Click the Effects button.
4. In the Gel section, select Gradient. The Gradient dialog box appears, as shown in Figure 7-17.

Figure 7-17: Setting Gradient gel options

5. Choose a Horizontal, Vertical, or Circular pattern:
 - **Horizontal:** Creates a pattern that blends the two colors from top to bottom
 - **Vertical:** Creates a pattern that blends the two colors from left to right
 - **Circular:** Creates a pattern that blends the two colors in a concentric pattern with the start color in the circle's center and the end color at its perimeter
6. Click the top color swatch to open the Color Picker and select the Start color.
7. Click the bottom color swatch to open the Color Picker andselect the End color.

Creating photographic effects

Special photographic and lighting effects can be applied to scene lights to create areas of visual interest. These effects can be applied to individual lights, as opposed to all lights of a particular type.

Light effects can be applied to Bulb and Spot lights but not Distant lights. You can apply more than one effect to a light. Light effects must be applied to visible light sources that are within camera range in order to be seen.

Note

Light Effects, Light Cone, Light Sphere, and Lens Flare dialog boxes feature a window that shows the effect as it's applied to the light. Changes are displayed almost instantly.

To apply a light effect to an light:

1. Select the light.

2. Drag open the Properties tray.

3. Click the Effects button.

4. Choose the desired effect from the Light Effects panel (see Figure 7-18).

Figure 7-18: Apply one or more of these effects to a light to create visual highlights in a scene.

Creating light streaks with the CrossScreen effect

The CrossScreen effect adds a glow and starburst effect to every light source it is applied to. This effect can be used to simulate bright points of light.

To apply the CrossScreen effect to a light:

1. Select the light.

2. Drag open the Properties tray.

3. Click the Effects button.

4. Check the Enable CrossScreen option in the Light Effects panel.

5. Click the Edit button. The CrossScreen dialog box appears, as shown in Figure 7-19.

Figure 7-19: Adjusting settings for the CrossScreen lighting effect

6. Adjust the following CrossScreen settings:

 • Drag the Glow Size slider to adjust the diameter of the glow.

 • Drag the Star Size slider to adjust the star's radius.

 • Drag the Angle slider to set the star's angle of rotation around the light source.

 • Drag the Branches slider to set the number of star rays.

 • Drag the Intensity slider to adjust the intensity of the effect.

7. Click OK to apply.

Creating a halo with the Glow effect

The Glow effect adds a halo around the visible light source to which it is applied. The overall effect depends on the light's color, intensity, and position in relation to the camera. The light must be within the production frame and not hidden from the camera for the effect to be seen.

To apply the Glow effect to a light:

1. Select the light.

2. Drag open the Properties tray.

3. Click the Effects button.

4. Check the Enable Glow option in the Light Effects panel.

5. Click the Edit button. The Glow dialog box appears (see Figure 7-20).

Figure 7-20: Adjusting settings for the Glow lighting effect

6. Adjust the following Glow settings:

 • Drag the Glow Size slider to adjust the diameter of the glow.

 • Drag the Intensity slider to adjust the intensity of the glow.

7. Click OK to apply.

Creating light streaks with the Nebula effect

The Nebula effect adds multicolored light streaks to every visible light source it is applied to. The Nebula effect creates a halo of kaleidoscope-like colors around the light.

To apply the Nebula effect to a light:

1. Select the light.

2. Drag open the Properties tray.

3. Click the Effects button.

4. Check the Enable Nebula option in the Light Effects panel.

5. Click the Edit button. The Nebula dialog box appears, as shown in Figure 7-21.

Figure 7-21: Adjusting settings for the Nebula lighting effect

6. Adjust the following Nebula settings:

 • Drag the Radius 1 slider to adjust the streak's starting radius.

- Drag the Radius 2 slider to adjust the streak's ending radius.
- Drag the Angle slider to adjust the streak's angle of rotation around the light source.
- Drag the Branches slider to adjust the number of streaks.
- Enable the Thick option to make the streaks thicker.
- Drag the Intensity slider to adjust the intensity of the effect.

7. Click OK to apply.

Creating dotted light streaks with the Pulsator effect

The Pulsator effect adds a halo of dotted streaks around every visible light source it is applied to. For the effect to be visible, the light source must be within the production frame and visible to the camera. It cannot be hidden by an object.

To apply the Pulsator effect to a light:

1. Select the light.
2. Drag open the Properties tray.
3. Click the Effects button.
4. Check the Enable Pulsator option in the Light Effects panel.
5. Click the Edit button. The Pulsator dialog box appears, as shown in Figure 7-22.

Figure 7-22: Adjusting the settings for the Pulsator lighting effect

6. Adjust the following Pulsator settings:
 - Drag the Size slider to adjust the radius of the dotted streaks.
 - Drag the Thickness slider to adjust the thickness of the dotted streaks.
 - Drag the Angle slider to adjust the dotted streaks' angle of rotation around the light source.
 - Drag the Intensity slider to adjust the intensity of the effect.

7. Click OK to apply.

Using the Stars effect

The Stars effect creates a star around every visible light source it is applied to. Use this effect to simulate car headlights, distant planets, and, of course, stars themselves.

To apply the Stars effect to a light:

1. Select the light.
2. Drag open the Properties tray.
3. Click the Effects button.
4. Check the Enable Stars option in the Light Effects panel.
5. Click the Edit button. The Stars dialog box appears (see Figure 7-23).

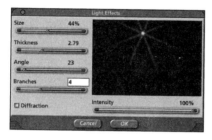

Figure 7-23: Adjusting the settings for the Stars lighting effect

6. Adjust the following Stars settings:
 - Drag the Size slider to adjust the star's radius.
 - Drag the Thickness slider to adjust the thickness of the star's branches.
 - Drag the Angle slider to adjust the angle of rotation of the branches around the light source.
 - Drag the Branches slider to adjust the number of branches for the star.
 - Enable the Diffraction option to split the star into rainbow colors.
 - Drag the Intensity slider to adjust the intensity of the effect.

7. Click OK to apply.

Adding the VarioCross effect

The VarioCross effect adds two light streaks to every visible light source it is applied to. The light source must be within the Production Frame and visible to the camera for the effect to be visible. The VarioCross effect works best when rendered against a dark background. This effect works well for simulating visible car headlights.

To apply the VarioCross effect to a light:

1. Select the light.
2. Drag open the Properties tray.
3. Click the Effects button.
4. Check the Enable VarioCross option in the Light Effects panel.
5. Click the Edit button. The VarioCross dialog box appears (see Figure 7-24).

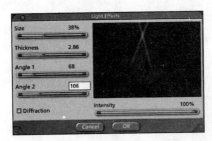

Figure 7-24: Adjusting the settings for the VarioCross lighting effect

6. Adjust the following VarioCross settings:
 - Drag the Size slider to adjust the streak radius.
 - Drag the Thickness slider to adjust the thickness of the streaks.
 - Drag the Angle1 slider to adjust the angle of rotation for the first streak around the light source.
 - Drag the Angle2 slider to adjust the angle of rotation for the second streak around the light source.
 - Enable the Diffraction option to split the star into rainbow colors.
 - Drag the Intensity slider to adjust the intensity of the effect.

7. Click OK to apply.

Creating atmospheric effects with the Light Cone effect

Take a look at the light filtering in through your kitchen window while you're having your morning coffee. You'll notice that the light bounces off small particles of dust and vapor, which creates a visible cone of light that emanates from the light source. The Light Cone effect does an excellent job of simulating this phenomenon. This effect will be visible within the Spot light's cone, and is visible even if the light source is out of the Production Frame. As long as the light's range is long enough and the light is bright enough, the light cone will be visible, but you must render against a background darker than the color you choose for the light cone.

To apply the Light Cone effect to a light:

1. Select the Spot light.
2. Drag open the Properties tray.
3. Click the Effects button.
4. Check the Enable option in the Light Cone panel.
5. Click the Edit button. The Light Cone dialog box appears (see Figure 7-25).

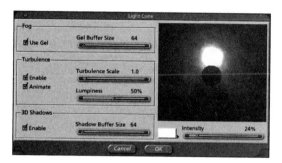

Figure 7-25: Adjusting the settings for the Light Cone effect

6. Adjust the following Fog settings:
 • Enable the Gel option to apply a gel's colors to the Light Cone effect. This option only works if a gel is applied to the light source.
 • The Gel Buffer Size option sets the quality of the gel effect within the light cone. Drag the slider to the right to increase quality.

7. Set Turbulence options:
 • Check Enable to create swirling fog within the cone.
 • Drag the Turbulence Scale slider to adjust the size of the fog wreath. This setting is measured in inches.
 • The Animate option, when checked, animates the fog over time.
 • Drag the Lumpiness slider to adjust the contrast of the fog.

8. Set 3D Shadows options:
 • Enable when checked causes objects within the light cone to cast shadows in the fog.
 • Drag the Shadow Buffer Size slider to adjust the quality of the shadow within the light cone.

Caution

The Light Cone option creates interesting lighting effects, but not without a cost. If you enable the Use Gel option or the Enable 3D Shadows option, don't use a buffer size of over 200 for either option unless you have a powerful computer.

9. Click the color swatch to open the Color Picker and select a color for the fog. The visible color of the fog is an interaction of the fog's color and the color of the visible light source.

10. Drag the Intensity slider to adjust the intensity of the effect.

11. Click OK to apply.

Creating atmospheric effects with the Light Sphere effect

The Light Sphere effect simulates the interaction of a bulb light with dust particles, haze, and smoke. This effect is similar to the Light Cone effect but is tailor-made for a Bulb light. This effect is visible even if the light source is out of the Production Frame. As with the Light Cone effect, you must render against a background color that is darker than the color of the light sphere. If the light's range is long enough and the light is bright enough, the light sphere will be visible.

To apply the Light Sphere effect to a light:

1. Select the light.

2. Drag open the Properties tray.

3. Click the Effects button.

4. Click the Enable option in the Light Sphere panel.

5. Click the Edit button. The Light Sphere dialog box appears, as shown in Figure 7-26.

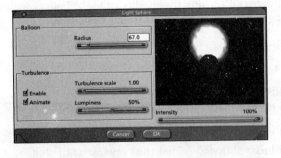

Figure 7-26: Adjusting the settings for the Light Sphere effect

6. Adjust the following Balloon setting:
 • Drag the Size slider to adjust the radius of the balloon that surrounds the light source.

7. Adjust the following Turbulence settings:
 • Check the Enable option to produce swirling fog in the balloon.
 • Drag the Turbulence Scale slider to adjust the size of the fog wreath. The setting is measured in inches.

- Check the Animate option to animate the fog.
- Drag the Lumpiness slider to adjust the contrast of the fog.
- Drag the Intensity slider to adjust the intensity of the effect.

8. Click OK to apply.

Creating photographic lighting with the Lens Flare effect

The Lens Flare effect simulates the flare you see in a photograph that has been taken by a camera facing a strong light source. The color and size of a photographic lens flare varies according to the type of lens used and the color and intensity of the light source at which the camera is aimed.

The effect varies depending on the light source's intensity and position. The light source must be located within the Production Frame and cannot be hidden by another object, even a transparent one. The rendering camera must fall within the light source's cone. The Lens Flare effect works best when rendered against a dark background with Ambient light at low settings or turned off. Lens flares are invisible when rendered against a white background.

To apply the Lens Flare effect to a light:

1. Select the light.
2. Drag open the Properties tray.
3. Click the Effects button.
4. Click the Edit button in the Lens Flare panel. The Lens Flare dialog box opens (see Figure 7-27).

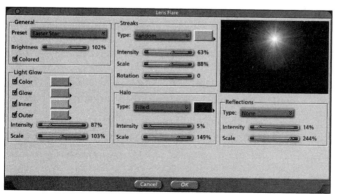

Figure 7-27: The Lens Flare dialog box

5. Adjust the following General options:

- Click the blue button to reveal the Preset drop-down menu (see Figure 7-28).

- Drag the Brightness slider to adjust the intensity of the flare.

- Enable the Colored option to render the flare in color.

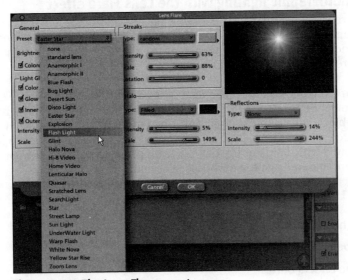

Figure 7-28: The Lens Flare preset menu

6. Adjust the following Light Glow options:

- Enable Color to set the color of the light. If enabled, click the color swatch to open the Color Picker and select a color for the light.

- Enable Glow to set the color of the glow surrounding the light. If enabled, click the color swatch to open the Color Picker and select the glow color.

- Enable Inner to set the color of the inner glow gradation. If enabled, click the color swatch to open the Color Picker and select the inner glow color.

- Enable Outer to set the color of the outer glow gradation. If enabled, click the color swatch to open the Color Picker and select the outer glow color.

- Drag the Intensity slider to adjust the strength of the light glow.

- Drag the Scale slider to adjust the size of the light glow.

7. Adjust the following Streaks options:

- Accept the Type default of none, or click the blue button to reveal the Streaks preset drop-down menu (see Figure 7-29).

- Drag the Intensity slider to adjust the intensity of the streaks.

- Drag the Scale slider to adjust the size of the streaks.

- Drag the Rotation slider to adjust the streaks' angle of rotation around the light source.

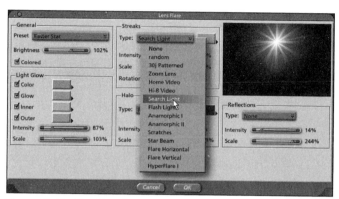

Figure 7-29: The Streaks preset menu

8. Adjust the following Halo options:

- Click the blue button next to Type to reveal the Halo drop-down menu and choose None for no halo, Filled for a solid color ring, or Lenticular for a rainbow-colored ring that gradually fades in intensity (see Figure 7-30).

- Click the color swatch to open the Color Picker and select the halo color.

- Drag the Intensity slider to adjust the intensity of the halo.

- Drag the Scale slider to adjust the size of the halo.

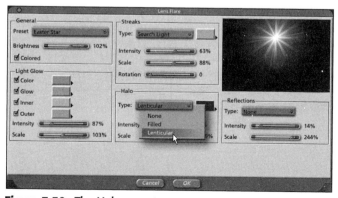

Figure 7-30: The Halo preset menu

9. Adjust the following Reflections settings:

- Accept the Type default of None or click the blue button to reveal the Reflections preset drop-down menu, as shown in Figure 7-31, and make a selection.

- Drag the Intensity slider to adjust the intensity of the reflections.

- Drag the Scale slider to adjust the size of the reflections.

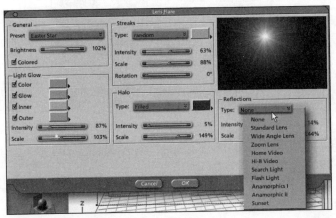

Figure 7-31: The Reflections preset menu

As you can see, lens flares can be created in myriad colors and styles. Mix and match the various flare options to add new and exciting visual effects to your scenes.

Lighting Techniques

Effective scene lighting comprises a combination of lights and effects. Although it's possible to light a scene with ambient lighting and one Spot light, you'll find yourself needing at least three lights to do the job right.

A three-light studio can effectively model a 3D scene by dappling the objects with shadows and lights.

To create a three-light studio:

1. Create a main Spot light in front of and to the left of the scene.

2. Aim the main light so it shines into the scene at an angle of 45 degrees from the scene's center. Set the main light's intensity at 75 percent and enable the Cast Shadows option.

3. Use the Point At command to have the main light point at a center of interest.

4. Create a fill Spot light in front of and to the right of the scene.

5. Aim the fill light so it shines into the scene at an angle of 45 degrees from the scene's center. This light should be slightly lower than the main light. Set the fill light's intensity at 25 percent and disable the shadows.

6. Use the Point At command to have the fill light point at a center of interest.

7. Create a back Spot light. Align the back light so it's shining into the scene from behind. Align the back light so that it shines parallel to the ground plane. Adjust the light's intensity to 25 percent and disable the shadows. This light is used to create a halo effect around scene objects.

8. The back light's Z axis height should be half the tallest object's Z dimension. Figure 7-32 shows a three-light studio setup.

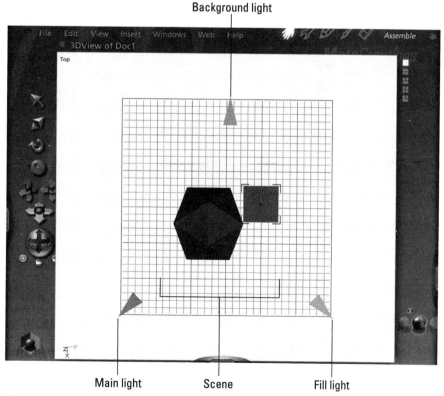

Figure 7-32: A three-light studio setup

On the CD-ROM In the Chapter 7 folder of the Content section of this book's CD-ROM, you'll find a generic three-light studio setup to experiment with. Depending on the size of the scene you're working with, you may have to adjust the coordinates of the lights to bring them closer or farther away from the scene.

A four-light studio is a variation of the preceding setup. This studio uses a main Spot light set at 75 percent intensity with shadows enabled, a fill Spot light set at 25 percent intensity with shadows disabled, a back Spot light set at 25 percent, and one background Spot light set at 50 percent intensity with shadows disabled. The background light shines up from the ground plane at a 45-degree angle and shines on a light-colored background wall before it is reflected back into the scene. Figure 7-33 shows a four-light studio.

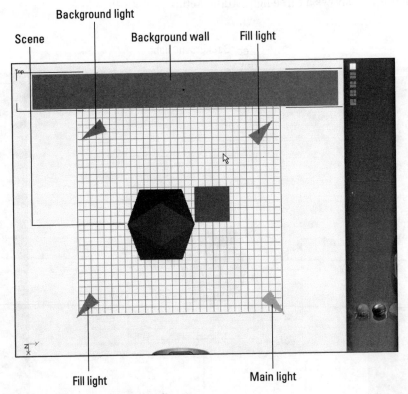

Figure 7-33: A four-light studio setup

To simulate an office with many rows of fluorescent lights, align rows of Bulb lights just below the object used to create the ceiling. Every light should have equal intensity. Experiment with different brightness settings until you achieve the effect you're after. The actual setting you choose will depend on the size of the scene and the number of Bulb lights used to illuminate it. If after doing a test render you find the shadows are too harsh, adjust each light's shadow intensity to a lower setting. If you have a powerful computer, enable the Soft Shadows option for each light.

These are just a few lighting possibilities. Experiment with variations of the three- and four-light studios to accommodate the lighting needs of a particular scene. If clashing shadows detract from a scene's effectiveness, in the Properties tray, turn off each light until you find the offending light and disable the light's shadow or decrease its intensity.

You can add lights as needed to augment a scene. To create a halo around an object, hide a light behind it and aim it directly at the camera using the Point At command. This technique is called *backlighting*. Adjust the light's intensity to suit your needs. Use the Area Render tool to test the effect and make adjustments as needed. To create a strong shadow-and-light effect, create a sidelight. Use a front fill light to reduce any harsh shadows. Bottom lighting can be used to create silhouette effects. This is a variation of the flashlight-under-the-chin trick children use to scare their neighbors at Halloween. If the detail is too minimal, add a fill light from above.

To add lighting to a dark part of a scene, use a Distant light. To precisely aim the Distant light, add a sphere or a Target Helper Object where you need the extra light and use the Point At command to aim it. After the light is aimed, you can either delete the sphere or disable the sphere's Visible option in the Properties tray, if you think you'll need it again. If you choose a Target Helper Object, you can leave it in the scene, as it is null and won't show up when the scene is rendered.

Summary

A 3D scene's success is highly dependent upon the way it is lit. Lighting sets the scene's mood through the effective blending of light and shadow. You can use ambient lighting, Distant lights, Spot lights, or Bulb lights to achieve a variety of lighting effects in Carrara 1.0. Mastery of scene lighting takes practice, patience, and perseverance.

✦ Ambient lighting is a shadowless unidirectional light. Ambient light should be turned off or set to low values.

✦ Distant lights are better choices for broad-based scene lighting. Distant lights send parallel light rays into a scene, affecting all objects. Distant lights cast shadows.

✦ Spot lights accentuate an object's form and surface characteristics with a cone of light that emanates from a single source. Spot lights cast shadows.

✦ Spot lights can be precisely aimed and aligned by using the direct manipulation handles.

✦ Lighting effects can be applied to Spot lights to create visual centers of interest in a scene.

✦ The Light Cone effect is used to simulate light bouncing of airborne particulate and vapor.

✦ Bulb lights are unidirectional lights that cast shadows.

✦ ✦ ✦

Building 3D Models in Carrara

◆　　◆　　◆　　◆

Modeling with Modifiers

Modifiers are a unique set of operations that alter the shape of an object. Applying a modifier to an object creates a new shape that would be difficult to achieve with Carrara's modelers. By combining different modifiers on scene objects, you can create a variety of interesting objects.

Modifiers can be animated. Modifiers can also be applied to objects to make them explode, dissolve, and disappear into a black hole.

Modifying Objects in Your Scene

Modifiers alter shapes by applying specific sets of instructions to an object. Applying one of Carrara's modifiers to an object literally gives it a whole new twist.

You can apply more than one modifier to a shape. Adding a new modifier builds on the existing modifier(s) to further contort the object. The last modifier applied is the highest in the order and will override duplicate settings used by any modifiers applied earlier.

Applying a modifier

Modifiers are accessed through the Properties tray. Each modifier has its own settings. You can remove, replace, and reorder modifiers as needed.

To apply a modifier to an object:

1. Select the object.
2. Drag open the Properties tray.

3. Click the Modifiers button.

4. Click the + button to open the Modifiers menu (see Figure 8-1).

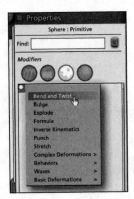

Figure 8-1: The Modifiers menu

5. Select a modifier and adjust the modifier's parameters to desired settings.

6. To apply another modifier, click the + button, choose a modifier, and repeat steps 1 through 5.

To remove a modifier from an object:

1. Select the object.

2. Drag open the Properties tray.

3. Click the Modifiers button.

4. Click the panel of the modifier you want to remove. The panel becomes highlighted in white.

5. Click the - button or press the Delete key. The modifier you selected is removed from the object.

During the course of designing a scene, if a particular modifier doesn't seem right for the shape you're trying to achieve, you can easily replace it with another.

To replace a modifier:

1. Select the object.

2. Click the Modifiers button.

3. Click the name of the modifier you want to replace from its panel. The Modifiers menu drops down.

4. Select a new modifier.

5. Adjust the new modifier's parameters.

If you have more than one modifier applied to an object, the last modifier applied takes precedence over the others. For example, if three modifiers all modify an object along the same axis, the last modifier applied will have the strongest effect or override other applied settings. You can change the effect modifiers have on an object by changing their order in the list.

To change a modifier's order in the list:

1. Select the object to which the modifiers are applied.

2. Drag open the Properties tray.

3. Click the Modifiers button.

4. Click to the left of a modifier's name to select it.

5. Drag it to a new position on the list. A border surrounds the modifier panel, indicating its position as you drag.

Manually controlling a modifier

Many modifiers can be controlled directly through the use of direct manipulation handles. This option makes it possible for you to alter the shape by dragging one of the modifiers' direct manipulation handles. Direction manipulation has three modes: Direct Manipulation On, Direct Manipulation Off, and Direct Manipulation On When Selected. When you add a modifier to an object, one of three icons is displayed in the modifier's panel (see Figure 8-2). If direct manipulation isn't available for a modifier, the modifier's panel always displays the Direct Manipulation Off icon.

Figure 8-2: The Direct Manipulation mode icons

To modify an object's shape using direct manipulation handles:

1. Select the object.

2. Drag open the Properties tray.

3. Click the Modifiers button.

4. Click the + button and select one of the available modifiers.

5. Click the modifier's Direct Manipulation button until the Direct Manipulation On icon appears. The modifier's direct manipulation handles appear on the object.

6. Drag the handles to alter the object's shape as desired (see Figure 8-3).

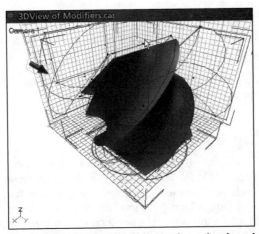

Figure 8-3: Altering an object's shape by dragging a modifier's direct manipulation handles

As you proceed through the rest of the chapter, you are strongly urged to have Carrara up and running on your computer. As you read about the different modifiers, experiment with them on various geometric primitive objects to see the effect they have. By the end of the chapter, you should have a good idea of which modifiers can be used on which objects to achieve a desired shape or effect.

Shaping objects with the Bend and Twist modifier

The Bend and Twist modifier bends and/or twists an object along a specific axis. This modifier can be used to fine-tune the surface of any object. Direct manipulation handles are available for the Bend and Twist modifier.

To twist an object's surface:

1. Select the object.

2. Drag open the Properties tray.

3. Click the Modifiers button.

4. Click the + button and select the Bend and Twist modifier. The Bend and Twist settings panel appears, as show in Figure 8-4.

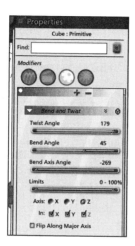

Figure 8-4: The Bend and Twist modifier panel

5. Drag the Twist Angle slider to set the degree of positive or negative twist.

 Alternatively, to twist the object using direct manipulation, click the Direct Manipulation button. A bounding box with 12 points surrounds the object. Drag one of the corner points along the bounding box in the direction you want to twist the object.

6. Drag the Limits sliders to set the portion of the object the twist is applied to. The lower setting adjusts where the twist begins on the object's lower value (Min) for the selected axis. The higher setting adjusts where the twist stops on the object's higher value (Max) for the selected axis. These settings are percentages of the object's dimension along the selected axis.

7. Select one of the Axis radio buttons to specify the axis where the twist occurs, if necessary.

8. Enable the In boxes for the axes in which you want the twist to occur.

 Note

 You cannot enable the In box option for the selected axis.

9. Enable the Flip Along Major Axis option to reverse the direction of the twist.

To bend an object:

1. Select the object.

2. Drag open the Properties tray.

3. Click the Modifiers button.

4. Click the + button and select the Bend and Twist modifier. The Bend and Twist settings panel appears. (Refer back to Figure 8-4.)

5. Drag the Bend Angle slider to set the degree of bend along the selected axis. For example, a setting of 180 bends an object back upon itself.

6. Drag the Bend Axis Angle to determine the direction of the bend along the specified axis.

 Alternatively, to bend the object using direct manipulation, click the Direct Manipulation button. A bounding box with 12 points surrounds the object. Drag one of the center points along the bounding box in the direction you want to bend the object.

7. Drag the Limits sliders to set the portion of the object the bend is applied to. The lower setting adjusts where the bend begins on the object's lower value (Min) for the selected axis. The higher setting adjusts where the bend stops on the object's higher value (Max) for the selected axis. These settings are percentages of the object's dimension along the selected axis.

8. Select one of the Axis radio buttons to specify the axis where the bend occurs, if necessary.

9. Enable the In boxes for the axes in which you want the bend to occur.

Note You cannot enable the In box option for the selected axis.

10. Enable the Flip Along Major Axis option to reverse the direction of the bend.

Note You can apply a bend and twist to the same object by adjusting all the parameters for the modifier.

Figure 8-5 shows an object after the Bend and Twist modifier has been applied.

Modifying objects with the Bulge modifier

The Bulge modifier causes an object's surface to uniformly pinch in or bulge out along a specified axis. The bulge or pinch is most prominent at the object's center and nonexistent at its edge. Direct manipulation is not available for the Bulge modifier.

Figure 8-5: Altering an object with the Bend and Twist modifier

To bulge an object's surface:

1. Select the object to which you want to apply the modifier.

2. Drag open the Properties tray.

3. Click the Modifiers button.

4. Click the + button and select Bulge. The Bulge settings panel appears (see Figure 8-6).

Figure 8-6: The Bulge modifier panel

5. Drag the Bulge slider to the left to pinch the object in and right to bulge the object out.

6. Drag the Limits sliders to set the portion of the object the bulge is applied to. The lower setting adjusts where the bulge begins on the object's lower value (Min) for the selected axis. The higher setting adjusts where the bulge stops on the object's higher value (Max) for the selected axis. These settings are percentages of the object's dimension along the selected axis.

7. Select one of the Axis radio buttons to specify the axis where the bulge occurs, if necessary.

8. Enable the In boxes for the axes in which you want the bulge to occur.

Note You cannot enable the In option for the selected axis.

Figure 8-7 shows an object with the Bulge modifier applied.

Figure 8-7: Altering an object with the Bulge modifier

Creating special effects with the Explode modifier

The Explode modifier is effective for still images or animations. Applying the Explode modifier to an object causes its surface to disintegrate. Direct manipulation is not available for the Explode modifier.

To explode an object:

1. Select the object you want to explode.

2. Drag open the Properties tray.

3. Click the Modifiers button.

4. Click the + button and select Explode. The Explode settings panel appears (see Figure 8-8).

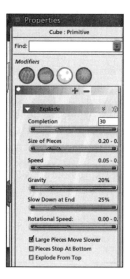

Figure 8-8: The Explode modifier panel

5. The Completion slider controls the percentage of the explosion. Lower settings simulate an object as it is just beginning to burst apart. For an animation, set this control at 0 when the animation starts and 100 when you want the explosion to complete.

Cross-Reference

For more information on animation, refer to Chapter 19.

6. Drag the Size of Pieces slider to set the lower and upper limits for the size of the pieces the explosion produces. Set the sliders far apart to create a greater variety in the size of the individual pieces.

7. The Speed slider determines the speed of the pieces as they move away from the object's original position. The left slider sets the speed for the slowest-moving pieces, and the right slider sets the speed for the fastest moving pieces. Drag the sliders farther apart for a greater variance in the speed of the pieces.

8. Drag the Gravity slider to determine the effect of gravity on the pieces as they fall. Higher settings cause pieces to fall faster. Use a low setting to simulate an explosion in a nongravity environment such as deep space.

9. Drag the Slow Down at End slider to determine the how fast the pieces are moving as they approach the end of an animation. A higher value dramatically slows the pieces at the end of an animation.

10. Drag the Rotational Speed sliders to determine the rotational speed of the pieces as they move away from the center of the explosion. The left slider determines rotational speed for the slower moving pieces, and the right slider determines rotational speed for the faster moving pieces.

11. Enable the Large Pieces Move Slower option to have larger pieces move slowly during an animation.

12. Enable the Pieces Stop At Bottom option to have the pieces stop at the bottom of the object's bounding box.

Tip

Use the Pieces Stop At Bottom option to simulate an exploding building. At the end of the animation, the building is reduced to a pile of rubble at the bottom of its bounding box.

13. Enable the Explode From Top option to have the explosion start at the top of an object and move down.

Figure 8-9 shows an object with the Explode modifier applied.

Figure 8-9: Exploding an object with the Explode modifier

Shaping objects with the Formula modifier

The Formula modifier uses mathematical equations to shape an object's surface. The Formula Editor is used to create formulas and apply mathematical operands. The Formula modifier is rather technical in nature. If you enjoy a challenge and are adept at math, try the Formula modifier.

Cross-Reference The Formula Editor is used throughout Carrara. For a detailed explanation of the Formula Editor, refer to the section "Modeling with Formulas" in Chapter 13.

Deforming objects with the Punch modifier

The Punch modifier creates a depression or bulge in an object's surface. The Punch modifier can be controlled through direct manipulation.

To punch an object's surface:

1. Select the object you want to punch.

2. Drag open the Properties tray.

3. Click the Modifiers button.

4. Click the + button and select Punch. The Punch settings panel appears (see Figure 8-10).

Figure 8-10: The Punch modifier panel

5. Drag the Strength slider left to bulge the surface and right to punch the surface.

6. Drag the Radius slider to the right to increase the area of the object that is being punched or left to decrease it.

Alternatively, to use direct manipulation to apply the Punch modifier, click the Direct Manipulation button. A square with five handles appears. Drag the center handle in to punch the object or out to bulge the object. Drag one of the outer handles to adjust the area of the object being punched. Drag outward to increase the area, inward to decrease the area.

7. Select the axis to which you want to apply the modifier.

8. Enable the Punch Other Side option to apply the modifier to the opposite side of the object.

Tip If you see a number value listed to the right of a slider, you can click the number to reveal a box in which you can enter a value in lieu of dragging the slider.

Figure 8-11 shows an object with the Punch modifier applied.

Figure 8-11: Altering an object with the Punch modifier

Deforming objects with the Stretch modifier

The Stretch modifier creates an exaggerated elongation effect. Picture grabbing a piece of saltwater taffy and tugging evenly at both ends, and you have an idea of what the Stretch modifier is capable of. The Stretch modifier can be controlled through direct manipulation.

To stretch an object:

1. Select the object you want to stretch.

2. Drag open the Properties tray.

3. Click the Modifiers button.

4. Click the + button and select stretch. The Stretch settings panel appears, as shown in Figure 8-12.

Figure 8-12: The Stretch modifier panel

5. Drag the Stretch slider left to squash an object and right to stretch it. When you squash an object, it gets flatter and its diameter increases, much like a piece of soft candy squashed between your fingers. When you stretch an object, its diameter decreases and it elongates.

 Alternatively, click the Direct Manipulation button. A bounding box with eight handles surrounds the object. Drag one of the handles away from the object to stretch it and towards it to compress it.

6. Select the axis to which you want to apply the modifier.

Figure 8-13 shows an object with the Stretch modifier applied.

Figure 8-13: Altering an object with the Stretch modifier

Applying the Basic Deformations modifiers

Basic Deformations modifiers transform objects by moving them or applying changes to their surfaces. The Basic Deformations modifiers can be used in animations. Direct manipulation is available for certain Basic Deformation modifiers. The Basic Deformations modifiers have their own submenu on the Modifiers menu (see Figure 8-14).

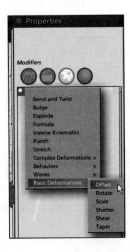

Figure 8-14: The Basic Deformations menu is found on the Modifiers menu.

Moving objects with the Offset modifier

The Offset modifier moves an object by the percentage specified within certain axes. The Offset modifier can be used to apply controlled movement to an object during an animation. Direct manipulation is not available for this modifier.

To apply the Offset modifier:

1. Select the object to which you want to apply the modifier.

2. Drag open the Properties tray.

3. Click the Modifiers button.

4. Click the + button and select Basic Deformations ➪ Offset. The Offset settings panel appears (see Figure 8-15).

5. Drag the Offset slider to increase the amount of offset.

6. Enable the In box for each axis in which you want the offset to occur.

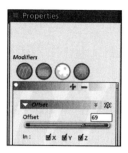

Figure 8-15: The Offset modifier panel

Turning an object with the Rotate modifier

The Rotate modifier spins an object on the specified axis. This is another good tool for introducing controlled movement during an animation. Direct manipulation is not available for this modifier.

To apply the Rotate modifier:

1. Select the object to which you want to apply the modifier.

2. Drag open the Properties tray.

3. Click the Modifiers button.

4. Click the + button and select Basic Deformations ➪ Rotate. The Rotate settings panel appears (see Figure 8-16).

5. Drag the Rotation Angle slider to set the angle of rotation.

6. Select the axis to which you want to apply the rotation.

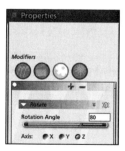

Figure 8-16: The Rotate modifier panel

Sizing objects with the Scale modifier

The Scale modifier is used to size an object. The modifier can be applied to the whole object, or a selected portion of it. Direct manipulation is not available for this modifier.

To apply the Scale modifier:

1. Select the object to which you want to apply the modifier.

2. Drag open the Properties tray.

3. Click the Modifiers button.

4. Click the + button and select Basic Deformations ⇨ Scale. The Scale settings panel appears (see Figure 8-17).

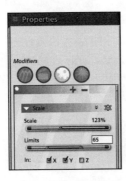

Figure 8-17: The Scale modifier panel

5. Drag the Scale slider to set increase the scale of the object.

6. Drag the Limits sliders to set the portion of the object that is scaled. The lower setting adjusts where the resizing begins on the object's lower value (Min) for the selected axes. The higher setting adjusts where the resizing stops on the object's higher value (Max) for the selected axes. These settings are percentages of the object's dimension along the selected axis.

7. Enable the In box for each axis you want to apply the modifier in.

Exploding objects with the Shatter modifier

The Shatter modifier is facet-based. It is best used on imported mesh objects or objects created within the Vertex modeler. When applied to geometric primitives or objects created in the Spline modeler, the Shatter modifier separates the individual patches that make up an object's surface, resulting in an unrealistic effect (see Figure 8-18). The Shatter modifier can be controlled by direct manipulation.

To apply the Shatter modifier to an object:

1. Select the object to which you want to apply the modifier.

2. Drag open the Properties tray.

3. Click the Modifiers button.

Figure 8-18: Applying the Shatter modifier to a nonvertex object produces poor results

4. Click the + button and select Basic Deformations ⇨ Shatter. The Shatter settings panel appears (see Figure 8-19).

Figure 8-19: The Shatter modifier panel

5. Drag the Scale slider to the right to increase the scale of the effect. Higher settings move the shattered pieces farther from the object's original position.

 Alternatively, click the Direct Manipulation button. A bounding box with eight handles appears around the object. Drag one of the handles to increase the scale of the effect.

Figure 8-20 shows the Shatter modifier applied to a vertex object.

Figure 8-20: Applying the Shatter modifier to a vertex object

Simulating windblown effects the Shear modifier

The Shear modifier produces a windblown effect by tilting an object while keeping the top and bottom of the object parallel to each other.

To apply the Shear modifier:

1. Select the object to which you want to apply the modifier.

2. Drag open the Properties tray.

3. Click the Modifiers button.

4. Click the + button and select Basic Deformations ⇨ Shear. The Shear settings panel appears (see Figure 8-21).

Figure 8-21: The Shear modifier panel

5. Drag the Shear slider right to apply a positive shear and left to apply a negative shear.

6. Drag the Limits sliders to set the portion of the object that the effect is applied to. The lower setting adjusts where the shear begins on the object's lower value (Min) for the selected axes. The higher setting adjusts where the shear stops on the object's higher value (Max) for the selected axes. These settings are percentages of the object's dimension along the selected axis.

7. Select the axis to which you want to apply the shear.

8. Enable the In box for each axis to which you want to apply the shear.

Note You cannot enable the In option for the selected axis.

9. Enable the Flip Along Major Axis option to invert the effect.

Figure 8-22 shows the Shear modifier applied to an object.

Shaping objects with the Taper modifier

The Taper modifier is used to taper one end of an object's surface along a specified axis.

To apply the Taper modifier:

1. Select the object to which you want to apply the modifier.

2. Drag open the Properties tray.

3. Click the Modifiers button.

4. Click the + button and select Basic Deformations ⇨ Taper. The Taper settings panel appears (see Figure 8-23).

Figure 8-22: Altering an object with the
Shear modifier

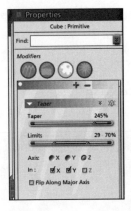

Figure 8-23: The Taper modifier panel

5. Drag the Taper slider right to increase the amount of taper.

6. Drag the Limits slider to set the portion of the object that is tapered. The
 lower setting adjusts where tapering begins on the object's lower value (Min)
 for the selected axes. The higher setting adjusts where tapering stops on the
 object's higher value (Max) for the selected axes. These settings are
 percentages of the object's dimension along the selected axis.

7. Select the axis to which you want to apply the taper.

8. Enable the In box for each axis to which you want to apply the taper.

Note You cannot enable the In option for the selected axis.

9. Enable the Flip Along Major Axis option to invert the effect.

Figure 8-24 shows the Taper modifier applied to an object.

Figure 8-24: Altering an object's surface with the Taper modifier

Applying the Complex Deformations modifiers

Complex Deformations modifiers are used to apply a number of interesting surface transformations to objects. Objects can be made to disappear, grow spikes, warp, or get sucked into a black hole. Complex Deformations modifiers work well for both still images and animations. None of these modifiers are controllable through direct manipulation. The Complex Deformations modifiers have their own submenu on the Modifiers menu (see Figure 8-25).

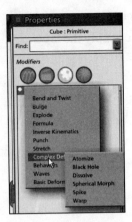

Figure 8-25: The Complex Deformations menu is found on the Modifiers menu.

Vaporizing objects with the Atomize modifier

The Atomize modifier replaces an object's surface with particles, which are displaced and juggled.

To atomize an object:

1. Select the object you want to atomize.

2. Drag open the Properties tray.

3. Click the Modifiers button.

4. Click the + button and select Complex Deformations ➪ Atomize. The Atomize settings panel appears (see Figure 8-26).

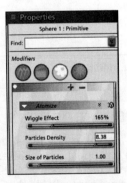

Figure 8-26: The Atomize modifier panel

5. Drag the Wiggle Effect slider to adjust the amount of movement in the particles.

6. Drag the Particles Density slider left to decrease the density of particles covering the object's surface.

Note

The default Particles Density slider produces no effect, as the density is too high. Drag the slider to the left to decrease the density and show the object disintegrating into individual particles. In an animation, use the default setting at the start of the animation to show the object as a whole. At the end of the animation, drag the slider to decrease the density and show some particles. For more information on animation, refer to Chapter 19.

Figure 8-27 shows the Atomize modifier applied to an object.

Figure 8-27: Altering an object with the Atomize modifier

Creating a vortex effect with the Black Hole modifier

The Black Hole modifier creates a circular vortex, much like water swirling down the drain. In an animation, an object with the Black Hole modifier appears to implode upon itself before being sucked into oblivion.

To apply the Black Hole modifier to an object:

1. Select the object to which you want to apply the modifier.

2. Drag open the Properties tray.

3. Click the Modifiers button.

4. Click the + button and select Complex Deformations ⇨ Black Hole. The Black Hole settings panel appears (see Figure 8-28).

Figure 8-28: The Black Hole modifier panel

5. Drag the Completion slider to set the state of the effect. In an animation, set this value to 0 when the animation begins and 100 when you want the effect to end.

6. Drag the Winding slider to control swirling motion of the vortex as the Black Hole forms. Drag to the right for clockwise rotation and left for counterclockwise rotation.

7. Drag the Spin Speed slider to the right to have the object spin faster as it deforms.

8. Drag the Depth slider to the right to adjust how gravity affects the black hole. A low setting results in gentle gravity pull, whereas a higher setting results in a strong gravity pull.

Figure 8-29 shows an object with the Black Hole modifier applied.

Making objects disappear with the Dissolve modifier

The Dissolve modifier reduces an object's surface integrity before gradually making it appear to vaporize into thin air. Use this modifier to create special effects in animations.

Figure 8-29: Altering an object with the Black Hole modifier

To make an object dissolve:

1. Select the object you want to dissolve.

2. Drag open the Properties tray.

3. Click the Modifiers button.

4. Click the + button and select Complex Deformations ⇨ Dissolve. The Dissolve settings panel appears (see Figure 8-30).

Figure 8-30: The Dissolve modifier panel

5. Drag the Completion slider to the right to control how much the object has dissolved. In an animation, set the slider to 0 when the animation begins and 100 when you want the object to completely disappear.

6. Drag the Size of Pieces slider to the right to have the object break up into larger pieces before it dissolves.

Figure 8-31 shows a partially dissolved object.

Figure 8-31: Altering an object with the Dissolve modifier

Deforming objects with the Spherical Morph modifier

The Spherical Morph modifier morphs an object's surface into a sphere.

To morph an object into a sphere:

1. Select the object you want to morph.

2. Drag open the Properties tray.

3. Click the Modifiers button.

4. Click the + button and select Complex Deformations ⇨ Spherical Morph. The Spherical Morph settings panel appears (see Figure 8-32).

5. Drag the Completion slider to the right to control the degree of transformation. In an animation, set the value at 0 for the start of the animation and 100 when you want the morph to complete.

Figure 8-32: The Spherical Morph modifier panel

Figure 8-33 shows an object with the Spherical Morph modifier applied.

Figure 8-33: Altering an object with the Spherical Morph modifier

Modifying objects with the Spike modifier

The Spike modifier grows spikes on an object's surface. Use the Spike modifier to simulate shrubs, distant trees, or spiky hair on a cartoon character's head.

To add spikes to an object's surface:

1. Select the object to which you want to add spikes.

2. Drag open the Properties tray.

3. Click the Modifiers button.

4. Click the + button and select Complex Deformations ➪ Spike. The Spike settings panel appears, as shown in Figure 8-34.

Figure 8-34: The Spike modifier panel

5. Drag the Spike Density slider to the right to add more spikes to the object.

6. Drag the Length slider to the right to create longer spikes.

7. Drag the Radius slider to the right to create thicker spikes, to the left for thinner spikes.

8. Drag the Messiness slider to the right to create wavier spikes.

9. Drag the Flow slider to the right to make the spikes wiggle during an animation.

10. Drag the Gravity slider to the right to increase the effect of gravity on the spikes. A higher setting makes the spikes bend noticeably downward.

11. Enable the Keep Original Object Intact option to have the object appear beneath the spikes. Disable this option to render spikes only.

Figure 8-35 shows an object with the Spike modifier applied.

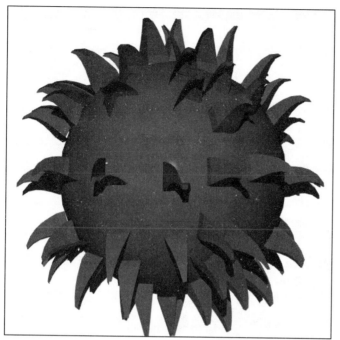

Figure 8-35: Altering an object with the Spike modifier

Deforming objects with the Warp modifier

The Warp modifier warps an object by rearranging the points that make up its surface. The modifier warps points in or out depending on how the modifier is applied. The Warp modifier has no effect on a sphere, as its points are all equidistant from its center.

1. Select the object you want to warp.

2. Drag open the Properties tray.

3. Click the Modifiers button.

4. Click the + button and select Complex Deformations ⇨ Warp. The Warp settings panel appears (see Figure 8-36).

5. Drag the Strength slider to the right of center (positive) to warp points near the center inward and points away from the center outward. Drag the Strength slider to the left of center to warp points near the center outward and points away from the center inward.

Figure 8-36: The Warp modifier panel

Figure 8-37 shows an object with the Warp modifier applied.

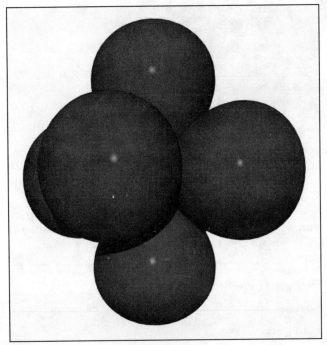

Figure 8-37: Altering an object with the Warp modifier

Applying the Waves modifiers

The Waves modifiers alter an object by applying wave-like ripples to its surface. The Waves modifiers have their own special submenu on the Modifiers menu (see Figure 8-38).

Figure 8-38: The Waves modifiers are found on the Modifiers menu.

Creating circular ripples with the Circle Wave modifier

The Circle Wave modifier alters an object by creating a pattern of circular ripples on its surface. The Circular Wave modifier cannot be controlled through direct manipulation.

To apply the Circle Wave modifier:

1. Select the object you want to modify.
2. Drag open the Properties tray.
3. Click the Modifiers button.
4. Click the + button and select Waves ➪ Circular Wave. The Circular Wave settings panel appears (see Figure 8-39).

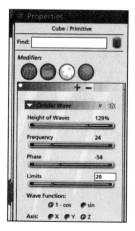

Figure 8-39: The Circular Wave modifier panel

5. Drag the Height of Wave slider to the right to create waves that raise the surface of an object and left to create waves that depress the surface of an object.

6. Drag the Frequency slider to determine the number of waves that appear on the surface of the object.

7. Drag the Phase slider to determine the position of the wave.

8. Drag the Limits slider to set the portion of the object's surface to which the wave is applied. The sliders adjust where the wave begins and ends. These settings are a percentage of the surface dimension for the axis to which the modifier is applied. At the default setting of 0 percent and 100 percent, the wave is applied to the entire surface of the object. Drag the lower value slider to start the wave at a specified point along the lower value (Min) of an axis. Drag the higher value slider to stop the wave at a specified point along the higher value (Max) of an axis.

9. For the Wave Function setting, select either 1 - cos or sin.

10. Select the axis to which you want to apply the modifier.

Figure 8-40 shows an object with the Circular Wave modifier applied.

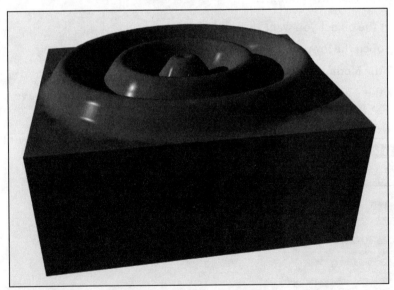

Figure 8-40: Altering an object with the Circular Wave modifier

Creating ripples with the Linear Wave modifier

The Linear Wave modifier creates uniform ripples on an object's surface. Direct manipulation is not available for the Linear Wave modifier.

To apply the Linear Wave modifier:

1. Select the object you want to modify.

2. Drag open the Properties tray.

3. Click the Modifiers button.

4. Click the + button and select Waves ⇨ Linear Wave. The Linear Wave settings dialog box appears (see Figure 8-41).

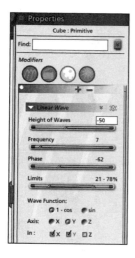

Figure 8-41: The Linear Wave modifier panel

5. Drag the Height of Waves slider to the right to create waves that raise the surface of an object and left to create waves that depress the surface of an object.

6. Drag the Frequency slider to determine the number of waves that appear on the object's surface.

7. Drag the Phase slider to determine the position of the wave.

8. Drag the Limits slider to set the portion of the object's surface to which the wave is applied. The sliders adjust where the wave begins and ends. These settings are a percentage of the surface dimension for the axis to which the modifier is applied. At the default setting of 0 percent and 100 percent, the wave is applied to the entire surface of the object. Drag the lower value slider to start the wave at a specified point along the lower value (Min) of an axis. Drag the higher value slider to stop the wave at a specified point along the higher value (Max) of an axis.

9. For the Wave Function setting, select either 1 - cos or sin.

10. Select the axis to which you want to apply the modifier.

11. Enable the In box for each axis in which you want the wave to occur.

Note You cannot enable the In option for the selected axis.

Figure 8-42 shows an object with the Linear Wave modifier applied.

Figure 8-42: Altering an object with the Linear Wave modifier

Creating wavy surfaces with the Wave modifier

The Wave modifier alters an object's surface by creating wave troughs and crests; it is excellent for animations. Use this modifier to simulate complex objects such as a swimming fish. The Wave modifier can be controlled by direct manipulation.

To apply the Wave modifier:

1. Select the object to which you want to apply the modifier.

2. Drag open the Properties tray.

3. Click the Modifiers button.

4. Click the + button and select Waves ➪ Wave. The Wave settings panel opens (see Figure 8-43).

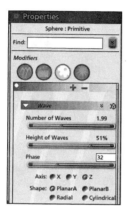

Figure 8-43: The Wave modifier panel

5. Drag the Number of Waves slider to adjust the number of waves. A setting of less than 1 will produce part of a wave.

6. Drag the Height of Waves slider to adjust the height of the waves. Dragging the slider left of center reverses the direction of the waves.

7. Drag the Phase slider to control the position of the waves.

Alternatively, click the Direct Manipulation button. A bounding box surrounds the object. Drag one of the corner handles to adjust the wave's height. Drag one of the center handles to adjust the wave's phase.

8. Select the axis where you want the wave to occur.

9. Select a shape for the wave. Choose from the following options:

- **Planar A:** Moves the wave along plane A. Plane A is parallel to the selected plane.

- **Planar B:** Moves the wave along plane B. Plane B is perpendicular to the selected plane.

- **Radial:** Creates waves from the center point outward.

- **Cylindrical:** Wraps the wave around the outside of the object as if it were a cylinder.

Figure 8-44 shows an object with the Wave modifier applied.

Figure 8-44: Altering an object with the Wave modifier

Animating Objects with Modifiers

Modifiers are wonderful tools for creating complex movements in animations. They can be used to make an object grow, expand, or explode. Modifiers can be paired to create complex effects such as an object increasing in size while rotating and sprouting spikes. Make fish swim with the Waves modifier. Create intergalactic scenes and use the Explode modifier or the Black Hole modifier to make planets disappear from a 3D galaxy.

Experiment with different modifiers to see how they react over time in an animation. Any modifier with a Completion slider is a prime candidate for animating. Use these tools with an open and imaginative mind, and in no time you'll be creating dazzling animations with special effects that rival Hollywood.

Summary

Modifiers make it possible to generate shapes that would otherwise be difficult to create. Modifiers can be used with other modifiers to amplify or combine effects. Use modifiers to create complex movement sequences in your animations.

✦ Modifiers change the shape of an object by manipulating its surface geometry.

✦ Modifiers can be used to augment modeling techniques by fine-tuning an object's surface.

✦ Certain modifiers can be controlled with direct manipulation handles.

✦ The last modifier applied to an object takes precedence over any previously applied modifiers.

✦ The order of any object's modifiers can be changed by moving them in the modifier list.

✦ Modifiers can be replaced and deleted as needed.

✦ ✦ ✦

Creating Spline Models

C H A P T E R

9

Carrara's Spline modeler creates 3D objects by extruding 2D shapes across a sweep path. The sweep path is perpendicular to the face of the 2D shape. A sweep path can be a straight line or a curved path, depending on the complexity of the object being modeled. An extrusion can be guided by an envelope that describes the outer shape of the object.

A single 2D shape can be used to create a model, or you can use several 2D shapes to form the skeleton for the 3D model. The technique of using several 2D shapes to define a model is known as *skinning*. Carrara creates a skin from shape to shape. Each shape is placed on a cross section, which can be moved along the sweep path.

When to Use the Spline Modeler

Man-made objects such as machinery, tools, and household items can be created with the Spline modeler. It effectively models smooth, flowing shapes such as bottles and teapots. The results are just as good on complex mechanical items such as gears and pumps. An object is a good candidate for the Spline modeler if its form can be described by geometric shapes such as a rectangle, polygon, or circle.

Introducing the Spline Modeler

The Spline modeler is one of three Carrara modelers tucked away in the Model room. It has its own unique set of tools and menu commands.

To begin creating a spline object, first open the Spline modeler using one of the following three methods:

 ✦ Select Insert ➪ Spline object.

✦ Drag the Spline Object tool (the second toolbar button, which is shaped like a wine glass) into the working box.

✦ Drag the Spline Object tool (see Figure 9-1) into the Sequencer tray's Universe list.

Figure 9-1: Use this tool to create a spline model.

Note Use either the first or third method of creating a spline object to place the finished model in the center of the scene.

The Spline modeler (see Figure 9-2) looks much like the working box in the Assemble room. The modeling box consists of three planes, one for each axis, plus a drawing plane. The drawing plane is used to create 2D shapes that will be extruded across the sweep path.

The modeling box has multiple views, which enable you to view the modeling process from different vantage points. The Director's Camera is the Spline modeler's default view. This reference gives a good view of the overall modeling process. You have access to all planes from this view plus a true 3D perspective. To switch to other viewpoints, click the current viewpoint name to reveal the camera list (see Figure 9-3).

The six positions at the top part of the camera list are 2D isometric views. Depending on the viewpoint you choose, you'll either see a bounding box of the model's shape or a pink line that signifies the sweep path. If you apply an extrusion envelope, you'll also see its path, which is signified by green lines on the ground plane and blue lines on the left plane. Isometric views make it easy to edit individual points along a path or envelope without the 3D view of the model blocking your view. The bottom positions on the camera list are 3D views as seen from the Director's Camera. You can modify any of these viewpoints by using the Dolly, Bank, Pan, and Axis Track tools. If you create a viewpoint that's useful, you can save the position to the camera list.

Cross-Reference For more information on changing and saving camera viewpoints, refer to Chapter 6.

Tip If you prefer to view a 3D object in the preset 2D isometric views, select File ⇨ Preferences ⇨ Spline Modeler and enable the Show 3D object in preset 2D views option.

Pen tool

Point tool flyout

Primitive Shapes Drawing tool flyout

Draw Text tool

Modeling box

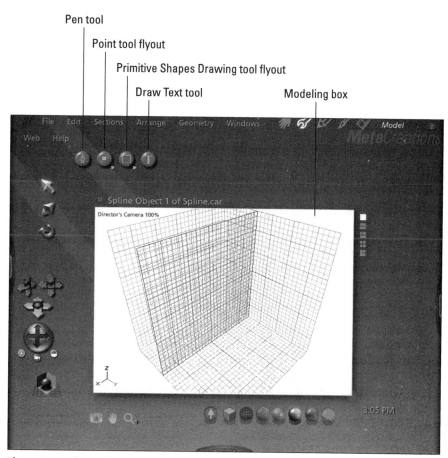

Figure 9-2: The Spline modeler

Figure 9-3: The Spline
modeler camera list

The 2D Pan tool (the hand icon to the lower-left of the modeling box) can also be used to modify your viewpoint. This tool works just as it did in the Assemble room. Click the 2D Pan tool to select it and then drag across the modeling box to pan to another view. Remember that you can activate the 2D Pan tool at any time by pressing the spacebar.

The Zoom tool (the magnifying glass icon to the lower-left of the modeling box) can be used to zoom in on a model. Click the Zoom tool and choose from one of the preset magnifications, or click it inside the modeling box to zoom in. Alt+click inside the modeling box to zoom out. You can also zoom in on a portion of the model by selecting the tool and dragging a marquee across a specific area.

Modeling with multiple views

The Spline modeler can also be used with a multiwindow view mode by selecting one of the multiwindow icons in the upper-right corner of the modeling box. This is especially useful when creating complex models. By switching from one pane to the next, it's possible to edit a sweep path, envelope, or individual cross sections without changing position. If you have a large monitor, this is an efficient way to model. Figure 9-4 shows a multiwindow view of a spline object.

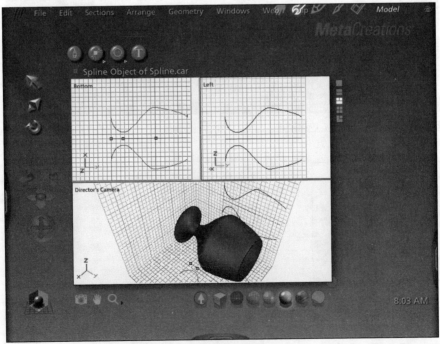

Figure 9-4: The Spline modeler in multiwindow mode

When working in multiwindow mode, always view one pane from a 3D viewpoint. Use the Dolly and Axis Track tools to align this viewpoint to specific points of a model while using a 2D isometric view to fine-tune the shape of the extrusion envelope or sweep path.

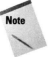

Note You can switch to any of the seven preview modes to simplify the modeling process. For example, in the wire mode, you can see through the model to view points along the sweep path.

Changing the modeling box size

When creating an especially large model, you may find yourself exceeding the bounds of the modeling box. This dilemma can be easily remedied by a simple menu command.

To change the size of the modeling box:

1. Select Geometry ➪ Modeling Box Size. The Modeling Box Size dialog box appears, as shown in Figure 9-5.

Figure 9-5: Resizing the modeling box

2. Enter a new size in the Box size text field.

3. Enable the Scale object with Modeling Box option to resize the model in proportion to the new modeling box size. This option comes in handy when you want to model an object at a specific scale.

4. Click OK to apply. The modeling box is resized.

Notice that every plane of the modeling box has a grid. Use the grid as reference when creating shapes on the drawing plane and editing sweep paths and envelopes. The grid spacing can be adjusted to suit the size of the object being modeling. The Snap to option can also be enabled. Snap to causes a point to anchor itself to intersecting grid lines. This option gives you better control over the drawing and editing process.

Note Certain editing tasks, such as fine-tuning the curve of an envelope, are easier to perform if the Snap to option is turned off.

To change grid spacing:

1. Select Geometry ➪ Grid (Ctrl+J). The Grid dialog box appears (see Figure 9-6).

Figure 9-6: The Grid dialog box

2. Enter a new value for Spacing.

3. Enter a value for Draw a line every. This option determines how often a grid line will appear. The default value, 1, places one grid line for each space.

4. Enable the Snap to option to have points snap to intersecting grid lines. The Show option toggles the grid on and off.

5. Click OK to apply.

Creating Objects with the Spline Modeler

Everything that happens in the Spline modeler revolves around the *drawing plane*. The drawing plane is also known as the *active plane*. When the Spline modeler is first opened, the drawing plane's default position is in front of the back plane. It is highlighted in black. The default position of the drawing plane is used to create 2D shapes that are then extruded along the sweep path. By switching the drawing plane to another plane, you can use it to draw a sweep path or an envelope.

To change the position of the drawing plane:

1. Select the Move/Selection tool and click to select the desired plane.

 Alternatively, click to select the desired plane inside the Working Box Control. The Working Box Control, located to the lower left of the modeling box, is identical to the one displayed in the Assemble room.

2. The selected plane becomes highlighted in black and is now the Drawing or Active plane.

3. To reselect the default 2D drawing plane, click the shape on the first cross section of the object you are creating.

Tip To hide any plane (except the drawing plane) in the working box from view, Alt+click the plane in the Working Box Control. Alt+click the plane in the Working Box Control to make it visible again.

Drawing 2D shapes

2D shapes are the basis for any spline object. They can be simple geometric shapes or complex shapes. The Spline modeler provides four tools for creating 2D shapes and one for creating text. These tools reside on the toolbar directly atop the modeling box. The Pen tool is first on the toolbar, and the Primitive Shape tools fly-out is the third tool. The Draw Text tool is the big T at the end of the toolbar (see Figure 9-7).

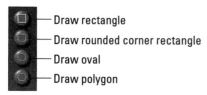

— Draw rectangle

— Draw rounded corner rectangle

— Draw oval

— Draw polygon

Figure 9-7: Use these tools to create 2D shapes on the drawing plane.

Cross-Reference 2D shapes created in vector drawing programs can be imported and used as the basis for complex 3D models. For more information on using 2D vector drawings in the Spline modeler, refer to Chapter 13.

Drawing an oval

Ovals can be extruded into many useful objects. Use them as the basis for models such as wine glasses and bottles.

To draw an oval:

1. Select the Draw Oval tool.

Note When a tool is selected, it becomes highlighted in yellow.

2. Drag the cursor across the drawing plane to create an oval. Hold down the Shift key while dragging to create a perfectly round circle.

Note When using the Shift key to constrain an object, always release the mouse prior to releasing the Shift key.

3. Select Sections ➪ Center (Ctrl+Shift+C) to center the oval shape on the drawing plane.

Tip Get in the habit of centering the first shape you create on the drawing plane. It makes the editing process much easier, especially when you're dealing with extrusion envelopes.

Drawing a rectangle

Rectangles can be extruded into many useful objects such as beams or girders.

To draw a rectangle:

1. Select the Draw Rectangle tool.

2. Drag the cursor across the drawing plane to create a rectangle. Hold down the Shift key while dragging to create a square.

3. Select Sections ⇨ Center (Ctrl+Shift+C) to center the rectangle shape on the drawing plane.

Drawing a rectangle with rounded corners

Rectangles with rounded corners can be the basis for objects such as fence posts or computer monitors.

To draw a rectangle with rounded corners:

1. Select the Draw Rounded Corners Rectangle tool.

2. Drag the cursor across the drawing plane to create a rectangle. To create a square with rounded corners, hold down the Shift key while dragging. The Round Rectangle dialog box opens, as shown in Figure 9-8.

 Figure 9-8: The Round Rectangle dialog box

3. Enter a value for the corner's Width and Height. Click OK to apply.

4. Select Sections ⇨ Center (Ctrl+Shift+C) to center the rounded rectangle shape on the drawing plane.

Drawing a polygon

Polygons can be used to create mechanical objects such as bolts and nuts. Polygons can have as few as three sides or as many as needed for the object you're trying to create. However, a polygon begins looking more like a circle when you include too many sides.

To draw a polygon:

1. Select the Draw polygon tool.

2. Drag the cursor across the drawing plane to create a polygon. The Number of Sides dialog box appears, as shown in Figure 9-9.

Figure 9-9: The Draw polygon tool Number of Sides dialog box

3. Enter the number of sides for the polygon. Click OK to apply.

4. Select Sections ➪ Center (Ctrl+Shift+C) to center the polygon on the drawing plane.

Drawing text

Text created in the Spline modeler can put a whole new twist on the written word. Literally.

To draw text:

1. Select the Draw Text tool.

2. Click the drawing plane. A dialog box opens.

3. Click the blue button that names the currently selected font to reveal the fonts drop-down list.

4. Click the desired font to select it.

5. Click the blue style button (plain is the default) and click a style to select it.

6. Enter a size in the Font Size text box.

7. Enter a value in the Scaling text box. Scaling increases the length of the text without affecting the height.

8. Click an Alignment icon to left justify, center, or right justify the text.

9. Enter a value in the Leading text box. This value sets the spacing between lines.

10. Enter a value in the Word Spacing text box. This value is in points and determines the spacing between words.

11. Enter a value in the Letter Spacing text box. This value is in points and determines the spacing between letters.

12. Enter the desired text in the large white textbox, shown in Figure 9-10.

13. Click OK to apply.

Figure 9-10: Adjusting the parameters for a spline text object

 For more information on creating text in the Spline modeler, refer to Chapter 13.

Using the Pen tool to create free-form 2D shapes

The Pen tool executes myriad functions in the Spline modeler. Use it to create 2D shapes, sweep paths, and extrusion paths.

To draw a shape with the Pen tool:

1. Select the Pen tool.

2. Click to create a point on the drawing plane.

3. Click to create another point on the drawing plane. A line joins the two points.

4. Continue in this manner, adding as many points as needed to define the shape you are creating.

5. Click the first point to close the shape.

Figure 9-11 shows a 2D shape being created with the Pen tool.

Use the drawing plane grid as a reference when you create a shape with the Pen tool. You may also find it helpful to have the Snap to (Ctrl+J) option enabled.

 Drag while you add a point to the shape to create a curve point. A curve point has handles that can be manipulated to fine-tune the shape of the curve.

Pen tool

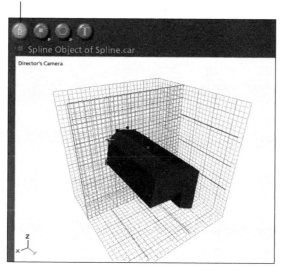

Figure 9-11: Creating a 2D shape with the Pen tool

Moving, resizing, and rotating 2D shapes

The Move, Rotate, and Scale tools can be used to move, rotate, and resize 2D shapes on the drawing plane. As a rule, you'll want to center shapes on the drawing plane. As you learn more about the Spline modeler and its capabilities, you may occasionally have multiple shapes on a single drawing plane and need to move one to edit a model.

Note If the shape you want to move or resize was created with the Pen tool, select all the points and group them (Ctrl+G) before selecting the shape.

To position a shape with the Move/Selection tool:

1. Click the Move/Selection tool to select it.

2. Click anywhere inside the shape to select it and drag to move it.

To resize a shape with the Scale tool:

1. Click the Scale tool to select it.

2. Click inside the shape and drag right to increase its size or left to decrease.

To rotate a shape with the Rotate tool:

1. Click the Rotate tool to select it.

2. Click inside the shape and drag to rotate.

Shapes can also be moved or resized using the Properties tray. The Properties tray has specific information about the individual shapes used to create a spline object. In fact, the Properties tray even has information about individual points used to create a spline object.

To move or resize a shape using the Properties tray:

1. Click the shape to select it.

2. Drag open the Properties tray. Information about the shape's position and size are displayed, as shown in Figure 9-12.

3. Enter new coordinates for the shape's left and top position.

4. Enter new values for the shape's width and height.

5. Enable the Keep Proportions option before resizing to constrain scaling to the shape's original proportions.

6. The Shape Number text box is used to change a shape's number when you have multiple shapes on one cross section.

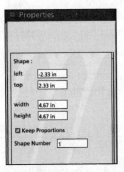

Figure 9-12: Using the Properties tray to change a shape's attributes

Astute readers may have noticed the Combine as Compound command and Break Apart Compound command on the Spline modeler's Arrange menu. These commands are covered in Chapter 13.

Modifying 2D shapes with the Point tool

Shapes created with the Pen tool may seem a little crude at first glance. You can modify them quite nicely by adding, deleting, or converting points. The Add Point, Delete Point, and Convert Point tools reside on the second tool's fly-out on the Spline modeler toolbar. These tools are also used to modify sweep paths and extrusion envelopes (see Figure 9-13).

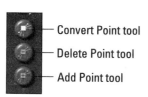

Convert Point tool

Delete Point tool

Add Point tool

Figure 9-13: Use these tools to modify 2D shapes, sweep paths, and extrusion envelopes.

Using the Add Point tool

The Add Point tool is used to create additional points on a shape, path, or envelope. Adding points enables you to better define a shape, path, or envelope.

To add a point to a shape, path, or envelope:

1. Click the Add Point tool to select it. The cursor changes to a black arrow with a square point at the end and a plus sign.

2. Click the spot on the shape, path, or envelope where you need to add the point.

Using the Delete Point tool

Use the Delete Point tool to remove unwanted points from a shape, path, or envelope.

To delete a point from a shape, path, or envelope:

1. Click the Delete Point tool to select it. The cursor changes into a lightning bolt.

2. Click a point to remove it from a shape, path, or envelope.

Note You can also remove a selected point by pressing the Delete key.

Using the Convert Point tool

The Convert Point tool changes a point from a corner point (which does not include handles) to a curve point. A curve point has handles that are used to modify the way the shape curves around the point. This tool is used to smooth out rough shapes and alter paths and envelopes.

To smooth a shape using the Convert Point tool:

1. Click the tool to select it.

2. Drag it across a point to smooth the shape. Two handles appear on either side of the point (see Figure 9-14).

Convert Point tool

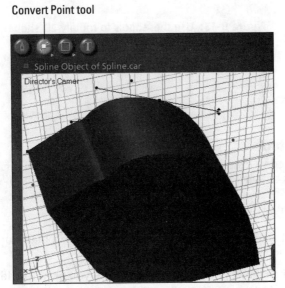

Figure 9-14: Smoothing a shape with the Convert Point tool

To convert a curve point to a corner point:

1. Select the Convert Point tool.

2. Click the curve point to retract its handles.

Tip

Hold down the Shift key while you drag the Convert Point tool to constrain the handles' movements to 45-degree increments. Hold down the Alt key while selecting a point to break apart its handles and then drag to edit one handle, effectively smoothing one side of the point. Hold down the Shift and Alt keys while dragging to edit only one handle and constrain its movements to 45-degree increments.

Moving points

To fine-tune a shape, reposition individual points with the Move/Selection tool.

To move a point:

1. Click the Move/Selection tool to select it.

2. Click the desired point and drag it to a new position.

Note For precise alignment, enable the Snap to (Ctrl+J) option.

Editing points with the Properties tray

A shape's points can also be edited using the Properties tray. When a shape is ungrouped, the Properties tray (see Figure 9-15) reveals information about the individual points used to create the shape. It lists each point's coordinates on the drawing plane as well as information about the control handles of curve points used to create the shape. The Properties tray can even be used to convert a corner point to a curve point and vice-versa.

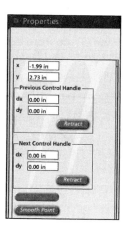

Figure 9-15: Converting a point's attributes using the Properties tray

To move a point using the Properties tray:

1. Using the Move/Selection tool, click a point to select it.

2. Drag open the Properties tray to reveal information about the selected point.

3. Enter new values for the point's X and Y coordinates. The point is moved to the desired position.

To smooth a point using the Properties tray:

1. Using the Move/Selection tool, click a point to select it.

2. Drag open the Properties tray.

3. Click the Smooth Point button. The point is converted to a curve point and the Smooth Point button becomes the Corner Point button.

To convert a curve point to a corner point:

1. Using the Move/Selection tool, click the curve point to select it.

2. Drag open the Properties tray.

3. Click the Corner Point button. The curve point is converted to a corner point and the Corner Point button becomes the Smooth Point button.

When you select a curve point, the Properties tray displays the coordinates of the point's control handles. Use the Properties tray to reposition a curve point's control handles or retract them.

To change the coordinates of a curve point's handles:

1. Using the Move/Selection tool, click the curve point to select it. The coordinates of the curve's point handles are displayed in the Properties tray.

2. In the Previous Control Handle section, enter new DX and DY coordinates to change the handle's position, or click the Retract button to retract the handle.

3. In the Next Control Handle section, enter new DX and DY coordinates to change the handle's position, or click the Retract button to retract the handle. Clicking the Retract button converts the curve point back to a corner point.

Tip Ungroup a shape to edit individual points and create a new shape. For example, ungroup an eight-sided polygon and drag every other point inward to create a star shape.

Exploring the sweep path

Whenever a 2D shape is created on the drawing plane, a pink line runs perpendicular from the shape's center along the bottom and side plane of the modeling box. This control line is called the *sweep path*. The default sweep path is drawn arrow-straight. Use the control point at the end of the sweep path to lengthen or shorten the sweep path. Additional points can be added to the sweep path and then moved to alter the course of the sweep path. Sweep paths can also be drawn freehand with the Pen tool.

Modifying the sweep path with the Point tool

The Point tool can be used to modify a sweep path by adding, deleting, or converting points. Select individual points and drag them to new positions to alter

the sweep path. The sweep path can also be edited independently on the bottom or left planes.

To add points to a sweep path:

1. Click the Add Point tool to select it.

2. Click the position on the sweep path where you want to add the point. The point is added to the path.

3. Use the Move/Selection tool to reposition the new point. Use the Convert Point tool to smooth the point.

To delete points from the sweep path:

1. Click the Delete Point tool to select it.

2. Click a point to delete it.

You can also remove a selected point from the sweep path by pressing the Delete key.

Tip If you need to move several points along the sweep path at once, use the Move/Selection tool to marquee-select the desired points and then drag them to a new position.

Drawing a sweep path with the Pen tool

The Pen tool can be used to create a unique sweep path. With it you can extend an existing sweep path by first selecting the path's last point and then using the Pen tool to extend the path. Remember that the sweep path shows up on two planes. You can use either plane to extend or alter the sweep path.

To draw a sweep path with the Pen tool:

1. Use one of the drawing tools or the Pen tool to create a shape on the drawing plane.

2. Using the Move/Selection tool, click the last point on the sweep path to select it.

3. Begin by dragging it back towards the first point on the sweep path. After you begin to drag, hold down the Shift key to constrain movement to the grid.

4. Continue dragging the point until it covers the first point on the path.

5. Click the Pen tool to select it.

6. Click to add points to the sweep path along either the bottom plane or the plane on the left side. You can also switch from one plane to another to draw a 3D sweep path. The 2D shape extrudes along the altered sweep path, as shown in Figure 9-16.

Pen tool

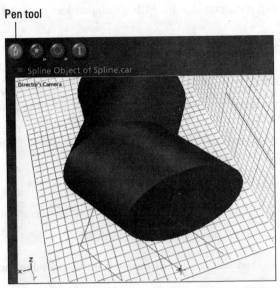

Figure 9-16: Drawing a sweep path with the Pen tool

Tip To create an indentation in the end of an object with multiple cross sections along its sweep path, click the last point and begin dragging it towards the previous point on the sweep path. After you begin dragging, hold down the Shift key to constrain motion to the grid. Drag the selected point up to and behind the previous point to create the indentation. The last cross section's shape must be smaller than the previous shapes for this technique to be effective.

Working with extrusion presets

Extrusion presets can be used to create interesting objects with a minimal amount of modeling. Once you supply a 2D shape on the drawing plane, extrusion presets take care of the sweep path. Use either a Primitive Shape tool or the Pen tool to create the shape. Imported 2D vector drawings can also be used.

Modeling with the Straight extrusion preset

The most basic extrusion preset is the Straight preset. By default, all extrusion presets are straight. The only time this menu command will come in handy is when you want to convert another extrusion preset back to a straight extrusion.

To create a straight extrusion:

1. Create a shape on the drawing plane.
2. Select Geometry ⇨ Extrusion Preset ⇨ Straight. The 2D shape is extruded along a straight sweep path with no envelope.

Modeling with the Spiral Extrusion preset

The Spiral Extrusion preset creates auger-like shapes. The Spiral Extrusion preset can be used to model things such as car springs.

To create a model with the Spiral Extrusion preset:

1. Create a shape on the drawing plane.

2. Select Geometry ⇨ Extrusion preset ⇨ Spiral. The Spiral dialog box appears, as shown in Figure 9-17.

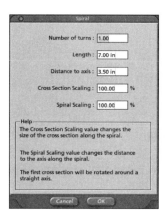

Figure 9-17: The Spiral dialog box

3. Enter a value for Number of Turns.

4. Enter a value for Length. The value determines the length of the sweep path. Choose a low value for a tightly wound spiral.

5. Enter a value for Distance to axis. The value determines how far the spiral's central axis is from the center of the cross section.

6. Enter a value for Cross Section Scaling. Entering a value less than 100 shrinks the size of the 2D shape along the spiral.

7. Enter a value for Spiral Scaling. Entering a value less than 100 creates a spiral that tapers as it travels along the sweep path.

8. Click OK to apply.

Figure 9-18 shows an object created using the Spiral Extrusion preset.

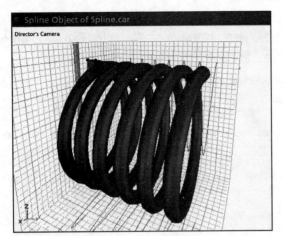

Figure 9-18: The Spiral Extrusion preset extrudes spring-shaped objects.

Modeling with the Torus Extrusion preset

The Torus Extrusion preset extrudes 2D shapes across a round sweep path. The mathematical definition for a Torus is a toroid (closed curve) generated by a circle — in other words, an object whose shape looks like a donut. This preset is perfect for modeling items such as tires and wheels.

To create a model with the Torus Extrusion preset:

1. Create a shape on the drawing plane.

2. Select Geometry ⇨ Extrusion preset ⇨ Torus. The Torus dialog box appears, as shown in Figure 9-19.

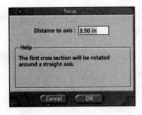

Figure 9-19: The Torus dialog box

3. Enter a value for Distance to axis. This value determines the radius of the circular sweep path.

4. Click OK to apply.

Figure 9-20 shows an object created using the Torus Extrusion preset.

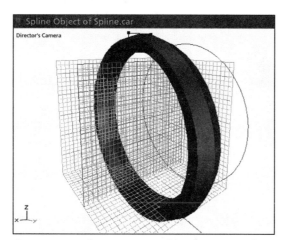

Figure 9-20: The Torus Extrusion preset extrudes shapes across a perfectly round sweep path.

Choosing the proper extrusion method for your spline model

Before committing to an extrusion envelope, you must choose an extrusion method. The extrusion method determines how cross sections are positioned in reference to the sweep path. The translation method of extrusion creates all cross sections perpendicular to the bottom plane of the modeling box. The pipeline method of extrusion creates all cross sections perpendicular to the curve of the sweep path.

Modeling with the translation method of extrusion

Use the translation method of extrusion to model objects such as funnels, chess pieces, and vases. It's a good idea to get in the habit of examining pictures of items you want to model; better yet, examine the real thing if possible. When you look at the item, try to dissect it into individual shapes or cross sections. If an item is composed of shapes that are parallel, use the translation method of extrusion to model it. To apply this method of extrusion to your model, select Geometry ➪ Extrusion Method ➪ Translation. Figure 9-21 shows an object modeled with the translation method of extrusion.

Figure 9-21: An object created with the translation method of extrusion

Modeling with the pipeline method of extrusion

Use the pipeline method of extrusion to model items such as exhaust pipes, plumbing fixtures, and lawn furniture. Pipeline extrusions also create nice flower petals. To apply this method of extrusion to your model, select Geometry ➪ Extrusion Method ➪ Pipeline. Figure 9-22 shows an object modeled with the pipeline method of extrusion.

Figure 9-22: The same cross section from Figure 9-21 with the pipeline method of extrusion applied

Applying an extrusion envelope to your spline model

An object's extrusion envelope defines the outer boundaries of an object. Consider an object such as a pear. Cut it in the middle and examine the outer shape of the pear's center. If you were to create a spline model of a pear, that shape would be the pear's extrusion envelope. Furthermore, because a pear is fairly symmetrical, you would choose a symmetrical extrusion envelope to model the pear.

Choosing the proper extrusion envelope

The best way to determine which extrusion envelope is needed to model an object is to examine it. Look at it both from the top and the side, to choose an envelope. If you choose the wrong envelope, you can start over from scratch by using one of two menus commands. Select Geometry ⇨ Reset Envelope to return the extrusion envelope to its original configuration, or select Geometry ⇨ Restart object from scratch.

Working with the symmetrical extrusion envelope

A wine glass is a perfect example of an object that is symmetrical in plane. Turn the glass on its side, just as it would appear in the modeling box. The outline of the wine glass looks the same from the side and from the top.

To apply a symmetrical extrusion envelope:

1. Create a shape on the drawing plane.

2. Select Geometry ⇨ Extrusion Method ⇨ Symmetrical. Envelope description lines extend from the edges of the shape to define the envelope.

3. Add points to the envelope description lines as needed to define the envelope.

4. Use the Move/Selection tool and Convert Point tool to fine-tune the envelope's shape (see Figure 9-23).

Move/Selection tool

Convert Point tool

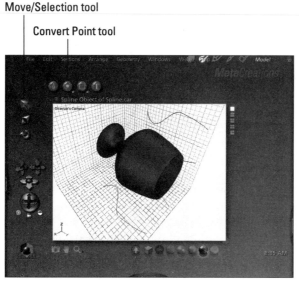

Figure 9-23: An object being modeled with a symmetrical extrusion envelope

Working with the symmetrical-in-plane extrusion envelope

An airplane wing is a perfect example of an object that should be modeled with a symmetrical-in-plane extrusion envelope. If you look at a wing from the side, you see one shape, but if you look at it from the top, you see another. These two shapes are symmetrical, but only in one plane.

To apply a symmetrical-in-plane envelope:

1. Create a shape on the drawing plane.

2. Select Geometry ⇨ Extrusion Method ⇨ Symmetrical in Plane. Envelope description lines extend from the edges of the shape to define the envelope (see Figure 9-24).

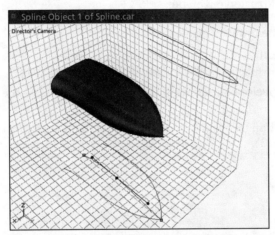

Figure 9-24: An object being modeled with a symmetrical-in-plane extrusion envelope

3. Add points to the envelope description lines as needed to define the envelope.

4. Use the Move/Selection tool and Convert Point tool to fine-tune the envelope.

Working with the free extrusion envelope

Model objects such as a computer mouse using a free extrusion envelope. Viewed from the side, the bottom of a mouse is flat, whereas the top of the mouse is curved. Viewed from the top, the outline of the mouse is asymmetrical.

1. Create a shape on the drawing plane.

2. Select Geometry ➪ Extrusion Method ➪ Free. Envelope description lines extend from the edges of the shape to define the envelope (see Figure 9-25).

Figure 9-25: An object being modeled with a free extrusion envelope

3. Add points to the envelope description lines as needed to define the envelope.

4. Use the Move/Selection tool and Convert Point tool to fine-tune the envelope.

Creating an extrusion envelope with the Pen tool

The Pen tool can also be used to create extrusion envelopes. This method comes in handy when you need to model a complex object that curves back on itself, such as a salad bowl.

To draw an extrusion envelope with the Pen tool:

1. Create a shape on the drawing plane.

2. Select Geometry ➪ Extrusion Envelope ➪ Symmetrical. Four description lines define the envelope.

3. Add points to one of the description lines to define the outside of the shape.

4. Use the Move/Selection tool and the Convert Point tool to move and smooth the points.

5. Click the Pen tool to select it.

6. Start adding points to define the inside of the shape. You want to add your first inside point close to the last outside point for a smooth transition. The envelope description line extends to the new points you add and defines the inside of the object.

7. Add one point right on top of the sweep path to close the envelope description lines (see Figure 9-26).

Pen tool

Figure 9-26: Using the Pen tool to draw a complex extrusion envelope

You can also use the Pen tool to create the entire extrusion envelope. This method involves collapsing the sweep path on itself and then using the Pen tool to create the envelope on the left or bottom plane wall.

To create an extrusion envelope from scratch using the Pen tool:

1. Create a shape on the drawing plane.

2. Select Geometry ➪ Extrusion Envelope ➪ Symmetrical in Plane.

3. Using the Move/Selection tool, select the last point on the sweep path.

4. Drag the point towards the first point on the sweep path. After you begin dragging, hold down the Shift key to constrain motion to the grid. Drag the last point until it eclipses the first point.

5. Select the Pen tool and begin adding points on the left or bottom plane. The envelope description lines branch out from the shape on the drawing plane to define the extrusion envelope.

6. After creating the envelope, use the Move/Selection tool and Convert Point tool to fine-tune the envelope.

Note Under certain lighting conditions, it may be difficult to pick out the individual points of a shape, envelope, or sweep path against Carrara's default background. If you experience this problem, select File ⇨ Preferences ⇨ 3D View Colors. Click the color swatch for Background and select a lighter color from the Color Picker.

Switching between envelopes

Switching from one extrusion envelope to another can come in handy for certain modeling projects. Take the example of the computer mouse. To begin modeling the mouse, use a symmetrical extrusion envelope to define the basic curves. After the preliminary shape has been established, switch to a free extrusion envelope to edit each envelope description line independently.

Modeling with cross sections

Cross sections are skeletons upon which a skin is extruded to define the outer shape of an object. Cross sections can consist of many different shapes. For example, one cross section could be an oval, the next a polygon, and the next a square (see Figure 9-27). The Spline modeler creates a skin that connects one cross section shape to the next. Cross sections can be filled or open.

Figure 9-27: Using different shapes on cross sections

Shapes on cross sections can be resized, moved, or rotated as needed. Individual cross sections can house multiple shapes to define complex models.

Creating a cross section

When you create a shape on the drawing plane, you create an object with one cross section. If a second cross section is needed, it is typically created at the last point on the sweep path.

To add a cross section at the end of the sweep path:

1. Select Sections ➪ Create. A new cross section is created.

2. Select and edit the new cross section's shape to define the object.

Note If you have more than two points on the sweep path, the Create command creates a new cross section at the next point on the sweep path.

Once an object has two cross sections, multiple cross sections can be created. The new cross sections are spaced equally between the selected cross section when the command was invoked and the next cross section in line.

To create multiple cross sections:

1. Click a cross section's shape to select it. Black dots appear at each corner of the cross section.

2. Select Sections ➪ Create Multiple. The Create Multiple Cross-Sections dialog box opens, as shown in Figure 9-28.

Press the Alt Key to activate this spinner.

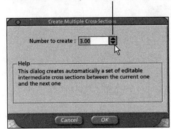

Figure 9-28: The Create Multiple Cross-Sections dialog box

3. Enter the number of cross sections you want to add.

4. Click OK to apply.

5. The specified number of cross sections are added and evenly spaced between the currently selected cross section and the next cross section in line.

Note If you invoke the Create Multiple command with only one cross section, new cross sections are created between the first cross section and the last point on the sweep path. If you have more than two points on the sweep path, the cross sections are created at the next point on the sweep path and then spaced equally between that point and the last point on the sweep path.

Adding a cross section with the Add Point tool

The Add Point tool provides another method to add a cross section to a model.

To add a cross section using the Add Point tool:

1. Click the Add Point tool to select it.

2. While holding down the Alt key, click the point on the sweep path where you want to add the cross section. The point is added to the sweep path along with a new cross section.

Navigating between cross sections

Each cross section has a black border surrounding its shape. To select a cross section, click the black border. When creating a complex model with many cross sections, it can become difficult to select an individual cross section. Fortunately, there are menu commands that make jumping from one cross section to the next relatively easy.

To go to the next cross section in line:

1. Select Sections ⇨ Next.

2. The next cross section is selected.

To go to the previous cross section in line:

1. Select Sections ⇨ Previous.

2. The previous cross section is selected.

To go to a specific cross section number:

1. Select Sections ⇨ Go To. The Go to Cross Section dialog box appears.

2. Enter the number of the cross sections you want to go to.

Tip By pressing the Alt key, a double-arrow spinner appears to the right of the Cross Section Number field. Click the up arrow to cycle up through the cross section numbers. Click the down arrow to cycle down through the cross section numbers. When the desired cross section number appears release the Alt key and press OK. A word of caution: Using the spinner arrows, it is possible to select a number higher than the number of cross sections in your model. When this happens, a warning dialog box appears prompting you to enter a number between 1 and the highest cross section number in your model. This spinner is also used in the Create Multiple Cross Sections dialog box, shown in Figure 9-28.

3. Click OK.

4. The desired cross section is selected.

Working with cross section options

Once cross sections have been created, they can be moved, rotated, and resized by using the conventional Move, Rotate, and Scale tools. If a cross section shape is defined by points, the points must all be selected and grouped before using a tool or menu command to modify a cross section shape. Menu commands and the Properties tray can also be used to edit cross sections.

To scale a cross section shape using the Scale command:

1. Using the Move/Selection tool, click the cross section's shape to select it. Black dots appear at each corner of the cross section.

2. Select Arrange ➪ Scale. The Scale dialog box appears, as shown in Figure 9-29.

Figure 9-29: The Scale dialog box

3. Enter a value in the Horizontal and/or Vertical text box by which to scale the cross section. These values are percentages. Selecting a value larger than 100 makes the cross section larger.

4. Click OK to apply. The cross section's shape is resized to the desired percentages.

To rotate a cross section's shape using the Rotate command:

1. Using the Move/Selection tool, click the cross section's shape to select it. Black dots appear at each corner of the cross section's shape.

2. Select Arrange ➪ Rotate. The Rotate dialog box appears, as shown in Figure 9-30.

Figure 9-30: The Rotate dialog box

3. Enter a value by which to rotate the cross section's shape in the Angle textbox.

4. Select CW (clockwise) or CCW (counterclockwise).

5. Enable Twist Surface to twist the surface of the object. Selecting this option will twist the surface between the cross section being rotated and its neighboring cross sections. An example of an object with a twisted surface would be a gnarled and twisted wooden fence post.

6. In the Rotation panel, select whether you want the cross section's shape to rotate around the shape's center or drawing plane's center.

7. Click OK to apply. The cross section's shape is rotated.

The Properties tray can also be used to resize and reposition a cross section shape.

To resize or reposition a cross section shape using the Properties tray:

1. Click the cross section's shape to select it. Black dots appear at each corner of the cross section.

2. Drag open the Properties tray to display the cross section shape's size and location.

3. Enter a new value for Left and/or Top to reposition the cross section's shape.

4. Enter a new value for Width and/or Height to resize the cross section's shape.

5. Enable the Keep Proportions option before resizing to scale the cross section's shape proportionately.

6. Leave the Shape Number at its current value as this option is used when you have multiple shapes on a cross section.

When modeling with multiple cross sections, it often becomes difficult to differentiate one cross section's shape from the next, especially in the Front view. This becomes frustrating when you need to edit individual points on a cross section's shape. To show only the current cross section, select Sections ➪ Show ➪ Current. All cross section outlines disappear except for the currently selected one.

During the course of editing a complex model, it may become necessary to remove a cross section. To remove a cross section, simply select Sections ➪ Remove. The selected cross section is then removed from the model.

Adding and deleting shapes to a cross section

Shapes can be added to a cross section by creating them on the drawing plane. If you have more than one shape on a cross section, Carrara numbers them and extrudes from shape number to shape number.

Working with multiple shapes on cross sections and numbering shapes is covered in greater detail in Chapter 13.

Shapes can be deleted from cross sections by selecting them and pressing the Delete key. If you have only one shape on a cross section, deleting it leaves a gaping void between neighboring cross sections. Create a new shape on the cross section to fill the void.

Setting cross section options

By default, a cross section skins from one shape to the next. Each cross section's shape is filled and connected to its adjoining cross section(s). Cross section options allow you to change the default settings to create different objects.

When you model an object such as a glass, one end must be left opened. This could be accomplished by adding points to define the inside of the glass, thereby creating the void. Or you could simply leave the cross section's shape unfilled by selecting Sections ➪ Cross Section Options and disabling the Fill Cross Sections option.

You can break a single object into multiple objects by disconnecting neighboring cross sections. This technique is useful on objects created with the Torus preset. Add multiple cross sections to the model and then disconnect every other one to create a series of shapes circling a central point. To disconnect a cross section, select Sections ➪ Cross Section Options and enable the Disconnect from next Cross-Section option.

The Spline modeler extrudes an object from shape to shape by default. By specifying skinning options, you can extrude a model from point to point. Point-to-point extrusions can only be accomplished if both the shapes being extruded have the same number of points. Shape-to-shape extrusions are smoother in nature, whereas point-to-point extrusions can produce sharp-edged models. To specify skinning options, select Sections ➪ Cross Section Options and from the Skinning section, select either point-to-point or shape-to-shape skinning.

Specifying surface fidelity

The Spline modeler creates smooth objects that render well. However, if an object doesn't render as well as you'd like, you can adjust its surface fidelity. Increasing an object's surface fidelity will produce better results when rendering.

To adjust a model's surface fidelity:

1. Select Geometry ➪ Surface Fidelity. The Surface Fidelity dialog box appears (see Figure 9-31).

2. Enter a value to increase the Surface Fidelity.

Figure 9-31: Adjusting an object's surface fidelity

Caution Higher surface fidelity values produce better results but require more memory and take longer to redraw.

Modeling with the Spline modeler's Ghost Menu

The Spline modeler includes a Ghost Menu that can make the modeling process highly intuitive. Instead of having to divert your attention from the task at hand to search for a tool on a toolbar, fourteen tools are literally right at your fingertips.

The Spline modeler Ghost Menu makes the following tools available to you:

✦ **Pen** (Pen tool)

✦ **Add** (Add Point tool)

✦ **Delete** (Delete Point tool)

✦ **Convert** (Convert Point tool)

✦ **Scale** (Scale tool)

✦ **Zoom** (Zoom tool)

✦ **Move** (Move/Selection tool)

✦ **Pan** (2D Pan tool)

✦ **Rotate** (Rotate tool)

✦ **Dolly** (Dolly tool)

✦ **Oval** (Draw Oval tool)

✦ **Rect** (Draw Rectangle tool)

✦ **Poly** (Draw polygon tool)

✦ **Round Rect** (Draw Rounded Corners Rectangle tool)

These tools function identically to their counterparts on the toolbars. They're just easier to access.

To activate the Spline modeler Ghost Menu, right-click and then drag to select a tool. When the tool you want is highlighted, release to select the tool (see Figure 9-32).

Figure 9-32: The Spline modeler Ghost Menu

Setting Spline modeler preferences

Now that you have an idea of how things work in the Spline modeler, it's time to set it up for the way you work.

To set Spline modeler preferences:

1. Select File ➪ Preferences (Ctrl+Shift+P) ➪ Spline Modeler. The Spline Preferences dialog box opens.

2. In the Resizing Shapes and Groups section, choose to resize the object from its center or opposite corner.

3. In the Grid Setting section, adjust the following parameters:
 - In the Spacing field, enter a value for grid spacing. This value determines how closely the grid is spaced.
 - Enter a value in the Draw a line every field. This setting determines how often a grid line is drawn. The default value draws one grid line for every space.

4. Enable the show 3D object in preset 2D views option to have the model's cross section show up in preset 2D views.

5. In the Color section, click the color swatches to open the Color Picker and select colors for the following:
 - Bezier curves
 - Sweep path
 - YZ envelope
 - XY envelope
 - 3D object

Creating Your First Spline Object

As you can see, the Spline modeler is a very powerful tool for creating intricate 3D models. Let's put it to work by creating a chess piece, namely a pawn.

The pawn will be modeled using only one shape, a circle. If you look at a pawn from the top, the shapes that define the surface are all circles. When viewed from the side, a pawn is symmetrical from front to back and from left to right, so the symmetrical extrusion envelope will be applied.

To begin modeling the pawn:

1. Launch Carrara and open a new document.

2. Drag the Spline Object tool into the working box or Sequencer tray's Universe list to open the Spline modeler. Alternatively, you can select Insert ⇨ Spline Object.

3. Click the Draw Oval tool to select it.

4. While holding down the Shift key, drag the tool across the drawing plane to create a circle. Remember to release the mouse before releasing the Shift key. If you don't, the circle will become an oval.

5. Select Sections ⇨ Center.

6. Select Geometry ⇨ Extrusion Envelope ⇨ Symmetrical.

7. Using the Move/Selection tool, drag the last point on the sweep path to extend it to the end of the modeling box. After you begin to drag, hold down the Shift key to constrain the point's motion to the grid.

8. Click the Add Point tool to select it.

9. Add nine points to the sweep path. Use Figure 9-33 as a guide for spacing the points.

Figure 9-33: Add nine points to the sweep path to begin shaping the pawn.

10. To define the envelope for the chess piece, use the Move/Selection tool to reposition the points on one of the envelope description lines. Because a symmetrical extrusion envelope has been applied, points on the other three envelope description lines are moved an equal distance and amount. Use Figure 9-34 as a guide to position the points.

Figure 9-34: The pawn begins to take shape.

11. To smooth the shape, select the Convert Point tool. Click the second point on one of the envelope description lines, and while holding down the Shift key drag the point to convert it to a curve point. Repeat with the fifth, seventh, and ninth points.

12. The chess piece curves inward after the first and second ridges on its surface. To create this inward curve, only one of the points handles needs to be moved. Select the Convert Point tool and click the third point on one of the envelope description lines, and while holding down the Alt key drag the point inward and slightly upward. Repeat with the sixth point. Your pawn should look similar to Figure 9-35.

13. To finish the model, use the Move/Selection tool and Convert Point tool to tidy up the envelope. Figure 9-36 shows the finished pawn model after texturing and rendering.

Congratulations! By successfully modeling the chess piece, you've taken the first step towards mastering the Spline modeler. Practice the techniques covered in this chapter to create other models. For your next Spline modeler project, consider creating a bishop to keep the pawn company.

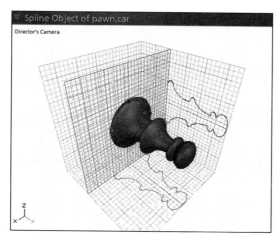

Figure 9-35: The completed extrusion envelope for the pawn model

Figure 9-36: The completed pawn model after texturing and rendering

Summary

The Spline modeler gives you all the tools needed to model man-made objects with smooth, flowing surfaces. The Spline modeler creates objects by extruding 2D shapes along a sweep path. By applying the proper extrusion envelope to the proper extrusion method, intricately detailed models can be created with a minimum of effort.

✦ 2D shapes can be created with the primitive shape tools or the Pen tool.

✦ Extrusion presets can be used to model objects such as springs and tires.

✦ The translation method of extrusion creates all cross section shapes perpendicular to the bottom plane of the modeling box.

✦ The pipeline method of extrusion creates all cross section shapes perpendicular to the sweep path.

✦ The symmetrical extrusion envelope's description lines are defined by four identical curves.

✦ The symmetrical-in-plane extrusion envelope's description lines are defined by two identical curves in each plane.

✦ The free extrusion envelope's description lines are defined four differently shaped curves.

✦ Cross section shapes are skeletons over which a skin is extruded to create the model.

✦ ✦ ✦

Creating Vertex Models

The Vertex modeler is a powerful weapon in Carrara's 3D arsenal. As with Carrara's other modelers, this modeler is a specialist. Its specialty is creating organic shapes. Use it in conjunction with the primitive shapes and other modelers to create one-of-a-kind 3D objects.

When to Use the Vertex Modeler

Carrara's Vertex modeler allows you to create wonderfully complex models that are organic in appearance. Whereas Carrara's Spline modeler allows you to extrude smooth complex shapes, the Vertex modeler allows you to mimic nature by directly manipulating the individual vertices of a shape. This capability to push and pull is akin to working with virtual putty.

The Vertex modeler is ideally suited for creating irregular organic shapes. If the object you intend to model exhibits less than perfect symmetry, it's an ideal candidate for the Vertex modeler. For example, objects that have wrinkles, dents, and bulging, bumpy surfaces model quite well in the Vertex modeler. The ability to edit individual points and surfaces gives you a great deal of flexibility in your modeling.

Understanding vertex modeling

A *vertex object* is composed of vertices, edges, and polygons. A *vertex* is an individual point of the vertex object located in 3D space. An *edge* is the line that connects two vertices, whereas a closed selection of edges defines an individual *polygon*. You learn to manipulate these parts of a vertex object to create *vertex models*.

A group of connected edges is called a *polyline*. A group of connected edges that forms a closed loop is referred to as a *closed polyline*. A closed polyline that is filled is called a *polygon*.

A *polymesh* consists of a group of vertices, edges, and polygons. Polymeshes can be flat surfaces or have volume like cubes or spheres.

In the Vertex modeler, lines that connect individual vertices are always straight. This may seem limiting at first, but by adding polygons and vertices to a model, you can create smooth curving shapes. You can also subdivide a selection of polygons to smooth out a surface.

Exploring the Vertex Modeling Window

When you insert a vertex object in your scene, you're automatically transported to the Model room, which opens up with a unique set of vertex modeling menus and tools. Inside this workspace you create vertex primitives, manipulate individual vertices, and create polylines to model a vertex object.

Use the Properties tray to reveal information about both your vertex model and the individual vertex primitives in your model. The Properties tray also gives you the ability to numerically position individual vertices and resize edges.

To create a vertex model:

1. Create a new file by selecting File ⇨ New.

2. To open the Vertex modeler, select Insert ⇨ Vertex Object.

 Alternatively, drag the Vertex Object tool (it's the third button on the top toolbar) into the working box, as shown in Figure 10-1.

 Or, drag the Vertex Object tool into the Sequencer tray's Universe list.

Figure 10-1: To create a vertex model, drag the Vertex Object tool into the working box.

Modeling with multiple views

The Vertex modeler opens with a default working box that is quartered into four individual windows with different viewpoints. The default viewpoints are Top, Director's Camera, Left, and Front. To change the viewpoint in an individual window, simply click the window to make it active, click the current viewpoint's name, and choose another viewpoint from the drop-down menu. This is a very convenient way to model. Any change you make to your vertex object is automatically updated in all the windows. By moving from window to window to edit a model, you'll avoid the hassle of switching to another view every time you need to edit your model from a different perspective.

To the lower-right of the Vertex modeler's working box, you'll find a Scene Preview window, which gives you a thumbnail view of what your model will look like once it's back in the Assemble room. The Scene Preview window automatically updates as you edit your vertex model. If you prefer to work without the Scene Preview window, click the white square to the left of the window's title to hide the window.

If you're not happy working in a four-window mode (shown in Figure 10-2), you have other options. The five icons located to the right of the Vertex modeler represent all other available configurations. You can choose from the following working box configurations: single window, two window, three window, four window, or single window with additional thumbnail view. Click the desired icon to change to a different working box setup.

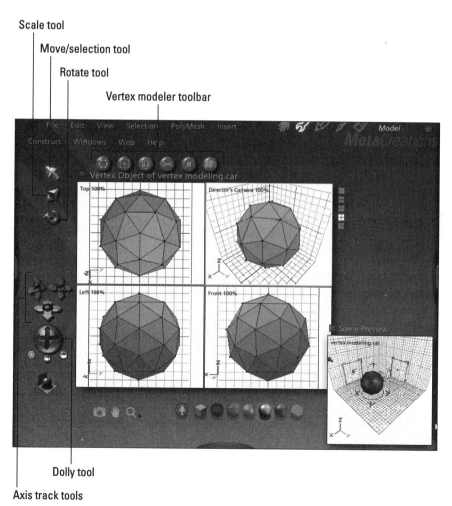

Figure 10-2: The Vertex modeler working box with the default four-window view configuration

No matter which setup you choose to work with, you can change viewpoints within individual windows by using the standard Carrara Dolly and Track tools.

Note Only the Dolly and Track XY tools are available when you're working with an isometric (2D) view.

To change viewpoints using the Dolly and/or Track tools:

1. Click a window to make it active.

2. Click the desired tool and drag to change viewpoint.

It is also possible to change viewpoints using menu commands. To change your view to a specific position:

1. Select View ➪ Send view to. The Send View to Position dialog box appears.

2. Enter the global coordinates of the desired position (see Figure 10-3).

Figure 10-3: Changing viewpoints using the Send View to Position menu command

3. Click OK to apply.

4. To restore the view to the original position select View ➪ Reset (Ctrl+Shift+R).

 Alternatively, select View ➪ Send View to Working Box.

Below the lower-left corner of the working box are three tools that you've probably noticed in the other Carrara rooms. These tools work the same in the Vertex modeler as they do in the other Carrara rooms.

1. Click the Area Render tool (the icon that resembles a camera) and drag it over all or part of your vertex model to perform a spot rendering.

2. Click the 2D Pan tool (the icon that resembles a hand) and drag to pan to a different viewpoint within a window.

Tip To momentarily select the Pan tool while using another tool, press the spacebar and drag to pan to a different viewpoint. When you release the spacebar, the last tool selected is reactivated.

3. Click the small arrow to the right of the Zoom tool (the icon that resembles a magnifying glass) and select one of the magnification options from the pop-up menu to zoom in on your work. You can also click the Zoom tool inside the modeling box to increase magnification.

Exploring the Vertex modeler toolbar

In addition to the familiar tools that carry over from the Assemble room, there is a toolbar that is unique to the Vertex modeler. Its default position is to the upper left of the working box. You use these six tools to create and edit vertex objects. Figure 10-4 shows an overview of the Vertex modeler toolbar.

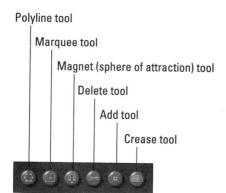

Polyline tool

Marquee tool

Magnet (sphere of attraction) tool

Delete tool

Add tool

Crease tool

Figure 10-4: The Vertex modeler toolbar

The Polyline tool is used to create open and closed polylines. Polylines can be used to create vertex objects. They can also be used as paths to extrude, sweep, or lathe a model.

To create a polyline:

1. Click the Polyline tool.

2. Click inside the working box to create the first vertex of the polyline and click to add additional vertices to the polyline.

3. To close the polyline, return to the first vertex and click it again.

Tip　To create 3D polylines, switch to another plane and continue adding vertices in that plane.

The Polyline tool can also be used to create smooth, curving shapes. To create a smooth, curved shape or line with the Polyline tool:

1. Select the Polyline tool.

2. Press Ctrl and drag the tool inside the working box. As long as you hold down the Ctrl key, the Polyline tool creates points as you drag. This is almost like drawing with a pencil.

3. If you want the polyline to be closed, deselect the Ctrl key and with the Polyline tool still selected, click the first point that was created.

The Marquee tool works like a lasso to select objects. To select edges, objects, and vertices with the Marquee tool:

1. Select the Marquee tool.

2. Drag inside the modeling box until the desired objects are surrounded by the marquee. The vertices in the selection will be highlighted in red.

Tip To add to the selection, hold down the Shift key before selecting additional edges, objects, or vertices.

The Sphere of Attraction tool (the button that looks like a horseshoe magnet) makes it possible for you to push or pull selected vertices and sculpt a vertex object. This tool will be covered in greater detail shortly.

The Delete tool is used to remove vertices and edges.

To delete a vertex or an edge:

1. Select the Delete tool.

2. Click the vertex or edge that you want to remove.

Note Removing a vertex also removes the vertex's connecting edges, but deleting an edge does not remove its connecting vertices.

The Add tool is used to add vertices to a vertex object.

To add a vertex:

1. Select the Add tool.

2. Click a point along an edge where you want to add a vertex. The new vertex is highlighted in red.

Tip Dragging with the Add tool will create and move a new vertex. The final position of the new vertex is determined when you release the cursor.

The Crease tool is used to create a visible crease in an object when it's rendered.

To crease an edge:

1. Select the Crease tool.

2. Click all edges you want to render as straight lines.

Note Creased edges are highlighted in yellow when selected, blue when deselected.

To smooth a creased edge:

1. Select the Crease tool.

2. Alt+click all creased edges (those highlighted in blue) you want to smooth.

In addition to the Marquee tool described previously, you can use the standard Carrara Move/Selection tool to select vertices, edges, and objects.

To select a vertex or edge:

1. Select the Move/Selection tool.

2. Click the desired vertex or edge to select it. The vertex becomes highlighted in red.

To select a polygon:

1. Select the Move/Selection tool.

2. Click the middle of the polygon you wish to select. The polygon becomes highlighted in red.

To select an object:

1. Select the Move/Selection tool.

2. Double-click the center of any polygon to select the entire object.

To select all objects, select Edit ⇨ Select all (Ctrl+A).

Modeling with the Vertex modeler's Ghost Menus

You were introduced to Ghost Menus in the Assemble room. Ghost Menus are handy little items that place frequently used commands just a right-click away. These menus enable you to model without having to stop and search for a frequently used tool or menu command. The Vertex modeler has its own Ghost Menu.

To access the Vertex modeler's Ghost Menu (see Figure 10-5), right-click anywhere in the Vertex modeling box. Click and drag to select a tool from the menu.

Figure 10-5: The Vertex modeler's Ghost Menu

You have ten different tools and commands at your disposal with the Vertex modeler Ghost Menu. They are:

✦ Add

✦ Delete

✦ Scale

✦ Zoom

✦ Move

✦ Pan

✦ Rotate

✦ Dolly

✦ Polyline

✦ Marquee

These tools function the same as their toolbar counterparts.

To add a point using the Ghost Menu:

1. Right-click anywhere in the Vertex modeler working box to activate the Ghost Menu, and drag to select the Add tool.

2. Click to add a vertex to an edge or polyline.

To delete a point or edge using the Ghost Menu:

1. Right-click anywhere in the Vertex modeler working box to activate the Ghost Menu, and drag to select the Delete tool.

2. Click a point or edge to delete it.

To scale an object or selection using the Ghost Menu:

1. Select the object or selection you want to scale.

2. Right-click anywhere in the Vertex modeler working box to activate the Ghost Menu, and drag to select the Scale tool.

3. To resize an object proportionately, drag across the object while in the Director's Camera view. Drag right to increase or left to decrease scale.

4. To resize an object on one of its axes, drag across the object in the appropriate isometric view window. Drag right to increase or left to decrease scale.

To zoom an object using the Ghost Menu:

1. Right-click anywhere in the Vertex modeler working box to activate the Ghost Menu, and drag to select the Zoom tool.

2. Click inside the modeling box to increase magnification. Click as many times as necessary to zoom to the desired magnification.

To move an object using the Ghost Menu:

1. Select the object or selection you want to move.

2. Right-click anywhere in the Vertex modeler working box to activate the Ghost Menu, and drag to select the Move/Selection tool.

3. Drag to move the object or selection to a desired position.

To pan using the Ghost Menu:

1. Right-click anywhere in the Vertex modeler working box to activate the Ghost Menu, and drag to select the Pan tool.

2. Drag inside the working box to pan to a new view.

To rotate an object using the Ghost Menu:

1. Select the object or selection you want to rotate.

2. Right-click anywhere in the Vertex modeler working box to activate the Ghost Menu, and drag to select the Rotate tool.

3. Drag across the object to rotate it freely 360 degrees.

To dolly using the Ghost Menu:

1. Right-click anywhere in the Vertex modeler working box to activate the Ghost Menu, and drag to select the Dolly tool.

2. Drag anywhere in the working box to dolly the camera to a different viewpoint.

To draw a polyline using the Ghost Menu:

1. Right-click anywhere in the Vertex modeler working box to activate the Ghost Menu, and drag to select the Polyline tool.

2. Click a plane to add vertices to the polyline.

 Alternatively, you can press the Ctrl key while dragging to create a smooth polyline.

3. Return to the first vertex and click it to close the polyline.

To make a marquee selection using the Ghost Menu:

1. Right-click anywhere in the Vertex modeler working box to activate the Ghost Menu, and drag to select the Marquee tool.

2. Drag around an area to lasso the desired selection. If you inadvertently select an unwanted edge or vertex, Shift+click the item to remove it from the selection. To add to the selection, Shift+click additional edges or vertices.

Creating objects with vertex primitives

You use vertex primitives as the building blocks for your vertex models. You can choose from a sphere, cylinder, rectangle, grid, or oval. By combining, shaping, and manipulating these primitives, you can create complex models.

Creating a sphere

A sphere primitive is an excellent starting point for a vertex model. Use them to create heads or torsos.

To create a sphere primitive:

1. Select Insert ⇨ Sphere. The Insert Sphere dialog box opens.

2. Enter the desired number of polygons and diameter for the sphere.

Note A larger number of polygons will result in a smoother sphere.

3. Click OK to insert the sphere (see Figure 10-6).

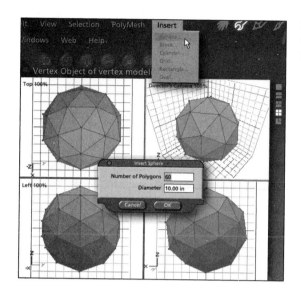

Figure 10-6: Inserting a sphere primitive in the Vertex modeler working box

Creating a block

Block primitives can be used as the starting point for geometric objects, such as furniture.

To create a block primitive:

1. Select Insert ➪ Block. The Insert Block dialog box opens.
2. Enter the desired size for the block's X, Y, and Z axes.
3. Click OK to insert the block (see Figure 10-7).

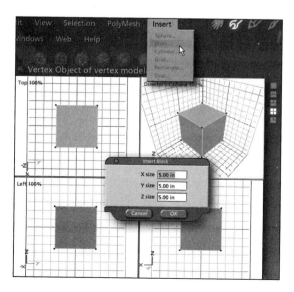

Figure 10-7: Inserting a block primitive in the Vertex modeler working box

Creating a cylinder

Cylinder primitives can be used to model such objects as oil drums or robots.

To create a cylinder primitive:

1. Select Insert ⇨ Cylinder. The Insert Cylinder dialog box opens.

2. Enter the desired diameter, height, number of sides, and number of segments for the cylinder. The more sides you add to the cylinder, the smoother it will be.

Note Think of segments as cross sections. Generating a cylinder with additional segments creates additional sections between the top and bottom of the cylinder. These additional segments or sections give you more vertices and polygons to manipulate and let you create a more complex shape.

3. Select an axis to align the cylinder to.

4. Click OK to insert the cylinder (see Figure 10-8).

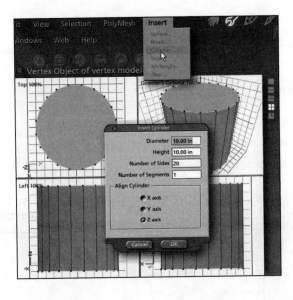

Figure 10-8: Inserting a cylinder primitive in the Vertex modeler working box

Creating a grid

The grid is a solid 2D object with an array of interconnecting lines that resembles a wire mesh. By manipulating the grid's vertices, you can model items such as wrinkled tablecloths.

To create a grid primitive:

1. Select Insert ⇨ Grid. The Insert Grid dialog box opens.

2. Enter the desired U size and V size.

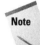

Note Since a grid is a 2D object, size is referred to in U (length) and V (width) coordinates and not X, Y, and Z.

3. Enter the desired values for U Vertex Count and V Vertex Count.

4. Specify the axis to which the grid should be perpendicularly aligned.

5. Click OK to apply (see Figure 10-9).

Figure 10-9: Inserting a grid in the Vertex modeler working box

Creating a rectangle

A rectangle primitive is also flat. A rectangle can be used as the starting point for creating a vertex model by using the extrude, sweep, loft, or lathe methods of construction.

To create a rectangle primitive:

1. Select Insert ⇨ Rectangle. The Insert Rectangle dialog box opens.

2. Enter the desired U Size (length) and V Size (Width) for the rectangle.

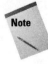

Note A rectangle is a 2D object and, like the grid, uses UV coordinates to specify its size.

3. Specify the axis to which the rectangle should be perpendicularly aligned.

4. Click OK to insert the rectangle (see Figure 10-10).

Figure 10-10: Inserting a rectangle in the Vertex modeler working box

Creating an oval

An oval is another flat 2D primitive. Use ovals to create vertex models using the extrude, sweep, loft, or lathe methods of construction.

To create an oval primitive:

1. Select Insert ⇨ Oval. The Insert Oval dialog box opens.

2. Enter the desired U Size (length) and V Size (Width) for the oval.

3. Enter the desired number of sides for the oval.

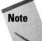

Note Specifying a higher number of sides results in a smoother oval.

4. Specify the axis to which the oval should be perpendicularly aligned (see Figure 10-11).

Figure 10-11: Inserting an oval in the Vertex modeler working box

Working with the drawing plane

The drawing plane is the current plane you are working on. You can think of the drawing plane as the active plane. The default drawing plane location is on the working box's X and Y axes.

Changing to a custom viewpoint

You need to change to a custom view when working on complex models that have vertices and edges hidden from Carrara's conventional preset views.

To change to a custom viewpoint:

1. Switch to single-window viewing mode by clicking the single window icon to the right of the working box.

2. Click the Dolly tool and rotate the working box to a different view.

To change your viewpoint to a specific coordinate:

1. Select View ⇨ Send View to.

2. The Send View to dialog box opens.

3. Specify the X, Y, and Z coordinates for the new viewpoint.

4. Click OK to apply.

Note

If the new viewpoint seems off-kilter or is impossible to work with, select View menu ⇨ Send View to Working Box to restore the view to the coordinate system's origin.

Sending the drawing plane to a selection

Certain operations you perform in the Vertex modeler use the drawing plane as the axis of symmetry. To send the drawing plane to a selection:

1. Select the edges, vertices, or polygons you want to align to drawing plane to.

2. Ctrl+click to complete the alignment.

Note If the selection you're aligning the drawing plane to is a single vertex, the plane is centered on that vertex without changing the plane's orientation. If you're aligning the drawing plane to a polygon or group of vertices, the drawing plane is aligned to the plane shared by the selection. If the polygons and vertices that make up the selection are in different planes, the drawing plane is realigned so that the plane is as near to the vertices as possible.

Sending the drawing plane to specific coordinates

You can also align the drawing plane to a specific set of coordinates. To align the drawing plane to a specific point in the working box:

1. Select View ➪ Send Drawing Plane to.

2. The Send Plane to Position dialog box opens.

3. Enter the X, Y, and Z coordinates where you want the plane to move to.

4. Select one of the following options:

 • **Drawing Plane:** Moves the plane on an axis perpendicular to itself by the amount that you specify. For example, if the drawing plane lies on the X or Y axis, enter a value for the Z axis.

 • **Drawing Plane centered:** Moves the plane on an axis perpendicular to itself and centers the plane on the remaining two axes. In the preceding example, the drawing plane would move along the Z axis and be centered along the X and Y axes.

 • **All Planes:** Moves the origin of the working box to the coordinates specified while centering all planes.

Moving a selection to the drawing plane

You use the Move/Selection tool to Drawing Plane command when adding to an existing object in the Vertex modeler. For example, if you wanted to use a single polygon on a sphere's surface as the base for an extrusion, you'd need to move the drawing plane to the polygon. To do this, first align the drawing plane with the polygon as detailed previously. Next, send the selection you were using as the base for the extrusion to the drawing plane.

To send a selection to a drawing plane:

1. Click to select the selection.

2. Select Selection ➪ Move to Drawing Plane.

 This command works best with 2D objects such as ovals and rectangles. If you select a 3D object and invoke the Move to Drawing Plane command, the object gets squashed flatter than the proverbial pancake. If you choose a single selection of a 3D object, only the selection moves to the drawing plane. The rest of the shape is left behind.

Constructing a vertex model

The Vertex modeler borrows a few modeling methods from the Spline modeler, and also introduces a few of its own. The Vertex modeler gives you tools to create a model by using a straight extrusion method, sweeping a 2D shape across a user-defined path, lathing a 2D shape around a center of rotation, or lofting a skin over 2D shapes.

Extruding a vertex model

A vertex extrusion can be a straight extrusion along a user-defined offset, or it can be extruded along a user-defined path.

To create a straight extrusion:

1. Create an object on the drawing plane by inserting one of the preset 2D shapes or creating a polyline.

 The object can be a closed or open polyline.

2. Select Construct ➪ Extrude.

3. The Construct Extrusion dialog box opens.

4. Enter an offset value.

5. Click OK to complete the extrusion (see Figure 10-12).

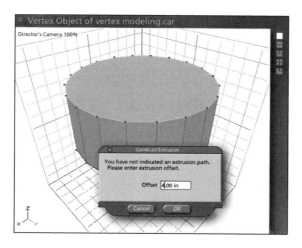

Figure 10-12: Extruding a vertex object

Tip Interesting vertex objects can be created by extruding individual polygons along an object's surface. Create a vertex sphere and then select an individual polygon. Apply the Extrude command to the polygon, and it jumps up from the surface of the sphere.

To create an extrusion along a path:

1. Create an object on the drawing plane by inserting one of the preset 2D shapes or creating a polyline.

Note The object can be a closed or open polyline.

2. Click the Move/Selection tool inside the working box to deselect the object.

3. If you're working in a multiwindow mode, click the Left or Front view to transform it into the active pane. If you're working in a single-view mode, switch to the Left or Front view.

4. Click the Polyline tool, and draw the extrusion path on plane perpendicular to the object you're extruding.

5. Select Edit ⇨ Select All (Ctrl+A).

6. To identify the starting vertex for the extrusion, select the Move/Selection tool, press the Ctrl+Alt keys, and click to select the starting vertex. The starting vertex is now highlighted in yellow.

7. Select Construct ⇨ Extrude to perform the extrusion (see Figure 10-13).

Note Select either the extrusion path's top or bottom vertex as the starting vertex. Selecting the extrusion path's bottom vertex creates an extrusion that follows the extrusion path from the bottom up, whereas selecting the top vertex creates an extrusion that follows the extrusion path from the top down. If you accidentally select the wrong starting vertex, select Edit ⇨ Undo Extrude (Ctrl+Z).

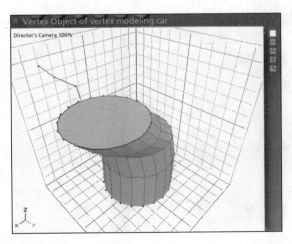

Figure 10-13:
Extruding a vertex object along a user-defined extrusion path

Sweeping a vertex model

Sweeping a vertex object is similar to extruding an object along an extrusion path. When you create an extrusion along an extrusion path, the orientation of the cross sections remains constant along the path. When you sweep an item along a path, the cross section is always perpendicular to the path.

To sweep a vertex object:

1. Create an object on the drawing plane by inserting one of the preset 2D shapes or creating a polyline.

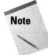
Note

The object can be a closed or open polyline.

2. Click the Move/Selection tool inside the working box to deselect the object.

3. If you're working in a multiwindow mode, click the Left or Front view to transform it into the drawing plane. If you're working in a single-view mode, switch to the Left or Front view.

4. Select the Polyline tool and draw the sweep path on the drawing plane.

Tip

If you sweep an object and end up with some awkward transitions, select Edit ➪ Undo Sweep (Ctrl+Z). Use the Add Vertex tool to add additional points where cross section transitions are awkward and resweep the object. Remember that when you sweep an object, cross sections are created perpendicular to the sweep path. More vertices result in smoother transitions between cross sections.

5. Select Edit ➪ Select All (Ctrl+A).

6. To identify the starting vertex for the extrusion, select the Move/Selection tool, press the Ctrl+Alt keys, and click to select the starting vertex. The starting vertex is now highlighted in yellow.

7. Select Construct ➪ Sweep to perform the sweep (see Figure 10-14).

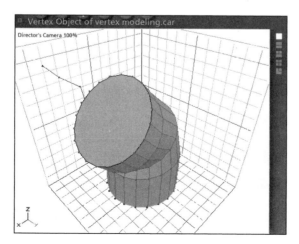

Figure 10-14: Creating a vertex object by sweeping along a user-defined path

Note Select either the extrusion path's top or bottom vertex as the starting vertex. Selecting the extrusion path's bottom vertex creates an extrusion that follows the extrusion path from the bottom up while selecting the top vertex creates an extrusion that follows the extrusion path from the top down. If you accidentally select the wrong starting vertex, select Edit ➪ Undo Extrude (Ctrl+Z).

Lathing a vertex model

The Lathe tool spins a mesh object from a 2D shape much like a woodworker's lathe spins a bowl from a block of wood.

To construct a vertex object using the Lathe method:

1. Create an object on the drawing plane by inserting one of the preset 2D shapes or creating a polyline.

2. With the object still selected, press Ctrl and click the object to send the drawing plane to the object.

Note The object can be a closed or open polyline.

3. Click the Move/Selection tool to deselect the object.

4. Switch to the Top, Left, or Front preset view.

5. Click to select the Polyline tool and draw the straight line that will be the lathe axis of rotation.

Note The shape created will vary depending on the plane in which you draw the lathe axis of rotation. The most predictable results are achieved when you draw the lathe axis of rotation parallel to the plane on which the shape you're lathing is created.

6. Select Edit ➪ Select All.

7. To identify the starting vertex for the extrusion, select the Move/Selection tool, press the Ctrl+Alt keys, and click the starting vertex on the polyline you just created. The starting vertex is now highlighted in yellow.

Note Because the object is spun 360 degrees around the lathe axis, selecting either vertex as the starting point will result in identical shapes.

8. Select Construct ➪ Lathe. The Construct Lathed Object dialog box opens.

9. Enter a value for Number of Steps.

Tip Entering a larger value for Number of Steps adds more polygons to the lathed object, resulting in a smoother shape.

10. Click OK to lathe the object (see Figure 10-15).

Tip

If you've been following along and constructing these objects in Carrara, you may have noticed more than one method of construction was highlighted on the menu for a given object and a path. Experiment on your own to see what shapes can be created by using the same object and path with different construction methods.

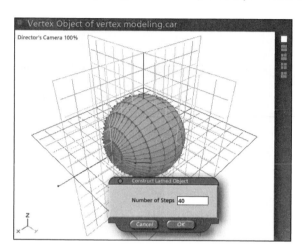

Figure 10-15: Creating a vertex object by lathing around an axis of rotation

Lofting a vertex model

Lofting can be used to create objects such as animal ears, faces, and organic objects such as legs and arms. When a vertex object is constructed using the loft method, a skin is draped over a skeleton of 2D cross sections. You can use as many 2D cross sections as needed to create a lofted model. The cross sections can be open or closed polylines, but you cannot mix open and closed polylines. The cross sections must lie in different positions.

To loft a vertex object:

1. Create a 2D shape on the drawing plane using one of the vertex primitives or the Polyline tool.

2. With the shape still selected, move to a different view and move the shape to the desired position.

3. Deselect the shape by clicking the Move/Selection tool inside the working box.

4. Repeat step 1 to create the second cross section on the drawing plane.

5. Repeat step 2 to move the shape to a different position.

6. Deselect the shape by clicking the Move/Selection tool inside the working box.

7. Repeat steps 1 through 3 until you've created all the cross sections for your model.

8. Select Edit ⇨ Select All (Ctrl+A).

9. Select Construct ⇨ Loft.

10. The shape is created (see Figure 10-16).

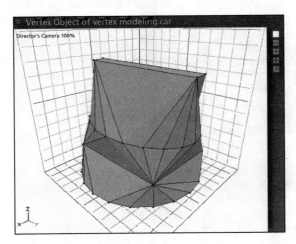

Figure 10-16: Creating a vertex model by lofting a skin over 2D cross sections

If the lofted object didn't turn out as intended, select Edit ⇨ Undo Loft (Ctrl+Z). Click the Move/Selection tool anywhere inside the working box to deselect the cross sections. Now you can edit the individual cross sections and redo the lofting process when satisfied.

Creating an organic vertex model

The organic method of construction takes a 2D shape and, using an algorithm known only to the program's creators, makes organic shapes from it. This method of construction can be used to create alien faces, cartoon characters, or reasonable facsimiles of the Sta-Puff Marshmallow Man.

To create an organic vertex model:

1. In the Vertex modeler, switch to the top view.

2. Create a 2D shape or draw a closed polyline with the Polyline tool. If you hold down the Ctrl key while dragging, you'll create a smooth-flowing shape.

3. Select Construct ⇨ Organic. An organic model is created, as show in Figure 10-17.

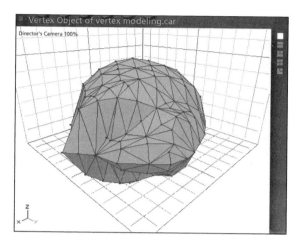

Figure 10-17: Creating an organic model with the organic method of construction

Replicating objects

The Replicate command duplicates a specified number of an object. The three available Replicate options are Linear, which repositions the duplicates; Array, which creates a rectangular array of duplicates; and Circle, which rotates the duplicates. The linear method of replicating is especially useful when combined with the loft method of construction. Replicate a 2D shape a specified number of times and offset as needed on the axes the shape is not aligned to. Apply the loft method of construction to the shapes to create a vertex object.

To replicate a shape or object:

1. Select the shape or object.

2. Select Edit ➪ Replicate. The Replicate dialog box opens, as shown in Figure 10-18.

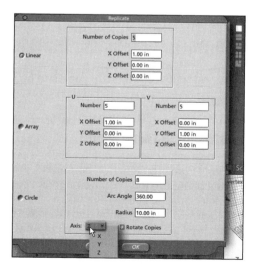

Figure 10-18: The Replicate command dialog box

3. If you're using the Linear Replicate option, set the following parameters:

 - Enter a value in the Number of Copies field.
 - Enter a value for X Offset. This value determines how far each copy is offset on the X axis.
 - Enter a value for Y Offset. This value determines how far each copy is offset on the Y axis.
 - Enter a value for Z Offset. This value determines how far each copy is offset on the Z axis.

4. The Array Replicate option sets up a rectangular array of duplicates. You can specify the desired number of duplicates across each axis. If you're using the Array Replicate option, set the following parameters:

 - In the U section (X axis), enter a value in the Number of Copies field.
 - In the U section (X axis), enter a value in the X Offset field.
 - In the U section (X axis), enter a value in the Y Offset field.
 - In the U section (X axis), enter a value in the Z Offset field.
 - In the V section (Y axis), enter a value in the Number of Copies field.
 - In the V section (Y axis), enter a value in the X Offset field.
 - In the V section (Y axis), enter a value in the Y Offset field.
 - In the V section (Y axis), enter a value in the Z Offset field.

5. The Circle Replicate method creates a specified number of duplicates of the original shape or object in a circle. If you're using the Circle Replicate method, set the following parameters:

 - Enter a value in the Number of Copies field.
 - Enter a value in the Arc Angle field.
 - Enter a value in the Radius field.
 - Click the blue Axis button and select the axis you want the duplicates to align with.
 - Enable the Rotate Copies option if you want the copies to be rotated.

6. Click OK to replicate the original.

Duplicating with symmetry along the drawing plane

Duplicating with Symmetry is a very powerful command, especially when you use it in conjunction with the Send Drawing Plane to Selection command. For example, you could create half a creature's face using the loft method of construction. After creating the object, click the Move/Selection tool anywhere inside the working box to deselect the object. Ctrl+click the selection that will become the center of the creature's head to send the drawing plane to it. Select Edit ⇨ Select All (Ctrl+A). Select Edit ⇨ Duplicate with Symmetry (Ctrl+Alt+D). A mirror object appears on the other side of the drawing plane. Use a Boolean operation to join the two halves.

Creating your first vertex model

Now that you understand the basics about vertex modeling, it's time to put your new knowledge to work and build a vertex model. In this section, you learn to use the lathe method of construction to model a salad bowl.

Follow these steps to create the salad bowl:

1. Drag the Vertex Object tool into the working box or select Insert ⇨ Vertex Object to open the Vertex modeler.

2. Select Insert ⇨ Oval.

3. Set the U Size and V Size to 6.00 and select the Y Axis for the Plane of Oval Perpendicular to option. Click OK to create the oval.

4. Select the Move/Selection tool and click anywhere inside the working box to deselect the oval.

5. If you're working in single-view mode, switch to the Front view. If you're working in multiview mode, click the Front view window to make it the active pane.

6. With the oval still selected, press Ctrl and click inside the oval to send the drawing plane to the oval.

7. Click the Marquee tool and drag it over the top half of the oval.

8. Press Delete to remove the selected vertices. You now have an open polyline that will form the cross section for the salad bowl.

9. If working in single-window mode, switch the Front viewpoint; otherwise, select a pane with the Front viewpoint. Click the Polyline tool and draw an axis of rotation line perpendicular to the opening of the polyline you created in step 7 (see Figure 10-19).

Figure 10-19: The partially completed salad bowl

10. Select Edit ➪ Select all (Ctrl+A).

11. Ctrl+Alt and click one of the points on the axis of rotation. This point should now be highlighted in yellow.

12. Select Construct ➪ Lathe. The Construct Lathed Object dialog box opens.

13. Enter 40 for the Number of Steps and click OK to lathe the bowl (see Figure 10-20).

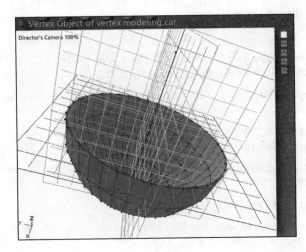

Figure 10-20: The salad bowl after lathing

14. Click anywhere inside the working box to deselect all highlighted vertices.

15. Click the axis of rotation line and press Delete to remove it.

16. Click the Assemble icon to return the salad bowl to the Assemble room.

Apply a nice wood grain texture to the salad bowl, add a few pieces of fruit, and you have the basis for a nice Carrara scene (see Figure 10-21).

Figure 10-21: The rendered salad bowl after a visit to the Texture room

Working with selections

As you'll soon discover, vertex models can become quite complex. As you add more objects to your vertex model, the polygon and vertex count rises, and it becomes increasingly difficult to work with the model. Finding individual parts of your model also becomes a daunting task. Learning to work with selections will greatly simplify your life as a vertex modeler.

Naming polygons, edges, and vertices

Naming individual parts of your vertex model will make it easier to select specific parts of your model. You can name a polygon, edge, or vertex.

To name a specific part of your model:

1. Select the polygon, edge, or vertex.

2. Select Selection ➪ Menu and choose one of the following:

 • Name Polygons

 • Name Edges

 • Name Vertices

3. A dialog box opens, prompting you to enter a name.

4. Name the selection and click OK to apply (see Figure 10-22).

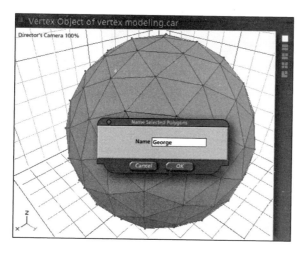

Figure 10-22: Naming individual parts of a vertex object makes them easier to locate

To select by name

After you've named several parts of your vertex model, it's a simple matter to find them again.

To find a section of your vertex model:

1. Select Selection ⇨ Select by Name and, depending on the type of selection you're trying to locate, click either Polymeshes, Vertices, Polygon, or Edges.

2. A dialog box opens showing the name of the first object in the list. Click the blue button with the downward-facing double arrow to expand the list (see Figure 10-23).

3. Click the desired name.

4. Click OK to select the named selection.

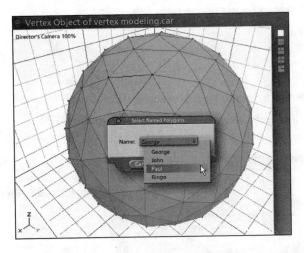

Figure 10-23: Selecting an object by name

Saving a selection

Another way to identify a specific part of your model is to save a selection. You can only save one selection at a time.

To save a selection:

1. Click to select the edges, vertices, and polygons you want to save.

2. Select Selection ⇨ Save Selection.

Restoring a selection

To restore a saved selection, select Selection ⇨ Restore Selection. The saved selection is now highlighted in red.

Note If you delete parts of a saved selection, the remaining edges and vertices are the only parts of the saved selection that can be restored.

Welding selections

Welding selections takes all specified vertices and joins them. This command comes in handy when you have several objects in a scene and want to join them as one.

To weld two selections together:

1. Select the vertices, edges, or polygons to be welded together.

2. Select Selection ⇨ Weld (Ctrl+Shift+W).

3. The Weld Selected Vertices dialog box opens (see Figure 10-24).

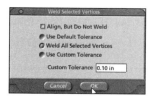

Figure 10-24: The Weld Selected Vertices dialog box

4. Select from these weld options:

- **Align But Do Not Weld:** Aligns the selected vertices but does not weld the vertices together to create one object

- **Use Default Tolerance:** Welds all selected vertices if they are within the default tolerance specified in the Vertex modeler preferences

- **Weld All Selected Vertices:** Welds all vertices regardless of distance

- **Use Custom Tolerance:** Welds all selected vertices within the Custom tolerance specified

- **Custom tolerance:** Specifies the maximum distance between vertices to be welded together

Linking vertices

Use this command to extend polylines and close polylines. When you link to vertices, an edge forms between them.

To link two vertices:

1. Shift+click to select the two vertices to be linked.

2. Select Selection ➪ Link (Ctrl+Shift+L). The two vertices are now linked.

To unlink two vertices:

1. Shift+click to select the two vertices to be unlinked.

2. Select Selection ➪ Unlink (Ctrl+Shift+U). The two vertices are now separated.

Hiding selections

You'll want to hide selections when working on complex models with high polygon counts. Hiding selections makes it easier to view and edit specific parts of your model.

To hide a selection:

1. Select the vertices you want hidden.

2. Select View ➪ Hide Selection.

To reveal hidden vertices, select View ➪ Reveal Hidden Vertices.

Modifying vertex objects

The Vertex modeler has many commands to fine-tune the shape of your vertex object. You'll be able to smooth an object, remove unnecessary polygons, smooth and crease edges, create holes in objects, and more.

Subdividing selections

Subdividing a selection adds edges and vertices, which creates a smoother appearing surface.

To subdivide an object or selection:

1. Use the Marquee tool or Move/Selection tool to select the polygons you want to subdivide.

2. Select Selection ➪ Subdivide (see Figure 10-25).

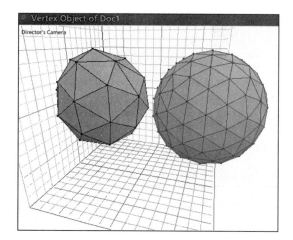

Figure 10-25: An object before and after being subdivided

MultiRes subdivide

The MultiRes subdivide command smoothes the object by subdividing the polygons, but you gain the added advantage of being able to adjust the resolution of the subdivided polygons. With a MultiRes subdivide you can model on different levels. For example, if you modeled a human head and wanted to move just a few vertices to create a dimple in a cheek, you'd use low resolution. When you adjusted everything to high resolution, the dimples would crease smoothly in the face.

To MultiRes subdivide an object or selection:

1. Use the Marquee tool or Move/Selection tool to select the polygons you want to MultiRes subdivide.

2. Select Selection ➪ MultiRes Subdivide.

3. Drag open the Properties tray.

4. Use the Resolution slider to adjust resolution levels as needed while modeling. The Resolution slider only has two settings. Drag left to select low resolution. Drag right to select high resolution. Figure 10-26 shows a MultiRes subdivided sphere at low resolution. Figure 10-27 shows the same sphere at high resolution.

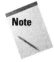

Note If you use MultiRes subdivide on only part of an object, you must select the entire object before changing resolution.

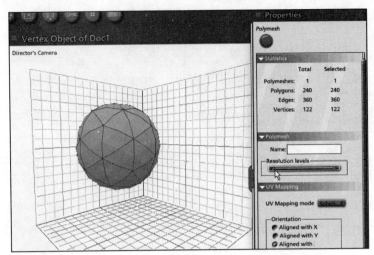

Figure 10-26: A MultiRes subdivided sphere at low resolution

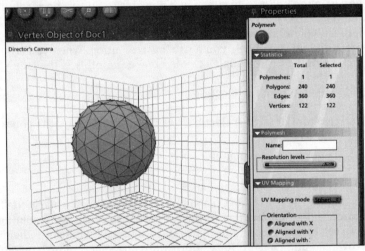

Figure 10-27: A MultRes subdivided sphere at high resolution

After creating your vertex model, select Selection ➪ Collapse MultiRes Subdivide. After collapsing the subdivision, the polygon count remains the same, but you can no longer select the lower resolution.

Decimating selections

Decimating a selection reduces polygon count. This command is useful if you get too heavy handed with the Subdivide command. You can also use it to reduce polygon count on mesh models you import into Carrara and edit in the Vertex modeler.

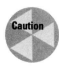

Caution Any time you change an object's polygon count, you loose surface fidelity. Before applying the Decimate command, save the model under another name. That way if you loose too much surface fidelity, you can open the saved file rather than recreating the model from scratch.

To decimate a selection:

1. Use the Marquee or Move/Selection tool to define the selection you want to decimate.

2. Select Selection ⇨ Decimate. The Decimate dialog box appears.

3. Select Decimate options.

 • Choose the percent to decimate the object by.

 • In the Decimate by section, choose to decimate by vertex count or fidelity. Decimating by vertex count removes the percentage of vertices specified in the Decimation % box. Decimating by fidelity removes vertices by decreasing surface fidelity up to the threshold specified in the Decimation % box.

 • In the Criterion section, choose to decimate by distance or angle. Decimating by distance removes vertices based on the proximity of the planes shared by neighboring vertices. Decimating by angle removes vertices based on the angles formed by polygons connecting neighboring vertices.

4. Click OK to decimate the object (see Figure 10-28).

Figure 10-28: A sphere, before and after being decimated

Triangulating polygons

Triangulating smoothes an object by breaking down large, blocky polygons into smaller triangles. Triangulating adds no additional vertices. The command uses existing vertices to create new edges, which become triangles. Use the Triangulate Polygon command after decimating an object to improve results.

To triangulate a polygon:

1. Click to select the desired polygon(s).

2. Select Selection ⇨ Triangulate Polygon to apply the command.

Note The Triangulate Polygon command only works on selections with more than three sides.

Smoothing edges

The Smooth Edges command causes edges less than a specified angle (the Crease angle) to be rendered as smooth.

To smooth an object's edges:

1. Select the edges to be smoothed.

2. Select Selections ⇨ Smooth Edges. The Smooth selected edges dialog box appears.

3. Enter a value for Angle Less Than. This option tells Carrara to smooth all edges with angles less than the amount specified. If you want to smooth all edges, select All.

4. Click OK to apply.

Creasing edges

The Crease Edges command causes edges greater than a specified angle (the Crease angle) to be rendered as creased.

To crease an object's edges:

1. Select the edges to be creased.

2. Select Selections ⇨ Crease Edges. The Crease selected edges dialog box appears.

3. Enter a value for the Crease angle. This option tells Carrara to crease all edges with angles greater than the specified value. To crease all edges, select All.

4. Click OK to apply.

Note You can also use the Crease tool to cause edges to be rendered as straight.

Filling polygons

You use the Fill Polygon command to convert closed polylines into polygons. The command can also be used to fill polygons that were inadvertently emptied during another modeling process.

To fill a polygon:

1. Select the polygon to be filled.

2. Select Selection ⇨ Fill Polygon (Ctrl+F).

Emptying polygons

The Empty Polygon command enables you to create holes in vertex objects. For example, this command could be used to create a jack-o-lantern's eyes and mouth.

To empty a polygon:

1. Select the polygon to be emptied.

2. Select Selection ⇨ Empty Polygon (Ctrl+Shift+F).

Detach polygons

Another way to create holes in vertex objects is to use the Detach Polygons command. After detaching a polygon, you can drag it to a new position and use it as the basis for another vertex object, or simply delete it. A void is left where the detached polygon used to be.

To detach a polygon:

1. Select the polygon(s) to be detached.

2. Select Selection ⇨ Detach Polygons.

3. Drag the detached polygon(s) to a new position or delete it.

Adding thickness to a vertex object

Vertex objects are paper thin by default. Adding thickness makes vertex objects appear more realistic, especially when you're creating objects that will have unfilled polygons. For example, if you were modeling a pumpkin, after deleting polygons to create the eyes and mouth, you'd want to add some thickness to make the finished product appear more realistic.

The Extrude command could be used to thicken a polygon, but this command would extrude selected polygons in the same direction. The Add Thickness command extrudes vertices at right angles to the planes of the selected polygons.

To add thickness to an object:

1. Select the polygons you want to thicken.
2. Select Construct ➪ Add Thickness. The Add Thickness dialog box appears.
3. Enter the desired value in the Distance box.
4. Click OK to apply (see Figure 10-29).

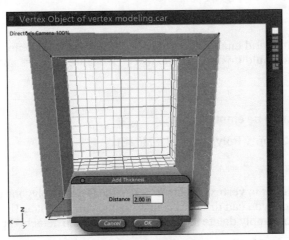

Figure 10-29: Use the Add Thickness command to increase an object's thickness.

Offsetting the surface of a vertex object

Another useful command at your disposal is the Offset Surface command. This tool expands the selected polygons and moves them outward. The resulting shape looks like a balloon about to burst.

To offset the surface of an object:

1. Select the polgons you want to offset.
2. Select Construct ➪ Offset surface. The Offset surface dialog box appears.
3. In the Distance box, enter the desired amount to offset the surface.
4. Click OK to apply.

Creating a complex vertex model with Boolean operations

You can create complex vertex models by combining simple objects and transforming them with the Boolean Union, Intersection, or Subtraction operations. After a Boolean operation is performed, the two objects become one. Objects must overlap before a Boolean operation can be applied.

Creating vertex models with the Boolean Union operation

Performing the Boolean Union operation creates a new object that encompasses all visible surfaces of both objects.

To perform a Boolean Union operation:

1. Create two 3D vertex objects, align them so that they overlap, and then select them.

2. Select Polymesh ⇨ Boolean Union to perform the operation (see Figure 10-30).

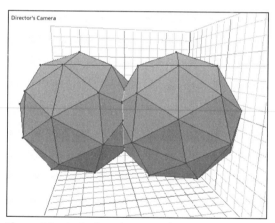

Figure 10-30: Performing a Boolean Union operation on two spheres

Creating vertex models with the Boolean Intersection operation

The Boolean Intersection operation creates a new shape by combining the volume where the two objects overlap.

To perform a Boolean Intersection operation:

1. Create two 3D vertex objects, align them so that they overlap, and then select them.

2. Select Polymesh ➪ Boolean Intersection to perform the operation (see Figure 10-31).

Figure 10-31: The Spheres in Figure 10-30 after a Boolean Intersection operation

Creating a vertex model with the Boolean Subtraction operation

The Boolean Subtraction operation cuts one object from another where the two objects overlap. Boolean Subtraction operations can be used to cut holes through objects or create indentations in objects.

To perform the Boolean Subtraction operation:

1. Create two 3D vertex objects, align them so that they overlap, and then select them.

2. When performing a Boolean Subtraction, specify which object should be subtracted from the other. Ctrl+Alt+click a vertex on the object that will be subtracted from. The selected vertex is highlighted in yellow.

3. Select Polymesh ➪ Boolean Subtraction to perform the operation (see Figure 10-32).

Figure 10-32: Performing a Boolean Subtraction operation on two spheres

Caution Performing Boolean operations on objects with unfilled polygons produces unpredictable results.

Animating Vertex Models

Anything you do in the Vertex modeler can be applied to an animation.

Follow these steps to animate a vertex model:

1. In the Sequencer tray, add a key event to the point on the vertex object's timeline where you want the transformation to occur.

2. Move the animation to that point on the timeline, and then double-click your vertex model to jump into the Vertex modeler.

3. Apply the changes you want to occur at this key event and then click the Assemble icon to return the model to the Assemble room.

Vertex modeling is perfect for animating life forms. Creating changing facial expressions, causing skin to crawl, and causing objects to grow are just a few of the effects possible. Imagination and experimentation are the keys here.

Cross-Reference For more information on animation, refer to Chapter 19.

Molding a vertex object with the Sphere of Attraction tool

The Sphere of Attraction tool works like a magnet. The tool attracts selected vertices and allows you to push and pull them to mold the object's surface.

To use the Sphere of Attraction tool:

1. Select the desired vertices to be transformed.

2. Select Construct ⇨ Sphere of Attraction. The Sphere of Attraction Options dialog box opens (see Figure 10-33).

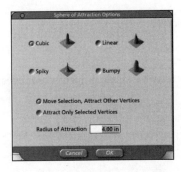

Figure 10-33: The Sphere of Attraction Options dialog box

3. Select from the following options:

 • **Cubic:** Creates a clean transformation, pulling the selected points away in a conical manner.

 • **Linear:** Drags the selected points away in a straight line.

 • **Spiky:** Creates spiky objects such as sharp thorns on a rose stem. It could also be used for the finishing touches on a king's crown.

 • **Bumpy:** Creates bumpy objects — great for rocks or the mottled flesh of an alien's head

 • **Move Selection, Attract Other Vertices:** Attracts and moves neighboring vertices within the tool's radius of attraction.

 • **Attract Only Selected Vertices:** Transforms selected vertices only

4. Enter a value for Radius of Attraction. This value adjusts the tool's area of influence

5. Click OK. The Sphere of Attraction magnet is now highlighted in yellow.

Pocket Watch
Credit: ©1999 by Wayne Kilgore

Still Life
Credit: ©1999 by Doug Sahlin

Deep Space
Credit: ©1999 by Steve McArdle

Space Station EXP 1701
Credit: ©1999 by Doug Sahlin

Bedroom Scene
Credit: ©1999 by Daniel J. Mancuso

Reprogramming An Analog Mind
Credit: ©1999 by Doug Sahlin

Plumbbot
Credit: ©1999 by Cecilia Ziemer

White Rabbit
Credit: ©1999 by Doug Sahlin

Inchy Whinchy Spider
Credit: ©1999 by Steve McArdle

Pterodactyl Scene
Credit: ©1999 by Daniel J. Mancuso

Late Night In The Cathedral
Credit: ©1999 by Doug Sahlin

A Rose For My Sweetheart
Credit: ©1999 by Doug Sahlin

Red 5
Credit: ©1999 by Doug Sahlin

Museum Scene
Credit: ©1999 by Doug Sahlin

Time Slippin' Away
Credit: ©1999 by Doug Sahlin

Holiday Feast
Credit: ©1999 by Doug Sahlin

Bathroom Scene
Credit: ©1999 by Doug Sahlin

Manatee Springs
Credit: ©1999 by Doug Sahlin

6. Click and drag inside the working box to attract the selected vertices to a new position.

Figure 10-34 shows the effect of using the Sphere of Attraction tool.

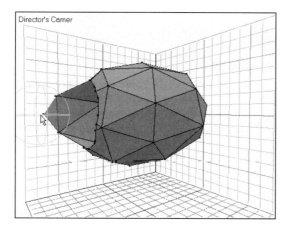

Figure 10-34: Use the Sphere of Attraction tool to mold vertex objects.

Note

In the working box, the tool shows up as a yellow circle with a cross-hair in the center. The circle signifies the radius of attraction.

Mapping shaders on vertex models

Vertex models can end up being quite complex and multifaceted. This makes it difficult to accurately map a shader on a vertex object. Carrara's standard parametric shading may produce unacceptable results when used to map shaders on vertex objects. The Vertex modeler allows you to specify how a shader will be mapped to a vertex object.

Specifying a vertex object's mapping mode

The Vertex modeler allows you to specify UV coordinate mapping for specific vertices. If you specify UV mapping in the Vertex modeler, be sure to choose the Parametric Mapping option when you apply a shader in the Texture room, or your settings will be overridden.

Cross-Reference

For more information on mapping shaders, refer to Chapter 17.

To change an object's mapping mode:

1. Select the object in the Vertex modeler.

2. Drag open the Properties tray.

3. In the UV Mapping panel, click the Mapping Mode button to open the drop-down menu.

4. Choose the shape that best fits your model: box face, cylindrical, spherical, or custom.

5. Choose your options and apply the settings.

Specifying box face mapping options

Specify box face mapping when you are shading vertex objects that are somewhat rectangular. To set box face options:

1. In the UV Mapping panel, click the Mapping Mode button and select Box Face from the drop-down menu.

2. Choose a mapping option:

 • **Full Box mapping:** Wraps the texture around the perimeter of the object

 • **Top, Bottom, Left, Right, Front and Back:** Map the shader to the selected face and continues around the side of the object

 • **Aligned with global axis orientation:** Aligns the shader with the object's bounding boxes

 • **Custom orientation:** Aligns the shader to a specific orientation

 • **Yaw, Pitch, and Roll:** Adjust the shader's orientation

Specifying cylindrical or spherical mapping options

Choose this option when the vertex object you're shading resembles a cylinder or sphere.

To specify cylindrical or spherical mapping options:

1. In the UV Mapping panel, click the Mapping Mode button and select Cylindrical or Spherical from the drop-down menu.

2. Choose an orientation:

 • Aligned with X

 • Aligned with Y

 • Aligned with Z

 • Custom Axis (when specifying this option, enter values for Yaw, Pitch, and Roll)

Specifying custom mapping options

Choose this option when you want to apply specific mapping options to a specific vertex or selection of vertices.

To specify custom mapping options:

1. In the UV Mapping panel, click the Mapping Mode button and select Custom from the drop-down menu.

2. Choose options for applying U and V coordinates to the section:

 - **Interpolated:** Applies U and V coordinates based on UV values for the neighboring vertices.

 - **Keep current value:** Uses the selection's current U and V values. The current U and V values for the selection are listed in their appropriate boxes.

3. Enable the Wrap option to map the shader around the vertex object from the specified U or V value.

Figure 10-35 shows the Vertex modeler's Mapping Mode options.

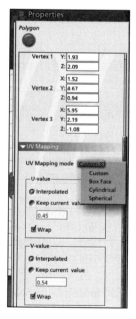

Figure 10-35: The Vertex modeler's UV Mapping options

Setting Vertex modeler preferences

Now that you've had a grand tour of the Vertex modeler, it's time to create your first model. But first you may want to adjust preferences for the Vertex modeler.

To set Vertex modeler Preferences:

1. Select File ⇨ Preferences ⇨ Vertex Modeler. The Vertex preferences dialog box opens.

2. In the Welding section, enter a Tolerance value. This value determines the default value for how close vertices need to be before they are welded.

3. In the Edge Propagation section, enter an Angle value. This value determines the angle edges will propagate at. High values create models with sharply defined edges.

Creating your second vertex model

Now that you're familiar with the Vertex modeler and its many powerful commands, it's time to flex those modeling muscles again. This time you'll be creating Vinnie the Vertex Cat. Grab your favorite beverage and a snack because you may be here awhile. When you're ready to begin, fire up Carrara, create a new scene, and open up the Vertex modeler.

Creating Vinnie, the Vertex Cat

1. To make the base for Vinnie's head, create a sphere. Increase the number of polygons to 120 for a smoother shape.

2. To create Vinnie's ears, you're going to use the Sphere of Attraction tool. Switch to the Front view and select the first vertex to the right of center. If you've inadvertently selected an edge, try again until you've selected just the vertex. Select Construct ⇨ Sphere of Attraction and in the Sphere of Attraction dialog box, change to the Linear option with a Radius of Attraction setting of 2.00. Click OK. Drag the selected vertex up to create Vinnie's right ear (see Figure 10-36).

3. When you've dragged Vinnie's right ear high enough, deselect the vertex and select the vertex that's just left of the sphere's center. Select the Sphere of Attraction tool (the magnet button) and drag the left ear upward. Drag this ear a little higher to give Vinnie a slightly comical appearance. At this stage, Vinnie should resemble Figure 10-37.

4. Select the two middle polygons below the midpoint of Vinnie's face. Select Selection menu ⇨ Detach Polygon to create Vinnie's mouth (see Figure 10-38).

5. Select Construct ⇨ Sphere of Attraction. In the Sphere of Attraction dialog box, select the Cubic option, specify a radius of attraction setting of .50, and individually edit the vertices of Vinnie's mouth to make him smile or snarl. To create a detailed mouth, use the Add tool to create a few additional vertices on Vinnie's mouth. Drag these to new positions with the Move/Selection tool or Sphere of Attraction tool.

Figure 10-36: Using the Sphere of Attraction tool to create one of Vinnie's ears.

Figure 10-37: Vinnie the Vertex Cat with two ears

6. Select Edit ➪ Select All (Ctrl+A). Select Construct ➪ Add Thickness. Enter .25 and click OK to apply. Now would be a good time to inspect what you've created so far. If any areas need to be edited, you can use the Sphere of Attraction tool or the Move/Selection tool to make any adjustments.

7. To make the nose, switch to the Left view, and using the Move/Selection tool, double-click any polygon to select Vinnie's head. Drag it to the left of the window and click anywhere in the working box to deselect the head.

8. Select Insert ➪ Sphere. Change the diameter to 3.00 and align the nose sphere to the middle of Vinnie's head. You may have to switch to another view to get the alignment perfect (see Figure 10-39).

Figure 10-38: Detaching a polygon to create
Vinnie's mouth

Figure 10-39: Aligning a small sphere in the center
of Vinnie's head to create his nose

9. Click the Move/Selection tool anywhere in the working box to deselect
 Vinnie's nose.

10. Select Edit ➪ Select All.

11. Select Polymesh ➪ Boolean Union to join Vinnie's nose to his head.

12. Click the Assemble icon to return Vinnie to the Assemble room.

13. To create one of Vinnie's eyes, drag the Vertex Object tool into the working
 box to open up the Vertex modeler.

14. Select Insert ➪ Sphere and enter 3.00 for the size.

15. Click the Assemble icon to return the sphere to the Assemble room.

16. Align the eye sphere you just created above and to the right of Vinnie's nose.

17. Duplicate (Ctrl+D) the eye sphere and drag the duplicate to the left of Vinnie's nose.

Introducing Vinnie the Vertex Cat (see Figure 10-40).

Figure 10-40: The completed rendering of Vinnie the Vertex Cat

Good work! While creating Vinnie, you learned a lot about vertex models. But before embarking on your own in the wonderful world of edges, vertices, and polygons, there are a few things to note. First, keep your model manageable. Reduce everything to its lowest common denominator, and don't subdivide any more of the model than you need to. Subdivision adds polygons, and a high polygon count chews up RAM and CPU horsepower. Another rule of thumb is if you won't see it in the final scene, don't build it. When building a complex model, you may want to consider building parts of it as other scenes and importing these scenes to assemble the final model. And above all, save early and save often. There's nothing more exasperating than spending hours on a modeling session, only to have it come to naught because of a computer glitch. Consider saving a backup of your file under a different name. That way if the worst happens, you can always resort to your last revised version.

The Vertex modeler is a powerful weapon in Carrara's arsenal. You won't master it overnight. But with imagination, inspiration, and dedication, the Vertex modeler will soon become a powerful tool in your 3D tool box.

Summary

The Vertex modeler will enable you to create "organic" looking objects. The vertex primitives are the building blocks for complex vertex models.

✦ The Sphere of Attraction tool enables you to manipulate individual vertices and mold your model into the shape you desire.

✦ The Loft, Lathe, Extrude, and Sweep tools enable you to create complex vertex objects.

✦ The Boolean operations enable you to create complex shapes by transforming two selected objects.

✦ The commands in the Polymesh menu enable you to fine-tune your mesh form models.

✦ The capability to hide selections lets you edit individual parts of your mesh form model.

✦ The capability to move selections and drawing planes lets you edit complex vertex models from different vantage points.

✦ ✦ ✦

Creating Metaball Models

Now it's time to meet the last of Carrara's speciality modelers, the Metaball modeler. If you enjoyed working with clay in art class, the Metaball modeler is right up your alley. With this modeler, you'll mix and match various primitive elements. The elements blend together and form a skin that creates the finished model.

When to Use the Metaball Modeler

Carrara comes complete with a modeler for just about any type of object you could ever hope to create. The Metaball modeler's specialty is organic shapes. To create Metaball models, you combine Metaball primitive shapes, which are the building blocks of Metaball models. These shapes interact with each other to form the finished model. Working with the Metaball modeler's shapes is like modeling with virtual clay.

Use the Metaball modeler to model organic shapes such as animals, cartoon characters, or humanoids. Objects such as puddles, toys, or primordial ooze can also be modeled to good effect in the Metaball modeler.

With any modeling project, it's a good idea to analyze the shape you intend to model before proceeding. Anything composed of smooth shapes that flow into each other is a good candidate for a Metaball model. A Metaball object can also be used as the basis for a more complex model. For example, you could create an alien's head in the Metaball modeler and use the Spline modeler to create the alien's body and appendages.

Cross-
Reference

Refer to Chapter 13 to learn how Metaball objects can be modified in the Vertex modeler.

Metaball modeling concepts

Metaball objects are created with primitives called *blob elements*, which blend with each other to form the whole. Blob elements are united by a skin that flows over and around individual blobs. One blob element affects another, and the size and proximity of the individual elements influence the resulting shape. Bigger objects assert bigger influences. The closer blobs are, the greater their effect on one another.

Metaball blob elements are available in four different shapes: sphere, cube, cylinder, and cushion. As each shape can be positive or negative, you have eight elements at your disposal for creating Metaball models.

Positive blob elements add to the overall volume of a shape by attracting each other. The level of this attraction depends on each blob element's size and relative distance from the other element, as well as the Surface Threshold setting. A skin forms where each blob element's field of influence overlaps another's. Figure 11-1 shows a rendering of different positive blob elements interacting with each other. Notice how the shapes differ when the objects are farther apart.

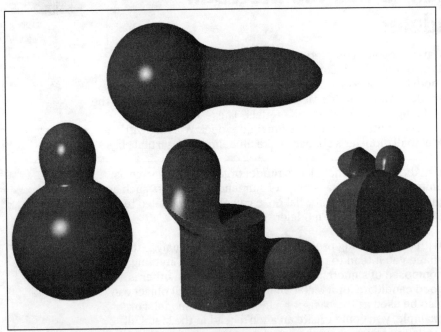

Figure 11-1: Positive blob elements interacting with each other to create organic-looking shapes

Negative blob elements repulse objects within their field of influence. A negative blob affects a positive blob element by pushing its skin back. The amount of repulsion depends on the negative blob element's size and distance from the positive blob element, as well as the Surface Threshold setting. Negative blob elements can be used to create depressions in positive blob elements. Figure 11-2 shows a rendering of negative blob elements interacting with positive blob elements.

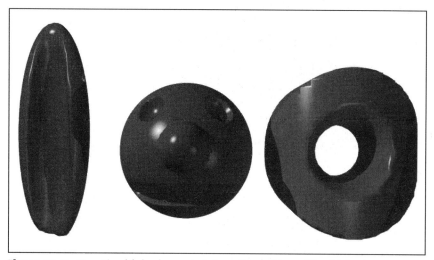

Figure 11-2: Negative blob elements interacting with positive blob elements to create organic-looking shapes

Exploring the Metaball Modeler

The Metaball modeler is where you combine positive and negative blob elements to create organic models. To enter the Metaball modeler:

1. Select Insert ➪ Metaball Object.

 Alternatively, select the Metaball Object tool (it's the seventh button on the top toolbar.) and drag to place it in the working box.

2. The Metaball modeler opens.

Like most working boxes in Carrara, the Metaball modeling box consists of three planes, one for each axis. Unlike other Carrara modeling boxes, only one plane is visible at a time. A set of three colored lines, representing the X, Y, and Z axes, denotes the center of the Metaball modeling box's universe. In addition, each Metaball primitive created has three colored lines emanating from its center, which become visible when you select or move the primitive. These lines can be used to good effect when aligning different primitive objects to each other and the working box grid (see Figure 11-3).

Rotate tool

Scale tool

Move/Selection tool

Zoom tool

Modeling box

Pan tool

Postitive Blob Element tool fly-out

Negative Blob Element tool fly-out

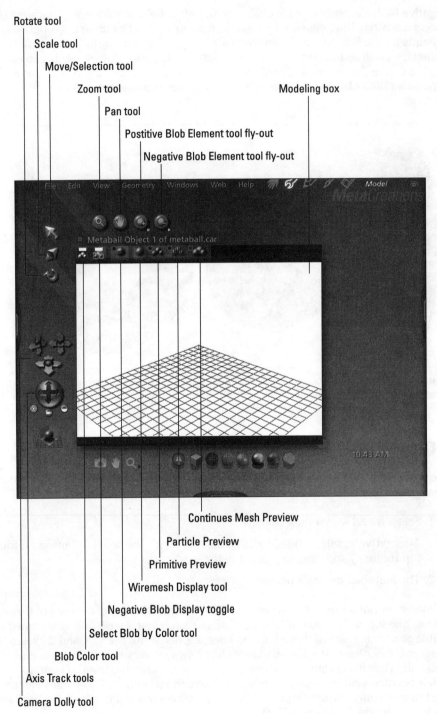

Continues Mesh Preview

Particle Preview

Primitive Preview

Wiremesh Display tool

Negative Blob Display toggle

Select Blob by Color tool

Blob Color tool

Axis Track tools

Camera Dolly tool

Figure 11-3: The Metaball modeler working box

Atop the Metaball modeling box is a toolbar with four sets of tools. With these tools, you can zoom in or out on your work, change the working box view, or create positive and negative blob elements. Figure 11-4 shows the available tools on this toolbar.

Zoom tool

Hand tool

Positive Blob Primitive tool

Negative Blob Primitive tool

Figure 11-4: With these tools, you change the working box view and create blob elements.

✦ **Zoom tool**: Changes the level of magnification inside the working box. To zoom in or out on your work-in-progress, click the tool and drag right inside the working box to zoom in and left to zoom out.

✦ **Hand tool**: Changes your view within the working box. Click the tool and drag inside the working box to pan to a different view.

✦ **Positive Blob Primitive tool:** This is actually four tools in one. You use it to create positive sphere, cube, cylinder, and cushion blob elements. To add a positive blob primitive to your scene, click the arrow to the right of the tool to expand the fly-out, and then click the desired blob element and drag to create it inside the working box. Figure 11-5 shows the expanded Positive Blob Primitive tool.

✦ **Negative Blob Primitive tool:** This, the last tool on the toolbar, is also four tools in one. With it, you create negative sphere, cube, cylinder, and cushion blob elements. To add a negative blob primitive to your scene, click the arrow to the right of the tool to expand the fly-out and then click the desired blob element and drag to create it inside the working box. Figure 11-6 shows the expanded Negative Blob Primitive tool.

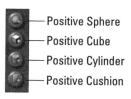

Positive Sphere

Positive Cube

Positive Cylinder

Positive Cushion

Figure 11-5: Use this tool to create positive blob elements.

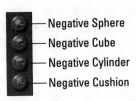

Negative Sphere
Negative Cube
Negative Cylinder
Negative Cushion

Figure 11-6: Use this tool to create negative blob elements.

In the upper-left corner of the Metaball modeler is the Preview Quality menu, offering seven tools to help you keep track of blob elements and let you control the preview quality of the Metaball model.

✦ **Set Selection Color tool:** Click the first icon on this menu, drag, and release to choose one of the nine available colors from the pop-up palette. The next blob primitive you create will be assigned this color. The assigned color is only visible when viewing primitives in the Primitive Preview and Particles Preview modes. Setting selection color makes it easier to identify individual blob elements when creating complex Metaball models. This tool can also be used to change the color of existing blobs. To do so, select the blob(s) you want to change, click this tool, and select a new color from the palette.

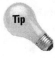

Tip

When creating a Metaball model with several blob elements, assign a separate color to each small element if possible. This will greatly simplify the task of selecting and editing small elements.

✦ **Select Primitive by Color tool:** Click the second icon on the menu and drag to choose one of the available colors. All blob primitives that were assigned this color are now selected. This feature comes in handy when creating and editing multi-element Metaball models.

✦ **Display Negative Primitives tool:** Determines whether negative blob elements are visible or not. The button to the left of the tool is red when negative primitives are displayed. To hide or unhide negative primitives, click the tool.

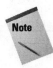

Note

When a negative primitive is hidden, you still have its bounding box for reference when it is selected. And you still are able to see how the hidden negative elements affect positive objects, except in the Primitive Preview mode.

✦ **Rendering tool:** Determines whether the preview is rendered in wiremesh or shaded mode. Click the tool to switch between modes.

✦ **Primitive Preview: No Interaction tool:** Enables a preview mode where all blob elements are visible (unless you've enabled the Display Negative Primitives tool), but the interaction between elements is not visible. Click the tool to enable or disable the mode. Use this mode to speed up editing and redraw time when working with a slow computer.

✦ **Particles Preview tool:** Enables a display mode where the surface of the Metaball model is rendered as small triangles. Click the tool to enable the mode.

✦ **Continuous Mesh Preview tool:** Enables a display mode that renders the surface of a Metaball model as a continuous mesh. This mode gives you the best idea of what the finished model will look like. Click the tool to enable or disable the mode.

To set preview precision, press + to increase precision and – to decrease precision. Increasing preview precision gives you a better idea of how individual blob elements are interacting to form the Metaball model.

All preview modes can be rendered in either wireframe or shaded mode. Use the Rendering tool to switch between modes.

In Particles Preview mode, increasing precision increases the number of triangles used to render the preview. In Continuous Mesh Preview mode, increasing precision increases the number of polygons used to render the preview. In Primitive Preview mode, precision settings have no effect.

Increasing preview precision results in slower redraws and longer editing time.

Now that you're familiar with basic Metaball modeling concepts and the layout of the Metaball modeling box, it's time to learn how to navigate in Metaball land.

Changing viewpoints in the Metaball modeling box

The Metaball modeling box view can be changed by using the standard Dolly and Track tools. These tools function the same as they do in other Carrara working boxes. Select the tool and use it to change the viewing orientation of the working box. Changing the orientation of the working box is useful when creating complex models.

To rotate your viewpoint in the Metaball working box:

1. Click and drag the Dolly tool to rotate the camera's viewpoint to the desired perspective.

2. To change your viewpoint using the Track tools, click either the Track XZ tool, the Track XY tool, or the Track YZ tool and drag along one of the tool's planes to change to the desired viewpoint.

To dolly while moving a selection:

1. Hold the Ctrl key while dragging the selection.

2. When you've rotated to the desired viewpoint, release the Ctrl key and continue dragging to position the selection.

Objects can be moved, rotated, and resized using the standard Move/Selection, Rotate, and Scale tools. These tools function the same as they do in other Carrara working boxes. Select the desired tool and click the object to use the tool.

To position a blob element using the Move/Selection tool:

1. Click the Move/Selection tool to select it.

2. Click and drag the blob element to the desired position.

To size a blob element using the Scale tool:

1. Click the Scale tool to select it.

2. Click and drag right on the blob element to increase its size. Click and drag left on the blob element to decrease its size.

Note You can only resize an element proportionately in all three planes when using the Scale tool.

To spin an element with the Rotate tool:

1. Click the Rotate tool.

2. Click and drag on the element to rotate it freely 360 degrees.

There will be times when you need to change the active plane in order to perform a task on your Metaball model.

To change the active plane:

1. Click the Move/Selection tool.

2. Click the plane you want to become active inside the Working Box Control.

Metaball Modeling with the Ghost Menus

As you may have noticed, the conventional menus and controls have their limitations in the Metaball modeler. Fortunately, the Metaball modeler comes with a second set of menus known as Ghost Menus. With Ghost Menus, all the blob elements and operations necessary to create a Metaball model are just a right-click away.

Exploring the Ghost Menu

The Ghost Menu provides a very intuitive way to work. Instead of having to distract your attention from the modeling process to select a menu item or tool, a right-click reveals a menu with all the necessary Metaball modeling elements right above your cursor. To activate the Ghost Menu, right-click anywhere inside the Metaball working

box. The Ghost Menu does everything but change viewpoints. Not to worry, there's another Ghost Menu, appropriately called the Alternate Ghost Menu, available for that purpose. Figure 11-7 shows the elements and tools available on the Ghost Menu.

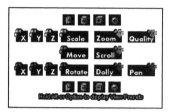

Figure 11-7: The Metaball modeler's Ghost Menu stays hidden until you need it.

To create a positive blob primitive using the Ghost Menu:

1. Right-click and drag to select the desired positive blob element from the top row of the Ghost Menu. Release the mouse button once you've selected the blob element.

2. Click and drag inside the workspace to create and size the element.

To create a negative blob element using the Ghost Menu:

1. Right-click and drag to select the desired negative blob element from the bottom row of the Ghost Menu. Release the mouse button once you've selected the blob element.

2. Click and drag inside the workspace to create and size the element.

Once you have positive and negative blob elements in the Metaball working box, you need to move, rotate, and scale them to create the desired model. The Ghost Menu greatly simplifies these tasks.

To resize an object using the Ghost Menu:

1. Constrain scaling to an object's X axis by selecting the object, and then right-clicking and dragging to select the X Scale tool from the second row of the Ghost Menu. Drag right to increase size, left to decrease.

2. Constrain scaling to an object's Y axis by selecting the object, and then right-clicking and dragging to select the Y Scale tool from the second row of the Ghost Menu. Drag right to increase size, left to decrease.

3. Constrain scaling to an object's Z axis by selecting the object, and then right-clicking and dragging to select the Z Scale tool from the second row of the Ghost Menu. Drag right to increase size, left to decrease.

4. Proportionately scale an object by clicking to select the object, and then right-clicking and dragging to select the Scale tool from the second row of the Ghost Menu. Drag right to increase size, left to decrease.

To zoom using the Ghost Menu:

1. Right-click and select the Zoom tool from the second row of the Ghost Menu.

2. Drag right to zoom in, left to zoom out.

To increase preview quality using the Ghost Menu:

1. Right-click and select the Quality tool from the second row of the Ghost Menu.

2. Drag right to increase quality, left to decrease.

To move an object using the Ghost Menu:

1. Select the object.

2. Right-click and drag to select the Move/Selection tool from the third row of the Ghost Menu.

3. Drag the object to the desired position. The blob element will move parallel to the active plane.

Tip Press the Alt key to move blobs perpendicular to the active plane. Hold down the Shift key to constrain the drag angle to 45 degree increments.

4. To move the object relative to another plane, click the Working Box Control and click a different plane to make it active.

To change your view using the Ghost Menu:

1. Right-click and drag to select the Scroll tool from the third row of the Ghost Menu.

2. Drag to move to a different viewpoint, or right-click and drag to select the Pan tool from the fourth row of the Ghost Menu.

3. Drag to move the camera to a different viewpoint.

To rotate an object using the Ghost Menu:

1. Constrain rotation to an object's X axis by selecting the object, and then right-clicking and dragging to select the X Rotation tool from the fourth row of the Ghost Menu. Drag to rotate the object within the X axis.

2. Constrain rotation to an object's Y axis by selecting the object, and then right-clicking and dragging to select the Y Rotation tool from the fourth row of the Ghost Menu. Drag to rotate the object within the Y axis.

3. Constrain rotation to an object's Z axis by clicking to select the object, and then right-clicking and dragging to select the Z Rotation tool from the fourth row of the Ghost Menu. Drag to rotate the object within the Z axis.

4. Rotate an object freely by selecting the object, and then right-clicking and selecting the Rotation tool from the fourth row of the Ghost Menu. Drag to rotate the object freely 360 degrees.

Tip Change viewpoints when using the rotation tools to get a better look at the effect the change is having on the Metaball model.

To apply a tool or edit to the entire Metaball model:

1. Select Edit ➪ Select All (Ctrl+A) to select all the elements that make up the model.

2. Select the desired tool or menu command.

3. Perform the edit.

4. Select the Move/Selection tool and click anywhere inside the working box to deselect the model.

To rotate the Metaball working box using the Ghost Menu:

1. Right-click and drag to select the Dolly tool from the fourth row of the Ghost Menu.

2. Drag to rotate the working box to the desired position.

Changing preset viewpoints with the Alternate Ghost Menu

Using the Alternate Ghost Menu and Ghost Menu as a team makes it possible for you to do almost all of your Metaball modeling without ever taking your eyes off of the work-in-progress. The Alternate Ghost Menu allows you to change viewpoints. With the Alternate Ghost Menu, you have the standard Carrara Reference 3D view and six isometric preset viewpoints from which to choose.

To change viewpoints using the Alternate Ghost Menu:

1. Hold down the Alt key and right-click to activate the Alternate Ghost Menu.

2. Drag to select the desired viewpoint from the menu and release to apply.

To return to the last viewpoint using the Alternate Ghost Menu:

1. Hold down the Alt key and right-click to activate the Alternate Ghost Menu (see Figure 11-8).

2. Drag to Last and release to apply.

Tip Use the Last position tool to return to a custom viewpoint you set up with the Dolly tool. Switching between a preset and custom viewpoint can greatly simplify the modeling process when fine-tuning a particular element on a Metaball model.

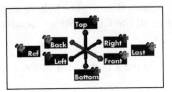

Figure 11-8: Use the Alternate Ghost Menu to switch between preset views in the Metaball working box.

Two other commands that you'll use frequently when creating Metaball models are the Duplicate and Duplicate with Symmetry commands.

To duplicate a blob element:

1. Click to select the desired element.

2. Choose Edit ⇨ Duplicate (Ctrl+D). A duplicate element is created in the same position as the original.

To duplicate a blob element with symmetry:

1. Click to select the desired element.

2. In the Working Box Control, click the desired plane of symmetry. The plane of symmetry is the plane the object will be symmetrically duplicated across.

3. Choose Edit ⇨ Duplicate with Symmetry (Ctrl+Alt+D). A duplicate element is created and mirrored on the other side of the active plane.

There are two important options available in the Geometry menu: Surface Fidelity and Surface Threshold. Changing the Surface Fidelity and/or Surface Threshold settings will greatly affect the look of your finished model.

The Surface Fidelity setting controls the amount of polygons used to create the finished model. If a Metaball object doesn't render smoothly, increasing the Surface Fidelity will break the model down into more polygons, which results in a smoother rendering.

To change the Surface Fidelity setting of a Metaball model:

1. Choose Geometry ⇨ Surface Fidelity.

2. When the Surface Fidelity dialog box appears, choose one of the following options and adjust settings for those options accordingly:

 • **Mesh Mode:** Generates an object similar to what you're viewing (in Continuous Mesh viewing, wireframe off mode) in the Metaball modeling window. Select a Fidelity setting anywhere between 0.13 and 400. Increasing fidelity creates a smoother object.

Caution

Increasing surface fidelity results in longer rendering times.

• **Spike Mode:** Generates an object with a spiky surface. This mode can be used to simulate furry animals or shrub-like foliage. The Size option controls spike length, whereas Amount controls the number of spikes.

3. Click OK to apply the new setting (see Figure 11-9).

Note

The results of changing the Surface Fidelity setting will only be visible when you return the object to the Assemble room.

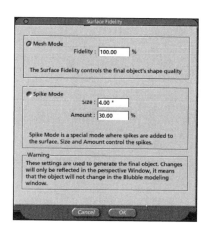

Figure 11-9: Increase the surface fidelity to render a smoother object.

The Surface Threshold setting controls the field of influence blob elements have upon each other. The distance at which blobs begin to blend is dependent on the Surface Threshold setting.

To change the Surface Threshold setting of a Metaball object:

1. Choose Geometry ⇨ Surface Threshold.

2. When the Threshold dialog box appears (see Figure 11-10), enter the desired setting. This option sets the percentage of blending that occurs between blob elements. A lower surface threshold results in smaller blobs and longer blends.

3. Click OK to apply the new setting.

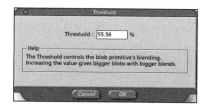

Figure 11-10: Change the Surface Threshold setting to alter the way blob elements blend with each other.

Figure 11-11 shows the effects of applying different Surface Threshold settings to the same object. The object on the left has a setting of 30, whereas the one on the right has setting of 70.

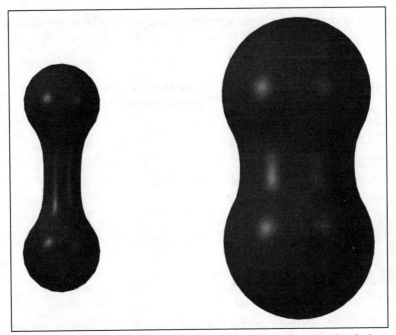

Figure 11-11: These two Metaball objects are identical except for their Surface Threshold settings.

Setting Metaball modeler preferences

Now that you know your way around the Metaball modeler, it's time to create your first model. But first you're going to set up the modeler just the way you like it by specifying preferences.

To set Metaball modeler preferences:

1. Select File ➪ Preferences ➪ Metaball modeler. The Metaball preferences dialog box opens.

2. Remember last command in Ghost Menu is enabled by default. This option keeps the last Ghost Menu command in memory. For example, if you use the Ghost Menu to create a positive blob element, you can create additional ones without having to invoke the Ghost Menu.

3. In the Grid Settings section, set the following parameters:

- In the Spacing field, enter a value for grid spacing.

- Enter a value in the Draw a line every field. This value determines how often a grid space is drawn in the modeling box. The default value draws one grid line for each grid space.

- The Show option is enabled by default. Disabling this option causes the grid to disappear from the modeling box.

- Enable the Snap to option to have objects snap to the grid.

4. In the Cycling section, specify a value for Delay. This value sets the delay in seconds between the time the Metaball modeler cycles from one element to the next when you hold the cursor down on a group of blob primitives.

Creating Your First Metaball Model

Learning how to navigate around the Metaball modeler and create positive and negative blob elements is a good way to begin, but now it's time to put that well-earned knowledge to work and actually create a Metaball object. So take a deep breath, roll up your sleeves, and launch Carrara.

Alf, the Metaball alien

Alf is a lovable little alien who has absolutely nothing to do with the TV character of the same name. Prior to this chapter, Alf was trapped in the author's imagination. There are millions of Alfs or characters just like him all around the world. All that's needed to bring the Alfs of the world to life is a little imagination and a Metaball modeler. Alf could be created by using menu commands exclusively, but in this tutorial you use the Ghost Menus to create Alf.

Follow these steps to create an Alf of your very own:

1. Create a new document in Carrara and launch the Metaball modeler by selecting Insert menu ⇨ Metaball Object, or by dragging the Metaball Object tool into the working box or Sequencer tray's Universe list. Once the Metaball modeler opens, switch to the Primitive Preview mode.

2. Hold down the Alt key and right-click to activate the Alternate Ghost Menu. Drag to the Left viewpoint and release.

3. Right-click to activate the Ghost Menu, drag to select a positive sphere element, and then release. Click and drag inside the working box to create the sphere.

4. With the sphere still selected, right-click to activate the Ghost Menu and select the Z Scale tool. Drag until the sphere is fifty percent taller than it is wide.

5. Deselect the sphere and click the Set selection color tool from the top toolbar. Drag to select the red color.

6. To create Alf's puffy cheeks, right-click to activate the Ghost Menu and drag to select a positive sphere element. Click and drag inside the working box to create the sphere. Notice that the new sphere element is red in color.

7. Hold down the Alt key, right-click to activate the Alternate Ghost Menu, and drag to select the Top view. Click to select the red sphere and drag to position it in Alf's head. If the sphere is not sized properly in relation to the rest of the head, right-click to activate the Ghost Menu and select the Scale tool. Drag right to increase the sphere's size, left to decrease.

Note

You may find it helpful to switch between the Top and Left viewpoints to align the sphere.

8. Hold down the Alt key and right-click to activate the Alternate Ghost Menu and drag to select the Front view.

9. Select the red sphere and duplicate it (use the keyboard shortcut Ctrl+D). Drag the sphere to the right to create Alf's left cheek. At this stage, Alf should look similar to the image in Figure 11-12.

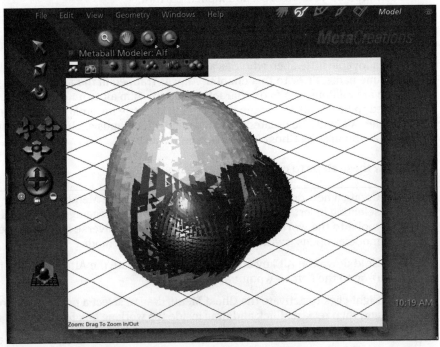

Figure 11-12: Alf the Alien in the early stages of modeling

Note

If your computer is responding sluggishly while creating Alf, choose Edit ➪ Select All (Ctrl+A) to select all elements. Right-click to activate the Ghost Menu and select the Scale tool. Drag left to decrease the size of the blob elements.

10. Hold down the Alt key, right-click to activate the Alternate Ghost Menu, and drag to select the Left view.

11. Deselect the red sphere and click the Set Selection Color tool from the top toolbar. Drag to select the green color.

12. To create Alf's nose, right-click to activate the Ghost Menu and drag to select a positive sphere element. Click and drag inside the working box to create the sphere.

13. With the sphere still selected, right-click to activate the Ghost Menu and drag to select the Y Scale tool. Drag right to increase the length of Alf's nose.

14. Drag to align the nose between the two spheres you created for the cheeks. If necessary, Alt+right-click to activate the Alternate Ghost Menu and drag to switch to the Top view. Alf should now look like the image in Figure 11-13.

Figure 11-13: Alf the Alien grows a nose.

15. Deselect the green sphere and click the Set Selection Color tool from the top toolbar. Drag to select the brown color.

16. Right-click to activate the Ghost Menu and drag to select the positive cylinder element. Click and drag inside the working box to create the cylinder that will become Alf's neck. Drag the cylinder to align it with the bottom of Alf's head.

17. Hold down the Alt key, right-click to activate the Alternate Ghost Menu, and drag to select the Front view.

18. Right-click to activate the Ghost Menu, drag to select the positive cylinder element, and release. Click and drag inside the working box to create the cylinder that will become one of Alf's antennae.

19. Right-click to activate the Ghost Menu. Use the X Scale, Y Scale, and Z Scale tools as needed to resize the cylinder so that it's narrower than the tip of Alf's nose, but as long as his head.

20. Right-click to activate the Ghost Menu and drag to select the positive sphere element. Click and drag inside the working box to create the sphere that will become the tip of Alf's antennae. Drag to align the sphere with the top of the cylinder.

21. Shift+click both the cylinder and the sphere to select them. Drag the cylinder and sphere, aligning them atop the right side of Alf's head.

22. Right-click to activate the Ghost Menu and drag to select the Y Rotate tool. Drag to rotate the cylinder and sphere to the left. You may need to switch views to accurately align the antenna (see Figure 11-14).

Figure 11-14: Using the Y Rotate tool to position one of Alf's antennae.

23. Click the Working Box Control and click the right plane to make it active.

24. With the cylinder and sphere selected, choose Edit ⇨ Duplicate with Symmetry (Ctrl+Alt+D). A duplicate cylinder and sphere are created on the other side of the active plane.

25. Select the duplicate sphere and cylinder and drag to align them atop the left side of Alf's head.

26. Now all that's left to do is create an indentation for Alf's mouth. Hold down the Alt key, right-click to activate the Alternate Ghost Menu, and drag to select the Left view.

27. Right-click to activate the Ghost Menu, drag to select a negative sphere element, and release. Click and drag inside the working space to create the negative sphere.

28. Right-click to activate the Ghost Menu and drag to select the Z Scale tool. Drag to decrease the sphere's Z dimension.

29. Drag the negative sphere below Alf's nose and into the sphere that forms his head to create the indentation for his mouth. Alf should look similar to what is shown in Figure 11-15.

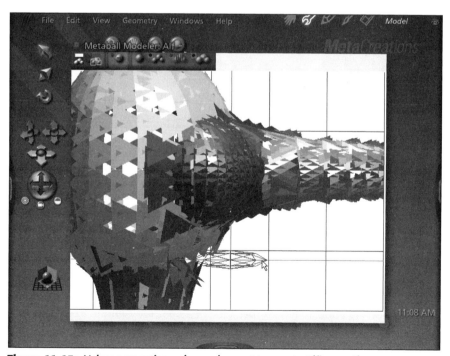

Figure 11-15: Using a negative sphere element to create Alf's mouth

30. Click the Assemble icon to return Alf to the Assemble room. To add eyes to Alf the Alien, create two spheres and align them on each side of his nose. Figure 11-16 shows Alf back in the Assemble room, getting fitted with a pair of spheres for his eyes. Figure 11-17 shows Alf after a trip to the Texture and Render rooms.

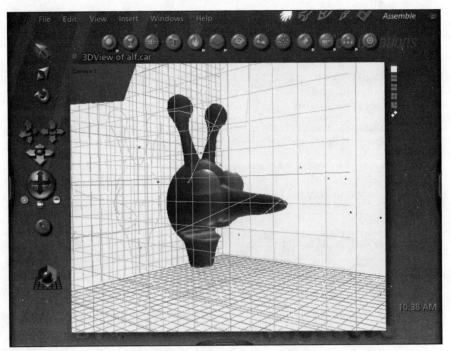

Figure 11-16: Alf after Metaball modeling, prior to rendering

Good work! In creating Alf the Alien, you've come a long way in your knowledge of Metaball modeling. Before branching out on your own into the wonderful world of blob elements, there are a few things to remember. Always reduce a model to its lowest common denominator. If an object won't show in the final rendering, don't include it in the model. Also keep the size of the model manageable. Metaball primitives are large by nature. Size the blob elements for comfortable viewing and manipulating, but not so large as to tax the resources of your CPU. Break complex Metaball models down into logical sections and then join them in the Assemble room. Save your work early and save it often. It's frustrating to see several hours of modeling come to naught because of a computer glitch. Save your model under different names, such as Alf1, Alf2, and so on. That way, if disaster strikes, you can always resort to an earlier version.

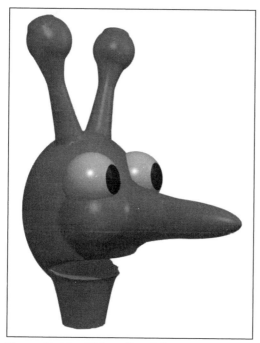

Figure 11-17: Alf the Alien, fully textured and rendered

The Metaball modeler will become a frequently used weapon in your 3D arsenal. Expand on the knowledge you've gained in this chapter and branch out to create more intricate Metaball models. The only limiting factors in your success are your patience, persistence, and, of course, imagination.

Summary

The Metaball modeler is a powerful tool used to create smooth organic models. By mixing positive and negative blob elements, you can model anything from cartoon characters to insects.

✦ The Metaball modeler enables you to create organic-looking objects.

✦ Metaball blob primitives interact with each other to create the finished model.

✦ Positive blob elements attract other blob elements and add to a model's surface area.

✦ Negative blob elements repulse other blob elements, pushing their surface skin back to create depressions or voids.

✦ Surface Threshold settings determine the amount of blending between blob elements.

✦ Surface Fidelity settings can be adjusted to create smoother-looking models.

✦ The Spike Mode lets you create models such as furry animals and shrubs.

✦ ✦ ✦

Creating Landscapes with Carrara

Carrara contains a powerful subroutine, called Four Elements, that allows you to model realistic landscapes. Whether you want mountains, rolling hills, craters, or vast expanses of ocean, you can faithfully replicate Mother Nature with Four Elements. Four Elements also lets you create an atmosphere to compliment your scene. Anything is possible — from hot hazy days to cool clear nights. Just add a touch of imagination, a dash of creativity, and you're on your way.

When using Carrara's other modelers, you work with primitive objects or create 2D images as a base with which to model an object, but with Four Elements, you start out with a terrain primitive. The Four Elements: Earth modeler's controls generate fractal grayscale images that are converted into terrain models. Although the algorithm that creates the images is a computer programmer's wonder, all you need to be concerned with is how grayscale images are converted into elevation maps. Grayscale colors are shades of gray ranging from pure black (0) to pure white (255). When translated into elevation maps, black colors become the very lowest points in valleys, and white colors become the lofty pinnacles of great mountains. The scales of gray in between form the mounds, plateaus, and rolling hills of the Four Elements terrain.

Adding an Earth Primitive to Your Scene

The basic elements of any Carrara landscape are terrain primitives. To insert a terrain primitive in the working box:

1. Select Insert ⇨ Terrain.

 Alternatively, select the Terrain Primitive tool (the mountain icon on the fifth tool button's fly-out on the top toolbar) and drag to place it in the working box. The Terrain dialog box appears (see Figure 12-1).

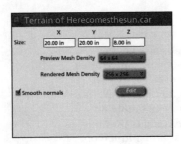

Figure 12-1: The Primitive Modeler Terrain window

2. Adjust the following settings:

 • **Smooth normals:** Selecting the Smooth normals option creates a terrain similar to rolling hills. If you want craggy mountain peaks, don't select this option.

 • **Preview Mesh Density:** This setting gives you control over the display quality of the mesh in the working box. A higher mesh density yields a more accurate representation of what the rendered mesh will look like. This setting is always lower than the Rendered Mesh Density setting.

Caution Choosing a high setting for Display Mesh Density taxes RAM and system resources and results in slower redraw times.

 • **Rendered Mesh Density:** This setting gives you control over the level of detail in the rendered terrain. A terrain with a higher Rendered Mesh Density will have more detail in the final rendered image.

Caution Due to the possibility of unpredictable results, always adjust Rendered Mesh Density before editing the terrain.

 • **Size:** This setting gives you control over the area and height of your terrain. Enter size values for X, Y, and Z.

Always edit the size of your terrain by using the Terrain dialog box in the Model room. Resizing a terrain in the working box by dragging its bounding box handles can lead to unpredictable results.

3. After adjusting the settings to your preference, click the Edit button to enter the Four Elements: Earth modeler. You are then prompted to save the object as a mesh file. Accept the default name and directory Carrara assigns the mesh or assign a different directory and name to the mesh.

It's a good idea to save terrain mesh files in a separate folder along with other scene elements. That way you'll be able to easily locate all elements of a scene for future use.

After saving the mesh file, the Four Elements: Earth modeler opens, allowing you to generate one of the Four Elements' preset terrain types or create a custom terrain using the Paint tools. The Four Elements: Earth modeler consists of four major areas.

✦ The large window on the left displays the grayscale elevation map used to generate the terrain. The floppy disk icon with the left-pointing arrow enables you to export the current elevation map for use in other programs. The floppy disk icon with the right-pointing arrow enables you to import a grayscale elevation map. These functions are covered in greater detail later in the chapter. The Undo/Redo option in this window allows you to undo or redo the last action performed in the modeler.

✦ Below the elevation map window are the Elevation Paint, Locally Raise or Lower the Terrain, Add Craters, and Locally Erode tools, which can be used to modify a terrain or create a custom terrain. You use these tools to paint directly on a terrain and add other features in the elevation map window.

✦ The small window in the upper-right of the modeler is the Global 3D terrain preview, where you can view a 3D representation of your work-in-progress. You can preview the terrain in two different modes:

• The Global view of terrain preview mode shows the terrain as a rotating 3D object. To access this mode, click the mountain icon in the terrain preview window.

• The Flight over terrain mode generates a tiled view of the terrain, which scrolls by as if you were viewing it from an airplane. To access the Flight over terrain mode, click the airplane icon in the Global 3D terrain preview window. While in the Flight over terrain mode, drag to the left or right to change the direction of the flight path. Drag up to increase speed, down to decrease speed.

✦ The lower-right corner of the Four Elements: Earth modeler contains two tabs, one containing options for generating a terrain and the other containing options for modifying it.

Generating a preset Four Elements terrain

Four Elements has a wide variety of preset terrain options, from sand dunes to mountain ranges. These presets are the easiest and quickest way to populate a Carrara landscape. To generate a Four Elements preset terrain:

1. Click the Generate tab in the Four Elements: Earth modeling window (see Figure 12-2) to activate the control.

2. Select one of the many available presets to generate a terrain.

Tip To create a different-looking terrain of the same type, click the Shuffle button and click the desired terrain again.

3. To start from scratch and generate a new terrain, click the Clear button. Click OK to generate the terrain.

4. Click the Assemble icon to return the finished terrain to the Assemble room.

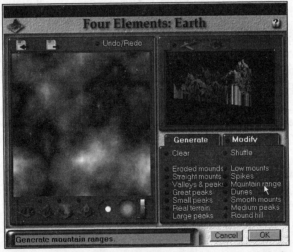

Figure 12-2: The Four Elements: Earth modeling window

Tip In nature, atmospheric haze blurs the details of distant terrain. In a scene with multiple types of terrain, choosing a lower value for Rendered Mesh Density results in the distant terrain mimicking this effect. It also results in faster rendering times due to the decreased level of detail.

Modifying terrain objects

The Four Elements: Earth modeler creates impressive terrain objects. However, there may be times when you want to modify a terrain to create a desired effect. To modify a terrain object in the Four Elements: Earth modeler:

1. Click the Modify tab to activate the control.

2. Choose one of the modifiers to change the characteristics of the terrain. You have several at your disposal:

 • **Smooth:** Smoothes the terrain

 • **Smooth more:** Smoothes the terrain even more than the preceding option

 • **Add noise:** Generates a rougher, rockier terrain

 • **Normalize:** Reduces the difference in altitudes between the terrain's top and bottom

 • **Erode 1:** Mimics the effects of time and Mother Nature on a terrain

 • **Erode 2:** Produces a more pronounced erosion effect than the preceding option, much like a glacier-cut valley

 • **Raise:** Increases terrain altitude

 • **Lower:** Decreases terrain altitude

 • **Hills:** Adds hills to the existing terrain

 • **Crests:** Adds craggy peaks to the existing terrain

 • **Invert:** Inverts high points to low points and vice-versa

 • **Posterize:** Flattens peaks into plateaus

 • **Zero Edges:** Removes a terrain's outer edges to create islands

 • **Gaussianize:** Smoothes a terrain's edges

Note You can use more than one modifier on a terrain. Any modification can be undone or redone by clicking the Undo/Redo tool. This tool can only be applied to the last modification.

Tip Use both the Zero Edges and Gaussianize terrain modifiers whenever you have a terrain meeting with a flat surface such as water or an infinite plane.

3. Choose the desired modifier to alter the terrain. To intensify the effect, click the modifier again.

4. When modifications to the terrain are complete, click OK.

5. Click the Assemble icon to return the modified terrain to the Assemble room. Figure 12-3 shows a terrain undergoing modification.

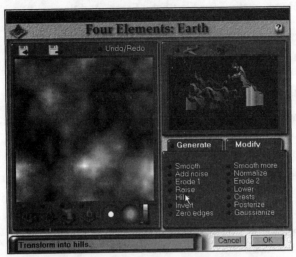

Figure 12-3: Modifying a terrain object in the Four Elements: Earth modeler

Painting terrain objects

You can create custom terrain objects to suit your scene by using the Four Elements: Earth modeler's Paint tools. To create a custom terrain:

1. Select Insert ➪ Terrain.

 Alternatively, select the Terrain Primitive tool and drag to place it in the working box. The Primitive Modeler Terrain window opens.

2. Select the desired settings for your custom terrain, click the Edit button, and save the mesh when prompted.

3. Once inside the Four Elements: Earth modeler, the large window on the left gives you a clear canvas on which to paint your terrain masterpiece. Using your pointing device in conjunction with the Elevation Paint tools enables you to create a unique terrain object. You can adjust the effect the Paint tool has on the terrain by modifying its settings, detailed in the following list. You paint your terrain from the top viewpoint. Watch the terrain take shape in the Global 3D terrain preview window.

 • **Change Brush Size:** Drag right or left on the tool to increase or decrease brush size.

- **Change Brush Softness:** Drag right or left on the tool to increase or decrease brush softness. This setting controls the strength of the line you paint. Choose a soft brush setting to blend your work into surrounding terrain objects. Choose a hard setting to paint a massive spire such as Devil's Tower.

- **Change Brush Altitude:** Drag up or down to change the brush's grayscale color value. Changing from a darker color to a lighter color effectively raises the altitude of the terrain you're painting.

Figure 12-4 shows a custom terrain taking shape.

Tip

If you have a digital pen and tablet, use it instead of a mouse to gain more precise control over the Elevation Paint tools.

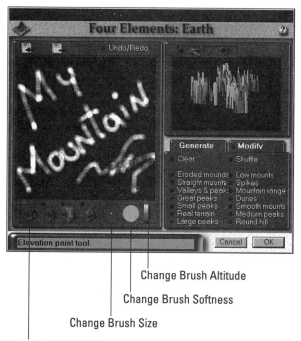

Change Brush Altitude

Change Brush Softness

Change Brush Size

Elevation Point Tool

Figure 12-4: Creating a custom terrain using the Elevation Paint tool

Modifying a terrain with the Paint tools

In addition to creating a terrain with the Paint tools, you can also modify a terrain with them. To modify an existing terrain with the Elevation Paint tools:

1. In the working box, select the terrain you wish to modify.

2. Either double-click the terrain or select the Model button to reopen the Primitive Modeler Terrain window.

3. Click Edit to open the Four Elements: Earth modeler.

4. The first tool at your disposal is the actual Elevation Paint tool itself. By adjusting the Brush Size, Brush Softness, and Brush Color controls, you can paint features on top of or carve into existing terrains.

5. The second tool is the Locally Raise or Lower the Terrain tool. This brush increases or decreases the height of specific areas of the terrain as you paint over it. When you select the Locally Raise or Lower the Terrain tool, the Brush Size control becomes available. Drag left or right on the control to set the brush size. Next, select the area of the terrain you want to modify. Drag the tool up to increase altitude and down to decrease altitude.

6. The next terrain modifier at your disposal is the Add Crater tool. Select the tool and click where you want to create the crater. Drag to adjust the diameter of the crater. Drag repeatedly to increase the depth of the crater.

7. Last but not least is the Locally Erode tool. This tool simulates the effect of water erosion. To erode an area, select the tool and drag it over the area you wish to erode. The effects of this tool are subtle. You may have to drag repeatedly over the same area to achieve the desired effect.

Figure 12-5 shows a terrain being modified with the Paint tools.

Note The Paint tools may be used in conjunction with the options under the Modify tab. Remember, you can always use the Undo/Redo tool on the last modification. If a terrain isn't turning out to your liking, click Clear on the Generate tab to start again from scratch.

Tip The Paint tools can be used to add rivers or valleys to a terrain object. Choose the Elevation Paint tool and set the brush size for the approximate width of the river or valley you wish to create. Set the brush softness to a medium setting and then change the brush altitude color to a dark gray. Drag an erratic path across the terrain to carve out the river or valley. If you're a stickler for detail, decrease the brush size, choose a darker brush color, and take another swipe at the terrain to create a tapered valley.

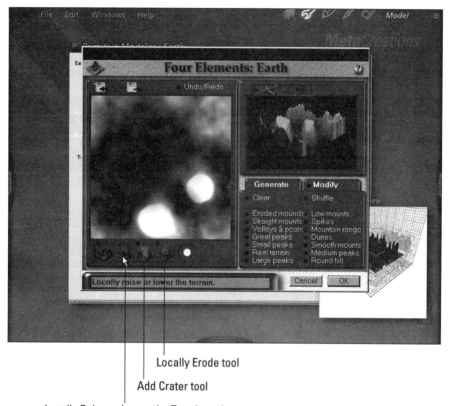

Locally Erode tool

Add Crater tool

Locally Raise or Lower the Terrain tool

Figure 12-5: Using the Paint tools to modify a terrain. Notice the two high peaks and the deep crater these tools created.

Importing images as elevation maps

Carrara's Four Elements: Earth modeler also has an option to import an image for use as an elevation map. Grayscale images work best. However, if you import a color image, the modeler converts it to grayscale. The default size for a Four Elements terrain is 20 × 20 inches, and the Four Elements: Earth modeling window is also square. With this in mind, it's best to import an image that is perfectly square. Rectangular images will be distorted to fit terrain proportions.

Tip

Use your favorite image editing program to create images for use as elevation maps. An image editing program with a plug-in that generates fractal patterns can produce excellent elevation maps. You can also use the image editing program's paint tools to create a highly detailed custom elevation map. Remember to convert the image to grayscale. A .bmp format image sized at 512 × 512 pixels with a resolution of 300 dpi works well in most instances.

To import an image for use as an elevation map:

1. Select Insert ➪ Terrain.

 Alternatively, select the Terrain Primitive tool, and drag to place it in the working box.

2. The Terrain dialog box opens in the Model room.

3. Select the desired settings for your custom terrain, click the Edit button, and save the mesh when prompted.

Note If you're importing an image that isn't square, adjust the proportions of the terrain object to match the proportions of the image.

4. Once inside the Four Elements: Earth modeler, click the floppy disk icon that shows an arrow pointing to the right.

5. The Load Picture dialog box opens, prompting you to load a picture. Locate the image you wish to wish to import as an elevation map and open it to convert it to a terrain. Figure 12-6 shows an imported grayscale image being converted into a terrain.

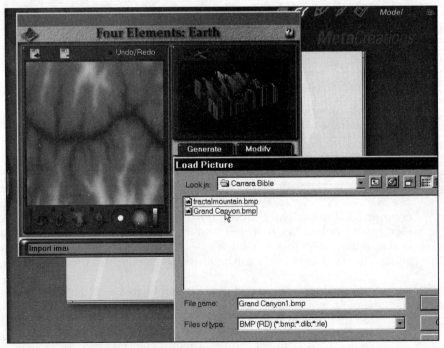

Figure 12-6: Importing an image for use as an elevation map

USGS Digital Elevation Models

It's possible to model terrain of actual places on Earth, thanks to Digital Elevation Models (DEMs). A DEM file is how the U.S. Geological Survey (USGS) records topographical information. Imagine a DEM file as a grid superimposed over a land mass. The elevation of the land mass is recorded where each grid point intersects. Each grid point sampling is combined to create a text description of the terrain being modeled.

Digital Elevation Models come in different resolutions and may be downloaded from the USGS Web site (`http://edcwww.cr.usgs.gov/doc/edchome/ndcdb/7_min_dem/ states.html`). To use a DEM as an elevation map in the Four Elements: Earth modeler, it must be converted to a grayscale image. There are several DEM conversion utilities that may be downloaded off the Internet.

Note Any terrain created in the Four Elements: Earth modeler can be exported for use in other programs. Select the floppy disk icon sporting a left-pointing arrow to export an image. This option comes in handy if you want to fine-tune an elevation map in an image editing program.

On the CD-ROM In the CD ROM's Goodies folder, you'll find a selection of DEMs already converted to grayscale images.

Adding infinite planes to your Carrara landscape

Unless you position the rendering camera in the middle of a huge mountain range or intend to have your landscape simulate a free-floating asteroid in deep space, the most carefully modeled terrain in the world isn't worth much unless you have something to rest it on. The infinite plane primitive serves as a worthy anchor for mountains, hills, valleys, or just about any other terrain the Four Elements: Earth modeler can generate. The infinite plane can be textured to serve as a land mass, a vast body of water, or the floor of an infinitely vast fantasy world. Your creative mind, imagination, and experimentation are the keys here.

To add an infinite plane to a landscape:

1. Select Insert ➪ Infinite Plane.

 Alternatively, select the Infinite Plane tool and drag it into the scene.

2. If necessary, use the Align tool to align terrain bases to the infinite plane.

Figure 12-7 shows an infinite plane inserted in a scene. Although the plane looks finite in this figure, the characteristics that make the plane appear to be infinite will be displayed when the scene is rendered.

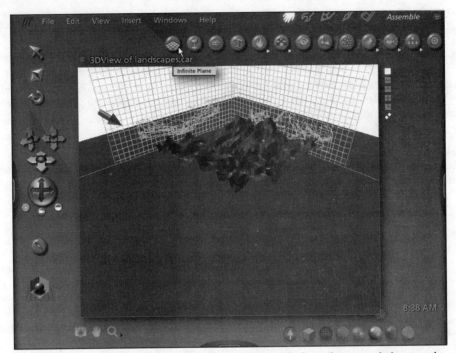

Figure 12-7: An infinite plane inserted in a scene and aligned to an existing terrain

Texturing infinite planes

Applying a shader to an infinite plane is a tricky proposition, especially if you're using a texture map or gradient. In order to apply a shader properly, you must adjust the infinite plane's tiling controls. If you don't adjust the infinite plane's tiling, Carrara will stretch the shader over the infinite plane, producing unpredictable results.

To adjust shader tiling on an infinite plane:

1. Double-click the infinite plane to open the Infinite Plane dialog box.

2. Select Tile UV Mapping.

3. Choose the tiling option that best suits your scene:

 • **Mirror UV in X Axis:** The shader is mirrored in the X Axis as it tiles across the infinite plane.

 • **Mirror UV in Y Axis:** The shader is mirrored in the Y Axis as it tiles across the infinite plane.

 Selecting both options will tile the shader seamlessly in both directions (see Figure 12-8).

Figure 12-8: Adjusting an infinite plane's mapping mode so applied textures tile properly across its surface

Adding water to your Carrara landscape

In addition to the infinite plane, Carrara provides you with plane primitives. Plane primitives can have many uses, but in a landscape they function quite well as small bodies of water.

To add a plane primitive to your Carrara landscape:

1. Select Insert ⇨ Plane.

 Alternatively, select the Plane tool (see Figure 12-9) and drag it into your scene.

2. With the plane still selected, drag the Properties tray open and numerically position the plane in your scene.

Note If desired, the plane can be positioned along the X and Y axis with a fair degree of accuracy using the Move and Rotate tools . However, due to the fact the plane has no height, it's difficult to precisely adjust the plane's position along the Z axis with the Selection tools.

Adding Texture to Terrain Objects

After meticulously modeling terrain primitives, aligning them, and maybe adding a body of water or two, it's time to give your scene an added bit of realism by applying textures to the objects. Carrara's Four Elements has its own set of components for shading terrain objects.

Texturing with the Four Elements Snow shader

The Four Elements Snow shader simulates snow. The effect varies depending on the surface it's applied to. The Snow shader can be applied to positive slopes, negative slopes, or both. The Snow shader achieves best results when used with the Mix or Multiply shader operators.

Figure 12-9: A plane primitive inserted in a Carrara landscape. With the proper shaders applied, this scene will simulate a body of water inside an extinct volcano.

To apply a Snow shader to a terrain:

1. With the terrain object selected, click the Texture icon to enter the Texture room. The Shader Tree Editor appears with Carrara's default for a Multi Channel shader.

2. The first channel on the Shader Tree is Color. Click the button and select the Mixer operator. Selecting the Mixer operator creates a node on the Shader Tree with three branches: Source 1, Source 2, and Blender.

3. Select the Color component for Source 1 and Source 2 and the Four Elements Shaders: Snow component for the Blender.

4. The colors you choose for each Source branch will depend on the effect you're trying to achieve. If you're simulating snow-covered peaks, select varying shades of white for each color source. For a craggy mountain with bare rock showing on steep slopes, choose a dark color for Source 1 and a shade of white for Source 2. The dark colors will show up as areas of rock poking through the white snow.

5. The Four Elements Shaders: Snow component has two options. Choosing the Positive Slope option will cause snow to appear on positive slopes, such as mountain slopes. Choosing the Negative Slope option will cause snow to appear on surfaces with negative slopes, such as the underside of spheres. Choosing both options causes snow to appear on the entire surface. No matter which option you select, snow will not appear on a vertical surface.

Figure 12-10 shows the Four Elements Shaders: Snow component being applied as a Blender in the Color channel.

Figure 12-10: The Four Elements Snow shader being applied to a craggy mountain range

Texturing with the Four Elements Wave shader

The Four Elements Wave shader simulates water in motion. By applying this shader to the plane primitive, you can depict waves in the ocean. The Wave shader is applied to the Bump channel.

To apply the wave shader to a channel, select Four Elements Shaders ➪ Water: waves. The shader has several adjustable parameters:

✦ **Completion:** Used when animating water. To animate waves, set the value at 0 for the first frame of an animation and 100 for the last frame of the animation.

✦ **Global Scale:** Controls spacing of the waves. A low value yields many small, closely spaced waves, whereas a high value yields fewer widely spaced waves.

✦ **Compute Interferences:** Determines the interaction between waves. When this option is checked, waves can eliminate each other. When this option is unchecked, waves will be added on top of each other.

✦ **Perturb Values:** Determines the depth of the waves. When this option is unchecked, the waves will appear flatter, with less color variation. When this option is checked, the waves will have greater depth and more color gradation.

The Four Elements Wave shader can create up to three waves. Each wave set has its own individual parameters. Combining each wave set's unique parameters will enable you to simulate a wide variety of water conditions. To add a wave set to the shader, check the Enable box. Each wave set has four parameters:

✦ **Angle:** Determines the orientation of the wave.

✦ **Amplitude:** Determines the height of the wave.

✦ **Scale:** Determines the frequency of ripples in individual waves.

✦ **Perturbation:** Determines the distortion of the wave. Use higher values to simulate agitated water.

Note The Scale and Perturbation parameters have a direct correlation to the size of the surface they're being applied to. Both parameters have greater effects on smaller objects when you select lower values.

Perturbation is directly affected by the Wave shader's Perturb Values parameter.

To texture a plane primitive with the Waves shader:

1. With the Plane selected, click the Texture icon to enter the Texture room. The Shader Tree Editor appears, with Carrara's default for a Multi Channel shader selected.

2. Click the Color channel button and select the Color component.

3. Click the color swatch and select the desired color for the body of water.

4. Click the Transparency channel button and select an appropriate value for the body of water you're simulating. A good starting point is 30 percent.

5. Click the Bump channel button and select the Four Elements Shaders Water: waves component. Set the parameters for type of wave action you want simulated (see Figure 12-11).

6. Click the Assemble icon to return the textured plane to the Assemble room.

Cross-Reference The Four Elements Wave shader is a multifaceted component that you can use on objects other than bodies of water. To learn more about the Wave shader, refer to Part III of this book, "Texturing Your Finished Models."

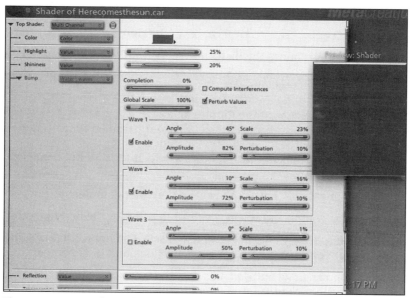

Figure 12-11: Applying the Four Elements Wave shader to a plane

Texturing with the Four Elements Ripples shader

Certain scenes require a more subtle water motion—for instance, simulating the ripples made by an acorn landing in a pond. The Four Elements Ripples shader is the perfect component for this type of scene. The shader has several parameters:

✦ **Completion:** Used when animating water. To animate ripples, set the value at 0 for the first frame of an animation and 100 for the last frame of the animation.

Cross-Reference

To learn more about animation, refer to Chapter 19.

✦ **Scale:** Determines the spacing of ripples. A low value creates fewer widely spaced ripples, whereas a high value creates many closely spaced ripples.

✦ **Amplitude:** Determines the height of the ripples. Higher values produce deeper ripples.

✦ **Damping:** Determines how the ripples interact with water. Use a higher value to have the ripples fade into the water's surface as they move away from the center.

✦ **Center H:** Determines the horizontal center of the ripples.

✦ **Center V:** Determines the vertical center of the ripples.

✦ **Perturbation:** Determines the distortion of the ripple. This parameter's effect depends on the size of the object the shader is being applied to. Smaller values work best on small objects.

To texture a plane primitive with the Ripples shader:

1. With the Plane selected, click the Texture icon to enter the Texture room. The Shader Tree Editor appears with Carrara's default for a Multi Channel shader selected.

2. Click the Color channel button and select the Color component.

3. Click the color swatch and select the desired color for the body of water.

4. Click the Transparency channel button and select an appropriate value for the body of water you're simulating. A good starting point is 30 percent.

5. Click the Bump channel button and select the Four Elements Shaders Water: ripples component. Set the parameters based on the type of ripple you're simulating (see Figure 12-12).

6. Click the Assemble icon to return the textured plane to the Assemble room.

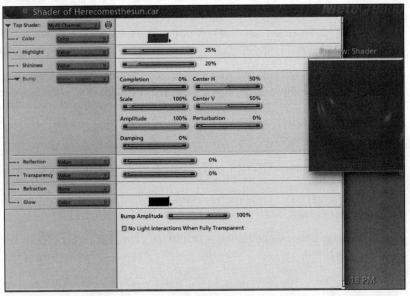

Figure 12-12: Applying the Four Elements Ripples shader to a body of water

 Tip To create an effect such as dew dripping from leaves into a small pond, create the object that will serve as the pond. Click the Texture icon to open up the Texture room. In the Color channel, click the color swatch to select a color for the pond. In the Bump channel, select Operators ⇨ Add. In the left and right channels, select Operators ⇨ Add. In each subshader's left and right channels, select Four Elements Shaders ⇨ Water: ripples. Use different settings for each ripple's H Center and V Center parameters. When completed, you'll have four different ripples in one shader.

Adding Atmosphere to Your Carrara Landscape

The final touch for a Carrara landscape is a convincing atmosphere. Adding a few layers of clouds, some haze, maybe a touch of fog, and a brilliant sun will dapple your terrain objects and bodies of water with brilliant splashes of shadows and light. But before an atmosphere can be added to the landscape, the scene lighting needs to be adjusted.

To adjust the lighting for an atmosphere:

1. Drag open the Properties tray and click the General button. Click the blue button with the downward-facing double arrow and click the default scene light, which is listed as Light 1.

2. Select Light ⇨ Sun Light (or Moon Light for a night scene). In Figure 12-13, the default light is being changed to a Sun light.

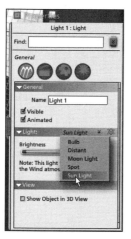

Figure 12-13: Adding a Sun light to a landscape scene

3. Drag the Sun light's Set Intensity slider right or left to control the sun's brightness. You then position the Sun light in the Four Elements: Wind window, which is explored shortly.

4. Click the blue button with the downward-facing double arrow and select Scene. Click the arrow to the left of Ambient to expand the section.

5. Change the Ambient Brightness setting to 0.

Note In most instances, landscapes are best lighted by the sun or the moon instead of ambient light. If you need additional lighting for special effects, you can always add any number of Carrara's other light sources to function as street lights, car headlights, interior lights, and so on. For more information on Carrara's lights, refer to Chapter 7.

After the scene lighting has been adjusted, it's time to add the atmosphere. Clouds, fog, haze, and other atmospheric settings are adjusted in the Four Elements: Wind editor.

To add an atmosphere to your Carrara landscape:

1. Select Atmosphere ➪ Wind.

2. Click the small triangle to the left of Atmosphere to expand the settings.

3. Click the Preset button to apply one of the many preset Four Elements: Wind atmospheres to your scene. Figure 12-14 shows the basic settings and available presets for a Four Elements Wind atmosphere.

Figure 12-14: Choose from one of the Four Elements: Wind presets to add atmosphere to a scene.

4. If you want to create a custom atmosphere, click Edit to open up the Four Elements: Wind editor.

5. After selecting an atmosphere type or creating a custom atmosphere, adjust the following settings:

- **Ground height:** Sets the ground altitude. In most cases the default setting of 0 works well.

- **Maximum Altitude:** Scales the size of the atmosphere. Using the default setting of 100, all fog, haze and cloud layer altitudes will set be between 0 and 100. As a rule of thumb set your atmosphere size to a value larger than your overall scene.

To simulate cloud layers below mountain tops or an airplane flying over cloud layers, use an Maximum Altitude setting lower than the highest object in your scene.

- **Shuffle:** Randomizes the appearance of the cloud layers.

Always set the camera to a higher altitude than the ground setting. If the camera is set below the ground setting, you'll be viewing your scene from underground.

Exploring the Four Elements: Wind editor

The Four Elements: Wind editor enables you to apply custom settings to an atmosphere. You have the tools available to simulate atmospheric effects ranging from a glorious summer day to a gaseous alien atmosphere. Use your creativity and imagination to get the most from these tools.

The Four Elements: Wind editor (see Figure 12-15) comprises six main parts:

- ✦ Preview window
- ✦ Sky editor
- ✦ Sun editor
- ✦ Moon editor
- ✦ Layers manager
- ✦ Layer editor

The Preview window gives you a real-time preview of the atmosphere, updating the changes you make almost instantaneously. The Preview window looks west, the equivalent of the Front view in the Assemble room working box. The Preview window has two display modes:

- ✦ **Standard Camera mode:** Previews the atmosphere with a conical camera looking west.

- ✦ **Fish-eye Camera mode:** Previews the whole atmosphere from ground view through a fish-eye lens.

Figure 12-15: The Four Elements: Wind editor

The Sky editor, as seen in Figure 12-16, lets you set the color of the sky and the ground. You can also use this control to add rainbows to the atmosphere.

Figure 12-16: Using the Sky editor to set sky and ground colors

To set the sky color:

1. Click the color swatch labeled Sky.

2. Drag over the Color Picker to choose the desired color and then release.

To set the ground color:

1. Click the color swatch labeled Ground.

2. Drag over the Color Picker to choose the desired color and then release.

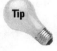

Tip Choosing the Sky editor to texture the ground results in a dull monotone base for your landscape. It's always better to choose an infinite plane for this task and texture it with a colorful shader.

To add a rainbow to the atmosphere:

1. Drag the Rainbow slider to the right to set the rainbow's intensity.

2. Drag the trackball in the Sun editor until the rainbow is visible in the Preview window.

The Sun editor lets you change the sun's position, color, halo color, and halo size. To adjust the sun's settings, follow these steps:

1. To set the sun's position, drag the trackball in the desired direction.

2. To switch between day and night, click the sun's Toggle front/back view control in the upper-left corner of the Sun editor (see Figure 12-17). This control toggles the sun between the front of the earth and the back.

Figure 12-17: Use the Sun editor to adjust the sun's parameters.

3. To set the sun's color, click the sun's color swatch. Drag over the Color Picker to choose the desired color and release.

4. To set the sun's halo size, click the Halo control and drag right to increase the size of the halo and left to decrease it.

5. To set the sun's halo color, click the sun's halo color swatch. Drag over the color picker to choose the desired color and release.

Figure 12-18 shows the orientation of the working box to the Four Elements: Wind compass.

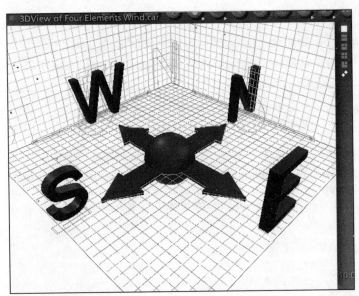

Figure 12-18: The Four Elements' compass as it relates to Carrara's working box

The Moon editor (see Figure 12-19) functions much like the Sun editor, allowing you to change the position, color, halo color, phase, and halo color size. To adjust the moon's settings, follow these steps.

Toggle Front/Back View

Set Moon Color

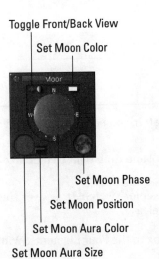

Set Moon Phase

Set Moon Position

Set Moon Aura Color

Set Moon Aura Size

Figure 12-19: Use the Moon editor to adjust the moon's parameters.

1. To set the moon's position, drag the trackball in the desired direction.

2. To switch between day and night, click the moon's Toggle front/back View control in the upper-left corner of the editor. This control toggles the moon's position between the front of the earth and the back of the earth.

3. To set the moon's color, click the moon's color swatch. Drag over the Color Picker to choose the desired color and release.

4. To set the moon's halo size, click the Halo control and drag right to increase the size of the halo and left to decrease it.

5. To set the moon's halo color, click the moon's halo color swatch. Drag over the color picker to choose the desired color and release.

6. To set the moon's phase, click the Moon Phase Selector in the lower-right corner and drag up or down to set the moon's phase. Drag right or left to rotate the moon in the desired direction.

Tip To include both the sun and moon in the same scene, use the sun's trackball control to move it to the west. Next, use the moon's trackball control to move it to the west and slightly to the right and above the sun. Use the Preview window to accurately gauge your progress. Now adjust the haze, fog, and cloud settings to suit your taste. This technique works best if you set the cloud layers fairly thin.

The Layers Manager lets you control haze, fog, and cloud layers and allows you to display or hide them (see Figure 12-20). There are individual settings for haze and fog, and you can include and edit up to four cloud layers. You have two options in the Layers Manager.

1. To display a layer, click the eye in front of the layer. A layer is hidden when the eye is covered by a red X.

2. To edit a layer, click the layer's name. A red button lights up, and the layer's settings are displayed in the Layer editor.

Figure 12-20: The Four Elements:
Wind Layer editor

The Layer editor lets you edit the settings for the various layers of the atmosphere you are creating. The results of your handiwork are promptly displayed in the Preview viewer. You can edit haze, fog, and cloud layers in the Layer editor.

The Haze Layer editor lets you vary the amount of blur that appears on the distant horizon due to atmospheric humidity (see Figure 12-21).

1. To set haze color, click the haze color swatch. Drag over the color picker to choose the desired color and release.

2. Drag the Haze intensity slider to the right to increase the amount of haze.

3. Drag the Haze altitude and Haze distance sliders to adjust their settings. The Haze altitude and Haze distance slider values are percentages of the atmosphere's maximum altitude. The default maximum altitude for the Four Elements Atmosphere is 100, which would allow for altitude and distance settings between 0 and 100.

Set Haze Color

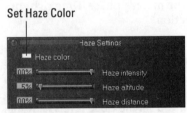

Figure 12-21: The Four Elements: Wind Haze Layer editor

The Fog Layer editor (see Figure 12-22) lets you adjust atmospheric fog color, intensity, altitude, and distance settings.

Set Fog Color

Figure 12-22: The Four Elements Wind: Fog Layer editor

1. To set fog color, click the fog color swatch. Drag over the Color Picker to choose the desired color and release.

2. Drag the Fog intensity slider to the right to increase the amount of fog.

3. The Fog start and Fog end settings adjust the starting and ending altitudes of the fog. These settings are a percentage of the maximum altitude setting. Drag the sliders to adjust their settings.

4. The Fog distance slider controls how far from the camera the fog becomes visible. Drag the slider to adjust its setting. Again, this setting is based on a percentage of the maximum altitude setting.

The Cloud Layer editor lets you adjust settings for each individual cloud layer you include in an atmosphere. You can set color, size, density, and altitude for each layer (see Figure 12-23). When working with multiple cloud layers, you can see how the layers interact with each other in the Preview window.

Set Cloud Lumpiness

 Set Cloud Layer Thickness

 Set Cloud Coverage

 Set Cloud Color

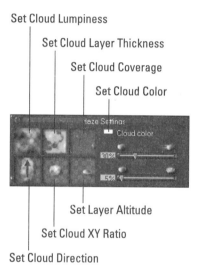

 Set Layer Altitude

 Set Cloud XY Ratio

Set Cloud Direction

Figure 12-23: The Four Elements: Wind Cloud Layer editor

1. To set cloud color, click the cloud color swatch. Drag over the Color Picker to choose the desired color and release.

2. The first of the six controls to the far left of the cloud color swatch lets you control cloud lumpiness or contrast. Drag this control to the right for a more pronounced cloud effect.

3. The next control lets you adjust cloud thickness. Drag from right to left to change from wispy, transparent clouds to thick, scudding storm clouds.

Tip Adjust cloud density setting to affect the way light interacts with clouds. Thick clouds block out the sun, whereas thin clouds intermittently deflect and diffuse light, creating subtle shadow patterns on the earth below.

4. The next control affects cloud coverage. Drag from left to right to change from blue skies to overcast conditions.

The bottom row of Cloud Layer editor controls allows you to change a cloud layer's geometry settings.

5. The cloud rotation control determines the direction clouds are moving in. This control is also used to good affect when animating a sky.

6. The next control lets you set the size of the layer's clouds. Drag to the right to increase cloud size.

7. The last control on the bottom row lets you set the altitude of each layer's clouds. By default, altitude hierarchy starts with Cloud Layer 1 at the lowest altitude, whereas Cloud Layer 4 is the highest altitude.

8. Below the cloud color swatch are two cloud animation sliders. One slider controls cloud speed. The second slider controls the transformation of cloud shapes over time.

Tip

The best way to get the most out of the Four Elements: Wind editor is to learn from the presets. Select one of the presets and then click the Edit button to open up the Four Elements: Wind editor. Study how each of the controls was set to achieve the look and mood of the preset. Study how each cloud layer was tweaked and manipulated to add to the overall effect of the atmosphere. Change individual settings to see how they affect the overall mood of the atmosphere.

The Four Elements components included with Carrara give you powerful tools to create realistic and imaginary landscapes. The more you work with these tools, the more proficient you'll get with them. Pretty soon you'll find yourself looking at the world around you and wondering how to recreate it with Carrara. And that's when the fun begins.

Summary

Carrara's Four Elements subroutine enables you to create scenes containing mountains, bodies of water, and clouds. By adjusting the various parameters for each Four Elements primitives, you can simulate anything from a mountain range to the dark side of the moon.

✦ Carrara's Four Elements enables you to create realistic landscapes.

✦ Carrara's Four Elements: Earth modeler lets you generate realistic terrain from a wide variety of presets and then modify them for a unique look.

✦ Carrara's Four Elements: Earth modeler lets you paint custom landscapes.

✦ Carrara's sun and moon lights can be used to dapple your landscapes with vibrant splashes of color.

✦ Carrara's Four Elements Water shaders enable you to simulate wave tossed oceans and rippling ponds.

✦ Carrara's Four Elements Wind editor gives you a wide variety of preset atmospheres to put the finishing touches on a landscape.

✦ Carrara's Four Elements Wind editor lets you create custom atmospheres as timid or as wild as your imagination allows.

✦ ✦ ✦

Advanced Modeling Techniques

In previous chapters, you learned how to create 3D objects by using the extensive modeling capabilities available in each of Carrara's three modelers. Each modeler is adept at creating certain types of shapes. The Spline modeler is used to create smooth objects with flawless surfaces that appear to have been machine-made or cast from a mold. The Metaball modeler is used to create smooth-flowing shapes that appear organic in nature. The Vertex modeler is used to create smooth and organic shapes. As an added bonus, the Vertex modeler lets you push and pull individual vertices and polygons as if you were sculpting an item by hand.

Completed models can be composed of shapes created by many different modelers. Objects created in one modeler can be modified in another. Carrara's menu commands can be used to create objects that would be difficult if not impossible to model. You can also use object modifiers to alter an object's shape. You'll soon discover how to mix and match modeling techniques to easily create complex 3D models.

Creating 3D Models by Importing 2D Vector Illustration Files

The Spline modeler's Pen tool lets you create 2D shapes on the drawing plane that you extrude along a sweep path. The Pen tool gives you some degree of control over the final shape. You can add, delete, or convert points after you've drawn the shape. The Spline modeler's grid can be used as a measuring and aligning device for the shape you want to

create. Nothing beats a good vector drawing program for creating a truly complex 2D shape, however.

One example of a shape that would be hard to create with the Spline modeler's Pen tool is a cross section of a multitoothed gear. The Pen tool could be used to create an individual gear tooth, but precisely duplicating the tooth and accurately spinning it around a central axis would be difficult at best. The drawing tools available in a good vector drawing program can create complex shapes like this with relative ease. Carrara can import Illustrator files with the following formats: .ai, .ai3, and .eps.

To import a 2D vector drawing into the Spline modeler:

1. Select File menu ⇨ Import. The Open an Illustrator file dialog box opens.

2. Locate the desired file and click Open to import it.

Note

If the file imports as connected points (a series of points will define the shape instead of a bounding box), select Edit ⇨ Group (Ctrl+G) to group them. You will not be able to scale, move, or rotate the shape if it is left as points.

3. The Illustrator file is placed on the drawing plane and extruded along a straight path (see Figure 13-1).

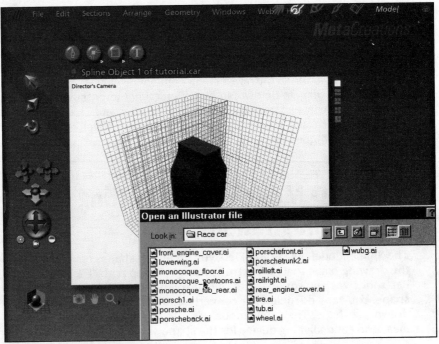

Figure 13-1: Importing an Illustrator file into the Spline modeler

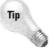

Tip If the Illustrator file you import is larger than the modeling box, use the Scale command to shrink it down to size. If you're importing different Illustrator files on multiple cross sections, be sure to scale each shape by the same amount to maintain proportions.

Once you've imported the 2D shape into the modeler, you can choose an extrusion method, apply an extrusion envelope, and use any of the Spline modeler's tools or commands to create the finished model.

You can also apply a series of 2D vector drawings as frames across multiple cross sections. Modeling a speedboat's hull is a good example of this. The first cross section, or the stern of the boat, would have a curved top with gently sloping sides that converged to form a convex bottom. The shape for the next cross section would increase the angle of the sides as they slope towards the knife-edged bottom. The next cross section would deepen the angle of the sides even further and sweep the sides outward to form the boat's gunwales, and the last section would curve to a point to form the front of the boat.

To import multiple 2D vector drawings:

1. Select File ⇨ Import. The Open an Illustrator file dialog box opens.
2. Locate the desired file and click Open to import it.
3. The Illustrator file is placed on the drawing plane and extruded along a straight sweep path.
4. Select Sections ⇨ Create to add a cross section at the end of the sweep path.
5. Select the cross section you just created by clicking its reference point on the sweep path.

 Alternatively, select Sections ⇨ Go to. Type the number of the cross section you want to go to in the dialog box — in this case, 2.

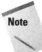

Note You can also press the Alt key, and a spinner will appear to the right of the Cross Section No field. Click the up arrow to go to the next cross section.

6. Select the shape on the last cross section. A bounding box will surround the shape. Press Delete to remove the last cross section's shape.
7. Repeat steps 1 and 2 to import the file for the last cross section. Carrara now smoothly extrudes the object from one 2D shape to the next.
8. If you need to create additional cross sections for your model, return to the first cross section by using either method in step 5.
9. Create additional cross sections as needed by choosing Section ⇨ Create Multiple. The Create Multiple Cross-Sections dialog box opens.
10. Enter the desired number of cross sections and click OK to apply.

11. Repeat steps 5 through 7 as needed to import 2D vector drawings as cross sections. Figure 13-2 shows the speedboat's hull.

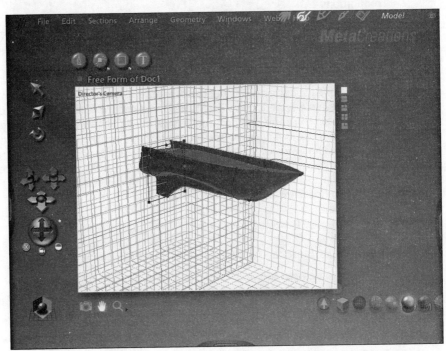

Figure 13-2: Modeling a boat hull by importing multiple 2D vector drawings

Tip
When working with multiple cross sections, it can be difficult to see individual shapes on the drawing plane. To view only one cross section at a time, select Sections ➪ Show ➪ Current.

You can also use 2D vector drawings in conjunction with Spline modeler presets to create complex shapes, such as a tire and a wheel.

On the CD-ROM
To follow along with the next example, open Chapter 13's folder in the Content section of this book's CD-ROM. In step 4, import the file tire.ai and in step 7, specify a value of 6.00 in the Distance to Axis field. In step 9, import the file wheel.ai, and in step 12, specify a value of 3.25 for the Distance to Axis field.

To create a tire and wheel with the Spline modeler's Torus preset:

1. Create the shape for the tire and wheel in a 2D vector drawing program, as shown in Figure 13-3.

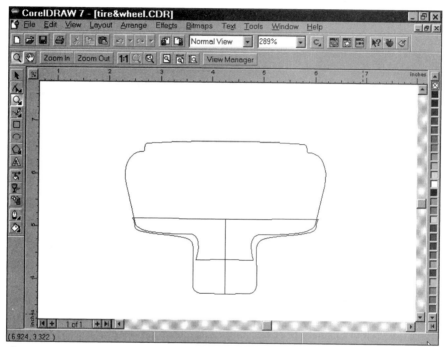

Figure 13-3: Create the cross section for the tire and wheel in a 2D vector drawing program.

2. Export each shape separately in either .ai, .ai3, or .eps format.

3. Launch Carrara and open the Spline modeler.

4. Select File ⇨ Import and import the file you created for the tire.

5. If the file imported as connected points, select Edit ⇨ Group (Ctrl+G) to group them.

6. Select Geometry ⇨ Extrusion preset ⇨ Torus. The Torus dialog box appears.

7. Enter a setting for Distance to Axis and click OK to create the tire. Your tire should resemble the one shown in Figure 13-4.

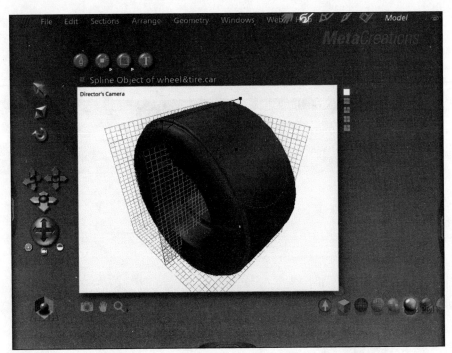

Figure 13-4: Extruding a 2D shape across the Torus preset to create a tire

8. Click the Assemble icon to return the modeled tire to the Assemble room.

9. Select File ➪ Import and import the file you created for the wheel.

10. If the file imported as connected points, select Edit ➪ Group (Ctrl+G) to group them.

11. Select Geometry ➪ Extrusion preset ➪ Torus. The Torus dialog box appears.

12. Enter a setting for Distance to Axis and click okay to create the wheel (see Figure 13-5).

13. Click the Assemble icon to return the modeled wheel to the Assemble room.

14. Align the two objects as needed.

15. To finish the model, add spokes and a center hub, as shown in Figure 13-6.

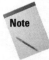

Note

When you are nesting one object inside another, such as in the tire and wheel example, the actual Distance to Axis value for each object will vary depending upon the cross-section profile of the object you are importing. You can use the Spline modeler's grid points to get a good idea of the size of the profile. Start with a high setting for the first object's Distance to Axis value and decrease the second object's Distance to Axis value until the two objects mate perfectly. Remember, you can always double-click the object in the Assemble room's working box to return it to the Spline modeler for further modification.

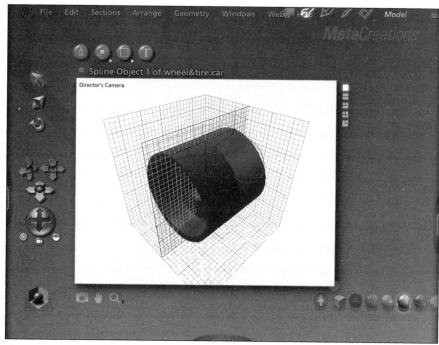

Figure 13-5: Extruding a 2D shape across the Torus preset to create a wheel

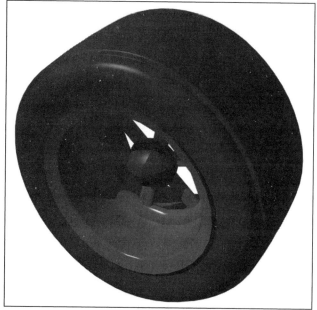

Figure 13-6: The completed tire and wheel with spokes and hub

Importing 2D Vector Drawings as Paths

2D vector drawings can also be used as paths. If you model an object that will be extruded across a complex sweep path, an imported 2D vector drawing will create a precise path.

To create a sweep path with a 2D vector drawing:

1. Create a 2D shape on the drawing plane.

2. Click the plane you want the sweep path to follow.

3. Select File ⇨ Import. The Open an Illustrator file dialog box opens.

4. Locate the file to import as a sweep path.

5. Click Open to import the file. The Import Artwork in Path dialog box opens (see Figure 13-7). If it's not already selected, choose Sweep Path for the Import As option. Click OK.

6. The sweep path is now drawn on the desired plane.

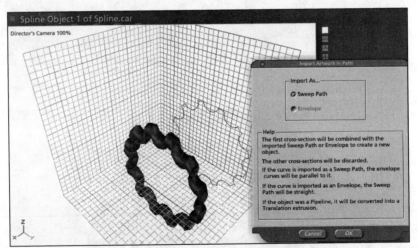

Figure 13-7: Importing a 2d vector drawing as a sweep path

2D vector drawings can also be imported as extrusion envelopes. If you're modeling an object that has a complex extrusion envelope, creating a 2D vector drawing to define the envelope is an excellent solution.

To create an extrusion envelope with a 2D vector drawing:

1. Create a 2D shape on the drawing plane.

2. Select Geometry ⇨ Extrusion Envelope, and choose either Symmetrical or Symmetrical in Plane.

3. Click the right or bottom plane to make it active.

4. Select File ⇨ Import. The Open an Illustrator file dialog box opens.

5. Locate the file to import as an envelope.

6. Click Open to import the file. The Import Artwork in Path dialog box opens. If it's not already selected, choose Envelope for the Import As option.

7. Click OK. The envelope is now drawn on the desired plane (see Figure 13-8).

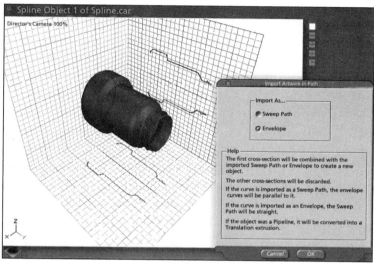

Figure 13-8: Importing a 2D vector drawing as an extrusion envelope

When Carrara imports a 2D vector drawing as a sweep path or envelope, it cannot be moved or rotated. When you draw a sweep path or envelope in a vector illustration program, draw from left to right so that the path will align correctly when you import it into Carrara.

When creating a drawing to import as an extrusion envelope, you only need to draw half of the envelope. Carrara will mirror the drawing to create the other half of the envelope when you import the drawing.

Creating complex pipeline extrusions

When you think of pipeline extrusions, you probably think of modeling objects such as frames for lawn chairs, exhaust pipes, and plumbing pipes. Pipeline extrusions can also be used to model delicate items such as leaves, flower petals, or blades of grass.

To model a pipeline flower petal:

1. Open the Spline modeler and switch to the Front view.

2. Select Geometry ⇨ Extrusion Method ⇨ Pipeline.

3. Select Geometry ⇨ Extrusion Envelope ⇨ Symmetrical in Plane.

4. Using the Pen tool, draw the flower's cross section on the drawing plane (see Figure 13-9).

Note You could also import a 2D vector drawing to create the flower's basic cross section.

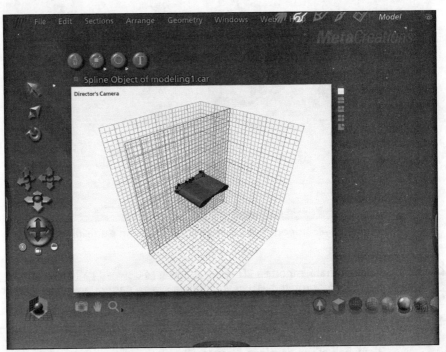

Figure 13-9: The flower's basic shape is created with the Pen tool.

5. Select Sections ⇨ Center (Ctrl+Shift+C).

6. Use the Convert Point tool to smooth the shape.

7. Select Sections ⇨ Create to create a cross section at the end of the sweep path.

8. Select Sections ⇨ Create Multiple. The Create Multiple Cross-Sections dialog box opens. Enter 3 to create three new cross sections.

9. Click to select the point at the end of the sweep and Shift+drag to lengthen the shape.

10. Click the right plane to convert it to the drawing plane.

11. Using the Move/Selection tool, drag the points along the sweep path (the pink line) to simulate the curve of a flower (see Figure 13-10).

12. Use the Convert Point tool to smooth the curve.

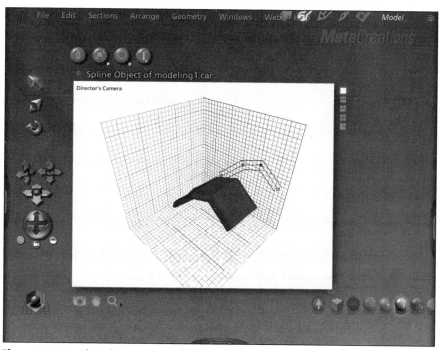

Figure 13-10: Alter the sweep path to bend the flower.

13. Click one of the blue lines to select the plane's extrusion envelope.

14. Use the Move/Selection tool to taper the beginning and end points along the extrusion envelope. Because you are working with a symmetrical-in-plane extrusion envelope, moving one point automatically adjusts the sibling point along the plane's envelope.

15. Use the Convert Point tool to smooth the envelope.

16. Click the bottom plane to make it active.

17. Click one of the blue lines to select the plane's extrusion envelope.

18. To define the flower's shape, use the Move/Selection tool to alter points along the plane's envelope (see Figure 13-11).

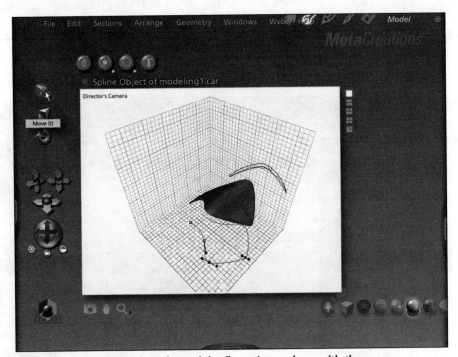

Figure 13-11: Defining the edges of the flower's envelope with the Move/Selection tool

19. To finish modeling the flower petal, use the Convert Point tool to smooth the extrusion envelope and any awkward transitions.

Advanced Modeling with Shapes

If you've been following examples in the book up to this point, your previous forays into using the Spline modeler have involved one or two shapes on the drawing plane at most. Lurking in the Spline modeler command menus are options that enable you to create intricate models by combining multiple shapes on cross sections.

Combining shapes as compounds

Whenever you create a shape within a shape and combine them as a compound, the smaller shape cuts a hole in the larger shape. The Combine as Compound command is handy for creating window and door openings in walls.

To combine shapes as a compound:

1. Create a 2D shape on the drawing plane.

2. Select Sections ⇨ Center.

3. Create and align the smaller shapes that will be cut out of the larger shape.

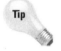

Tip For precise alignment of the smaller shapes, enable the Snap to Grid (Ctrl+J) option.

4. Shift+click each shape to select them or select Edit ⇨ Select All (Ctrl+A).

5. Select Arrange ⇨ Combine as Compound (see Figure 13-12).

Figure 13-12: Using the Combine as Compound command to cut holes in a shape

Note If the smaller shapes didn't cut cleanly out of the larger shape, select Arrange ➪ Break Apart Compound. Deselect all shapes. Use the Add Point tool to add additional points to the shapes. Select all shapes and invoke the Combine as Compound command again.

Tip To create concentric circles on the drawing plane, use the Draw Oval tool while holding down the Shift key to create a large circle. Select Sections ➪ Center. Select Edit ➪ Copy. Deselect the circle and select Edit ➪ Paste. You now have a duplicate circle on top of the original circle. Select Arrange ➪ Scale. Enter a percentage to scale the circle vertically and horizontally. You now have a smaller circle concentric to the larger circle.

An object created using the Combine as Compound command will have holes in it. However, at times you'll want to fill the holes. For example, if you want to create a wall with windows, with this command you'd still have to fill in the resulting holes. You could create another object and then use the Move/Selection, Rotate, and Scale tools to size and position the object. Fortunately, there's an easier way.

To create windows in a wall:

1. Select the Spline Object tool and drag it into the working box or Sequencer tray's Universe list.

 Alternatively, select Insert ➪ Spline Object.

2. The Spline modeler opens. Use the Draw Rectangle tool to create the rectangular shape that will be the wall.

3. Use any of the drawing tools to create the shapes that will be the windows. Most windows are rectangular, but if you were creating a window for a church, you'd use the Pen tool to create an arched window. The Draw Oval tool would be used to create a circular window.

4. Position the shapes that will become windows inside of the wall shape.

5. Select all shapes by selecting Edit ➪ Select All.

6. Select Arrange ➪ Combine as Compound. The window shapes now cut holes in the wall shape.

7. Click the last dot on the sweep path and drag it towards the first shape to create a narrow wall. After you begin dragging, press the Shift key to constrain motion to the grid. Your finished wall should resemble Figure 13-13.

8. Click the Assemble icon to return the wall to the Assemble room.

9. With the wall still selected, select Edit ➪ Duplicate. An exact duplicate of the wall is created.

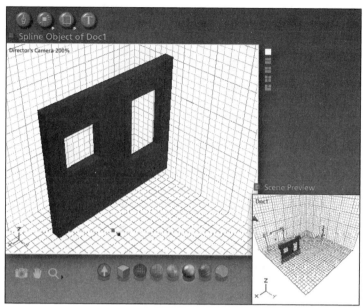

Figure 13-13: Creating windows in a wall using the Combine as Compound command

10. Double-click the duplicate to return to the Spline modeler. The Editing Object dialog box appears. Accept the default setting of Create New Master and click OK. By creating a new master, you can create a new shape, in this case windows for the wall. If you had selected Edit the Master, the changes you are about to make would have been applied to the original object.

11. Select Arrange ⇨ Break Apart Compound.

12. Using the Move/Selection tool, click inside the modeling box to deselect all items.

13. Select the outer shape (the wall) and select Edit ⇨ Delete or press the Delete key. The outer wall disappears, and you are left with the window shapes.

14. Click the last point on the sweep path and drag the point backwards to make the windows narrower than the walls. After you begin dragging, press the Shift key to constrain motion to the grid. Your finished windows should resemble Figure 13-14.

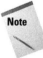

Note

Depending on your grid spacing setup, you may need to zoom in on the sweep path and use a grid line as reference to constrain motion to the grid. If you create an object narrower than the grid spacing, holding down the Shift key will no longer constrain motion to the grid.

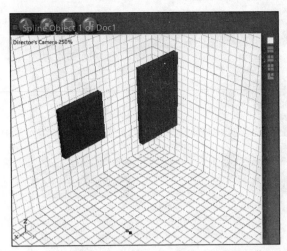

Figure 13-14: Creating the windows for the wall

15. Click the Assemble icon to return the windows to the Assemble room.

16. The windows are perfectly aligned inside the wall, as shown in Figure 13-15.

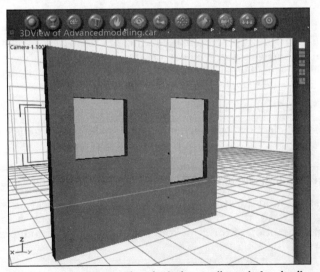

Figure 13-15: The completed window wall, ready for shading

Modeling with multiple cross section shapes

Populating cross sections with more than one shape takes your modeling to a new level. Creating cross sections with multiple shapes makes it possible to model complex items such as distributor caps, trees, or octopi.

When you create a cross section with more than one shape, the Spline modeler extrudes from shape to shape. The Spline modeler assigns a number to each shape you create in a cross section. When the Spline modeler extrudes from one cross section to the next, it creates a skin from shape number to shape number. For example, if the first cross section of your model has one shape, the second cross section of your model has three shapes, and the third cross section of your model has two shapes, shape 1 in the first cross section extrudes to shape 1 in the second cross section, and shapes 2 and 3 in the second cross section extrude to the two shapes, numbered 2 and 3, in the third cross section. Normally the two shapes created on the third cross section would be numbered 1 and 2; however, as you'll learn shortly, there is a way to assign new numbers to shape objects so they'll extrude the way you want them to.

To create a model using multiple cross section shapes:

1. Create a shape on the drawing plane.

2. Select Sections ⇨ Create.

3. Select Sections ⇨ Create multiple and add at least one more cross section.

4. Select Sections ⇨ Go To and enter 2 to select the second cross section.

5. Create and align desired shapes to the second cross section.

6. Click+Shift to select the new shapes and select Edit ⇨ Copy to copy the shapes to the clipboard.

7. Select Sections ⇨ Go To and select the third cross section.

8. Click the shape to select it and press Delete to remove it from the cross section.

9. Select Edit ⇨ Paste to add the shapes from the clipboard to the cross section. The Spline modeler extrudes from shape number to shape number across the three cross sections. Chances are the shapes didn't extrude properly because the shape numbers were reassigned when you pasted them onto the last cross section. Use the Set Shapes Number command to renumber the shapes.

10. Select Sections ⇨ Previous.

11. Select one of the shapes you pasted to the last section and select Sections ⇨ Set Shape Number. The Shape Number dialog box appears. Don't change the number, just record the shape's number. Repeat for the next shape on the cross section and record its number.

Note You can also drag open the Properties tray to see a shape's number. The Properties tray can also be used to assign a new number for the shape by entering a new value in the Shape Number field.

12. Select Section ⇨ Next.

13. Select one of the shapes and select Sections ⇨ Set Shape Number. The Shape Number dialog box appears. Change the shape number to correspond with the same shape on the last section. Repeat for the next shape on this cross section. The object will now extrude correctly (see Figure 13-16).

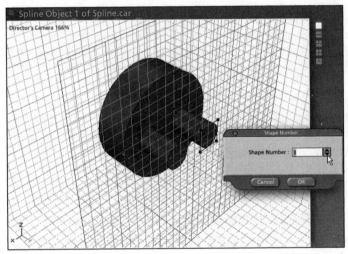

Figure 13-16: Using the Set Shape Number command to renumber shapes

Advanced Modeling with Cross Sections

When you create multiple cross sections, you have a number of options for defining an object's shape. For example, you could use extrusion envelopes to define an object's shape. Or, you could use the Rotate and Scale menu commands to define a cross section's shape. You could also mix and match shapes and commands on each cross section to create a unique object. Add a cross section or two with multiple shapes, and you're well on your way to creating a unique model.

Creating a shape within a shape

For centuries, optimists and pessimists have been debating whether the glass is half empty or half full. Meanwhile, latter-day 3D artists are still coming to grips with

filling the glass. With the help of multiple cross sections and some judicious point editing, you can easily create a shape within a shape using the Spline modeler. The steps that follow show how to fill a wine glass. This same method could be used to fill any vessel's interior.

To fill a wine glass:

1. Open the Spline modeler by selecting Insert ⇨ Spline Object, or drag the Spline Object tool into the working box.

2. Select Geometry ⇨ Extrusion Envelope ⇨ Symmetrical.

3. Create a round shape on the Spline modeler's drawing plane.

4. Select the last point on the sweep path and Shift+drag the point until it covers the first point on the sweep path.

5. Click the right plane to convert it to the drawing plane.

6. Use the Pen tool to draw the wine glass's envelope. When you get to the wine glass's rim, mirror the wine glass's outer points to create its interior.

Tip
Enable the Snap to Grid (Ctrl+J) option to ensure precise placement of the wine glass's points.

7. Use the Convert Point tool to smooth the points as desired (see Figure 13-17).

Figure 13-17: Defining the envelope for a wine glass

8. Click the last point on the sweep path and select Sections ⇨ Create.

9. Now determine how high you want to fill the glass. Select the Add Point tool and click to add a point to the sweep path that defines where the contents of the wine glass stop.

10. With the point still selected, select Sections ⇨ Create to add another cross section.

Tip Alt+clicking while using the Add Point tool creates a new cross section where you add the point.

11. Click the Assemble icon to return the wine glass to the Assemble room.

12. Duplicate (Ctrl+D) the wine glass.

13. Double-click the duplicated wine glass to return it to the Spline modeler. The Editing Object Spline Object warning dialog box appears. Select the Create new master option.

14. Select the Delete Point tool and begin deleting points from the wine glass's perimeter.

15. Continue deleting points until you reach the cross section that defines the top of the wine glass's contents.

16. Select Sections ⇨ Cross Section Options. The Cross Section Options dialog box appears.

17. Click to select the Fill Cross Section option. Figure 13-18 shows the finished shape that will be used to fill the wine glass.

Figure 13-18: This shape will fill the wine glass.

18. Click the Assemble icon to return the shape to the Assemble room. The shape within a shape is perfectly aligned and ready for shading. Figure 13-19 shows the rendered model.

Figure 13-19: Is the glass half empty or half full?

19. If after the initial rendering you find the inner shape fits a little too snuggly and leaves visual artifacts on the shape it's nestled within, drag open the Properties tray and click the Motion/Transform button. In the Transform panel, enable the Keep Proportions option. In the Scaling field, reduce the overall scale of the inner shape by about .10 percent. This will give the inner shape (in this case, wine) a little room to breathe. Perform a spot rendering with the Area Render tool to test the fit. Remember, you can always Undo (Ctrl+Z) the operation if you reduce the scale by too much.

Creative Modeling with Text

Text is everywhere. You see it on TV, in the newspaper, in this book. And you see text in 3D scenes. Carrara comes with a perfectly good Text modeler in the Assemble room. However, like the other shapes in the Assemble room, it's

primitive. Instead of following a straight path like the text created in the Assemble room, text modeled in the Spline modeler can take on a personality of its own. You can apply all of the Spline modeler's tools and commands to create a distinct block of text for use with an animation, a 3D scene, or a client's logo. Imagination is the only limiting factor.

The best way to explore modeling text in the Spline modeler is to just do it. Open the modeler, create a string of text, and then start experimenting with the various tools and commands. Create multiple cross sections and scale or rotate the text from one cross section to the next (as shown in Figure 13-20). Apply an extrusion envelope and tweak the envelope to create some unique text shapes. Apply a pipeline extrusion and alter the path to create text that undulates. Apply one of the extrusion presets to a string of text for really wild results. Have fun with this. Let your inner child play with text the way you played with alphabet blocks when you were a kid.

Figure 13-20: Free form text modeled in the Spline modeler

Modeling with Boolean Operations

As you learned in Chapter 10, Boolean operations create a new shape from two overlapping shapes. Luckily for you, Boolean operations are not the exclusive domain of the Vertex modeler. You have a full set of Boolean operations at your disposal in the Assemble room. The Boolean operations available in the Assemble room will create a new shape from any two overlapping shapes from any modeler or other source.

Need to cut text from a block? Create a block and some text, align the text so that it intrudes into the block, and perform a Boolean Subtraction. Need to punch a hole through a cylinder? Just create two cylinders, align them so one passes completely through the other, and perform a Boolean Subtraction. Need to join a Metaball object to a spline object? Use the Boolean Union command.

You have three Boolean operations at your command: Boolean Intersection, Boolean Union, and Boolean Subtraction.

Creating objects with the Boolean Intersection command

When you perform a Boolean Intersection on two objects, a new object is created with a surface that encompasses the volume where the two objects overlap.

To create a new object with the Boolean Intersection command:

1. Overlap Object A and Object B in the Assemble room working box.

2. Make sure both objects are selected and select Edit ➪ 3D Boolean. The 3D Boolean dialog box opens (see Figure 13-21).

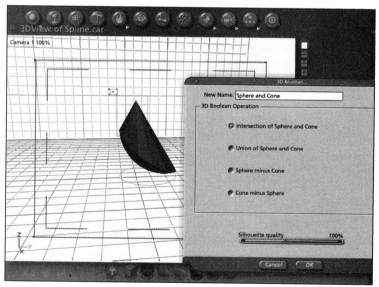

Figure 13-21: Creating a new object with the Boolean Intersection command

3. Choose Intersect Object A and Object B (Sphere and Cone in the example shown in Figure 13-21).

4. Click OK to apply.

Note

When you've got a model with multiple groups, the two objects to which the Boolean command is being applied must be in the same group.

Creating new objects with the Boolean Union command

When you perform a Boolean Union command, a new object is created with a surface that encompasses all visible surfaces of both objects.

To create a new object with the Boolean Union command:

1. Overlap Object A and Object B in the Assemble room working box.

2. Make sure both objects are selected and select Edit ⇨ 3D Boolean. The 3D Boolean dialog box opens.

3. Choose Union of Object A and Object B (Sphere and Cone in the example shown in Figure 13-22).

4. Click OK to apply.

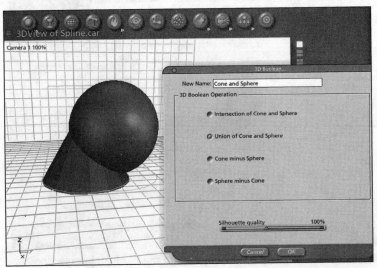

Figure 13-22: Creating a new object with the Boolean Union command

Creating objects with the Boolean Subtraction command

When you perform a Boolean Subtraction operation, a new object is created where one object cuts out of the surface of the other object and leaves an indentation or hole.

To create a new object with the Boolean Subtraction command:

1. Overlap Object A and Object B in the Assemble room working box.

2. Make sure both objects are selected and select Edit ➪ 3D Boolean. The 3D Boolean dialog box opens.

3. Choose either Object A minus Object B or Object B minus Object A (Cone minus Sphere in the example shown in Figure 13-23).

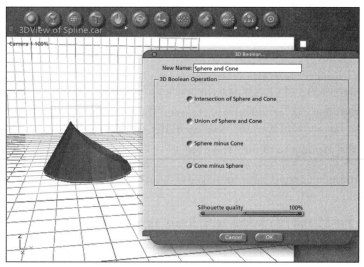

Figure 13-23: Creating a new object with the Boolean Subtract command

4. Click OK to apply.

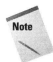

Note

If you inadvertently choose the wrong Boolean Subtraction operation, select Edit menu ➪ Undo 3D Boolean (Ctrl+Z) and redo the command with the other Boolean Subtraction operator.

The possibilities with Boolean operations are literally endless. You can create a new object with one Boolean operation, overlap the new object with another object, and

then create another shape with a yet another Boolean operation. Using multiple Boolean operations on an object is similar to using different dies in a machine shop to create a new object and then welding that object to another shape to create yet another object. Once you've experimented with Boolean operations, you'll find yourself using them to come up with new and innovative ways to create objects in Carrara.

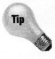

Tip Carrara assigns new names to Boolean objects that are not very descriptive. To name a Boolean object, enter a name in the New Name field of the Boolean operation's dialog box. To assign a name after the object is created, select it, drag open the Properties tray, and type in a new name for the object.

Modeling with Formulas

Formulas are not only for math wizards. They're also used in a powerful Carrara modeler. It helps to be fluent in math formulas, but you can still create interesting shapes if you're not.

To create a formula object:

1. Click to select the Formula tool (the sixth button on the toolbar atop the working box) and drag it into the working box.

2. Double-click the formula object to open the Formula modeler in the Model room. The current formula is listed in the Formula Editor.

3. Edit the formula to modify the object.

Note The Formula Editor is case sensitive, and each statement must end with a semi-colon.

4. Drag the P1 and P2 (parameter) sliders as desired.

5. Click the More button to open up a window with two additional sliders (P3 and P4).

Tip The P1 through P4 sliders can also be used to animate the formula model by applying different settings to the sliders at different key frames.

Cross-Reference For more information on animation, refer to Chapter 19.

6. Click the Parse button to apply the edited formula. The Scene Preview window will update, and you'll be able to view the effects your changes have on the formula model (see Figure 13-24).

7. Click the Assemble icon to return the formula object to the Assemble room.

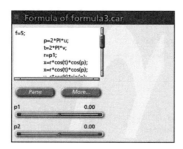

Figure 13-24: Creating a formula object

The best way to learn more about formula modeling is to use the base formula for a starting point and experiment by changing the formula's values and mathematical operators. Tables 13-1 and 13-2 show the components used to create formulas.

<table>
<tr><td colspan="2" align="center">Table 13-1
Formula Operators</td></tr>
<tr><td>*Formula Operator*</td><td>*Description*</td></tr>
<tr><td>sin(x)</td><td>Sine of x</td></tr>
<tr><td>cos(x)</td><td>Cosine of x</td></tr>
<tr><td>tan(x)</td><td>Tangent of x</td></tr>
<tr><td>atan2(y,x)</td><td>Arctangent of y/x</td></tr>
<tr><td>asin(x)</td><td>Arcsine of x</td></tr>
<tr><td>Arcos(x)</td><td>Arccosine of x</td></tr>
<tr><td>atan(x)</td><td>Arctangent of x</td></tr>
<tr><td>sinh(x)</td><td>Hyperbolic sine of x</td></tr>
<tr><td>cosh(x)</td><td>Hyperbolic cosine of x</td></tr>
<tr><td>tanh(x)</td><td>Hyperbolic tangent of x</td></tr>
<tr><td>sqrt(x)</td><td>Square root of x</td></tr>
<tr><td>pow(x,y)</td><td>x raised to the power of y</td></tr>
<tr><td>exp(x)</td><td>Exponential</td></tr>
<tr><td>log(x)</td><td>Logarithm</td></tr>
<tr><td>log10(x)</td><td>Base-10 logarithm</td></tr>
<tr><td>floor(x)</td><td>Largest integer less than or equal to x</td></tr>
<tr><td>ceil(x)</td><td>Largest integer greater than or equal to x</td></tr>
<tr><td>abs(x)</td><td>Absolute value of x</td></tr>
<tr><td>mod(x,y)</td><td>x modulus y</td></tr>
</table>

Table 13-2
Comparison Operators

Comparison Operator	Description
<	Less than
>	Greater than
<=	Less than or equal to
>=	Greater than or equal to
==	Equal to
!=	Not equal to
&&	Logical "and"
\|\|	Logical "or"

If you didn't major in math, the preceding tables may seem a little overwhelming. If you're not comfortable creating your own formulas, you can find parametric equations in textbooks or on the Internet. These equations must then be converted into a language Carrara can understand.

Carrara formulas use intervals from 0 to 1. Most formulas you find in textbooks or on the Internet refer to specific intervals such as 0 to 2PI. In addition to having to deal with different parameters, you'll also have to add mathematical operators to make the formula work in Carrara. Many formulas you encounter will refer to theta and phi values for variables. These refer to angular distances using the spherical coordinate system. In Carrara, you convert these to u and v.

Take a look at the following formula as an example:

$$\sin(t), \sin(2t) + \sin(u), \sin(2t) + \cos(u), \{t, -pi/2, pi/2\}, \{u, 0, 2pi\}$$

The formula is plotting the x, y, and z values of the object and the last two expressions refer to the formula's variables. In other words, $x = \sin(t)$, $y = \sin(2t) + \sin(u)$, and $z = \sin(2t) + \cos(u)$. In addition, the formula's t variable ranges from a low limit of (–2/pi) to a high limit of (2/pi), and its u variable ranges from a low limit of (0) to a high limit of (2pi).

To begin the conversion process:

1. Carrara will not recognize pi, so you'll need to change all occurrences of pi to PI.

2. Add the multiplication sign to the formula for y, changing it to $y = \sin(2 * t)$.

3. Add the multiplication sign to the u variable's upper limit formula, changing it to (2 * PI).

4. The t and u variables must be changed to u and v.

The revised formula reads as follows:

$$\sin(t), \sin(2 * t) + \sin(u), \sin(2t) + \cos(u), \{u, -PI/2, PI/2\}, \{v, 0, 2 * PI\}$$

The original formula specifies a t variable ranging from $(-PI/2)$ to $(PI/2)$ and a u variable ranging from (0) to $(2 * PI)$. Carrara recognizes a range from 0 to 1 for a variable's limits. Set up conversion variables a and b to convert these ranges into a value Carrara can use:

✦ Conversion variable a = lower limit(t) + ((upper limit(t) – lower limit(t) * u)

✦ Conversion variable b = lower limit(u) = ((upper limit(u) – lower limit(u) * v)

These are then converted to the following:

✦ $a = (-PI/2) + ((PI/2 - (-PI/2)) * u)$

✦ $b = (0) + ((2 * PI - 0) * v)$ or $2 * PI * v$

Formulas converted into formula objects are rather small by nature. You could resize the object by using the Properties tray, or you could include a factor in the formula to increase the object's size before leaving the Formula modeler. Including a factor to size your formula object gives you the added advantage of being able to view changes as you make them in the Scene Preview window. If you include a factor in your converted formula, add three expressions at the end of the formula to multiply each axis value by the factor. For example: x = factor * x.

So then the original formula:

$$\sin(t), \sin(2t) + \sin(u), \sin(2t) + \cos(u), \{t, -pi/2, pi/2\}, \{u, 0, 2pi\}$$

becomes:

factor = 5;

$a = (-PI/2) + ((PI/2 - (-PI/2)) * u)$;

$b = 2 * PI * v$;

$x = \sin(a)$;

$y = \sin(2 * a) + \sin(b)$;

$z = \sin(2 * a) + \cos(b)$;

x = factor * x;

y = factor * y;

z = factor * z;

Figure 13-25 shows the object created by using the preceding formula in the Formula modeler.

Figure 13-25: This shape resulted from the converted formula.

Modeling with Modifiers

Modifiers are yet another Carrara tool for creating shapes that would be otherwise impossible to model. Used in conjunction with shapes created in the Spline, Vertex, and Metaball modelers, modifiers give you additional modeling clout.

Cross-Reference Refer back to Chapter 8 if you need more information about object modifiers.

For example, you could create a skullcap by performing a Boolean Subtraction operation on two spheres. Use the Spike modifier to grow hair on the skullcap. To create the spiked ball at the end of medieval mace, apply the Spike modifier to a sphere. Use the Punch modifier to indent an object. Use one of the Wave modifiers to create an object that simulates corrugated siding.

The possibilities are endless. Create objects, combine them, perform Boolean operations on them, and then subject them to modifiers. Create objects in Carrara's modelers, and then create new shapes by applying modifiers to them. Figure 13-26 shows objects created with modifiers.

Figure 13-26: Creating new shapes with modifiers

Modifying an Object in Another Modeler

The type of object you are modeling dictates the modeler you use. However, during the course of a modeling project, you may need to do some subtle tweaking that can't be achieved in the object's native modeler. Carrara makes this tweaking possible by giving you the freedom to convert objects to another modeler. Objects created in the Metaball and Spline modelers can be converted to vertex objects; however, vertex objects can only be edited in the Vertex modeler.

For example, a car modeled in the Spline modeler turns out perfect — just as smooth and shiny as a car on the showroom floor. Imagine that after creating the model you decide to create an animation in which the car runs into a stationary object and the fender is crumpled. This would be difficult to accomplish in the Spline modeler, but the Vertex modeler's Sphere of Attraction tool allows you to push and pull individual polygons to crumple the fender.

To convert an object to another modeler:

1. In the Assemble room, double-click the object to return it to its native modeler.

2. Select Edit ➪ Convert to Another Modeler. The Convert to Another Modeler dialog box opens. A heart icon designates the object's native modeler.

3. Click to select another modeler.

4. Drag the Fidelity when converting into Facets slider to control the object's fidelity after conversion. A setting less than 100 percent creates an object with fewer polygons, whereas a setting of more than 100 percent adds additional polygons to the object. At a setting of 100 percent, Carrara converts the model with enough polygons to create a reasonable facsimile of the object as it appeared in its native modeler.

Caution When a model is converted, the surface is converted to meet the modeler's needs, which may result in the model becoming unusable. You can always undo the conversion by selecting Edit ⇨ Undo Convert (Ctrl+Z). However, it's always a good idea to save the model in its present format before converting it. That way, if you begin editing the converted model and aren't pleased with the results, you still have the preconversion model to fall back on.

5. Click OK to complete the conversion. The converted model opens up in its new modeler (see Figure 13-27).

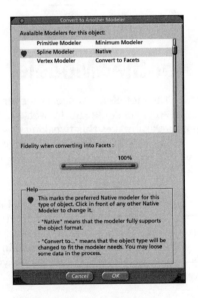

Figure 13-27: Converting an object to another modeler

The model in Figure 13-28 shows just one of the possible uses for converting an object to another modeler.

Tip You can also convert Carrara primitives to another modeler. Converting a sphere primitive to a vertex object creates an object with slightly different polygon mapping than a native Vertex modeler sphere. Because of this, a converted primitive sphere responds differently to the Vertex modeler's tools. Formula objects can also be converted to vertex objects.

Figure 13-28: A spline model's fender after being converted to a vertex object and crumpled with the Sphere of Attraction tool

Modifying Preset Models

Carrara comes with a large variety of preset models. These models represent many hundreds of hours of work by skilled modelers. As good as the models are, they may not be perfect for the scene in which you plan to use them. By this point, you know that anything created or imported into Carrara can be customized to suit your needs.

If the model you want to modify is a Carrara file (.car), open the file and examine the model in the Assemble room. If you only need to change the model's size or proportions, drag open the Properties tray and make the necessary adjustments. If you want to alter the object's shape, you'll have to open it up in the modeler you used to create it, or convert it to another modeler. If the model you want to alter is made up of many objects, you'll have to edit each individual part. To do this, first ungroup the model, and then select individual objects by double-clicking them in the working box or by double-clicking the object's name in the Sequencer tray's Universe list. The Model room opens and you have the object's native modeler and its tools ready to reshape the object. If the model has many objects, it may be easier to double-click its name from the Master Objects list in the Sequencer tray. Editing individual pieces of a complex model may seem like a daunting task, but it's usually easier than starting from scratch.

Another method of editing a complex model is to double-click the group containing the items you need to edit. This opens up another working box for only the items in the group. The new working box is complete with all the Assemble room tools, menu commands, and trays. However, when you edit a group in another window, the only objects listed in the Sequencer tray are the objects in the group being edited. To edit an individual item in the group, double-click it to edit it in its native modeler. When you're done editing, click the Assemble icon to return the edited item to the new working box. Click the blue Jump Out button to the top right of the new working box to return the group items to the main working box.

If the model you want to modify wasn't created in Carrara, examine it in the Assemble room. Double-click one of the model's parts and watch what happens. If the Vertex modeler opens up, you're home free. If the Primitive modeler opens, convert the object to a vertex object and edit away.

Tutorial: Product Packaging

Creating product mock-ups with Carrara is an excellent way to present a concept or idea to a client. Many design houses employ an artist to create a rendering of a product before presenting it to a client. By using the skills presented in this chapter, you could create the mock-up in Carrara and present a photo-realistic image of the product as it would appear on store shelves. After creating the initial scene in Carrara, you could render it from different angles and different lighting and assemble a collage of the product. You could even create an animation of the product, showing it from all sides as the camera revolves around it.

In this scenario, your client markets a vitamin called "Nutz and Boltz." Sales have been slack, and they decide to redesign the product packaging in conjunction with a massive advertising campaign. Your assignment is to redesign the bottle that Nutz and Boltz is packaged in.

After studying the product and your client's packaging requirements, you decide to create a bottle shaped like a bolt with a nut for the cap. After some brainstorming, you sit down at your computer and doodle in a vector drawing program, creating sweeping curves that approximate the shape of the bottle.

On the CD-ROM

The files you'll need to complete this tutorial are located in a folder named Nutz&Boltz, which is located in the folder for Chapter 13 in the Contents section of this book's CD ROM.

Now it's time to put Carrara to work and create the product mock-up:

1. Launch Carrara, create a new document, and select Insert ➪ Spline object or drag the Spline Object tool into the working box to open the Spline modeler.

2. Select Geometry ➪ Extrusion Envelope ➪ Symmetrical.

3. Draw an oval on the drawing plane.

4. Drag open the Properties tray and resize the oval to a width and height of 4.50 inches.

5. Select Sections ⇨ Center.

6. Click the right plane to convert it to the drawing plane.

7. Select File ⇨ Import and load the bottle.ai file from the CD ROM. Carrara extrudes the circle to fill the envelope you just imported.

8. Select Sections ⇨ Create. Carrara creates a cross section.

Note

When you import a file to use as an extrusion envelope, Carrara creates points on the sweep path to match the envelope's points. When you create a cross section, Carrara creates it on the next point on the sweep path unless you click a specific point to select it.

9. Select Sections ⇨ Next, and then select Sections ⇨ Create.

10. Repeat step 9.

11. Select Sections ⇨ Create. You should now have five cross sections (see Figure 13-29).

Figure 13-29: Creating cross sections to define where the vitamin bottle's major shape changes occur

12. Select Sections menu ⇨ Go to and enter 2.

You can also press the Alt key to reveal an arrow spinner in the Go To Cross Section dialog box. Click the up arrow to increase the number in the Cross Section No field, or press the down arrow to decrease the number.

13. Click the shape on cross section 2 and press Delete.

14. Click to select the Draw polygon tool and Shift+drag to create a polygon.

15. Enter 8 for the number of sides.

16. Drag open the Properties tray and resize the polygon to a width and height of 6.00 inches.

17. Select Sections ⇨ Center.

18. Select Edit ⇨ Copy.

19. Select Sections ⇨ Go to and enter 3.

20. Click the shape on cross section 3 and press Delete.

21. Select Edit ⇨ Paste. The polygon you pasted is now copied onto cross section 3.

22. Select Sections ⇨ Center. At this stage, your vitamin bottle should resemble Figure 13-30.

Figure 13-30: The partially created vitamin bottle

23. Select Sections ⇨ Go to and enter 5.

24. Click the shape on cross section 5 to select it.

25. Select Edit ⇨ Copy.

26. Click the Assemble icon to return the bottom of the vitamin bottle to the Assemble room.

A pill bottle wouldn't be worth its salt without a cap. To create the cap for the bottle:

1. Select Insert ⇨ Spline object or drag the Spline Object tool into the working box to open the Spline modeler.

2. Select Edit ⇨ Paste to paste the shape you copied from the vitamin bottle onto the drawing plane.

Tip

When you create a model where one part intersects or aligns with another, copy the shape from the first part where the two parts will eventually intersect. When you open the Spline modeler to create the second part, paste the shape you copied onto the drawing plane, and you'll have an exact fit when you align the two parts in the Assemble room.

3. Select Sections ⇨ Create to add a cross section at the end of the cap's sweep path.

4. Select Sections ⇨ Create Multiple and enter 3 to add three new cross sections to the cap.

5. Select Sections ⇨ Go to and enter 3.

6. Select the shape on cross section 3 and press Delete to remove it.

7. Click to select the Draw polygon tool and Shift+drag to create a polygon.

8. Enter 8 for the number of sides.

9. Drag open the Properties tray and resize the polygon to a width and height of 4.00 inches.

10. Select Sections ⇨ Center.

11. With the polygon still selected, select Edit ⇨ Copy.

12. Select Sections ⇨ Go to and enter 4.

13. Select Edit ⇨ Paste. The polygon you pasted is now copied onto cross section 4.

14. Select Sections ⇨ Center.

15. Click to select cross section 2's point on the sweep path.

16. Shift+drag to shorten the distance from cross section 1 to cross section 2. After you begin to drag, hold down the Shift key to constrain motion to the grid. Repeat with the points for cross sections 3 and 5. Your completed cap should resemble Figure 13-31.

Figure 13-31: The completed vitamin bottle cap

17. Click the Assemble icon to return the completed cap to the Assemble room for further alignment and modification.

18. You'll be using this file again in Chapter 17, which discusses advanced shading techniques, so save the completed file as nutzboltz. Figure 13-32 shows the completed vitamin bottle before shading.

Note If you intend to present the model with the cap off, align a small cylinder inside the cap, select the two objects, and use a Boolean Subtraction operation to hollow the cap's interior. Alternatively, you could choose to leave the first cross section unfilled, but this would create a cap with wafer-thin sides.

Congratulations! Creating the Nutz and Boltz bottle and cap has brought you one step closer to achieving the title of Carrara master modeler. Practice the techniques presented in this chapter on your own models, and in no time you'll be creating wonderful renderings of both real and imaginary items.

Figure 13-32: All the Nutz and Boltz bottle needs is a little bit of color and a label.

Before you branch out on your own, it's important to remember some of the things you've learned in the other modeling chapters. Save your work often and save it early. Computer glitches can turn hours of good modeling work into naught. Save the file under another name for the same reason. If the worst happens, you can rely on the backup file instead of having to remodel from scratch. Never model more than is needed. If you won't see it in the final render or animation, don't build it. Remember the old Zen maxim, "Less is more." Above all, experiment and have fun with the process.

Summary

2D vector drawings can be imported to create complex shapes, sweep paths, or envelopes. Creating multiple shapes on cross sections makes it possible to generate intricate models. Carrara models can be customized to suit your needs.

✦ Pipeline extrusions can be used to create delicate curved objects such as flowers or blades of grass.

✦ Modifiers can be used to create intricate shapes.

✦ Spline and Metaball objects can be modified by converting them into vertex objects and editing their individual vertices, edges, and polygons.

✦ The Formula modeler converts the cold hard logic of math into beautiful objects.

✦ Complex models can be created by overlapping two objects and performing Boolean operations on them.

✦ ✦ ✦

Texturing Your Finished Models

Introducing the Carrara Shader Browser

Carrara uses shaders to define an object's outward appearance. In addition to defining surface texture and color, shaders also determine how an object reacts to light. The proper choice of shaders can turn an otherwise mundane scene into a dazzling photo-realistic image.

When you add an object to a Carrara scene, its surface characteristics are defined by a default shader, which colors the object's surface gunmetal gray. Gunmetal gray looks good on battleships, but if you're creating a 3D flower, something a little more artistic is in order. As you begin your exploration into texturing objects, it's a good idea to begin with the presets in the Carrara Shader Browser. Here, you'll find a wide variety of textures that can be used to shade objects in your scene.

Exploring the Carrara Shader Browser

The Carrara Shader Browser is part of the Browser tray. In the Shader Browser, you'll find a library of shader folders. Each folder contains shaders with similar characteristics. The Shader Browser can be configured to contain only folders with shaders you frequently use. Shader files can be added to or removed from folders as needed. Shader folders can be added to or removed from the browser as needed.

To access the Shader Browser:

1. Drag open the Browser tray.

2. Click the Browser: Shaders button (the button that resembles a paintbrush) to open the Shader Browser, as shown in Figure 14-1.

Figure 14-1: The Carrara Shader Browser

The open Shader Browser displays all the shader folders you currently have loaded. Click the triangle to a folder's left to expand it (see Figure 14-2).

Keep in mind that every time you launch the program, Carrara loads thumbnail images of every shader you have saved in the Browser into your computer's memory. If you're working with a slower computer, a hefty Browser tray can quickly gobble up CPU resources. Fortunately, the Browser tray makes it easy to manage the number of shader folders you have. Folders can be added to or deleted from the Shader Browser at any time.

To add a folder to the Shader Browser:

1. Drag open the Browser tray.

2. Click the Browser: Shaders button to open the Shader Browser.

3. Click the Folder icon in the upper-right corner of the Shader Browser.

4. Select Add Folder. The Browse for Folder dialog box opens.

5. Locate the desired folder and click OK to add.

Figure 14-2: Expand a folder to view its contents.

To remove a folder from the Shader Browser:

1. Drag open the Browser tray.
2. Click the Browser: Shaders button to open the Shader Browser.
3. Click the folder you want to delete.
4. Click the Folder icon in the upper-right corner of the Shader Browser.
5. Select Remove Folder to remove the folder from the Shader Browser.

The Shader Browser also makes it possible for you to delete unwanted shader files from a Shader Browser's folder.

To delete a file from a Shader Browser's folder:

1. Click the Shader Browser folder that the file is stored in to open it.
2. Click to select the unwanted file.
3. Click the Folder icon in the upper-right corner of the Shader Browser.
4. Click Delete File to remove the file from the folder.

Note Click to select any shader inside the Shader Browser and then right-click to reveal a menu that has the same options as the Folder menu.

Texturing with shader presets

Once you've opened a shader folder, the shader files are displayed and ready for use. Three round buttons located to the left of the folder button are used to determine how shader files are viewed in the browser. Shader files can be displayed in one of three modes: Small Preview, Large Preview, or Name only. Click the desired preview button to change a shader file's display mode.

From the Shader Browser, you can select a shader and apply it to an object's surface.

To apply a shader to an object's surface:

1. Drag open the Browser tray.
2. Click the Browser: Shaders button to display the shader folders.
3. Click the triangle to the left of the desired folder to expand it.
4. Click to select the desired shader.
5. Drag and drop it on the object (see Figure 14-3).

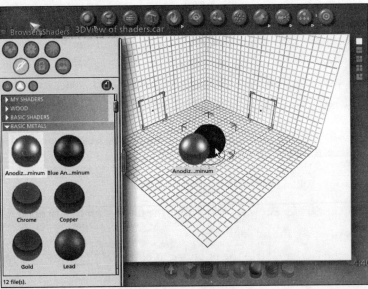

Figure 14-3: Drag and drop a shader to apply it to an object's surface.

When you drop a shader on an object's surface, Carrara simultaneously copies the shader to the object's surface. A copy of the file is also placed in Sequencer tray, where it becomes part of the scene and is referred to as a master shader. The new master shader becomes part of the Master Shaders list.

Carrara creates a default shader for the first object you create in a scene and applies it to every object created until you apply a new master shader to an object's surface. During the course of editing a scene, you may decide to use different shaders on certain objects. If the shader you decide to use is not already a master shader, you can add it directly to the Sequencer tray from the Browser tray.

To add a master shader to the Sequencer tray:

1. Drag open the Sequencer tray.

2. Click the Master Shaders button.

3. Drag open the Browser tray.

4. Click the Browser: Shaders button to display the shader folders.

5. Click the triangle to the left of the desired folder to expand it.

6. Click to select the desired shader.

7. Drag the shader directly into the Sequencer tray (see Figure 14-4). The shader is added to the scene as a master shader.

Note　Click any master shader in the Sequencer tray and then right-click to reveal a menu that allows you to cut, copy, paste, delete, or duplicate a master shader.

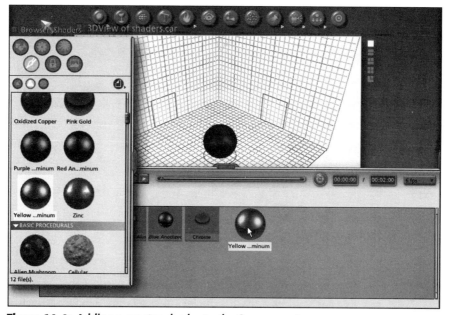

Figure 14-4: Adding a master shader to the Sequencer tray

Modifying shader presets

The shader presets that come with Carrara provide interesting surface textures, colors, and patterns that work well for a wide variety of 3D objects and models. There will be times, however, when you need to tweak a preset shader for an object in your scene.

To modify a preset shader:

1. Select the object to which the shader is applied.

2. Click the Texture icon to open up the Shader Tree Editor in the Texture room (see Figure 14-5). Edit the necessary channels on the Shader Tree Editor.

Cross-Reference The Shader Tree Editor will be covered in greater detail in Chapter 15.

3. Click the Assemble icon to return to the Assemble room. The edited shader is applied to the object.

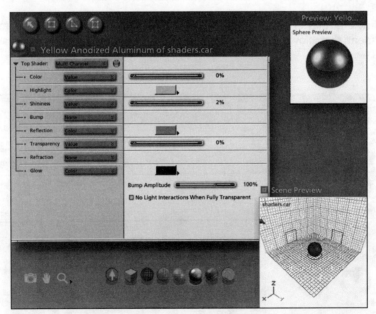

Figure 14-5: Modifying a preset shader with the Shader Tree Editor

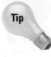
Tip You can also double-click a shader's thumbnail in the Shader Browser or Sequencer tray's Master Shader section to open the file in the Texture room. You can also double-click a master shader's name in the Sequencer section's Master Shaders list to open the file in the Texture room.

Now that you have an idea of how a shader is modified in the Texture room, it's time to see how this actually works by modifying one of Carrara's preset shaders. In this exercise, you're going to apply the preset Pink Gold shader to a sphere and then modify it in the Texture room.

To modify the Pink Gold shader:

1. In the Assemble room, select Insert ⇨ Sphere.

 Alternatively, drag the Sphere tool into the working box or Sequencer tray's Universe list.

2. Drag open the Browser tray.

3. Click the Browser: Shader button and then click the triangle to the left of the Basic Metals folder to expand it.

4. Locate the thumbnail for the Pink Gold shader, click it to select it, and then drag it into the working box and drop it onto the sphere you just created.

5. Select the sphere and then click the Texture icon (the icon that looks like a paintbrush) to enter the Texture room. The Pink Gold Shader Tree is displayed as shown in Figure 14-6.

6. Examine the Shader Tree Editor to see the individual components that make up the shader. Notice it's a Multi Channel shader. Now examine each of the individual channels that make up the shader. Notice that the shader picks up all of its color from the Color component (pink) in the Highlight and Reflection channels instead of the Color channel. This is not uncommon when creating a metal shader. Metals exhibit bright highlights and are highly reflective, especially a precious metal such as gold. Also notice that a Value component is in the Shininess channel. Shininess is turned up to its maximum value to simulate a shiny metal surface.

7. Notice that the Value component is used in the Color channel. When a noncolor component is used in the Color channel, the Color channel returns a grayscale hue. In this case, the Value slider is set at 0, or pure black in the grayscale color range. Drag the slider to the right and watch what happens to the shader in the Preview window.

8. Click the blue button to the right of the Color channel and click the Color component to select it. The shader becomes a shiny, bright red. Click the color swatch to open up the Color Picker. Experiment with different colors to see their effect on the shader. After you're done experimenting, select red for the channel's color.

9. Click the blue button to the right of the Color channel and select Operators ⇨ Mixer. Two Source channels and a Blender channel appear as shown in Figure 14-7.

Bump channel

Shininess channel

Highlight channel

Color channel

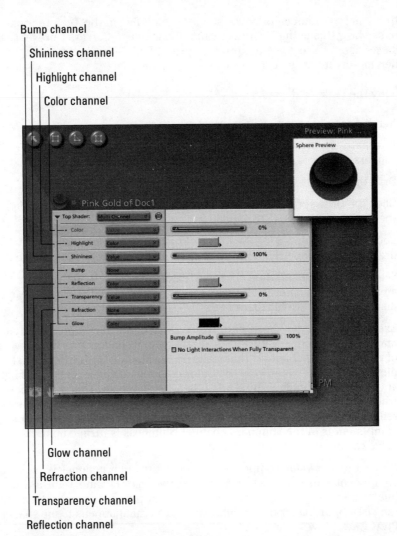

Glow channel

Refraction channel

Transparency channel

Reflection channel

Figure 14-6: The Pink Gold Shader Tree

10. If you've been following the steps, the Color component should be in the Source 1 channel. If not, click the blue button in the Source 1 channel and select Color. Leave the color at its default red.

11. Add the Color component to the Source 2 channel by clicking the blue button and selecting Color. Click the color swatch to the right of the channel and select white from the Color Picker.

12. Click the blue button in the Blender channel and select Pattern Function ➪ Checkers. You now have a shiny red-and-white checkerboard pattern on your sphere (refer back to Figure 14-7).

Source 1 Source 2

Color channel Blender

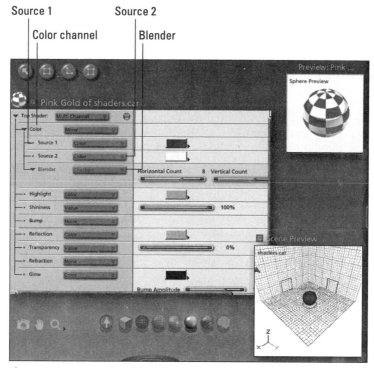

Figure 14-7: Inserting the Mixer component into the Color channel

13. Drag the Checker functions Horizontal and Vertical Count sliders and notice how the checkerboard pattern changes.

14. Click the blue button to the right of the Color channel's Blender and select Pattern Functions ➪ Wires. Now you have a gilded cage of red bars surrounding a white sphere.

15. Drop down to the Highlight channel. Click the arrow to the right of the color swatch and drag it to the Color channel's Source 2 color swatch. When your cursor is over the color swatch, release it. The Highlight channel's color is now identical to the color used by the Color channel's Source 2 channel. Any time you click the arrow to the right of a color swatch, you can drag anywhere in Carrara's interface to sample a color. As soon as you release the mouse key, the color the cursor is over is sampled and applied to the color swatch.

16. Drop down to the Reflection channel, click the arrow to the right of the color swatch, and capture the white from the Color channel's Source 2 channel. Before modifying the shader, it had a strong pink reflection and highlight. Now the highlight and reflection are white.

17. Drop down to the Transparency channel and drag the Value slider to the right. Hmm, the sphere is vanishing before your eyes. After experimenting with the Value slider, drag it back to 0.

18. Now go back up to the Reflection channel. Click the blue button to the channel's right and select Value. Notice that the sphere in the Shader review window suddenly looks very dull.

19. The Reflection channel's section should be highlighted in yellow. If not, click the channel's name to select it. Now press the Ctrl key, and click and drag the selection up. An outline of the selected channel follows to indicate your progress. Release the mouse key when the outline is directly over the Highlight channel. By pressing the Ctrl key and dragging a selected channel, you can copy its contents into another channel. After performing this last modification, the sphere should look very dull indeed. Drag the value slider to the right to put some spark back in the old boy.

20. Now go to the Color channel's Blender. Click the blue button to its right and select Natural Functions ⇨ Cellular. Hmm, now our sphere looks like a speckled red alien egg.

21. Click the Color channel's Blender and then Ctrl+drag to the Bump channel. Release the mouse key when the outline is directly over the channel. Yikes, now our alien eggs have bumps!

22. Drag the blue scroll bar to the right of the Shader Tree Editor and scroll down until you see the Bump Amplitude slider. Drag it right and left to see what effect it has on the sphere's bumpy surface.

23. Continue experimenting with the shader for as long as you like. Add different components to different channels, and watch the Shader Preview window to see the effect doing so has on the sphere's surface characteristics. When you're done, click the Assemble icon to return to the Assemble room.

Congratulations. You've just passed Shaders 101. Exploring and modifying the components of existing shaders is the best way to learn how to create shaders of your own. If you like the shader you just created, follow the steps in the next section to save it to the Shader Browser for future use.

Saving a shader to the Browser

As you learn more about shaders and create some of your own, you'll want to save your creations so you can use them on other Carrara models.

To add a custom shader to the Shader Browser:

1. Drag open the Browser tray.

2. Click the Browser: Shaders button to open the Shader Browser.

3. Click the folder to which you want to add the new shader.

4. Drag open the Sequencer tray and click the Master Shaders button to view the Master Shaders list.

5. Click to select the master shader you want to add to the Shader Browser.

6. Drag it to the Shader Browser and drop it under the name of the folder you want to add it to. The selected folder is highlighted and the File Info dialog box opens up.

7. Enter a name for the new shader and any comments that may help you identify its characteristics.

8. Click OK to add the new shader to the folder (see Figure 14-8).

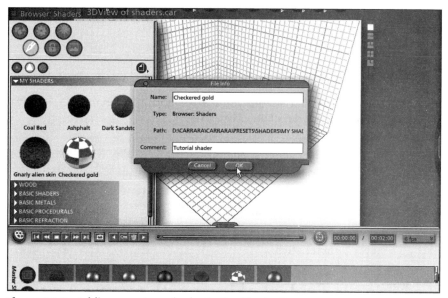

Figure 14-8: Adding a custom shader to the Shader Browser

> **Tip**
>
> As you learn more about shaders, you'll find yourself creating lots of custom shaders. Use your computer's operating system to create a folder for storing your creations, and add it to the Shader Browser.

Working with Master Shaders

Master shaders provide a convenient way to manage the textures and colors you apply to objects in a scene. Whether you shade an object with a shader from the Shader Browser or create a unique shader for an object, the file is saved with your scene as a master shader. All master shaders remain conveniently tucked away in the Sequencer tray until you need them.

To shade an object with a master shader:

1. Drag open the Sequencer tray.

2. Click the Master Shaders button to view the master shader thumbnail previews.

3. Click the master shader you want to apply to the object.

Alternatively, click the master shader's name from the Sequencer section's Master Shaders list.

4. Drag and drop the master shader on the desired object to apply.

Master shaders can be modified directly from the Sequencer tray. You use this feature when you want to change the appearance of all objects textured with a master shader.

To modify a master shader:

1. Drag open the Sequencer tray.

2. Select the master shader you want to modify by double-clicking its name in the Master Shaders list.

Alternatively, click the Master Shaders button and double-click the thumbnail preview of the master shader you want to modify. The Texture room opens and the Shader Tree Editor is displayed.

3. Make the desired modifications to the master shader.

4. Click the Assemble icon.

All objects with this master shader applied are updated to reflect the shader's new characteristics.

Editing individual objects with master shaders applied

As handy as master shaders are, occasionally you will need to vary a shader's characteristics to prevent a scene from becoming monotonous. For example, you model a fluted column and apply a marble shader to it. You duplicate and align the columns, add a few statues on pedestals, adjust scene lighting, aim the camera, and render the scene. The resulting image looks good, but even to the untrained eye it would be obvious that the columns were cloned. To enhance the final image, select a few columns near a major point of interest, and edit each column's master shader.

To edit a master shader for an individual object:

1. Click the object to select it.

2. Click the Texture icon to open the Texture room.

3. The Editing Shader warning dialog box appears, informing you that you are about to edit a master used by several objects (see Figure 14-9).

Figure 14-9: The Editing Shader warning dialog box

4. Select one of the following two options:

 • **Create a new Master:** Applies the changes only to the object you're editing

 • **Edit the Master:** Applies the changes to all instances where the master shader is applied

5. Click OK. The Shader Tree Editor appears.

6. Edit the master shader.

7. Click the Assemble icon to return to the Assemble room. The edited master shader is applied to the object.

Every time you create a new master shader by editing one currently used in the scene, it is given a new name. The new master shader shares the old master shader's name followed by its numerical instance. For example, Marble Shader would become Marble Shader 1, Marble Shader 2, and so on.

Modifying a scene's default shader

When you initially create a scene, a default shader is applied to all objects that populate the scene. This shader stays with an object until you apply a shader from the Shader Browser or modify the default shader.

To modify a default shader:

1. Drag open the Sequencer tray.

2. Click the Master Shaders button.

3. Double-click the Default shader's thumbnail.

 Alternatively, double-click Default in the Sequencer section's Master Shaders list.

4. The Texture room opens. Edit the Default shader as desired (see Figure 14-10).

5. Click the Assemble icon to return to the Assemble room. The edited Default shader is now applied to all instances where it was used.

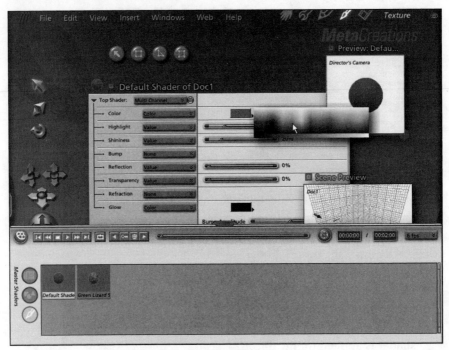

Figure 14-10: Editing a scene's Default shader

The Sequencer tray can also be used to apply existing master shaders to objects in your scene.

To apply a master shader from the Sequencer tray:

1. Drag open the Sequencer tray.

2. Click the Master Shaders button.

3. Click the desired master shader's thumbnail to select it.

 Alternatively, click the master shader's name in the Sequencer section's Master Shaders list.

4. Drag the master shader and drop it on the object you want to shade.

Tip To get an idea of how an applied shader looks with scene lighting, click the Area Render tool (the camera icon below the lower-left corner of the working box) and drag it across an area of your scene to view a quick spot rendering.

As you add more objects and models to a Carrara scene, you'll end up using many different shaders. Remember that any time you apply a shader to an object, you create a master shader that will be added to the scene. During the course of editing an object, you may end up replacing one shader with another. This may cause you to end up with unused master shaders in the Sequencer tray. Unused master shaders add to the scene's impact on your computer's resources. To remove unused master shaders from your scene, select Edit ➪ Remove Unused Masters ➪ Remove Unused Shaders.

Using the Eyedropper tool

The Eyedropper tool lets you capture a shader from one object in the working box and apply it to another. The Eyedropper tool can be filled and refilled as needed, or you can capture a shader and apply it to many objects in the same scene.

To use the Eyedropper tool:

1. Click the Eyedropper tool to select it, as shown in Figure 14-11.

2. Click an object in the Assemble room, Storyboard room, or Scene Preview window to capture its shader.

3. Click the Eyedropper tool on another object to apply the captured shader.

Figure 14-11: Use the Eyedropper tool to capture a shader from one object and apply it to another

Note Shift+click fills the Eyedropper with the captured shader and lets you apply it to multiple objects. The Eyedropper tool stays filled with the captured shader until you release the Shift key. After you release the Shift key, the Eyedropper will still have one application of the shader left. Click it on an object that already has the captured shader to empty it.

Applying a master shader using the Properties tray

As you've already learned, every shader you add to the scene is also added to the Sequencer tray's Master Shaders list. Scene master shaders are also recorded in a drop-down menu in the Properties tray. Applying an existing master shader to an object is as simple as selecting it from the Shader menu in the Properties tray.

To apply a shader using the Properties tray:

1. Select the object to which you want to apply the shader.

2. Drag open the Properties tray and click the General button.

3. In the General panel, click the blue button with the downward-facing double arrows to open the Shader drop-down menu, as shown in Figure 14-12. Click the desired shader from the list to apply it.

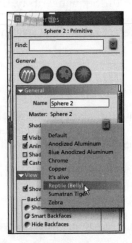

Figure 14-12: Using the Properties tray to apply a shader

Carrara's Shader Browser lets you organize your shader libraries. Use the Shader Browser in conjunction with the Sequencer tray to manage the textures applied to your scene's occupants. By carefully managing your application of master shaders, you can create interesting images without breaking your computer's memory bank.

But this is just the tip of the shader iceberg. The Shader Tree is just around the next bend. With it, you'll create custom shaders from scratch and have the Shader Browser bulging at the seams in no time.

Summary

The Shader Browser helps you effectively manage a library of preset and custom shaders. Shaders can be applied by the drag-and-drop method from either the Shader Browser or the Sequencer tray.

✦ The master shader list gives you total control over the shaders in a scene.

✦ The Properties tray lets you edit master shader names.

✦ The Properties tray tells you which objects have a master shader applied.

✦ The Eyedropper tool makes it possible to capture a shader from one object and transfer it to another.

✦ ✦ ✦

Creating Custom Shaders

Carrara's Texture room is where you apply the finishing touches to your 3D models. The Texture room has all the necessary components to create a realistic-looking texture for your 3D masterpiece. You add, mix, multiply, and subtract various components, functions, and operators on the branches of Carrara's Shader Tree to mimic reality. Just like a tree in nature, the Shader Tree can get quite big and complex, branching out in many directions, adding more and more complexity to the texture being applied to the model. And with complexity comes reality.

Understanding the Shader Tree

Once inside the Texture room, Carrara's Shader Tree blossoms, showing all the available channels that can be utilized to bring your model to life. It may be helpful to think of the eight Shader Tree Channels as branches. You can put a node on each branch to subdivide it and then subdivide each one of those nodes. In theory, you could split each channel infinitely (until your computer ran out of memory, of course). But before you can explore each channel in depth, it's important to understand the components and functions you can use in each channel. Figure 15-1 shows the Shader Tree Editor and its channels.

Working with basic shader components

The basic shader components are the workhorses of the Carrara Shader Tree. You'll find yourself relying on them time and again as the foundations for a complex shader. The four basic shader elements include components, operators, functions, and natural functions.

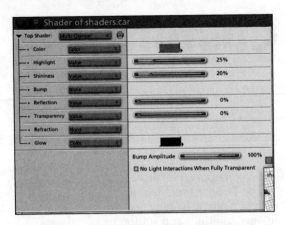

Figure 15-1: The Shader Tree Editor in Carrara's Texture room

Adding the Color component to a channel

The Color component can be used anywhere in the Shader Tree to specify color. The Color channel is the most obvious place to use this component, but you'll also use it to good effect in the Highlight, Reflection, Transparency, and Glow channels.

When you add color to a noncolor channel such as Shininess or Highlight, it is converted to a value. Dark colors have low values, and light colors have high values.

To add the Color component to a channel:

1. Click to select the desired channel.

2. Click the blue button to the right of the channel and select the Color component from the drop-down menu. A color swatch appears to the right of the channel.

3. Click the arrow to the right of the swatch to open the horizontal Color Picker and drag to select the desired color.

Tip

Selecting the horizontal Color Picker lets you pick a color from anywhere in the Texture room, even from the interface (see Figure 15-2). To sample a color from anywhere in the interface, click the arrow to the right of the color swatch and drag to the color you want to sample. When you release the mouse, the selected color is sampled.

4. Alternatively, click the color swatch to pick a color from the Color Picker wheel. The Color Picker wheel appears at the bottom-right corner of the interface after you click the color swatch.

Note

The Color Picker wheel has seven different models from which to choose. Click the current color model selection to reveal the other choices from the drop-down menu (see Figure 15-3). The choice of color menu is purely personal preference and has no effect on the shader.

The Horizontal Color Picker

Figure 15-2: Choosing a color from the horizontal Color Picker

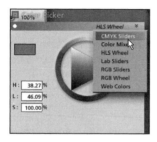

Figure 15-3: Choosing a color from the Color Picker wheel

Note

There is also a Reference Shader component to the Shader Tree. A reference shader is any master shader that is currently part of the scene. Reference shaders can be used to fill any channel, but are best suited as part of a Multi Channel Mixer, which will be explored in Chapter 17.

Adding a Value component to a channel

The next choice for filling a channel is the Value slider, which allows settings between 0 and 100 percent. This component will be useful in all channels as either a primary component or as part of a channel's subshader. Subshaders are covered in greater detail in Chapter 17.

The Value component could be used by itself to set a constant value for the channel's attribute, which is applied equally over the surface of the object or layer. For example, setting the Value slider at 50 in the Transparency channel would render an object 50 percent transparent.

The Value component could be used in the Color channel, which would result in a color from the grayscale color model. A value of 0 would result in pure black, whereas a value of 100 would result in pure white — a value of 255 on the grayscale color model.

The Value component could also be used as an opacity mask for a layer in the Layers List shader. Layers are covered in greater detail in Chapter 16.

To add the Value component to a channel:

1. Click to select the desired channel.

2. Click the blue button to the right of the channel and select the Value component from the drop-down menu. A slider appears to the right of the channel

3. Drag the slider (shown in Figure 15-4) from left to right to set the desired value.

Figure 15-4: The Value slider

Adding a texture map to a channel

Texture maps are 2D images that can be applied to a channel and are useful in virtually every channel. Texture maps make it possible to achieve a degree of realism that might not otherwise be possible with conventional shader components. Scanned photos are a good source for texture maps, as are images created in 2D photo-editing programs.

Color texture maps work exceptionally well in the color channel. A scanned photo showing a section of knotty tree bark could be imported into the color channel and tiled seamlessly across a cylinder to simulate a log. Apply the same photo, identically tiled to the Bump channel, to create surface whorls and knots on the log. Texture maps can also be applied to layers to create decals on the surface of a model. Texture maps used in noncolor channels are converted to the grayscale color model.

Texture maps can be used for all manner of tasks. Apply a texture map with random holes across its surface to the Transparency channel to simulate the holes in Swiss cheese, for instance.

Tip Make sure your texture maps are large enough to show detail in the finished render. An image size of 512 × 512 pixels produces good results. The resolution of the image should be equal to or greater than the resolution you're rendering the final scene at.

To import a texture map to a channel:

1. Click to select the desired channel.

2. Click the blue button to the right of the channel and select the Texture Map component. A dialog box opens in a pane to the right of the shader channel.

3. Click the folder icon to display the Open dialog box.

4. Locate the desired texture map file and click Open to apply. The Choose File Format dialog box appears. Click OK.

5. A thumbnail of the image appears in the Texture Map dialog box's preview window (see Figure 15-5). The Shader Preview window shows the texture map applied to the object.

Image Positioning buttons

Folder button

Texture Map Preview Window

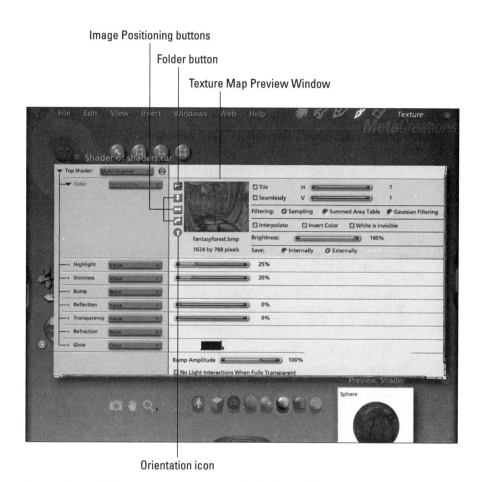

Orientation icon

Figure 15-5: Adding a texture map to a shader channel

6. To flip or rotate the texture map's position, click one of the buttons to the left of the texture map preview window. The bottom button indicates the orientation of the texture map compared to its original position. When you initially open a texture map, the arrow is pointing straight up. As you use the buttons to change the orientation of the texture map, the arrow moves to indicate the new orientation.

7. To tile the texture map across the surface of the object, click the Tile option and drag the H (horizontal) and V (vertical) sliders to set the number of repetitions in each direction. To have Carrara match the edges of neighboring tiles, click the Seamlessly option.

8. Apply one of the three Filtering options:

- **Sampling:** Provides the lowest quality and quickest rendering.

- **Summed area table:** Produces better results but uses large amounts of memory. This option is not recommended for large texture maps.

- **Gaussian Filtering:** Blurs adjacent pixels to create a pleasing blend of colors. This filter produces the best results.

9. The White is invisible option disregards all pure white (255,255,255) areas of the image and lets the underlying texture show through.

10. Check the Interpolate option when the object the image map is applied to will be viewed close-up.

11. Select the Invert Color option to change all colors to their opposite values.

12. Drag the Brightness slider to determine how bright the texture map will be in the finished shader.

Tip

The Invert Color option comes in handy when you're using images as bump maps. If the image colors in your bump map render desired high points as low points, inverting color will often put things right.

13. The Save option specifies how the texture map is stored. Choose the Internally option to save the texture map with the scene file. Storing texture maps internally keeps your scenes organized by keeping everything in one tidy bundle, but results in larger file sizes. Storing texture maps externally results in smaller files sizes. When you store a texture map externally, Carrara records the location of the file as part of the scene information. If after saving the scene you move an externally saved texture map on your hard drive, Carrara prompts you to locate it the next time you load the scene.

Adding a movie to a channel

Carrara lets you import movies into shader channels. Movies function like texture maps except the image changes as you change frames in an animation. Movies can be added to a shader to bring a television screen to life during an animation. Another good use for a movie in a shader channel would be to create a billboard with changing messages or a scrolling stock ticker screen in a stock brokerage. Sequenced image files and .avi and .mov movies can be imported into shader channels.

To import a movie into a channel:

1. Click to select the desired channel.

2. Click to select the Movie component. A dialog box opens in a pane to the right of the shader channel.

3. Click the folder icon to display the Open dialog box. Click the small arrow to the right of the Files of Type window to reveal a drop-down menu. Select Movie Files.

4. Locate the desired movie file and click Open to apply.

5. A thumbnail of the movie appears in the movie preview window (see Figure 15-6). Underneath the thumbnail are three VCR controls that allow you to play, stop, or loop the movie. These controls are only applicable in the preview window. The Shader Preview window shows the movie applied to the object.

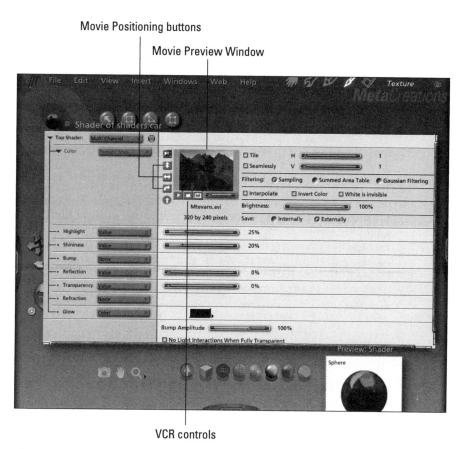

Figure 15-6: Importing a movie into a shader channel

6. To flip or rotate to movie's position, click one of the buttons to the left of the preview window.

7. To tile the movie across the surface of the object, click the Tile option and drag the H (horizontal) and V (vertical) sliders to set the number of repetitions in each direction. Click the Seamlessly option to match the edges of neighboring tiles.

8. Apply one of the three Filtering options:

 • **Sampling:** Provides the lowest quality and quickest rendering.

 • **Summed area table:** Produces better results but uses large amounts of memory.

 • **Gaussian Filtering:** Blurs adjacent pixels to create a pleasing blend of colors. This filter produces the best results.

9. The White is invisible option disregards all pure white (255,255,255) areas of the movie and lets the underlying texture show through.

10. Select the Interpolate option when the object the movie is applied to will be viewed close-up.

11. Select the Invert Color option to change all colors to their opposite values.

12. Drag the Brightness slider to determine how bright the movie will be in the finished shader.

13. The Save option specifies how the movie is stored. Choose the Internally option to save the movie with the scene file. Storing movies internally helps organize your scenes by keeping everything in one tidy bundle, but results in larger file sizes. Storing movies externally results in smaller files sizes. Carrara records the movie's location as part of the scene file. If after saving a file you move a externally saved movie on your hard drive, Carrara prompts you to locate it the next time you load the scene.

Importing movies into shader channels is discussed in greater detail in Chapter 17.

Combining Shader components with operators

Consider operators as building blocks for shaders. Operators enable you to create wonderfully complex shaders by combining multiple component sources in one channel. The fun doesn't stop there; add another operator to one of the source channels to add more branches and more complexity to the shader. When you start adding operators to channels, the possibilities are almost limitless.

Using the Add operator

Placing an Add operator in a shader channel creates a node on the Shader Tree with two branches extending below it. The components you add to each branch determine the channel's contents, which affects the shader's overall effect. Figure 15-7 shows a color being added to a texture map.

Left Source

Add Operator

Shader Preview

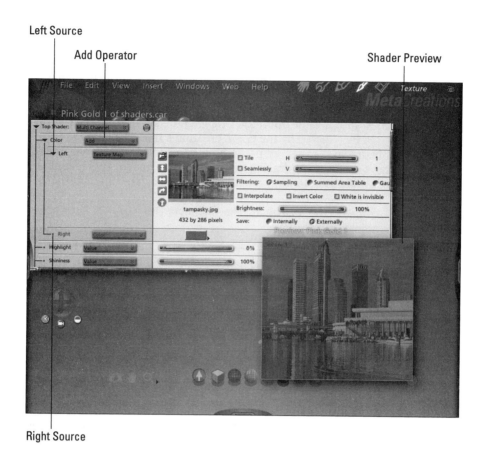

Right Source

Figure 15-7: The Add operator adds each component's value to determine the channel's overall effect on the shader.

Use the Add operator to produce a subtle tinting effect by adding color to one of the natural functions or a texture map. For example, if you added a light brown color to a grayscale texture map, you'd simulate a sepia image.

To add the Add operator to a channel:

1. Click to select the desired channel.

2. Click the blue button to the right of the channel and select Operators ⇨ Add. A node appears in the channel with Left and Right placeholders.

3. Click the blue button to the right of each placeholder and add the desired the desired component or function from the drop-down menu.

Using the Mixer operator

The Mixer operator can be thought of as the Shader Tree Editor's workhorse. You'll probably use this versatile operator more than any other tool in your shader toolbox. Adding a mixer to a shader channel creates three branches: Source 1, Source 2, and Blender. The Blender mixes the two sources to create he channel's contents. Figure 15-8 shows the texture map and color used in Figure 15-7 being blended with a Value operator. Dragging the slider from the right will cause the image to be affected by the color, creating a tint. The farther to the right the slider is dragged, the more predominate the color will become until it completely takes over, in effect erasing the texture map image. This technique can be used in an animation to have an object change surface characteristics.

Cross-Reference For more information on animation, refer to Chapter 19.

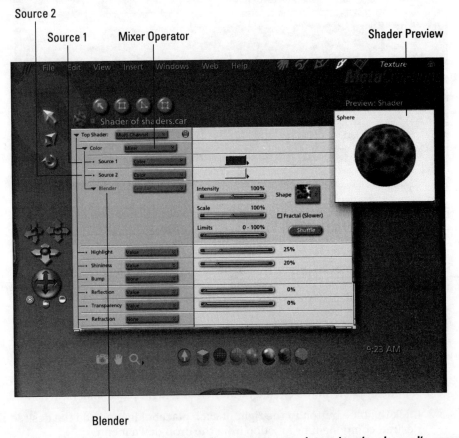

Figure 15-8: The Mixer operator blends two sources to determine the channel's overall effect on the shader.

To add the Mixer operator to a channel:

1. Click to select the desired channel.

2. Click the blue button to the right of the channel and select Operators ⇨ Mixer from the drop-down menu. A node appears in the channel with Source 1, Source 2, and Blender placeholders.

3. Click the blue button to the right of each placeholder to add the desired component or function from the drop-down menu.

4. Click the blue button to the right of Blender and select a component from the drop-down menu.

The Mixer operator could also be used to create a shader for a Dalmatian by mixing black-and-white colors and blending them with the Spots function in the Color channel, as shown in Figure 15-9. To achieve this effect, use the Color component in the Mixer's Source 1 and 2. Choose black for Source 1 and white for Source 2. Click the blue button to the right of the Blender and select Natural Functions ⇨ Spots. Adjust the spot size and blending options to achieve the desired effect.

For more information on the Spots function, see the section "Creating patterns of dots with the Spots function" later in this chapter.

Using the Multiply operator

Placing the Multiply operator in a channel adds two sources, which are multiplied to produce the channel's contents. For example, place a texture map in one source and a color in the other source to produce a texture map strongly tinted with the selected color.

To add the Multiply operator to a channel:

1. Click to select the desired channel.

2. Click the blue button to the right of the channel and select Operators ⇨ Multiply. A node appears in the channel with Source 1 and Source 2 placeholders. Figure 15-10 shows the texture map and color in Figure 15-7 with the Multiply operator applied. Compare the image in this figure's Shader Preview window to the Shader Preview window image in Figure 15-7 to get an idea of how the operator affects the look of the shader.

3. Click the blue button to the right of each placeholder to add the desired component or function from the drop-down menu.

Source 2 (black)

Source 1 (white)

Shader Preview

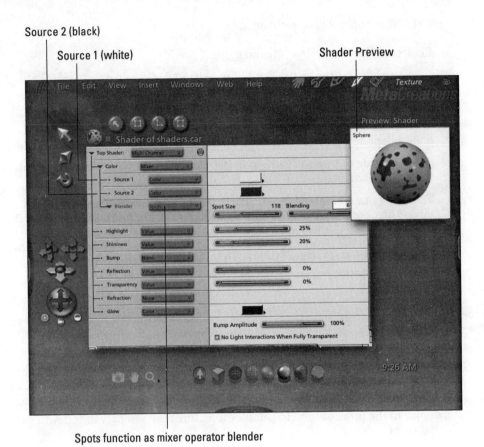

Spots function as mixer operator blender

Figure 15-9: Mixing two colors with the Spots function to create a Dalmatian shader

Using the Subtract operator

Placing the Subtract operator on the Shader Tree creates two sources. The operator subtracts Source 2 from Source 1 to create the channel's effect. You could use the Subtract operator to change the hue of a texture map by subtracting a predominant color from it. For example, insert a texture map in Source 1 of a Subtract operator. If the texture map has a light center bordered by dark red, insert a Color component in Source 2, click the arrow to the right of the color swatch and drag into the texture map preview window to sample the dark red color. The dark red color in Source 2 is subtracted from the texture map in Source 1, effectively removing the dark red color and rendering the texture map's background as black.

Source 2

Source 1

Multiply Operator

Shader Preview

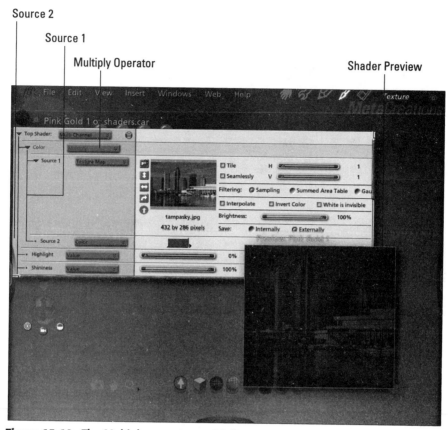

Figure 15-10: The Multiply operator multiplies two sources to produce the channel's contents.

To add the Subtract operator to a channel:

1. Click to select the desired channel.

2. Click the blue button to the right of the channel and select Operators ⇨ Subtract. A node appears in the channel with Source 1 and Source 2 placeholders. Figure 15-11 shows the texture map and color in Figure 15-7 with the Subtract operator applied. Compare the image in Shader Preview window in Figure 15-11 with the Shader Preview window images in Figures 15-10, 15-8, and 15-7 to get a good idea of the different effects possible with operators.

3. Click the blue button to the right of each placeholder to add the desired component or function from the drop-down menu.

Source 1

Subtract Operator

Shader Preview

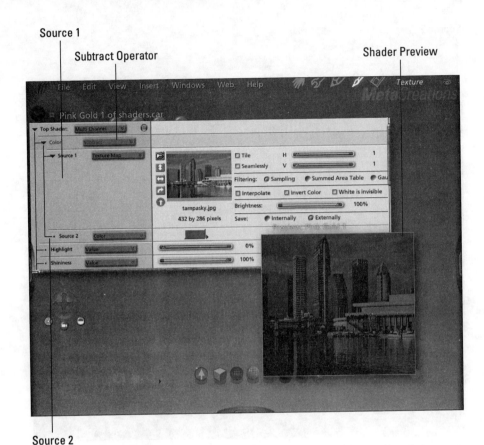

Source 2

Figure 15-11: The Subtract operator subtracts one source from another.

Tip

Filling up the channels on the Shader Tree Editor can produce marvelous shaders, but it can also result in a logistical nightmare as the tree starts branching out in every direction. To simplify matters, once you're done editing a channel, click the triangle to its left to collapse it. If you need to edit the channel later, click the triangle to expand the channel.

Filling shader channels with Natural functions

Natural functions are used to simulate naturally occurring objects. Natural functions can be used by themselves or modified by combining them with operators. The Mixer operator produces excellent results when used with Natural functions. For example, you can create an effective shader for a frog's skin by mixing two shades of green and using the Cellular function to blend them.

Creating organic shaders with the Cellular function

With the Cellular function you can simulate organic cells by applying one of t he function's preset texture maps across an object. You could create an utterly convincing alien by mixing two shades of green and blending them with the Cellular function in the Color channel. The Cellular function could also be used to simulate lizard skin, leather, or plant cells.

The Cellular function works well as a blender in the Color channel. Click the blue button to the right of the Color channel and select Operators ⇨ Mixer. Use the Color component in Source 1 and Source 2. Select a different color for each source. For the Blender, select Natural Functions ⇨ Cellular, and you've created an organic shader.

Cellular is a 3D function. Applying this function to an object gives the appearance that the object was carved out of a solid block.

To apply the Cellular function to a shader channel:

1. Click to select the desired channel.

2. Click the blue button to the right of the channel and select Natural Functions ⇨ Cellular.

3. A dialog box opens in a pane to the right of the shader channel. Adjust the function's settings to suit your model:

 • **Intensity:** Adjusts the contrast between the two colors you are blending with this function. Drag the slider to choose a setting between –100 percent and 100 percent. Negative settings invert the range.

 • **Scale:** Changes the size of the cell shape you apply. Choose a setting between 1 percent (tiny cells) to 200 percent (large cells).

 • **Limits:** Determines the balance between the dark and light colors that make up the Shape presets. The left slider controls lower limits (dark colors), whereas the right slider controls upper limits (light colors).

 • **Shape:** Click the large blue button with a picture of the current cellular shape to expand this menu and choose one of the available presets (see Figure 15-12).

 • **Fractal:** Replaces the regular cell shapes with fractals.

 • **Shuffle:** Randomizes the pattern.

Caution

Using the Fractal option creates interesting cell shapes but can increase the time required to redraw and render your model.

Cellular Function Adjustable Parameters

Shapes Drop-down Menu

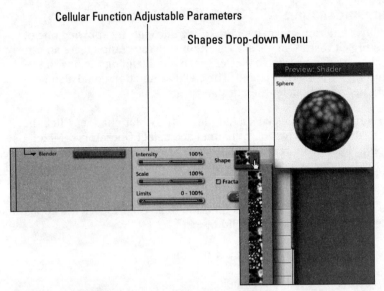

Figure 15-12: Applying the Cellular function to a shader channel

Creating marble patterns with the Marble function

Use the Marble function, which is a 3D function, to simulate natural marble. Applying this function to an object gives the appearance that the object was carved out of a solid block. This function is best used as a blender to mix two colors in the Color channel. It can also be used to create surface relief in the Bump channel.

To apply the Marble function to a shader channel:

1. Click to select the desired channel.

2. Click the blue button to the right of the channel and select Natural Functions ➪ Marble.

3. A dialog box opens in a pane to the right of the shader channel. Adjust the function's settings to suit your model (see Figure 15-13).

 - **Global Scale:** Adjusts the size of the marble pattern in relation to the object it's being applied to.

 - **Vein Count:** Adjusts the number of veins in the pattern. Use high values to produce rich-looking surfaces with dense vein patterns.

 - **Perturbation:** Adjusts the amount of waviness in the vein pattern. Higher settings produce erratic vein patterns that best resemble natural marble; lower settings produce smooth vein patterns.

Direction Drop-down Menu

Marble Function Adjustable Parameters

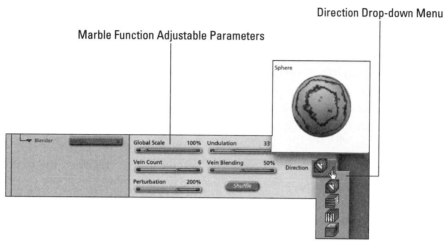

Figure 15-13: Applying the Marble function to a shader channel

- **Undulation:** Adjusts the frequency of the vein's undulation. Lower settings produce erratic, wildly undulating veins; higher settings produce gently rolling veins.

- **Vein Blending:** Adjusts the transition between individual veins and adjacent spaces. Lower settings produce abrupt transitions; higher settings produce a gentle blending from vein to space to vein.

- **Direction:** Click the downward-pointing double arrow to expand this menu and set the orientation of the marble pattern in relation to the object being shaded.

- **Shuffle:** Randomizes the pattern.

Cross-Reference

The Marble function is covered in greater detail in the Chapter 17.

Creating patterns of dots with the Spots function

Use the Spots function to create random irregular patterns of spots. The Spots function, a 3D function, effectively creates textures such as concrete or stucco. Spots can even be used to simulate skin pores. You'll use the Spots function often in the Color and Bump channels.

To apply the Spots function to a shader channel:

1. Click to select the desired channel.

2. Click the blue button to the right of the channel and select Natural Functions ⇨ Spots.

3. A dialog box opens in a pane to the right of the shader channel. Adjust the function's settings to suit your model:

- **Spot Size:** Determines the size of the spots. Drag the slider to the right to create larger spots.

- **Blending:** Determines how the spots blend together. Drag the slider to adjust settings. Lower settings produce blends in which the spots are noticeable; higher blend settings blend the spots almost completely together. The overall effect is determined by the spot size combined with the blending.

- **Shuffle:** Randomizes the pattern.

Figure 15-14 shows the process of applying spots to the shader channel.

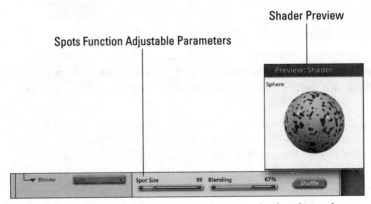

Figure 15-14: Applying the Spots function to a shader channel

Creating grain patterns with the Wood function

Use the Wood function, a 3D function, to simulate wood grain patterns. By mixing different colors and using the Wood function as a blender, it's possible to create unique grain patterns that can be used on a variety of objects. You could use the Wood function to simulate patterns in aging parchment or mottled patterns in plastic. Imagination is your only limiting factor.

Figure 15-15 shows the options available when applying the Wood function to the shader channel.

To apply the Wood function to a shader channel:

1. Click to select the desired channel.

2. Click the blue button to the right of the channel and select Natural Functions ➪ Wood.

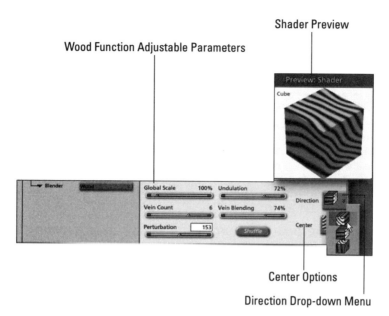

Figure 15-15: Applying the Wood function to a shader channel

3. A dialog box opens in a pane to the right of the shader channel. Choose from the following options to adjust the function's settings to suit your model:

- **Global Scale:** Adjusts the size of the wood grain pattern in relation to the object it's being applied to.

- **Vein Count:** Adjusts the number of veins in the pattern. Use high values to produce rich-looking surfaces with dense vein patterns.

- **Perturbation:** Adjusts the amount of waviness in the vein pattern. Higher settings produce erratic vein patterns that resemble knotty wood; lower settings produce smooth vein patterns.

- **Undulation:** Adjusts the frequency of the vein's undulation. Lower settings produce erratic, wildly undulating veins; higher settings produce gently rolling veins.

- **Vein Blending:** Adjusts the transition between individual veins and adjacent spaces. Use lower settings to simulate kiln dried wood and higher settings to simulate sappy green lumber.

- **Direction:** Choose a setting from this pop-up menu to set the orientation of the wood grain pattern to the object being shaded.

- **Center:** Choose from one of the three patterns in this pop-up menu to determine if the wood grain is taken from the center of the tree or farther from the center.

- **Shuffle:** Randomizes the pattern.

Note Astute readers may have noticed a Particle Shaders function. This is a specialized shader function that is used with Particle Emitters. This shader function is presented in conjunction with Particle Emitters in Chapter 18.

Shading objects with Pattern functions

Carrara's Pattern functions let you fill shader channels with intricate designs that run the gamut from a plain-Jane checkerboard pattern to a sixties' psychedelic pattern. These functions can be mixed and matched in different shader channels to achieve a wide variety of patterns. Spend a bit of time experimenting with the different Pattern functions and soon you'll become a master at subtle art of texturing with patterns.

Creating a checkerboard pattern with the Checkers function

The Checkers function adds a pattern of light and dark squares to the channel you apply it to. The resulting pattern looks much like a classic checkerboard. This function has many different uses depending on the shader channel in which it's placed. You can use the Checkers function to achieve results ranging from a striped pattern on a flat surface to a relief map for a brick wall.

To apply the Checkers function to a shader channel:

1. Click to select the desired channel.

2. Click the blue button to the right of the channel and select Pattern Functions ⇨ Checkers. A dialog box opens in a pane to the right of the shader channel.

3. Drag the Horizontal Count slider to adjust the number of horizontal squares.

4. Drag the Vertical Count slider to adjust the number of vertical squares (see Figure 15-16).

Tip To design a striped pattern, adjust one of the sliders to 0.

Creating abstract patterns with the Formula function

The Formula function is a math wizard's friend. For those of you not fluent in algebraic functions, it's best to apply subtle changes to the preset formula and hope for a happy accident.

To apply the Formula function to a shader channel:

1. Click to select the desired channel.

2. Click the blue button to the right of the channel and select Pattern Functions ⇨ Formula.

3. A dialog box opens in a pane to the right of the shader channel.

Shader Preview

Checkers Function Adjustable Parameters

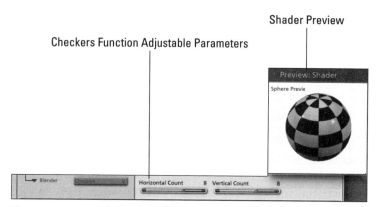

Figure 15-16: Applying the Checkers function to a shader channel

4. Adjust the function's settings to suit your model.

- Apply desired changes to the basic formula.
- Click the Parse button to apply the changes.
- Drag the P1 through P4 sliders to further adjust the formula.

Figure 15-17 shows the results of applying the Formula function to a shader channel.

Shader Preview

Formula Function Formula Editor

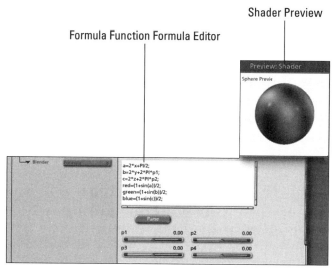

Figure 15-17: Applying the Formula function to a shader channel

Tip If you're mathematically challenged, you can still achieve interesting results by changing the numerical values in the basic formula and then adjusting the P1 through P4 sliders. Another area you can experiment with is replacing mathematical operators. Try replacing sin with cos or tan or sqrt. When you get a "happy accident," be sure to save it in the Shader Browser for future use.

Creating blended patterns with the Gradient function

The Gradient function blends. The most obvious use for the Gradient function is as a blender to mix colors in the Color channel. You can also use the Gradient function to good effect in the Transparency channel.

To apply the Gradient function to a shader channel:

1. Click to select the desired channel.

2. Click the blue button to the right of the channel and select Pattern Functions ⇨ Gradient.

3. A dialog box opens in a pane to the right of the shader channel. Adjust the function's settings to suit your model:

 • **Turbulence:** Jumbles the pattern as the colors change

 • **Direction:** Enables you to choose a vertical or horizontal blend

Figure 15-18 shows the results of applying the Gradient function to a shader channel.

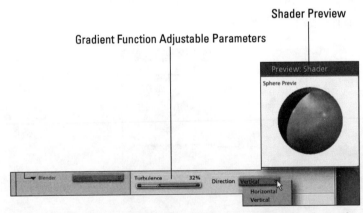

Figure 15-18: Applying the Gradient function to a shader channel

Creating abstract patterns with the Julia set function

The Julia set is an abstract fractal pattern that can be applied to a shader channel to add interesting designs to the surface of a 3D model. A Julia set pattern resembles fantasy dragon figures when mapped across the surface of a 3D object.

To apply the Julia set function to a shader channel:

1. Click to select the desired channel.

2. Click the blue button to the right of the channel and select Pattern Functions ⇨ Julia set. A dialog box opens in a pane to the right of the shader channel.

3. Drag the Top, Right, Bottom, and Left sliders to position the Julia set pattern on the object.

Figure 15-19 shows the results of applying the Julia set function to a shader channel.

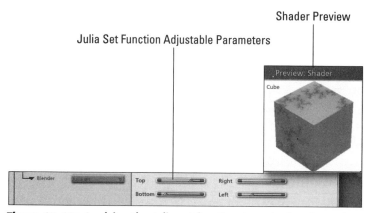

Figure 15-19: Applying the Julia set function to a shader channel

Creating abstract patterns with the Mandelbrot set function

The Mandelbrot set is an abstract fractal pattern based on the fractal geometry work of French mathematician Benoit Mandelbrot. A Mandelbrot set pattern resembles a delicate snowflake or the edge of an abstract lace doily.

To apply the Mandelbrot set function to a shader channel:

1. Click to select the desired channel.

2. Click the blue button to the right of the channel and select Pattern Functions ⇨ Mandelbrot set. A dialog box opens in a pane to the right of the shader channel.

3. Drag the Top, Right, Bottom, and Left sliders to position the Mandelbrot pattern on the object (see Figure 15-20).

Creating colorful patterns with the Psychedelic function

The Psychedelic function can be used to create colorful patterns reminiscent of the tie-dyed tee shirts and lava lamps of the sixties. The Psychedelic function can produce interesting swirling effects when used in animations. Psychedelic is a 3D function (see Figure 15-21).

Shader Preview

Mandelbrot Set Adjustable Parameters

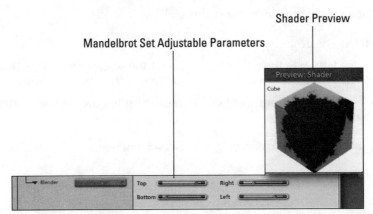

Figure 15-20: Applying the Mandelbrot set function to a shader channel

Shader Preview

Psychedelic Function Adjustable Parameters

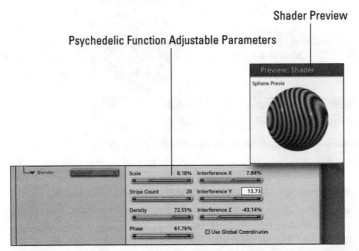

Figure 15-21: Applying the Psychedelic function to a shader channel

To apply the Psychedelic function to a shader channel:

1. Click to select the desired channel.

2. Click the blue button to the right of the channel and select Pattern Functions ⇨ Psychedelic.

3. A dialog box opens in a pane to the right of the shader channel. Adjust the function's settings to suit your model:

 • **Scale:** Adjusts the size of the elements

 • **Stripe Count:** Adjusts the number of elements

- **Density:** Adjusts the density of the pattern

- **Phase:** Adjusts the position in the Psychedelic function

- **Interference X**, **Interference Y,** and **Interference Z:** Adjusts the interference in each plane

- **Use Global Coordinates:** Causes the shading to remain static as the object it's applied to moves during an animation

Creating grid patterns with the Wires function

The Wires function creates a grid pattern by placing a lined pattern on the object being shaded. The Wires function can be used to create tile-like patterns on an object.

To apply the Wires function to a shader channel:

1. Click to select the desired channel.

2. Click the blue button to the right of the channel and select Pattern Functions ➪ Wires.

3. A dialog box opens in a pane to the right of the shader channel. Adjust the function's settings to suit your model:

 - **Horizontal Count:** Adjusts the number of horizontal wires

 - **Width:** Adjusts horizontal line width

 - **Vertical Count:** Adjusts the number of vertical wires

 - **Height:** Adjusts vertical line width

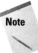

Note

The Vertical/Horizontal Width/Height settings are based on a percentage of the object's overall width/height. For example, if you set the Height slider to 50 percent and have 10 vertical lines, each line occupies 5 percent of the object's total height.

 - **Gray Scale:** Creates smooth transitions between the wires and adjacent spaces.

Figure 15-22 shows the results of applying the Wires function to a shader channel.

Tip

When you use any of the Natural or Pattern functions in the Color channel, you can create convincing surface relief by copying the Color channel's contents into the Bump channel. For example, use the Cellular function as a blender to mix a light and dark color in the Color channel. Copy the Color channel's contents into the Bump channel to create a bumpy skin surface on which the size and position of the bumps match the color pattern perfectly. To copy a channel's contents from one channel to another, click the channel with the contents you want to copy and then Ctrl+drag to the channel you want to copy to. When the outline of the copied channel is over the target channel, release the mouse.

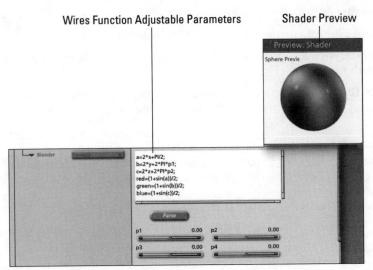

Figure 15-22: Applying the Wires function to a shader channel

Working the Four Elements shaders

The Four Elements shaders were designed primarily for use with Four Elements terrain objects. However, these versatile shaders can also be used to good effect on other objects. For example, you could use the Waves shader to create a pattern that simulates aged metal. The Snow shader could be used to simulate frost on an ice cream cone.

Simulating flame with the Fire shader

Use the Fire shader to simulate flame. Anything from a flickering candle flame to a turbulent log fire is possible with this shader. The most realistic simulation of flame is achieved when the Fire shader is used in the Transparency and Glow channels.

To apply the Fire shader to a shader channel:

1. Click to select the desired channel.

2. Click the blue button to the right of the channel and select Four Elements Shaders ➪ Fire.

3. A dialog box opens in a pane to the right of the shader channel. Adjust the function's settings to suit your model:

 • **Color swatch:** Click the Fire shader color swatch or the arrow to the right of it to choose a flame perimeter hue from the Color Picker.

- **Turbulence:** Adjusts the flame's turbulence. Low settings simulate a candle flickering in a light breeze; high settings simulate a raging fire.

- **Completion:** This setting is used in animation. A typical setting would be 0 percent for the first frame and 100 percent for the last frame.

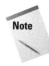

Note When used in multiple channels, Fire shader Completion settings should be identical in each channel.

- **Shuffle:** Randomizes turbulence

- **Transparency:** Enable this option when using this shader in the Transparency channel.

Figure 15-23 shows the results of applying the Fire shader to a shader channel.

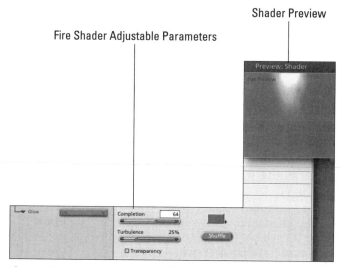

Figure 15-23: Use the Fire shader to simulate flame.

Simulating snow with the Snow shader

Applying the Snow shader to a shader channel simulates a snow effect. You can apply snow to positive or negative sloping surfaces.

To apply the Snow shader to a shader channel:

1. Click to select the desired channel.

2. Click the blue button to the right of the channel and select Four Elements Shaders ⇨ Snow.

3. A dialog box opens in a pane to the right of the shader channel. Adjust the function's settings to suit your model:

- **Snow Covers Positive Slope:** Applies snow to positive slopes
- **Snow Covers Negative Slope:** Applies snow to negative slopes

Check both boxes to apply snow to positive and negative slopes.

Figure 15-24 shows the results of applying the Snow shader to a shader channel.

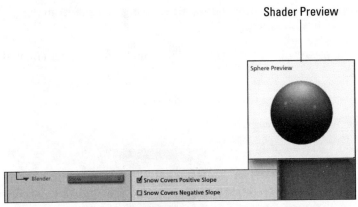

Figure 15-24: Applying the Snow shader to a shader channel

Creating rippled patterns the Ripple shader

Apply the Four Elements Ripple shader to an object to simulate a rippled surface. This shader works best in the Bump channel. You can also use it as a blender to mix two colors in the Color channel to create interesting surface patterns.

To apply the Ripple shader to a shader channel:

1. Click to select the desired channel.

2. Click the blue button to the right of the channel and select Four Elements Shaders ➪ Water: ripples.

3. A dialog box opens in a pane to the right of the shader channel. Adjust the function's settings to suit your model:

- **Completion:** This option is used in animation. Set the first frame at 0 percent and the last frame at 100 percent.
- **Scale:** Adjusts the spacing of the ripples.
- **Amplitude:** Determines the height of the ripples. When applied to the Bump channel, higher settings produce deeper ripples.

- **Damping:** Adjusts how the ripples fade away as they move from the center. Higher settings produce a greater fadeaway effect.

- **Center H** and **Center V:** Set the horizontal and vertical centers of the ripples.

- **Perturbation:** Adjusts the amount of distortion in the ripples. Use lower settings on smaller objects.

Figure 15-25 shows the results of applying the Ripple shader to a shader channel.

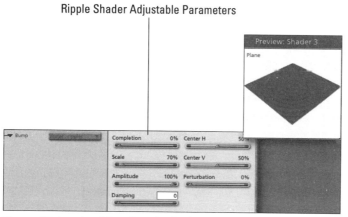

Ripple Shader Adjustable Parameters

Figure 15-25: Applying the Ripple shader to a shader channel

Simulating water motion with the Wave shader

Use the Wave shader to put motion in your ocean. The Wave shader works best in the Bump channel. You can also use the Wave shader to create interesting surface patterns by using it as a blender to mix two colors in the Color channel.

To apply the Waves shader to a shader channel:

1. Click to select the desired channel.

2. Click the blue button to the right of the channel and select Four Elements ➪ Water: waves.

3. A dialog box opens in a pane to the right of the shader channel. Adjust the function's settings to suit your model:

 - **Completion:** This option is used in animation. Set the first frame at 0 percent and the last frame at 100 percent.

 - **Global Scale:** Adjusts the spacing of the waves. Low values produce small, closely spaced waves; high settings produce fewer, widely spaced waves.

- **Compute Interferences:** Controls interaction between waves. When this option is checked, waves can eliminate each other.

- **Perturb Values:** Adds greater depth to waves.

4. You can add up to three wave sets to your shader. To add a wave set, check the wave set's Enable option.

5. Each wave set you add has the following parameter settings to which you can make changes:

- **Angle:** Adjusts the orientation of the wave.

- **Amplitude:** Adjusts the height of the wave.

- **Scale:** Adjusts wave ripple frequency.

- **Perturbation:** Adjusts the amount of distortion in the wave. Higher settings produce frothy, agitated waves.

Figure 15-26 shows the results of applying the Wave shader to a shader channel.

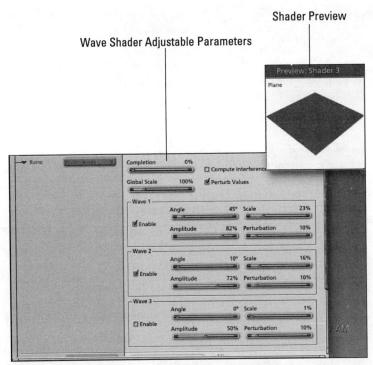

Figure 15-26: Applying the Wave shader to a shader channel

Creating Custom Shaders

To create custom shaders to texture your models, you fill some or all of the Shader Tree Editor's channels with components and functions. The individual components with which you fill each channel will depend on the effect you're trying to achieve. The type of object you're shading will determine whether or not you need to fill a channel with a component, function, or operator.

Pick up an apple and examine it. The surface of the apple is colored with subtle variations of red with perhaps a hint of green. If it's a Washington Red Delicious apple, it's shiny with sharp highlights. If it's a Granny Smith apple, it's dull with large highlights.

To shade the red apple, mix shades of red in the Color channel and blend them with the Cellular or Spots function. The red apple would have a high value in the Highlight and Shininess channels.

To shade the green apple, mix shades of green in the Color channel and blend them with the Cellular or Spots function. The green apple would have a low value in the Highlight and Shininess channels.

How would you shade a golf ball? It's white, it's shiny, and it's got dimples. The golf ball's attributes dictate an approach like this one: Fill the Color channel with a shade of white, adjust the Value slider in the Highlight and Shininess channels to high settings, and fill the Bump channel with a custom texture map.

Now that you've got an idea of the power of the Shader Tree Editor, it's time to explore the individual channels you'll use to texture your 3D masterpieces.

Exploring the Color channel

The Color channel has the greatest effect on the outward appearance of your model. The contents of this channel determine how light and shadow affect the model. You can use this channel to apply a simple wash of color to an item or create an intricate pattern of different colors.

Texture maps produce excellent results in the Color channel. A detailed texture map can often duplicate effects not otherwise possible with conventional shader operators and functions.

The Mixer operator also produces excellent results in the Color channel. Place a different color in each source and then blend them with any of the Pattern or Natural functions. You can mix two colors and blend them with a texture map to achieve interesting results. Source 1 will be applied to dark areas of the texture map, and Source 2 will be applied to light areas.

Tip If single colors look bland or artificial when applied to an object, place the Mixer operator in the Color channel and fill each source with different variations of the desired hue. Blend the colors with the Spots function. Drag the Spot Size and Blending sliders to complete the effect while viewing the results in the Shader Preview window.

Exploring the Highlight channel

The contents of the Highlight channel determine how light interacts with the surface of your model. Objects in nature show bright spots or reflections when light reflects off them.

Use the Value operator in the Highlight channel to adjust the intensity of the highlight. To simulate objects such as dull plastic, use low settings. To simulate objects such as metal, use high settings. Highlights are white by default. Use the Shader Preview window to view the results of your changes.

Tip Sometimes you can get a better idea of what your shader looks by previewing it differently. For example, if you're applying a marble texture to a sphere, it's hard to see the intricacies of the pattern because the Shader Preview window hides the back half of the sphere. To solve this problem, click the current preview mode in the Shader Preview window. Choose a new preview mode from the pull-down menu (see Figure 15-27).

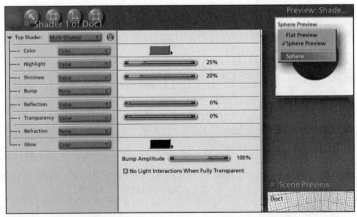

Figure 15-27: Change preview modes to get a better idea of what the shader looks like.

To highlight complex models such as a rusty wrecking ball, it may be necessary to fill the Highlight channel with a custom texture map. Other models such as a gold-colored watch may respond best to colored highlights.

Exploring the Shininess channel

The Highlight and Shininess channels work hand in hand to determine how light reacts to your shaded model. Using a low setting in the Shininess channel results in a large diffuse highlight. Using a high setting in the Shininess channel results in a small highlight.

If certain parts of the object you're shading need to be shiny but others dull, use a texture map in the shininess channel. For example, a texture map could be used to good effect when simulating a partially rusted object. Fill the Color channel with a texture map of a partially rusted object and then place copies of it in the Shininess and Highlight channels. If the shiny parts of the texture map aren't showing as shiny or highlighted in the Shader Preview window, check the texture map's Invert Color option in the Shininess and Highlight channels.

Exploring the Bump channel

The contents of the Bump channel can be used to simulate surface relief on a model. The components you place in the Bump channel alter the way light hits the surface of the model, tricking the eye into believing the surface is raised or indented. By applying the proper component to the Bump channel, you can simulate surface characteristics that would be extremely difficult to model. This technique works well when objects are viewed head on. If you need to show surface relief in silhouette, you'll have to resort to one of the modelers. Any of the Pattern or Natural functions work well in the Bump channel.

Texture maps are an excellent way to add bumps to the surface of a model. When you assign a texture map to the Bump channel, light areas appear to raise the surface of the object, whereas dark areas appear to lower it. A grayscale texture map works best in the Bump channel. If you apply a color texture map to the Bump channel, it is converted to grayscale values.

Tip

If you are creating a bump map in a 2D editing program, it's best to apply a Gaussian filter to slightly blur the image before exporting it. A texture map with a wide range of darks and lights may create harsh transitions if not blurred.

To change the amount of bumping applied to your model, drag the Bump Amplitude slider to the right to increase or to the left to decrease bumping. The Bump Amplitude slider can be found at the bottom of the Shader Tree Editor.

Exploring the Reflection channel

The Reflection channel makes it possible to control surface reflections. Objects such as shiny metal, mirrors, and polished wood are highly reflective.

The Value slider can be used to adjust a model's surface reflection characteristics. Use higher settings to simulate reflective objects like mirrors or polished metals.

You can also adjust an object's reflective characteristics by using the Color component in the Reflection channel. Pick a hue that's close to the object's color to create a surface that's reflective, but doesn't appear washed out.

If you're simulating a metal like chrome, use the Color component in the Color channel and choose pure black. Use the Value component in the Reflection channel and adjust the slider to a very high setting. The Color component could also be used in the Reflection channel if you're simulating a colored chrome surface. As black is the absence of all color, when this shader is applied to an object, the object will reflect all colors. Adjust the slider to 100 percent to create a mirror shader.

To precisely control an object's reflection, consider using a texture map in the Reflection channel.

Tip

A mixer works quite well in the Reflection channel. Mix two colors in the Color channel and use one of the Pattern functions to blend them. In the Reflection channel, insert the Mixer component. For Source 1, use the Color component and use the Color Picker to select one of the colors you mixed in the Color channel. For Source 2, use the same Pattern function you used in the Color channel. For the Blender, use the Value component. By dragging the slider right or left, you can vary the amount of reflection for one color and not the other.

Exploring the Transparency channel

Transparency determines the amount of light that passes through an object. Objects such as water, glass, and translucent plastic all have varying degrees of transparency. You can adjust an object's transparency by using components in the Transparency channel.

The default component for the Transparency channel is the Value slider. Increasing the slider's value increases an object's transparency. You could also use a Pattern function such as Wires in the Transparency channel to create transparent grid on an object. You could also use a texture map in the Transparency channel to create voids that would be difficult, if not impossible, to create in a modeler.

Exploring the Refraction channel

When light passes through a semitransparent object, its path is deflected. This phenomenon distorts the appearance of all objects behind it, and is known as *refraction*. Objects such as water, glass, and other semitransparent materials exhibit varying degrees of refraction.

To simulate refraction, use the Refraction channel's default Value slider. Drag right to increase refraction. To simulate glass, use a refraction value of about 15 percent. Ice and water have slightly lower values. Experiment with different refraction values to achieve the effect you're looking for.

Exploring the Glow channel

Objects that glow have their own luminance. Use the Glow channel to create shaders that glow in the dark. Glowing shaders can be used to highlight objects in dark rooms or create glowing neon signs or flickering neon LCDs. Glowing objects don't cast light upon other objects in the scene, nor are they capable of creating shadows.

The best choices for filling the Glow channel are the Color and Texture Map components. If you're using color in both the Color and Glow channels, choose a similar color for best results. A color's hue determines the color of the glow and a color's intensity determines the brightness of the glow.

Tip To create a shader that simulates a TV screen glowing in a dark room, insert a Value component into the Color channel and set it to 0. Insert a Mixer component in the Glow channel. In Source 1, insert the texture map that will be the image on the TV screen. In Source 2, insert a Value slider. For the Blender, use a Value slider. Adjust the settings of the two Value sliders to vary the brightness of the texture map. To use a glowing TV screen in an animation, substitute a movie for the texture map.

Now that you've explored the Shader Tree Editor, its functions, and components, it's time to branch out and do some exploration on your own.

One of the best ways to learn how to create your own shaders is to analyze the preset shaders that ship with Carrara. Create a sphere and assign one of the preset textures to it. Then click the Texture icon to enter the Texture room. Analyze each shader channel to see which component, function, or operator was used in it. Ask yourself why this particular component, function, or operator was used. This will start to give you more insight on the process of texturing 3D models with the Shader Tree Editor.

After you've analyzed a shader, change the components or setting used in each channel to see what effect your changes have. If you end up creating a "happy accident," be sure and save it in your Shader browser.

The next step is to model some objects and experiment with creating your own shaders. Shading isn't alchemy or black magic. It's a lot of fun and can be exceptionally rewarding.

Summary

The Shader Tree Editor has components, functions, and operators that are used to texture 3D models. The Shader Tree Editor's capability to branch out makes it possible to create complex shaders that can be used to effectively simulate real-world textures.

✦ The Cellular function makes it possible to simulate objects such as leather, lizard skin, and plant cells.

✦ Texture maps make it possible to simulate complex surfaces.

✦ The Bump channel makes it possible to simulate surface relief.

✦ The Glow channel makes it possible to create glowing shaders, which give objects luminance in dark settings.

✦ ✦ ✦

Texturing with Layers

Using the Shader Tree Editor to fill shader channels with components, functions, and operators is the standard method of texturing models in Carrara. As discussed in Chapter 15, the Shader Tree Editor can create wonderfully complex textures and patterns to apply to your models. These textures and patterns are precisely mapped across the entire surface of your model. Although the results look quite convincing, it's very rare that you find an object in nature without some variations in surface texture. Even man-made objects exhibit variations in surface texture after being subjected to nature. Rusted metal is a good example of this. Layers make it possible for you to mimic variations in an object's surface color or texture by placing layer shapes on the model where the imperfection occurs.

Adding Layers to a Model

Layers are applied to an object's surface in the Texture room. When you drag one of the layer tools across your model, you create a layer. It may help to think of a layer as an individual brush stroke applied over an object with a primed surface. Another brush stroke would add another layer, and so on. These individual brush strokes become part of the object's surface, just as layers become part of the 3D object's shader.

Adding a layer creates another branch to the Shader Tree. The default Multi Channel shader converts to a Layers List shader. The top branch on the Shader Tree now designates the mapping mode for the shader. Figure 16-1 shows the Shader Tree Editor in Layers List mode.

Cross-
Reference
For more information on mapping modes, refer to Chapter 17.

Layer's Opacity Mask channel

Layer's Shader channel

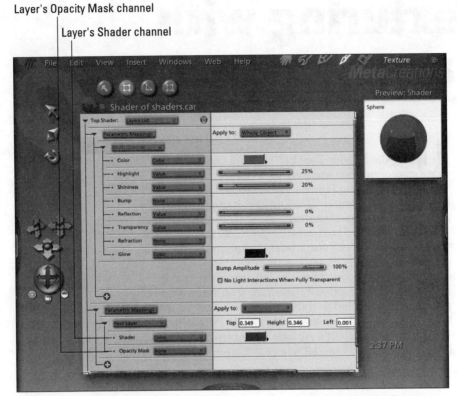

Figure 16-1: Adding a layer to an object creates a Layers List on the Shader Tree

Carrara provides you with three layer shapes (rectangle, oval, and polygon) to apply to your models. The default position of the Layers tools is to the left and directly above the Shader Tree (see Figure 16-2).

Select Layer tool

Rectangle Layer tool

Polygon Layer tool

Oval Layer tool

Figure 16-2: Add layers to a shader with these Layer tools.

Adding a rectangular layer

The Rectangle Layer tool, accessible through the second button on the Layers toolbar, lets you create rectangular layers on the surface of your model.

To create a rectangular layer:

1. Click the Rectangle Layer tool.

2. Drag it across the surface your model in the Shader Preview window. As you drag, a rubber band preview box defines the borders of the rectangle.

3. After creating the shape, a Rect Layer channel is added to the Shader Tree (see Figure 16-3).

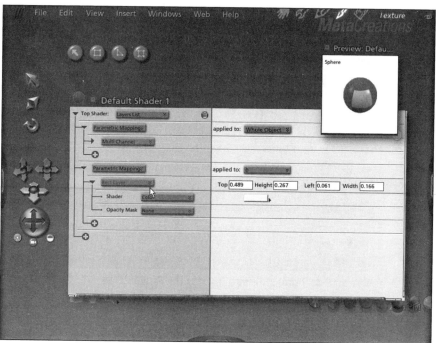

Figure 16-3: Adding a rectangular layer to the Shader Tree

Adding an oval layer

The Oval Layer tool, accessible through the fourth button on the Layers toolbar, lets you create elliptically shaped layers on the surface of your model.

To create a oval layer:

1. Click the Oval Layer tool.

2. Drag it across the surface your model in the Shader Preview window. As you drag, a rubber band preview box defines the borders of the oval.

3. After creating the shape, an Oval Layer channel is added to the Shader Tree (see Figure 16-4).

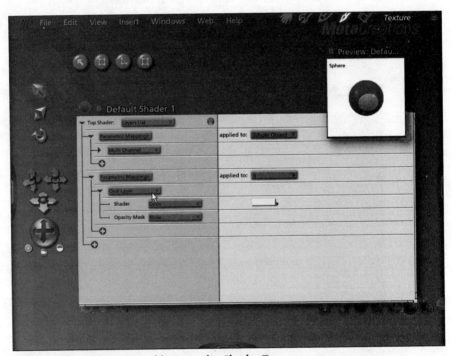

Figure 16-4: Adding an oval layer to the Shader Tree

Note When you add a layer to an object, Carrara follows the shortest path between one corner of the layer's bounding box and the opposite corner of the layer's bounding box, which places the layer across the front of the object. To wrap the layer around the back of the object, press the Alt key while dragging.

Adding a polygon layer

The Polygon Layer tool, accessible through the third button on the Layers toolbar, lets you create irregularly shaped layers on the surface of your model.

To create a polygon layer:

1. Click the Polygon Layer tool.

2. Click the surface of your model in the Shader Preview window to add a point. Add additional points to define the layer's shape. Click the first point to close the shape. You may find it helpful to increase the size of the Shader Preview window when applying a polygon layer. A larger window makes it easier for you to see the individual points as you create them. To enlarge the Shader Preview window, click the round white tab at the lower-right corner of the window and drag.

3. After creating the shape, a Polygon Layer channel is added to the Shader Tree (see Figure 16-5).

Polygon layer

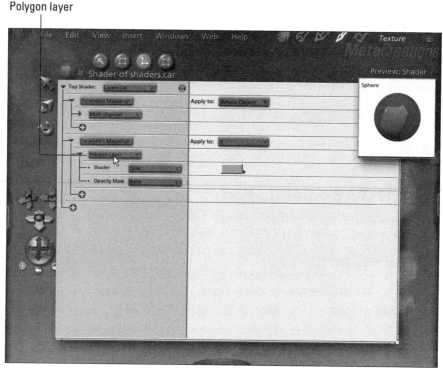

Figure 16-5: Adding a polygon layer to the Shader Tree

Tip When you start adding layers to the Shader Tree, it branches out and becomes quite large. If you're through editing a particular channel or layer, click the triangle to its left to collapse it and shrink the size of the Shader Tree.

To add a layer directly to the Shader Tree:

1. Click the default Multi Channel button on the Top Shader branch of the Shader Tree.

2. From the drop-down menu select Complex Shaders ➪ Layers List. The Shader Tree now becomes a Layers List. At the bottom of the Layers List is a large plus sign.

3. Click the plus sign and choose one of the mapping options from the drop-down menu to add a layer to the list. The plus sign becomes a blue button with the selected mapping mode displayed on its face. To change to a different mapping mode, click the blue button and select a new mode from the drop-down menu.

4. Click the plus sign below the selected mapping option and choose one of the shapes from the drop-down menu.

5. Adjust the layer's numerical properties to size and position the layer.

6. Click the blue button to the right of the layer's shader channel and select a shader component, operator, or function from the drop-down menu.

7. Click the blue button to the right of the layer's Opacity Mask channel and select a component, operator, or function from the drop-down menu.

Selecting a paint layer

The first button on the Layer Shapes toolbar is used to select layers. You use this tool when you have an object with multiple layers.

To select a layer:

1. Click the Select Layer tool.

2. In the Shader Preview window, click the shape you want to modify to select it.

Tip To get a better view of your shaded model, click and drag the circular white tab in the lower-right corner of the Shader Preview window and drag to increase its size.

Removing unwanted layers

To the right of the Layers List button, notice a little button that looks like a trashcan. You use this tool to remove unwanted layers.

To delete a layer:

1. Click the unwanted layer on the Shader Tree to select it. The selected layer is now highlighted in yellow.

2. Click the Trashcan button to remove the layer from the list.

Alternatively, follow these steps:

1. Click the layer on the Shader Tree to select it.

2. Press the Delete key.

Here's yet another method to delete a layer:

1. Click the Select Layer tool.

2. Inside the Shader Preview window, click the layer you want to remove.

3. Click the Trashcan button.

Painting Surface Relief on a Model with Layers

After you've added a layer to the Shader Tree, you have two channels to fill: Shader and Opacity Mask. These channels interact with the channels of the underlying shader to create the final appearance of the object you're shading. The contents of the Layers List's shader channel determines what the layer actually looks like. The Layers List's Opacity Mask channel is used to determine how much if any of the underlying shader is visible through the layer.

When you have more than one layer applied to an object, a hierarchy evolves. The contents of the top layer take precedence over any layers applied underneath it. When layers overlap, the top layer blocks out the overlapped area of the lower layer unless you have applied an opacity mask. In addition, the contents of the top layer's shader channels will override the channels of the underlying base shader. The exception to this rule is when you fill the layer shader's Opacity Mask channel. Then you can let varying amounts of the underlying shader peek through the surface of the top layer. For example, if you apply red to the color channel of the underlying shader and fill the layer shader's color channel with yellow, the layer will appear yellow. If you fill the layer shader's Opacity Mask channel with a Value slider (see Figure 16-6), you can move the slider towards the middle to let varying amounts of red shine through to create shades of orange.

Opacity Mask channel

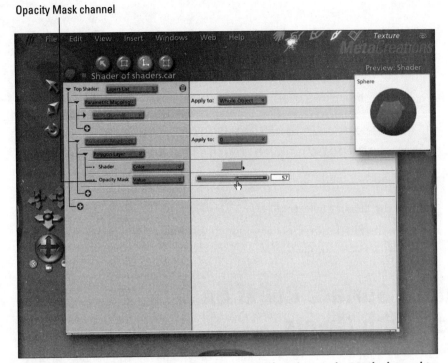

Figure 16-6: Applying the Value component to a layer's Opacity Mask channel to let the underlying color shine through

If, however, you leave the contents of one or more of a top layer's shader channels empty, the contents of those channels in the underlying shader will prevail. For example, if the base shader has a filled Bump channel and the layer shader does not, the bump from the base shader will carry over to the top layer, creating a bumpy layer. If you need a smooth layer applied over a bumpy surface, specify a Multi Channel shader for the layer's shader and fill the Bump channel with the Value component. Adjust the slider to any setting and none of the underlying shader's Bump channel will be visible in the layer because you have applied a constant value to the channel (see Figure 16-7).

When choosing the contents for a layer's shader channel, consider the overall effect you're trying to achieve. If you just need to simulate one effect on a layer's surface, add a single channel to the layer's shader. If you're looking to create a complex effect like the dimpled surface of an object decorated with a painted design, add the Multi Channel component to the layer's shader channel and fill the appropriate channels to achieve the effect you're after. Remember that if you leave a channel empty in the top layer's shader, the underlying channels will take precedence. Creating a complex Multi Channel shader for a layer involves the same techniques you learned in Chapter 15.

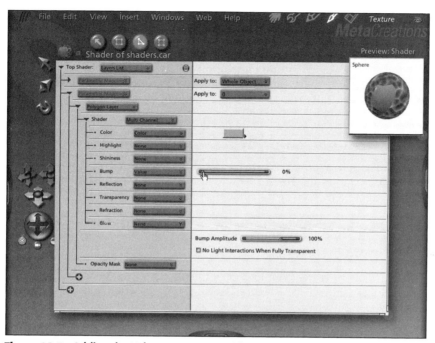

Figure 16-7: Adding the Value component with a constant value to the layer shader's Bump channel will produce a smooth layer over an otherwise bumpy surface.

Simulating Scratched Metal Surfaces

To simulate a scratched metal surface, use your favorite photo-paint program to create an image with a jagged streak of colored paint surrounded by white.

1. Name the image "Scratch map" and save it.

2. In Carrara, open the model you want the scratch to appear on.

3. In the Texture room, apply a rectangular layer to the object where you want the scratch to appear.

4. In the layer's shader channel, add the Multi Channel component.

5. Fill the layer shader's Color channel with the texture map component and open up the scratch map.

6. Check the texture map's White is Invisible option.

7. Copy the Color channel's texture map into the Bump channel to apply the scratch.

Organizing Layers

Models with complex surface textures and multiple layers often need a bit of fine-tuning to make everything line up properly. By using the Shader Tree Editor in conjunction with the Select Layer tool, you'll be able to effectively organize all the layers and create the dazzling effect you're after.

Moving and resizing layers

Once you've added layers to the surface of an object, you need to move them into their proper positions and resize them to fit the model you're shading. You can use either the Select Layer tool or the Shader Tree Editor to accomplish these tasks.

To move a layer with the Select Layer tool:

1. Click the Select Layer tool.

2. In the Shader Preview window, click the center of the desired layer to select it and drag to move it (see Figure 16-8).

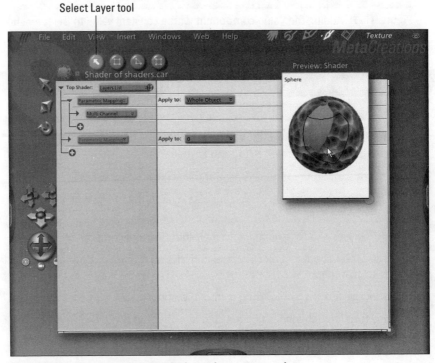

Figure 16-8: Moving a layer with the Select Layer tool

To resize a layer with the Select Layer tool:

1. Click the Select Layer tool.

2. In the Shader Preview window, click the desired layer and drag one of the bounding box handles to resize (see Figure 16-9). The bounding box handles are small dots at the corners of the shape. If you are editing an oval layer, the dots appear beyond the boundary of the shape at the corners of an invisible rectangle the length and width of the oval.

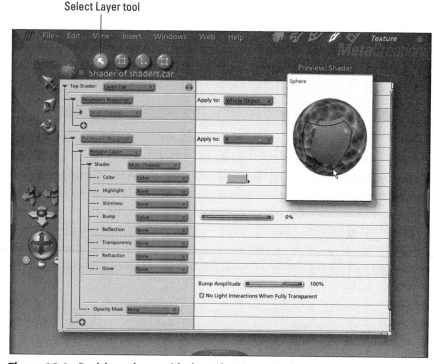

Figure 16-9: Resizing a layer with the Select Layer tool

To move or resize a layer using the Shader Tree Editor:

1. Click to select the desired layer from the Shader Tree's Layers List. To the right of the layer's button, notice settings for Top, Height, Left, and Width.

2. Enter the desired settings to move or resize the layer (see Figure 16-10).

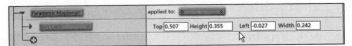

Figure 16-10: Numerically changing a layer's size and position using the Layers List

Tip To understand how the layer's numerical properties relate the layer's actual size and position on the object, drag and resize the layer with the Select Layer tool and observe how each property changes in the Layers List.

Changing layer hierarchy

As you learned earlier, the top layer's shader supersedes the shaders of all layers beneath it. Occasionally you may need to promote or demote a layer's rank in the hierarchy. An example of this would be when you have a blue layer applied atop a green layer. Wherever the blue layer overlaps the green layer, you see blue on the object's surface. If during additional shader editing you decide the object would look better with the green layer on top, it's easy to reverse the order using the Layers List. To change layer hierarchy, just click the desired layer on the Layers List, and drag it to a new position on the Shader Tree.

Caution If you have only two layers on the Layers List and need to reorder them, drag the top layer down. If you drag the bottom layer up, the top layer disappears. If you inadvertently make a layer disappear, select Edit ➪ Undo Set Shader (Ctrl+Z), and the layer will appear again.

Applying Decals to a Model with Layer Tools

In addition to using layers to add texture and color to specific areas of a model, you can also use them to apply logos or decals to a model. Imagine that you modeled a WWII fighter plane and wanted to add that extra bit of realism by including a painting of a poster girl on the fuselage. Either a scanned photo or an image created in a photo-paint program would produce excellent results. If the image you're applying has an irregular shape, isolate it by using the photo-paint program's masking capabilities and fill the surrounding area with white. To apply the decal to the model, create a layer on the plane's fuselage and fill the layer's shader channel with the Texture Map component. Check the White is Invisible option, and the smiling poster girl will be displayed on your model airplane.

Adding a label to a soup can

Now that you understand how layers interact with an object's base shader, it's time to put this knowledge to practical use. In this exercise, you paste an imaginary soup company's label onto a can. If you're adept at working with photo-paint programs, create a label that's 200 pixels wide by 300 pixels high, or use the label (soup.tif) provided in this chapter's folder in the Contents section of the book's CD-ROM.

1. Create a cylinder in the Assemble room. (If you need a refresher course on creating cylinders, refer to Chapter 4.)

2. Drag open the Properties tray and click the Motion/Transform button. Change the cylinders dimensions to X = 6.00, Y = 6.00, and Z = 8.50.

3. Click the Texture icon to open the Texture room.

4. Apply the following settings to the base shader:

 • In the Color channel, enter your favorite color.

 • In the Highlight and Shininess channels, enter a value of 75 percent.

 • Leave the rest of the channels at their default settings.

5. Select the Rectangle Layer tool, and in the Shader Preview window, drag the tool across the face of the soup can. Find the new Rect Layer in the Layers List and change the layer's height to .30 and its width to .20 (see Figure 16-11).

Tip

When you create an image to use as a decal, always change the layer's height and width to match the image's proportions. For example, the soup.tif file created for this tutorial is 200 pixels wide by 300 pixels high. In step 5, the layer's size was changed to .20 wide by .30 high.

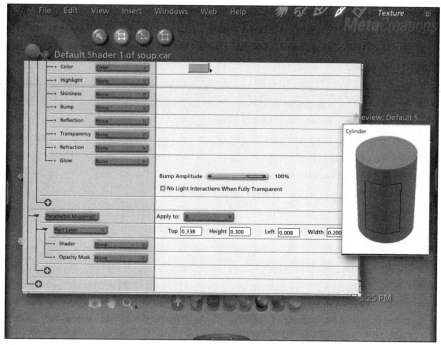

Figure 16-11: The partially completed soup can with a rectangle layer applied

6. Click the blue button for the layer's shader channel and select Texture Map component. Click the folder button and locate the image file you created for the can's label. Click Open. The Choose File Format dialog box appears. Click OK to apply the label. If the label doesn't align correctly on the can's surface, click the appropriate buttons to the left of the Texture Map preview window to flip or rotate the image (see Figure 16-12).

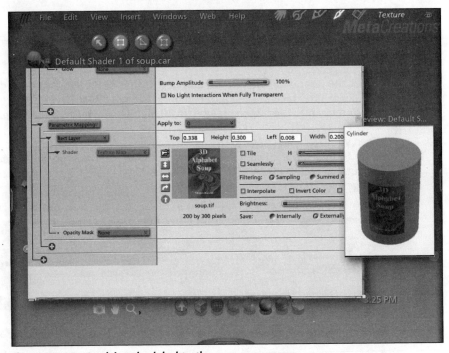

Figure 16-12: Applying the label to the can

7. Click the Assemble icon to return the model to the Assemble room for lighting adjustments before rendering.

Figure 16-13 shows the completed rendering of the soup can.

Great work! Who says adding realism to models has to be difficult? Now that you understand how to use layers to add creative touches to your modeling, you're encouraged to experiment on your own. Model an object and then add different layer shapes to its surface. Add different components to the layer's shader channel to see the overall effect it has on the model's surface. Try your hand at adding the Multi Channel component to the layer's shader channel and add different components or functions to each of the layer Shader's channels. As you experiment, your overall knowledge of layers and shaders will increase. Pretty soon, you'll be producing 3D scenes with unparalleled realism that will leave your friends and colleagues speechless. Your newfound skill in texturing may leave you speechless, too.

Figure 16-13: The rendered soup can

Summary

Layers help you create splashes of localized color and texture on a 3D model's surface.

+ Layer shapes can be resized and moved manually or numerically.

+ Layer shaders supersede an object's base shader unless one or more of a layer's shader channels is left empty.

+ The layer shader's Opacity Mask channel makes it possible to combine the effects of the base shader with the layer shader.

+ Layer shaders can be used to apply corporate logos or decals to models.

+ The Layers List gives you complete control over all layers applied to a model.

✦ ✦ ✦

Advanced Shading Techniques

◆ ◆ ◆ ◆

In This Chapter

Understanding mapping modes

Shading with Multi Channel Mixers

Creating realistic shaders

Achieving special effects with texture maps

Shading with movies

◆ ◆ ◆ ◆

A good 3D scene is a combination of many things: meticulous modeling, intricate lighting, careful camera placement, and interesting textures. If a scene's occupants are textured with dull, drab shaders, the rendered image will lack visual impact.

Previous chapters discussed the various components that are added to Shader Tree channels to create textures. The various components you add to each channel combine to produce a shader that when applied to an object determines how the object interacts with a scene's lighting. Components can be mixed and matched as you choose and blended with different operators to produce both real and surreal effects. Now it's time to take your knowledge of shaders to the next level.

Understanding Mapping Modes

Most objects you create in Carrara will work well with the Shader Tree Editor's default mapping mode, parametric mapping. When an object is created in a native modeler, Carrara takes care of all the computations and does a good job of mapping the texture to the object. The notable exception would be a complex object created in either the Vertex or Metaball modeler.

Note Within the Vertex modeler, you have the ability to create a custom map using the modeler's available UV mapping options. All vertex objects with custom maps should use the Shader Tree Editor's default mode of mapping; otherwise, the mapping changes made in the Vertex modeler will be erased.

Projection mapping takes a shader's surface information and maps it around an object based on the type of mapping mode you choose. For example, spherical mapping projects the shader onto an invisible sphere primitive, which surrounds the object. The information is then mapped from the imaginary sphere to the object itself.

You have four projection mapping modes to choose from:

✦ **Cylindrical:** Works well on objects such as oil drums and paint cans. When you specify cylindrical mapping, you can choose the axis the shader aligns with.

✦ **Flat:** Works on geometric shapes such as boxes. When you specify flat mapping, you can choose whether the shader aligns with a specific face or the whole box.

✦ **Parametric:** Works well on a variety of 3D objects. Parametric mapping is Carrara's default method of mapping a shader to an object. When you choose parametric mapping, each pixel of shader information aligns with a specific point on the object's surface.

✦ **Spherical:** Works well on objects such as beach balls. When you choose spherical mapping, you can choose the axis with which the shader aligns.

Changing mapping modes

You'll want to change mapping modes when a shader that you've applied to an object doesn't look quite right. Before deciding which mapping option to apply, examine the object you're shading and choose a mode that closely resembles its shape.

To apply cylindrical mapping:

1. Click Top Shader ⇨ Projection Mapping ⇨ Cylindrical Mapping. The Top Shader mode changes to Cylindrical Mapping.

2. Click the Apply to button and choose an option (see Figure 17-1).

Note　In most cases, you want to apply cylindrical mapping to the whole object.

3. Select an axis to align the shader to it. The first button aligns the shader with the X axis. The second button aligns the shader with the Y axis. The third button aligns the shader with the Z axis.

4. Preview the shaded object in the Shader Preview window.

5. Click the Assemble icon to return the object to the Assemble room.

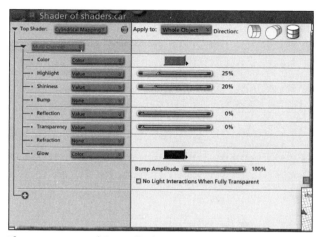

Figure 17-1: Applying cylindrical mapping to an object

To apply flat mapping:

1. Click Top Shader ⇨ Projection Mapping ⇨ Flat Mapping. The Top Shader mode changes to Flat Mapping.

2. Click the Apply to icon and choose an option (see Figure 17-2).

Figure 17-2: Applying flat mapping to an object

3. Select a face to apply the shader to, or choose the whole box. Each button aligns the shader using a different option. Hold your cursor over the button and a ToolTip appears, telling you which option the button will apply.

4. Click the Assemble icon to return the object to the Assemble room.

To apply spherical mapping:

1. Click Top Shader ⇨ Projection Mapping ⇨ Spherical Mapping. The Top Shader mode changes to Spherical Mapping.

2. Click the Apply to button and choose an option.

Note

In most cases, you want to apply spherical mapping to the whole object.

3. Select the axis to which you want to align the shader (see Figure 17-3). The first button aligns the shader to the X axis. The second button aligns the shader to the Y axis. The third button aligns the shader to the Z axis.

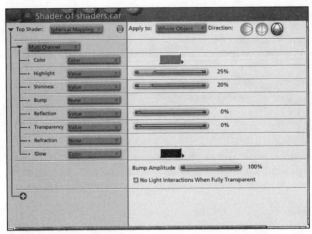

Figure 17-3: Applying spherical mapping to an object

4. Preview the shaded object in the Shader Preview window.

5. Click the Assemble icon to return the object to the Assemble room.

Shading with Multi Channel Mixers

A Multi Channel Mixer mixes two sources to produce a complex shader. Complex shaders are often used to put the finishing touches on an intricately detailed model. A Multi Channel Mixer makes it possible to blend two shaders with different surface characteristics.

When you add a Multi Channel Mixer to the top of the Shader Tree, three nodes are added. The two source nodes are mixed with the blender node to create the final shader. The source nodes can be either Complex shaders or Multi Channel shaders. A Multi Channel shader applied to a source node is composed of the standard eight shader channels: Color, Highlight, Shininess, Bump, Reflection, Transparency, Refraction, and Glow. These channels can be filled with any component or function that you desire. The beauty of the Multi Channel Mixer is that you can blend different components in each source node of the shader. It's an ideal way to mix rough and smooth textures on alternating parts of an object's surface. You could create a shiny surface immediately adjacent to a dull one. In addition, the shiny surface could have a smooth texture and the dull surface a bumpy one. The

surfaces could be two different colors or two different patterns. You could even apply different texture maps to each Multi Channel node and blend them with the Checkers function.

To create a Multi Channel Mixer:

1. Select the object to which you want to apply the mixer.

2. Click the Texture icon to open up the Texture room.

3. Click the Top Shader's default Multi Channel button and select Complex Shaders ⇨ Multi Channel Mixer. The Top Shader's default Multi Channel is replaced with Source 1, Source 2, and Blender (see Figure 17-4).

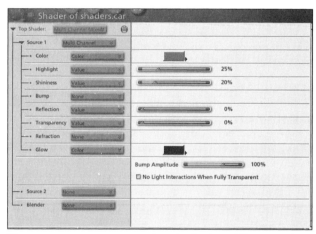

Figure 17-4: Create a complex shader by adding a Multi Channel Mixer to the root of the Shader Tree.

4. Depending on your needs, fill Source 2 with either a Multi Channel shader or a Complex shader.

5. Select a component for the Blender.

6. Fill the individual channels of each shader and view the changes in the Shader Preview window.

7. Click the Assemble icon to return the shaded object to the Assemble room.

As you explore Multi Channel Mixers further, you'll discover that each source can be filled with another Multi Channel Mixer, a Layers List, a Reference Shader, or a single shader channel. You could literally get the Shader Tree to branch out infinitely, or until your computer runs out of resources and gives up. Figure 17-5 shows the available options for filling a source channel.

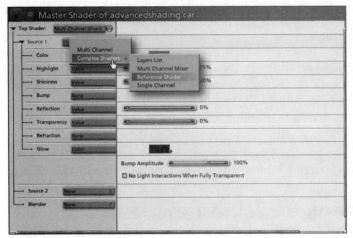

Figure 17-5: Fill a Multi Channel Mixer's source channel with one of these options.

Another option for filling a source channel is a Single Channel shader. When you apply a Single Channel shader to a source channel, you will only alter one characteristic in the other source channel. For example, in Source 1 of a Multi Channel Mix, you apply a texture map to the Color channel and use the Flat Mapping option to paste it into the Front Box of cube primitive. In Source 2, you use a Single Channel shader with the Color component. Fill to Source 2's Color channel with a different texture map. Choose the Value component for the Blender. Drag the slider to the right, and the texture map in Source 2 replaces the texture map in Source 1. This technique can be used to good effect in an animation.

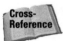

Cross-Reference For more information on animation, refer to Chapter 19.

Creating a Multi Channel Mixer shader

To get a better idea of the capabilities of a Multi Channel Mixer, let's create a shader for an acoustical ceiling tile grid. A shader for an individual acoustic ceiling tile can be created easily by blending white and black using the Spots function. Acoustic ceiling tile is pitted to absorb and deflect sound. To simulate the pitted surface of the tile, fill the Bump channel with a mix of black and white blended with the Spots function. To simulate the matte finish of ceiling tile, fill the Highlight and Shininess channels with a low value.

This shader would work well if you were only shading one or two tiles. The problem comes when you're modeling a large office filled with ceiling tile. To individually model a ceiling full of tile suspended by a metal grid would be an arduous task indeed. The easier solution is to create a flattened cube for the ceiling and then

apply a shader to create the ceiling grid. As the acoustic ceiling tile and grid have different characteristics, this is a perfect application for a Multi Channel Mixer.

To create a ceiling tile shader in the Assemble room:

1. Create a cube by selecting Insert ➪ Cube or drag the Cube tool into the working box. The size of the cube will vary depending on the size of the office scene you're creating. For the purpose of this exercise, adjust the cube's dimensions as follows: Size X = 10.00, Size Y = 20.00, Size Z = 1.00.

2. Click the Texture icon to open the Texture room.

3. For Top Shader, select Complex Shaders ➪ Multi Channel Mixer.

4. Source 1 will shade the grid. Ceiling grids are generally made of shiny colored aluminum. Click the color swatch to the right of the color channel and choose a dark black.

5. In the Highlight channel, drag the slider to 70.

6. In the Shininess channel, drag the slider to 70.

7. In the Reflection channel, drag the slider to 25. Figure 17-6 shows the completed shader for Source 1 of the acoustical tile shader.

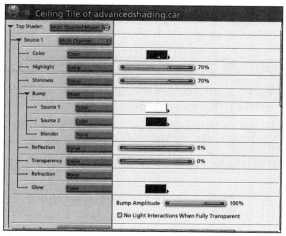

Figure 17-6: Source 1 of the acoustical ceiling tile shader

8. Source 2 will shade the actual ceiling tile. For Source 2, select Multi Channel.

9. Fill Source 2's Color channel with the Mixer component.

10. Fill Source 1 of the Mixer with the Color component.

11. Click the component's color swatch and select white.

12. Fill Source 2 of the Mixer with the Color component.

13. Click the component's color swatch and select black.

14. For the Blender, use the Spots function at its default settings.

15. For the Highlight channel, insert a Value component and drag its slider to 12.

16. For the Shininess channel, insert a Value component and drag its slider to 12.

17. Fill the Bump channel with the Mixer component.

18. Fill Source 1 of the Mixer with the Color component.

19. Click the component's color swatch and select white.

20. Fill Source 2 of the Mixer with the Color component.

21. Click the component's color swatch and select black.

22. For the Blender, use the Spots function at its default settings.

> **Tip** You can also copy the contents of the Color channel into the Bump channel by clicking the Color channel section to select it. Next press Ctrl and drag the Color channel to the Bump channel.

23. Leave the rest of the channels at their default settings. Figure 17-7 shows the completed shader for Source 2 of the acoustical tile shader.

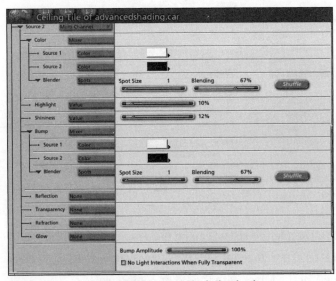

Figure 17-7: Source 2 of the acoustical tile shader

24. For the Multi Channel Mixer's Blender, select the Wires function.

25. Adjust the values for Horizontal Count to 8, Vertical Count to 16, Width to 4 percent, and Height to 8 percent. Figure 17-8 shows the finished shader applied to a flattened cube.

Figure 17-8: The finished acoustical tile shader applied to a flattened cube

Now that you've created the shader, it's time to step back and see what makes it work. Source 1 of the shader produced the shiny black metal that simulates a ceiling grid when applied to an object. The settings of the Highlight, Shininess, and Reflection channels were increased to simulate a shiny metallic surface.

Source 2's shader produced the pitted matte finish of the ceiling tile. The Spots function was chosen for Source 2's Color channel to simulate the speckled appearance of a ceiling tile. Low settings were applied to the Highlight and Shininess channels to simulate a matte finish. The Spots function was used in the Bump channel to create irregular depressions in the surface, just like real ceiling tile. By using the same settings that were used in the Color channel, the depressions occur in the exact same places where the color black appears. Remember, the Bump channel reads blacks as surface depressions and whites as elevations.

The Wires function was chosen as a blender because of its capability to simulate a ceiling grid. Ceiling tiles usually measure 24 × 48 inches, hence the choice of 8 and 16 for the Horizontal and Vertical counts. The Width was set to 4 percent and the Height to 8 percent as these numbers divide evenly into 24 and 48 to produce equal-sized grid bars in both directions. This shader is also scaleable. To create smaller or larger ceiling tiles, proportionately increase or decrease the Vertical and Horizontal counts. To simulate square ceiling tiles, change the Horizontal and Vertical counts to equal numbers and change the Width and Height to equal percentages.

Using the Multi Channel Mixer to mix existing shaders

The Multi Channel Mixer can also be used to mix existing shaders. Veterans of Ray Dream Studio will remember this as the Global Mix function. There are two methods of doing this. The first method is to fill the Multi Channel Mixer with Reference Shaders and blend them. The second method is to fill the Multi Channel Mixer with shaders from the Shader Browser.

To create a Multi Channel Mixer shader using Reference Shaders:

1. Select the object you want to shade and click the Texture icon to open up the Texture room.

2. For Top Shader, select Complex Shaders ➪ Multi Channel Mixer.

3. For Source 1, select Complex Shaders ➪ Reference Shader. The Shader button appears to the right of the Source 1 channel.

4. Click the Shader button and select one of the Reference Shaders from the drop-down menu.

Note The Reference Shader component refers to existing master shaders already used in the scene. Reference Shaders are stored in the Master Shader list in the Sequencer tray. Whenever a Reference Shader is edited, all references of it in a scene are updated.

5. For Source 2, select Complex Shaders ➪ Reference Shader. The Shader button appears to the right of the Source 2 channel.

6. Click the Shader button and select one of the Reference Shaders from the drop-down menu.

7. Click the button to the right of the Blender channel and select the desired blender. Figure 17-9 shows the blending of two Reference Shaders in a Multi Channel Mixer shader.

8. Click the Assemble icon to return the shaded object to the Assemble room.

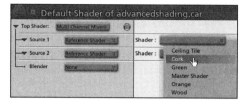

Figure 17-9: Blending two Reference Shaders with a Multi Channel Mixer

To create a Multi Channel Mixer using the drag-and-drop method:

1. Select the object you want to shade and click the Texture icon to open up the Texture room.

2. For Top Shader, select Complex Shaders ➪ Multi Channel Mixer.

3. Accept the default settings for Source 1 and Source 2.

4. Drag open the Shader Browser or the Sequencer tray.

5. Click to select an existing shader. Drag and drop it onto the Source 1 Reference shader channel.

6. For Source 2, select Complex Shaders ➪ Reference Shader. The Shader button appears to the right of the Source 2 channel.

7. Drag open the Shader Browser or the Sequencer tray.

8. Click to select an existing shader. Drag and drop it onto the Source 1 Reference shader channel.

9. Click the button to the right of the Blender channel and select the desired blender.

10. Click the Assemble icon to return the shaded object to the Assemble room.

Creating Realistic Textures with Nested Shaders

The flexibility of the Shader Tree Editor makes it possible for you to simulate complex natural and man-made textures. Take a look at a highly polished wooden tabletop. It has a smooth, shiny surface and a grain pattern. Now look closer and you'll begin to see more complexity in the grain pattern and color of the wood. A piece of wood actually has layers of different grain patterns. Mixing two colors with the Wood function could never reproduce this complexity. Fortunately, you can nest shaders to reproduce this effect.

When you nest shaders, you're creating subshaders within a channel and mixing them with a function or operator. To see how the process works, let's create a complex marble shader.

Creating a nested marble shader

Marble is smooth, shiny, and reflects light. A marble shader is built almost entirely in the Color channel with a bit of tweaking in the Highlight, Shininess, and Reflection channels.

1. Create a sphere by selecting Insert ➪ Sphere Object or drag the Sphere tool into the working box.

2. With the sphere selected, click the Texture icon to open the Texture room. Accept the Top Shader's default Multi Channel mode.

3. For the Color channel, select Operators ➪ Mixer.

4. For the Mixer's Source 1, select Operators ➪ Add.

5. For the Add Operator's Left channel, select Operators ➪ Mixer.

6. For the Mixer's Source 1 channel, select the Color component. Click the color swatch and select a dark green.

7. For the Mixer's Source 2 channel, select the Color component. Click the color swatch and select a different shade of green than used in the Source 1 channel.

8. For the Blender, select Natural Functions ➪ Marble. Apply the following settings: Global Scale = 100 percent, Undulation = 23 percent, Vein Count = 4, Vein Blending = 70 percent, Perturbation = 229 percent.

9. Click the Direction button and select the third direction icon. The Add Operator's Left channel should resemble Figure 17-10.

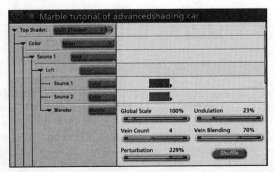

Figure 17-10: The first layer of a complex marble shader

10. For the Add Operator's Right channel, select Operators ⇨ Mixer.

11. For the Mixer's Source 1 channel, select the Color component. Click the color swatch and select a dark green that's slightly different than the greens you've already used.

12. For the Mixer's Source 2 channel, select the Color component. Click the color swatch and select a different shade of green than used in the Source 1channel.

13. For the Blender, select Natural Functions ⇨ Marble. Apply the following settings: Global Scale = 110 percent, Undulation = 15 percent, Vein Count = 7, Vein Blending = 91 percent, Perturbation = 250 percent.

14. Click the Direction button and select the fourth direction icon. The Add Operator's Right channel should resemble Figure 17-11.

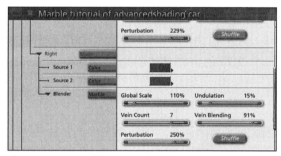

Figure 17-11: Adding another layer to the marble shader

15. For the Mixer's Source 2, select Operators ⇨ Mixer.

16. For the Mixer's Source 1 channel, select the Color component. Click the color swatch and select a dark green that hasn't been used yet.

17. For the Mixer's Source 2 channel, select the Color component. Click the color swatch and select a different shade of green than used in the Source 1 channel.

18. For the Blender, select Natural Functions ⇨ Marble. Apply the following settings: Global Scale = 100 percent, Undulation = 11 percent, Vein Count = 4, Vein Blending = 11 percent, Perturbation = 112 percent.

19. Click the Direction button and select the first direction icon. The Mixer Operator's Source 2 should resemble Figure 17-12.

20. For the Color channel's Blender, select Natural Functions ⇨ Marble. Apply the following settings: Global Scale = 100 percent, Undulation = 10 percent, Vein Count = 8, Vein Blending = 100 percent, Perturbation = 300 percent.

21. For the Highlight channel, drag the Value slider to a setting of 85 percent.

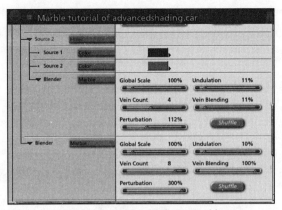

Figure 17-12: The marble shader's final layer

22. For the Shininess channel, drag the Value slider to a setting of 80 percent.

23. For the Reflection channel, drag the Value slider to a setting of 30 percent. Figure 17-13 shows the marble shader as rendered on a sphere.

Figure 17-13: The marble shader as rendered on a sphere

The marble shader that you just created illustrates the beauty of nesting shaders. The shader's Color channel used three different variations of the Marble function to mix slightly different shades of green. The Marble function was used as the Color channel's final blender to create a pleasing layered surface texture with a degree of complexity that indeed simulates natural marble. Experiment with different settings and colors to create your own library of marble shaders.

The nesting shaders technique can also be used to create realistic wood, rust, tile, and cork shaders. Look around your house or office for textures that are candidates for nested shaders, and then try to duplicate them in Carrara. Experience is the best teacher with this technique. After a bit of trial and error, you'll be able to simulate almost any surface using nested shaders. For the surfaces that can't be created using these techniques, you can always rely on texture maps.

Creating Special Effects with Texture Maps

Texture maps are 2D images that can achieve a stunning degree of realism when applied and mapped to 3D models. The most obvious use for texture maps is in the Color channel. Texture maps can also be used to good effect in the Shader Tree's other channels. With texture maps, you can achieve textures that would otherwise be impossible to create. Used in the Bump and Transparency channels, texture maps augment your modeling by creating surface relief and voids that would be difficult to achieve with Carrara's modelers.

Using texture maps in the Color channel

The Color channel is the most obvious channel in which to use a texture map. If the surface you're simulating can't be created using Shader Tree components, operators, or functions, an image map is the way to go. Of course, that doesn't mean you have to use only the texture map component in the Color channel. Operators can be used to apply color to a texture map; just add the Color component to a texture map to tint the image. Subtract the Color component from a texture map to create a negative image. Multiply the Color component across a texture map to produce a strong tinting effect.

Texture maps can also be mixed in the Color channel. Use the Value component to blend a color and a texture map. Drag the Value component's slider to increase or decrease the amount of color applied to the texture map. Use this technique in animations to increase a tint in a texture map through time.

Use the Checkers function to blend two texture maps with a Multi Channel Mixer to create an alternating tile pattern of the two images. Select the Tile option for both texture maps and match H and V values to the Horizontal and Vertical counts for the Checkers function (see Figures 17-14 and 17-15).

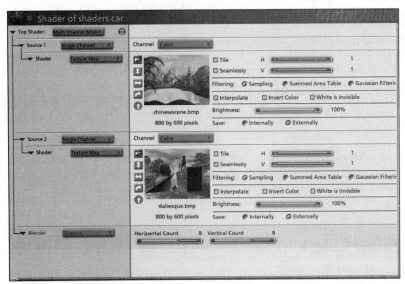

Figure 17-14: Blending two texture maps with the Checkers function to produce a tile pattern

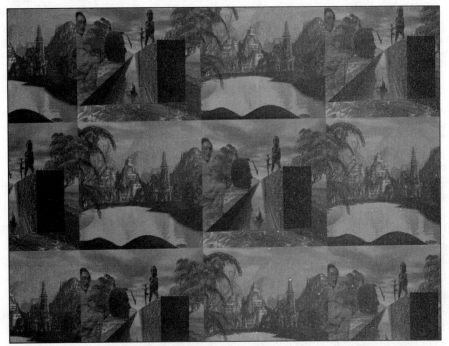

Figure 17-15: The tiled shader as applied to a plane

Using texture maps as masks

Grayscale texture maps make great masks. Create a texture map in your favorite photo-editing program and then use it to blend two components in the Color channel.

To use a texture map as a mask in the color channel:

1. Select the item to which you want to apply the mask shader.
2. Click the Texture icon to open the Texture room.
3. Accept the Top Shader's default Multi Channel mode.
4. For the Color channel, select Operators ➪ Mixer.
5. Add the desired components for Source 1 and Source 2.
6. For the Mixer's Blender, select Texture Map. The Open dialog box opens.
7. Locate the texture map file you want to apply as a mask (see Figure 17-16).

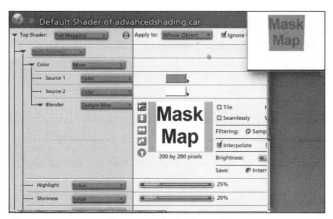

Figure 17-16: Creating a mask shader using a texture map

8. The Choose File Format dialog box appears. Click OK. Figure 17-17 shows the applied mask shader.

Using texture maps as decals

Texture maps also work well as decals. You can use scanned images for decals or create your own in a photo-paint program. Make sure the area surrounding the decal is pure white (255,255,255). Enable the texture map's White is invisible option, and Carrara will ignore the white area around the decal and let the underlying shader shine through.

Figure 17-17: The mask shader as applied to a cube

Decals like symbols and corporate logos are usually applied to specific parts of a model. To precisely position a decal, add a layer that approximates the decal's shape and use the Select Layer tool to move it. Fill the layer's shader channel with the texture map component, open the file that contains the decal, and apply it.

Tip Most photo-paint programs anti-alias an image so neighboring pixels of differing colors blend smoothly. Anti-aliasing works great for images, but leaves a halo around decals when used with the Texture Map component's White is invisible option. To eradicate this halo, make sure to uncheck your photo-paint program's anti-alias option. Depending on the program you use, you'll find this option with the masking or resampling commands.

Using Texture Maps in the Highlight and Shininess Channels

Texture maps can also be used in the Highlight and Shininess channels. When you add a color texture map to either of these channels, it is converted to grayscale. The grayscale range of 0 to 255 is then converted into values between 0 and 100 percent. Using texture maps lets you apply varying degrees of highlight and/or

shininess across the shaded object's surface. The most common application for this technique would be to use the same texture map in a shader's Color, Highlight, and Shininess channels. When the shaded model is rendered, areas with low values (dark colors) would have a matte finish, and areas with high values (light colors) would have a shiny finish.

Using texture maps in the Bump channel

When used in the Bump channel, texture maps are often referred to as *bump maps*. Adding a texture map to the Bump channel creates surface relief or bumps on the surface of a model. Bump maps are usually grayscale, but color images can be used. When used in the Bump channel, Carrara converts color images into the grayscale range of 0 to 255 and then into values from 0 to 100 percent. Low values (dark areas) show up as depressions on the object's surface, whereas high values (light areas) show up as elevations.

Bump maps make it possible to create objects that would be difficult if not impossible to create in Carrara's modelers. Bump maps can be used to simulate the leathery skin of a lizard, the dimpled carapace of a turtle, or the corrugations on a tin roof. Figures 17-18 through 17-21 show examples of bump maps and the surfaces created by them.

Figure 17-18: A grayscale bump map created in a photo-paint program

Figure 17-19: The bump map in Figure 17-18 applied to a sphere

Figure 17-20: A grayscale bump map created in a photo-paint program

Figure 17-21: The bump map in Figure 17-20 applied to a sphere

Using texture maps in the Transparency channel

When used in the Transparency channel, texture maps are often referred to as *transparency maps*. Applying a texture map to the Transparency channel creates varying levels of opacity across an object's surface. The levels of opacity are directly related to the colors of the texture map. As with other noncolor shader channels, a texture map's colors are converted to values. Low values (dark colors) have little or no transparency. Middle values are translucent. High values (light colors) are almost completely transparent, and pure whites are transparent.

In addition to controlling transparency, texture maps applied to the Transparency channel can also be used to model objects that would be impossible to create using Carrara's modelers. For example, a transparency map could be used to create holes in a chain link fence, a lace doily, or a medieval soldier's chain mail. Figures 17-22 through 17-25 show transparency maps and the shapes created by them.

Figure 17-22: A grayscale transparency map created in a photo-paint program

Figure 17-23: The transparency in Figure 17-22 applied to a sphere

Figure 17-24: A grayscale transparency created in a photo-paint program

Figure 17-25: The transparency map in Figure 17-24 applied to a sphere

Using texture maps in the Glow channel

Applying a texture map to the Glow channel simulates luminosity, making objects appear to glow in low-light situations. A texture map used in the Glow channel retains its original color information. A convenient way to apply a texture map to the Glow channel is to use the Mixer operator. Apply the texture map to the Mixer's Source 1 and use the Value component for Source 2. Blend the two sources with the Value component. Drag the Value sliders in Source 2 and the Blender to control the amount of glow applied to the object's surface. This technique is also useful in animations. By dragging the shader's Value slider to a higher or lower setting at a key frame, you can make an object glow brighter or dimmer at a specific point in time during an animation.

Texture maps in the Glow channel can be used to simulate faces of LED clocks, TV screens, or illuminated dashboards. You are urged to experiment and come up with your own bag of tricks for texture maps in the Glow channel. Figure 17-26 shows two spheres, one with a texture map applied to the Glow channel and another with an empty Glow channel.

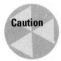

Caution 3D artists like to achieve high degrees of realism in their scenes and have been known to resort to detailed texture maps to get desired results. A scanner can be used to good effect when creating texture maps. In fact, there's a report that one 3D artist, in his search for the perfect fur texture, actually scanned his cat's tail. You are advised against this technique unless you have a very docile, declawed cat.

Creating Custom Texture Maps

After you gain some experience using texture maps, you'll be tempted to try creating some of your own. A good photo-paint program and a bit of imagination make it possible to create convincing texture maps. A digital pen and tablet are also good tools to have when creating texture maps.

Use a combination of real photos combined with the program's paint tools to create realistic maps for your models. Start with a map for the Color channel and then use a variation of the same map for the other channels. When creating a map for the Bump channel, remember to convert it to grayscale. Bump maps with adjacent areas of varying colors work better if you apply a Gaussian Blur filter to them. When creating texture maps, always use a resolution equal to or greater than the resolution desired for your rendered image.

Figure 17-26: A texture map has been applied to the left sphere's Glow channel

Rotoscoping

Rotoscoping lets you add animations or movies to shader channels. You can add .avi movies, .mov movies, or sequenced image files into shader channels. You'll use rotoscoping most frequently in the Color, Bump, Transparency, and Glow channels. Adding a movie to a shader channel makes it possible to create a scene in a movie house and actually have a movie play on the screen during the animation. Another excellent use of a movie in a shader channel would be to animate a radar screen.

To import a movie into a shader channel:

1. Click the channel to which you want to add the movie.

2. Select the Texture Map component.

3. Click the Folder icon. The Open dialog box appears. Select Movie Files (or the appropriate Sequenced file) from the Files of type drop-down menu.

4. Locate the desired movie file and click Open to apply it to the channel. Figure 17-27 shows a movie file as imported into the Color channel.

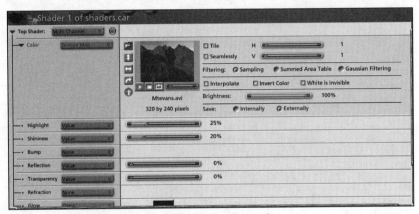

Figure 17-27: Adding a movie to a shader channel

When you add a movie to a shader channel, you have a full set of VCR controls to preview the footage. There are also buttons to flip and rotate the movie to properly orient it to the object you're shading.

Rotoscoping is used with animations to make shader channels change their characteristics over time. When added to a shader channel, a movie will start when the animation starts and play until it is complete or the animation is over.

Tip

If the animation you're applying to the shader channel is shorter than the animation you're creating, use the Oscillate Tweener to play the animation over and over until the animation ends. For example, if you're applying a five-frame animation to a shader channel, and the animation you're creating will be fifteen frames long, set the Oscillate Tweener to three oscillations, and the movie will repeat three times for a total length of fifteen frames.

Cross-Reference

For more information on Tweeners, refer to Chapter 19.

Rotoscoping in action

You'll find a wide variety of uses for rotoscoping in shader channels. Rotoscoping in the Color channel could be used to simulate a scrolling message on a billboard or a teleprompter, or an object's surface undergoing a metamorphosis. Rotoscoping in the Bump channel could be using to simulate crawling skin, bubbling water, or tank treads in motion. In the Transparency channel, rotoscoping could be used to simulate raindrops falling, a hole magically appearing in an object's surface, or an alien materializing in a transporter tube. Rotoscoping in the Glow channel could be used to simulate flickering neon lights, an LCD timer counting down, or a pulsing, glowing phantasm. These are just a few of the many effects you can achieve with rotoscoping.

On the CD-ROM In the Gels and Bump Maps folders in the CD ROM's Goodies section, you'll find movies to experiment with in shader channels.

Shader Tips

Now that you know some of the more advanced shading techniques, it's time to add a few tips to your knowledge of shading. These tips were learned through experimentation and the school of hard knocks. They are presented here so you'll avoid the pitfalls suffered by 3D artists who've traveled this road before you.

Preview texture maps in the Color channel

When you're applying texture maps to noncolor channels, it's sometimes difficult to see the overall effect they're having on a shader, especially in the Transparency and Refraction channels. Preview the texture map in the Color channel first and do a test rendering to see how the image looks on an object's surface. The same holds true when you're applying functions or operators in noncolor channels. Preview them in the Color channel and do a test or an area rendering to see how the function or operator affects the objects appearance. In lieu of a test rendering, you can use the Shader Preview window to see how the texture map looks.

Reflective objects

When you create an object with highly reflective surfaces such as mirrors or chrome wheels, create foreground objects to show up as reflections. Convex objects such as teapots reflect objects beyond camera range. A perfect example of this would be a shiny hot rod with big round hub caps parked out on a desert highway with mountains in the background. Create some foreground mountains and cacti to show up as reflections on the car's side and hub caps. This extra bit of effort will greatly add to the realism of your scene.

Applying the Boolean Union command instead of grouping objects

Sometimes the only way to create a complex model is to build it in pieces and put it together in the Assemble room. The problem comes when applying a single complex shader to each object in the group. Unfortunately, the shader maps differently to each object, and the rendered image doesn't look like a single object as intended. When this happens, join the pieces together using the Boolean Union command and apply the desired shader. The shader now maps correctly. This solution is a tad cumbersome when you have to join several objects. Be sure to save the file under another name before performing a Boolean Union operation on the objects. That way you'll have a backup if the conversion doesn't come out as planned. Figure 17-28 shows a complex shader applied to a group of objects. Figure 17-29 shows the same shader as applied to the model after the objects were joined with a Boolean Union command.

Creating glass shaders

Glass shaders can be tricky to create. When you look at a glass object, you think of it as colorless and completely transparent, yet it isn't. Hold a glass object up to the light and you'll definitely see color. You'll also notice subtle distortions as you look through the glass. This is caused by light refracting or bending as it passes through the glass object. All these characteristics must be included to properly simulate real glass.

To create a realistic glass shader, choose jet black for the Color channel. Adjust the Highlight and Shininess channel settings to 100. Glass is highly reflective. For the Reflection channel, choose a setting between 45 and 55. Refraction settings will vary depending on the type of glass you're creating. Start with a setting of about 15, but keep it below 20. Keep the Transparency setting at a high value. Start with a value of 80 and work up from there. If you're simulating colored glass, apply the Color component in the Transparency channel instead of a Value slider and then choose the desired color.

The interaction of scene lighting with the glass surface will go a long way towards convincing the viewer they're looking at a photograph of a glass object and not a 3D rendering. Experiment with different light and ambient settings. Use multiple lights to highlight the reflective properties of the glass. Give your glass object something to reflect and something to reflect in.

Figure 17-28: Applying a complex shader to a group of objects

Figure 17-29: Applying the same shader after the objects were joined with a Boolean Union command

Creating planked floorboards

If you're creating a scene that calls for planked floorboards, you could create a wood shader, apply it to an individual board, duplicate it, align it, and then duplicate and align it again and again until you've created a room full of planked floorboards. If that sounds like too much work, you're right. Luckily, there is an easier way.

To create planked floorboard shader:

1. Create a cube and resize it to the dimensions of the room you're creating.

2. Click the Texture icon to open the Texture room.

3. Create a basic wood shader by nesting shaders in the Color channel.

4. Click the blue button to the right of the Bump channel and select Pattern Functions ⇨ Wires.

5. Choose whether you want the planks to run vertically or horizontally and adjust the wire count for that direction. Set the other direction count to 0.

6. Depending on the direction your planks are running, adjust the setting for Width or Height (Width = Horizontal, Height = Vertical). Start with a setting of 5 percent.

7. Click the Grayscale box if you want rounded edges to your planks. Figure 17-30 shows the completed shader as applied to a flattened cube.

Using color shaders to manage complex scenes

The Shader Tree Editor's Color channel defines the surface color of an object in your scene. The Default shader is gunmetal gray. As your skill level increases, you'll create scenes that are populated by hundreds of objects. If you were to shade each object as you built the scene, you'd end up using a large chunk of your computer's memory to store information about the different shaders applied in your scene. This would bog your computer down and make it difficult to move and edit scene objects. In cases like this, it's best to leave shading until the eleventh hour when the all parts of your scene are built and properly aligned. Unfortunately, you are then faced with the problem of identifying individual parts in a sea of gunmetal gray.

The first step to solving this problem is to create a library of shaders with information in only the Color channel. Use varying colors that will be easy to identify in a busy scene. Create a separate folder for these shaders in the Shader Browser. Then, when you create a new object in your scene, use one of the colored shaders to identify the object. If you're creating several objects that will be textured identically, apply the same color shader to make them easier to identify as you add more objects to the scene.

Figure 17-30: Use the Wires function to created planked floorboards.

Any shader that you add to a scene becomes a master shader. Consider assigning a unique name to a shader to make it easier to identify when you're doing your final shading. For example, if you're creating a motorcycle wheel with hundreds of spokes, apply one of the color shaders to the first spoke. Drag open the Sequencer tray and click the Master Shader button. Select the color shader you just applied to the spoke and drag open the Properties tray. The color master shader will be listed along with all instances of its application. Assign a new name to the master shader. In this case, "Spoke" would be a good choice. Now create the rest of the spokes by duplicating the original. The Duplicates will all receive the Spoke master shader. When you're done creating the scene, drag open the Sequencer tray and double-click the Spoke master shader to edit it in the Texture room. After you're done editing the shader, all instances where you used the Spoke master shader will be updated.

Tip When editing a master shader in the Texture room, you can drag and drop a shader from the Shader Browser into the master shader's Top Shader level. This replaces the shader's contents and changes all instances where this master shader was used. In the preceding motorcycle spoke example, you could drag the Chrome preset shader into the Top Shader level of the master shader to instantly change all of the spokes to chrome.

Applying a Surface Texture to the Nutz and Boltz Vitamin Bottle

Now that you're familiar with Carrara's advanced shading techniques, it's time to put your knowledge to use by applying a surface texture to the Nutz and Boltz vitamin bottle that you modeled in Chapter 13. The texture that you apply to the bottle will be composed of texture maps, layer shapes, and operators.

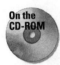

On the CD-ROM

All the files you need to shade the vitamin bottle are in a folder called Nutz and Boltz, which is located in Chapter 17's folder on the CD-ROM.

To shade the Nutz and Boltz vitamin bottle:

1. Launch Carrara and open the nutzboltz.car file.

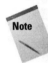

Note

Select the nutzboltz.car file from Chapter 13's folder. The nutzboltz.car file in Chapter 17's folder is the completed tutorial.

2. Click to select the vitamin bottle.

3. Click the Texture icon to open the Texture room. The Editing Shader warning dialog box appears. Select Create a new master and click OK to edit the shader.

4. Accept the Top Shader's default setting of Multi Channel.

5. For the Color channel, select Operators ➪ Mixer.

6. For Source 1, use the Color component. Click the color swatch to the right of the component to open the Color Picker. Click the double-facing downward arrow next to the current color model and select RGB Sliders. Drag the sliders to the following settings:

 - R = .66

 - G = .00

 - B = .64

7. For Source 2, use the Color component. Click the color swatch to the right of the component and choose white.

8. For the Blender, select the Texture Map component. The Texture Map dialog box opens. Click the Folder icon, locate the file maskmap.tif from the CD ROM, and click Open. The Choose File Format dialog box appears. Click OK.

9. Select the Tile option and drag the H and V sliders to 4. Notice the series of purple nut shapes that now appear on the surface of the vitamin bottle (see Figure 17-31).

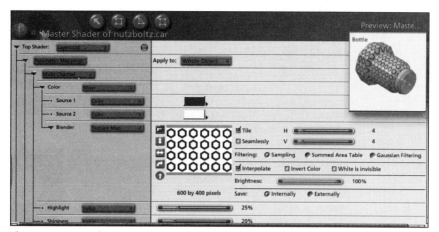

Figure 17-31: Using a texture map as a mask to apply a pattern of nuts to the vitamin bottle.

10. A layer will be added to the shader to put a label on the bottle. But before you can accurately place the shape, you need to realign the bottle in the Preview: Master Shader window. Click the window to select it. Click the Dolly tool and drag it until the bottle is aligned top to bottom.

11. Click to select the Rectangle Layer tool and drag it across the front of the vitamin bottle. Start the layer just below the neck of the bottle and end it just above the bottle's bolt-shaped base. Don't be too concerned about size or alignment at this stage.

12. Scroll down through the Shader Tree until you locate the layer you just applied. Accept the default parametric mapping and fill the layer's shader channel with the Texture Map component. The Texture Map dialog box opens. Click the Folder icon. The Open dialog box appears. Locate the file label.tif from the CD ROM. The Choose File Format dialog box appears. Click OK. If needed, use the alignment buttons to rotate or flip the texture map.

13. Use the Select Layer tool to position the label.

14. To size the layer, enter .30 for the Height and .20 for Width. Your partially shaded vitamin bottle should resemble Figure 17-32.

15. To finish texturing the bottle, you need to apply a small band at the top of the bottle's neck. Select the Rectangle Layer tool and Alt+drag it across the bottle's neck.

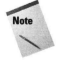

Note　　Holding down the Alt key while dragging applies the layer around the back of the bottle.

Figure 17-32: Applying a texture map to label the vitamin bottle

16. Scroll down through the Shader Tree and locate the layer you just applied. Accept the default parametric mapping and fill the layer's shader channel with the Texture Map component. The Texture Map dialog box opens. Click the Folder icon. The Open dialog box appears. Locate the file band.tif from the CD ROM. The Choose File Format dialog box appears. Click OK.

17. If the band didn't wrap completely around the neck of the bottle, adjust the layer's Height to 1.00. Adjust the layer's Width to cover the neck of the bottle. Your partially shaded vitamin bottle should resemble Figure 17-33.

Figure 17-33: Using a texture map to apply a band around the neck of the bottle

18. When you're satisfied with the size and alignment of the layer shape, click the Assemble icon to return the vitamin bottle to the Assemble room.

19. Click to select the bottle cap.

20. Click the Texture icon to open the Texture room.

21. Accept the Top Shader's default setting of Multi Channel.

22. For the Color channel, select Operators ⇨ Mixer.

23. For Source 1, use the Color component. Click the color swatch to the right of the component to open the Color Picker. Click the double-facing downward arrow next to the current color model and select RGB Sliders. Drag the sliders to the following settings

- R = .66

- G = .00

- B = .64

24. For Source 2, use the Color component. Click the color swatch to the right of the component and choose white.

25. For the Blender, select the Texture Map component. The Texture Map dialog box opens. Click the Folder icon, and locate the file maskmap.tif from the CD ROM. The Choose File Format dialog box appears. Click OK.

26. Select the Tile option and drag the H and V sliders to 3. Click the curved arrow below the Folder icon to rotate the map 90 degrees. The cap should now resemble the one shown in Figure 17-34.

Figure 17-34: Shading the bottle cap

27. To finish shading the bottle cap, follow steps 14 through 17 to apply a band to the bottom of the cap.

Figure 17-35 shows the rendered Nutz and Boltz vitamin bottle.

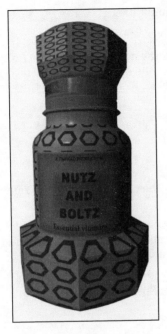

Figure 17-35: The completed Nutz and Boltz vitamin bottle

Well done! Now that you've shaded the Nutz and Boltz bottle, it's time to apply advanced shading techniques to your own creations. Experiment with the different techniques discussed here to increase your skills as a Carrara 3D artist. If you have a photo-paint program, create some texture maps of your own. Remember that texture maps can be used to good effect in most channels on the Shader Tree. By all means build complexity into your shaders. Nest subshaders to create surfaces that mimic reality. Remember to save your masterpiece shaders in a special folder in the Shader Browser for future use.

Summary

Observe surface textures you see every day and then put your imagination to work to recreate them in Carrara.

✦ Mapping modes can be changed to apply textures to irregularly shaped objects.

✦ Multi Channel Mixers can be used to blend shaders with different characteristics.

✦ Multi Channel Mixers can be used to create a new shader by blending existing Reference Shaders.

✦ Texture maps can be used to create textures that would be difficult to create with the Shader Tree's other components, functions, and operators.

✦ Texture maps can be used as transparency maps, bump maps, highlight maps, shininess maps, and glow maps.

✦ Nesting shaders creates complex surface textures by blending layers.

✦ Rotoscoping adds movement to textures during an animation.

✦　　✦　　✦

Putting It All Together

Carrara Special Effects

Carrara has many forms of special effects. Previous chapters demonstrated how to create special effects by using lights, camera, shaders, and modelers. This chapter is devoted to environmental effects.

Carrara's environmental primitives make it possible to simulate raging fires, swirling fog banks, and gently rolling clouds. Environmental primitives can be used effectively in still images and animations.

On the other hand, Particle Emitters are used almost exclusively in animations. All manner of special effects can be achieved with particles. You can simulate fireworks, roiling smoke, and shock waves, to name a few.

Creating Special Effects with Environmental Primitives

Carrara's four environmental primitives create effects ranging from bubbling fountains to raging fires. These effects can be used to enhance still images or animations. Experiment with the different primitives to see the effects they are capable of. Choose from the primitives Fire, Fountain, Fog, or Clouds. Better yet, include more than one environmental primitive in a scene.

The environmental primitive tools are found on the fifth tool's fly-out on the top toolbar (see Figure 18-1).

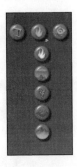

Figure 18-1: The environmental primitive tools

Creating fire

The Fire primitive is a volumetric effect. Use this primitive to simulate objects on fire. When the Fire primitive is introduced to a scene, there is no on-screen preview. All you see is the primitive's bounding box. To view the effect of the primitive without committing to a full-blown rendering, drag the Area Render tool over the bounding box.

Place objects within the primitive's bounding box to make those objects appear to be burning. You can change the area that the fire encompasses by dragging the primitive's bounding box handles or by entering new values for its size in the Properties tray. This primitive can also be animated.

To add the Fire primitive to a scene:

1. Drag the Fire tool into the working box or Sequencer tray's Universe list.

 Alternatively, select Insert ⇨ Fire. The Fire dialog box appears in the Model room, as shown in Figure 18-2.

Figure 18-2: Adjusting the Fire primitive's parameters

2. Accept the default color for the fire's tip, or click the color swatch to select a different color.

3. Accept the default color for the fire's base, or click the color swatch to select a different color.

4. Drag the Completion slider to control the animation of the fire. Set the slider at 0 percent when the animation starts and 100 percent at the end of the animation.

5. Drag the Quantity slider to adjust the amount of fire.

6. Drag the Quality slider to adjust the image quality of the rendered flames.

7. Drag the Detail slider to adjust the amount of detail present in the rendered flames.

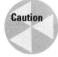

Caution Higher Quality and Detail settings produce better-looking flames but increases rendering time.

8. Click the Container button and choose a box, cylinder, or sphere.

9. Drag the Density slider to control the density of the fire. A low setting creates a more transparent fire effect, whereas a high setting creates an opaque fire effect.

10. Drag the Edge Falloff slider to adjust how the fire looks at its boundary. A low setting creates an abrupt falloff; a higher setting creates a gradual one.

11. Drag the Pointiness slider to control the appearance of the fire. A high setting produces a large quantity of pointy flames.

12. Drag the Upward Speed slider to determine how quickly the flames rise from the base of fire. This option is used for animations.

13. Click the Shuffle button to vary the look of the fire.

14. Drag the Area Render tool over the Scene Preview window to see how the fire looks in the scene.

15. Click the Assemble icon to return the completed fire to the Assemble room.

Simulating fog

You may remember that fog was one of the components of a Four Elements Wind atmosphere. Cloudy Fog and Distant Fog were other choices available for an overall scene atmosphere. These types of fog affect the entire scene.

The environmental primitive Fog produces localized fog. Use it to simulate anything from light, misty fog to pea soup. Areas of localized swirls and clumping fog can be animated. Objects can be placed within the fog and out of the fog. You can change the area that the fog encompasses by dragging the handles on its bounding box or by entering new values for its size in the Properties tray.

The Fog primitive is surrounded by a bounding box and cannot be previewed on screen. To view the fog without committing to a rendering, drag the Area Render tool over the primitive's bounding box in the working box.

To insert the Fog primitive into a scene:

1. Drag the Fog tool into the working box or Sequencer tray's Universe list.

 Alternatively, select Insert ⇨ Fog. The Fog dialog box appears in the Model room, as shown in Figure 18-3.

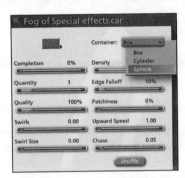

Figure 18-3: Adding fog to a scene

2. Accept the default fog color, or click the color swatch to select a different color.

3. Drag the Completion slider to control the animation of the fog. Set the slider at 0 percent when the animation starts and 100 percent at the end of the animation.

4. Drag the Quantity slider to control how many patches of fog are in the container.

5. Drag the Quality slider to control the quality of the rendered fog.

Caution Higher Quality settings produce better-looking fog but increases rendering time.

6. Drag the Swirls slider to control how the fog swirls as it moves upward.

7. Drag the Swirl Size slider to control the size of the swirls.

8. Click the Container button and choose a box, cylinder, or sphere.

9. Drag the Density slider to control the density of the fog. Use lower settings to simulate wispy fog and higher settings to simulate pea soup fog.

10. Drag the Edge Falloff slider to control the fog's appearance at its boundary. A low setting creates an abrupt falloff; a higher setting creates a gradual one.

11. Drag the Patchiness slider to control the fog's consistency. Low settings create a blanket of fog, whereas high settings create patchy fog.

12. Drag the Upward Speed slider to control the fog's speed as it swirls upward.

13. Drag the Chaos slider to control the appearance of the fog. Low settings produce uniform fog, whereas high settings produce random patches and swirls within the fog.

14. Click the Shuffle button to randomize the settings. This option comes in handy when you have more than one fog object in a scene.

15. Click the Assemble icon to return the fog to the Assemble room.

Figure 18-4 shows a scene with the Fog environmental primitive added.

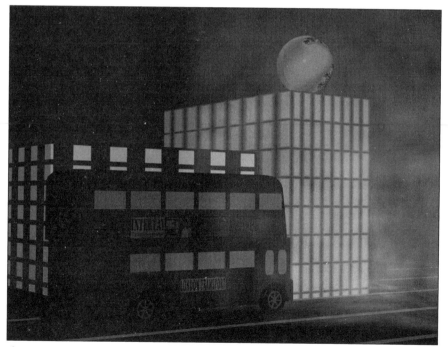

Figure 18-4: A foggy scene courtesy of the Fog tool

Simulating clouds

Clouds are another atmospheric component available in both Four Elements and atmosphere scene settings. The difference again boils down to the fact the environmental primitive clouds are localized.

A bounding box restricts environmental primitive clouds. The clouds can be placed anywhere in a scene for specialized effects. Objects can be placed in or out of clouds. To change the area that the clouds encompass, drag one of the bounding box's handles or enter new values for its size in the Properties tray.

To add the Clouds primitive to a scene:

1. Drag the Cloud tool into the working box or the Sequencer tray's Universe list.

 Alternatively, select Insert ⇨ Clouds. The Clouds dialog box appears in the Modeling room (see Figure 18-5).

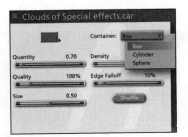

Figure 18-5: Adding clouds to a scene

2. Accept the default cloud color or click the color swatch to select a different color.

3. Drag the Quantity slider to adjust the number of clouds in the container.

4. Drag the Quality slider to determine the quality of the rendered clouds.

Caution Higher Quality settings produce better-looking clouds but increases rendering time.

5. Drag the Size slider to adjust the size of the individual clouds in the container.

6. Click the Container button and choose from box, cylinder, or sphere.

7. Drag the Density slider to control the density of the cloud mass. Low settings produce thin wispy clouds; higher settings produce thick opaque clouds.

8. Drag the Edge Falloff slider to control the cloud's appearance at the edge of the bounding box. A low setting creates an abrupt falloff, whereas a higher setting creates a gradual one.

9. Click the Shuffle button to randomize the cloud swirls. This option comes in handy when you have more than one cloud mass in a scene.

10. Click the Assemble icon to return the clouds to the Assemble room.

In the image shown in Figure 18-6, the Fire primitive was used to create the shuttle's booster flames. The Fog primitive added the smoke around the boosters, and the Cloud primitive dotted the sky with fleecy clouds.

Figure 18-6: Simulating a shuttle launch with the Fire, Fog, and Clouds environmental primitives.

Creating fountains

Fountain is a particle system that can be used to create objects such as fountains or swirling dust devils. The primitive can be used for still images, but is better suited to animations.

To insert a Fountain primitive into a scene:

1. Drag the Fountain tool into the working box or Sequencer tray's Universe list.

 Alternatively, select Insert ➪ Fountain. The Fountain dialog box appears in the Model room (see Figure 18-7).

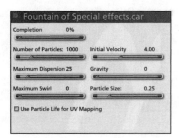

Figure 18-7: Adding a fountain to a scene

2. Drag the Completion slider to control the animation of the fountain. Set the slider at 0 percent when the animation starts and 100 percent at the end of the animation.

3. Drag the Number of Particles slider to adjust the number of particles in the fountain.

4. Drag the Maximum Dispersion slider to determine how far the particles disperse from their center of origin.

5. Drag the Maximum Swirl slider to adjust the particle's rotation parallel to the ground plane during an animation. A low setting produces very little rotation.

6. Drag the Initial Velocity slider to determine the speed at which the fountain begins. A low setting produces a slow spouting fountain, whereas a high setting produces a rapidly spouting one.

7. Drag the Gravity slider to determine the effect of gravity upon the particles. Low settings cause the particles to fall slowly; high settings produce rapidly falling particles.

8. Drag the Particle Size slider to determine the size of the individual particles.

9. Enable Use Particle Life For UV Mapping to apply a shader to the entire fountain object. Particles will look differently depending on where they are in the fountain and where the fountain is in its life cycle. When disabled, the shader is applied to each particle as if they were separate entities.

10. Click the Texture icon to return the fountain to the Texture room.

11. Use the Shader Editor Tree to create a shader for the fountain.

12. Click the Assemble icon to return the fountain to the Assemble room.

Tip

Drag the Area Render tool across an environmental primitive's bounding box in the Scene Preview window to see how applied changes affect the object in the scene.

Creating particles

Carrara's Particle Emitter can be used to create specialized effects such as fireworks, explosions, and flying sparks. A Particle Emitter creates thousands of tiny polygons that move during the course of an animation. Particle size, appearance, and behavior are fully adjustable. The Particle Emitter tool is the eighth button on the top toolbar (see Figure 18-8).

Figure 18-8: Use this tool to insert a Particle Emitter in a scene.

The Particle Emitter has a menu of preset effects from which you may choose, or you can create a custom effect by adjusting the various parameters.

To insert a preset Particle Emitter in a scene:

1. Drag the Particle Emitter tool into the working box or Sequencer tray's Universe list.

 Alternatively, select Insert ⇨ Particle Emitter. The Particle Emitter dialog box opens in the Model room.

2. Click the Preset button and choose a preset (see Figure 18-9).

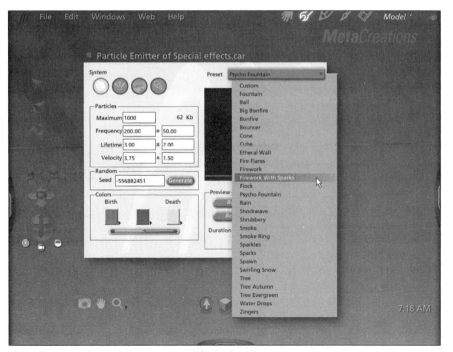

Figure 18-9: Inserting a preset Particle Emitter into a scene

3. In the Preview panel, the Particle Emitter will run through one cycle. To preview it again, click the Run button.

4. Enter a value in the Duration box to set the time duration of the effect. This value is in seconds.

5. Use the Pan and Zoom tools to change your point of view. The Pan and Zoom tools are to the lower right of the Particle Emitter preview window.

Note The Particle Emitter must be running for the Pan or Zoom tool to have an effect on the preview.

6. Click the Reset button to restore the original preview.

7. Click the blue button below the Pan and Zoom tool and select the Front, Right, or Top preview position.

8. Click the Assemble icon to return the Particle Emitter to the Assemble room.

9. To resize the Particle Emitter, select one of the handles on its bounding box and drag with the Scale tool.

 Alternatively, drag open the Properties tray, click the Motion/Transform button, and enter new values for the Particle Emitter's size.

Once the Particle Emitter is positioned and sized in the scene, there are two more parameters that need to be adjusted: the ground level, where the particles actually collide, and the size and shape of the individual particles.

To finalize Particle Emitter settings:

1. With the Particle Emitter selected, drag open the Properties tray. If it's not already selected, click the General button to open the Properties tray's General section.

2. Drag the blue scroll bar down until the Particle Emitter tab is visible.

3. Enter a value for Ground Level. This value sets an imaginary plane in your scene that is considered the ground plane for the Particle Emitter. Particles collide at ground level. To mask the resulting collision, enter a Ground Level value that's lower than the scene's ground level.

4. In the Rendering panel, click the blue button and select a particle shape (see Figure 18-10).

5. Enter a value for size.

Tip To view the effects changing particle size and shape have on the Particle Emitter, drag open the Sequencer tray and drag the scrub slider to move the animation forward in time. Drag the Area Render tool over the Particle Emitter's bounding box to view the particles as they will render.

Preset Particle Emitters are a good starting point. As you gain more experience with this tool, you'll want to create some custom Particle Emitters to make your own unique special effects.

Figure 18-10: Adjusting the polygon size and shape for particles in a Particle Emitter

To add a custom Particle Emitter to your scene:

1. Drag the Particle Emitter tool into the working box or Sequencer tray's Universe list.

 Alternatively, select Insert ⇨ Particle Emitter. The Particle Emitter dialog box opens in the Model room.

Creating a custom Particle Emitter involves several steps. When the Particle Emitter dialog box first opens, you see four icons in the top-left corner: System, Emit, Env, and FX. Each icon links to a different section. The System section opens by default when the dialog box opens.

2. In the System section (see Figure 18-11), edit the following settings in the Particles panel:

 • Enter a value for Maximum. This determines the maximum number of particles visible at any time. Enter a value in the +/- box to randomly fluctuate the maximum number of particles within the value you specify.

 • Enter a value for Frequency. This determines how many particles are emitted per second. Enter a value in the +/- box to randomly fluctuate the frequency within the value you specify.

 • Enter a value for Lifetime. This value determines the lifetime in seconds of the particles after they are emitted. Enter a value in the +/- box to make some particles live longer than others within the value you specify.

 • Enter a value for Velocity. This value determines the speed at which the particles travel after they are emitted. Enter a value in the +/- box to have some particles travel faster or slower than others by the value you specify.

3. In the System section's Random panel, enter a value for Seed. Seed determines the random order in which particles are generated. If you have two identical Particle Emitters in a scene with the same settings, the effect will look contrived. Change the Seed value to make each emitter behave slightly differently. You can also click the Generate button to create a random seed value.

4. Click the color swatches to determine the particle's colors at birth, life, and death. These colors are not applied to the actual particles. They are for reference and preview only. A shader needs to be applied to the Particle Emitter after it is created.

Figure 18-11: The Particle Emitter's System settings

5. Click the Emit icon. The Particles Emitter Emit section opens, as shown in Figure 18-12.

Figure 18-12: The Particle Emitter's Emit settings

6. In the Emit Duration panel, edit the following settings:

- Enter the time in the animation when you want the particles to begin emitting in the From box.

- Enter the time in the animation when you want the particles to die in the To box.

- If you want the particles to freeze at a certain point in the animation, enable the Freeze option and enter the time when you want the particles to freeze.

7. The actual size of the Particle Emitter is predetermined. The particles emit from the center base of the emitter. Enter values in the +/- X and/or +/-Y and/or +/-Z boxes to vary the area of the emitter along the selected axes within the amount specified.

8. In the Emit Dispersion panel, enter a value for Angle. This setting determines the angle of the particles as they are ejected from the emitter. Enter a value in the +/- box to introduce some randomness into the dispersion angle.

9. Click the Env icon. The Particle Emitter's Env section opens (see Figure 18-13).

Figure 18-13: The Particle Emitter's Env settings

10. Adjust the following settings in the Env section's Environment panel:

- Enter a value for Air Friction. This setting simulates how air will interact with the particles. Enter a larger value to slow the particles down as they are ejected from the emitter. Enter a negative value (-) to speed particles up as they are ejected from the emitter.

- Enter a value for Floor Friction. This setting determines the amount of friction particles encounter when they collide with the floor or ground level. Higher values slow particles down as they approach the floor. A setting of 0 has no effect on the particles as they approach the floor. This setting has no effect on the Bounce Factor.

- Enter a value for Bounce Factor. This setting determines how high the particles bounce after they hit the floor or ground level. Higher values cause particles to bounce higher.

- Enter a value for Gravity in each axis. Positive settings cause particles to defy gravity in a specified axis. Negative settings cause particles to become affected by gravity in a specified axis. The higher the value, the stronger the attraction or repulsion.

11. Click the FX icon. The Particle Emitter's FX section opens (see Figure 18-14).

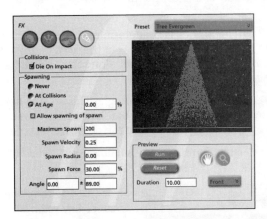

Figure 18-14: The Particle Emitter's FX settings

12. In the Collisions panel, enable the Die on Impact option to have the particles disappear when they collide with the floor or ground level. Use this option to prevent particles from bouncing and spreading on impact.

13. The Spawning panel settings determine whether or not particles spawn. When particles spawn, new particles are created from old. The default Spawning setting is Never. If you decide to have particles spawn, first select how you want them to spawn.

- Select At Collisions to have the particles spawn on impact.

- Select At Age to have particles spawn at a specified age. Enter the age to pawn at in the adjacent box.

- Enable Allow spawning of spawn to have the original spawn's offspring spawn. This option is only available when particles spawn at collision.

Caution Enabling this option will quickly create lots of particles. If you allow spawns to spawn, you'll have to set the maximum number of particles very high, which can cause your computer's performance to lag.

- Enter a value for Maximum Spawn. This setting determines the maximum number of offspring a spawn can have.

- Enter a value for Spawn Velocity. This setting determines the minimum velocity a particle must be traveling in order to spawn.

- Enter a value for Spawn Radius. This setting determines the radius of dispersion for the spawned particles.

- Enter a value for Spawn Force. This setting determines how fast a spawn travels. The value entered is a percentage of the original spawn's speed. A low value causes the offspring to lag behind the original particle, whereas a high setting causes the offspring to shoot ahead of the original particle.

 - Enter a value for Angle. This setting determines the angle of the arc in which the spawns are emitted. Enter a value in the +/- box to introduce variation in the arc angle up to the specified value.

14. Click the Run button in the Preview panel to preview the emitter.

15. Adjust any previous settings to fine-tune the effect.

16. Click the Assemble icon to return the Particle Emitter to the Assemble room.

17. Drag open the Properties tray, click the General button, and in the Particle Emitter panel, adjust settings for the Particle Emitter's Ground Level and Size. Click the blue Polygon button and choose a shape from the drop-down menu.

Shading Particle Emitters

As you learned in the previous section, the colors specified in the Systems section of the Particle Emitter dialog box are only for preview. To apply final surface color to a Particle Emitter requires a trip to the Texture room.

To shade a Particle Emitter:

1. With the Particle Emitter selected, click the Texture icon to open the Texture room. The Shader Tree Editor is displayed.

2. For the Color Channel, select Operators ⇨ Mixer.

3. For Source 1, select Color. Click the color swatch to set the color.

4. For Source 2, select Color. Click the color swatch to set the color.

5. For the Blender, select Natural Functions ⇨ Particle Shader (see Figure 18-15).

6. Click the Assemble icon to return the Particle Emitter to the Assemble room.

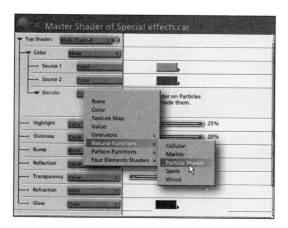

Figure 18-15: Applying a shader to a Particle Emitter

Tip If you're rendering the Particle Emitter against a dark background, copy the contents of the Color channel into the Glow channel. This produces particles that glow in the dark.

Animating Particles

Particle Emitters are capable of creating many interesting effects when they're stationary on a ground plane. The particles eject from the center of the emitter like olive oil from a hot griddle. Stationary Particle Emitters can be used to simulate stars going supernova, exploding volcanoes, and sparkling fireworks displays.

To create dazzling special effects with Particle Emitters, consider putting them in motion. For example, create an animation in which a space ship speeds into camera view and then banks sharply away from the camera and explodes. The Explode modifier will take care of exploding the ship, and Particle Emitters will take care of the ship's exhaust and debris field as the ship explodes. Before setting up the animation, create a Particle Emitter to simulate the ship's exhaust trail. Align it with the rear of the space ship. Group the space ship and Particle Emitter. Create another Particle Emitter to simulate an explosion. Have the emitter begin ejecting particles as the ship begins to explode. Align this emitter with the center of the ship and add it to the previous group. Finally, create a motion path for the ship over time, render the animation, and you're as good as George Lucas.

Summary

Carrara's environmental primitives are used to create special effects like swirling fog banks, wispy cloud masses, and gurgling fountains. Particle Emitters can be used to simulate effects like vapor trails, rain storms, and hail storms. With the exception of clouds, all these objects can be animated.

✦ The Fire tool is used to introduce volumetric fire into a scene. Objects placed within a fire object appear to be burning.

✦ The Fog tool introduces localized patchy fog into a scene. The size and density of the fog bank can be adjusted. Fog can be animated.

✦ The Cloud tool introduces a cloud mass into a scene.

✦ The Fountain primitive can be used to simulate items such as water fountains and tornadoes.

✦ Particle Emitters eject small polygons from a central source to simulate a variety of special effects.

✦ Particles can be made to bounce as they collide with the ground.

✦ Spawning causes particles to multiply as they collide with the ground.

✦ ✦ ✦

Creating an Animation

◆ ◆ ◆ ◆

In This Chapter

Understanding
animation

Using the timeline

The Storyboard room

Controlling motion
with Tweeners

◆ ◆ ◆ ◆

In addition to using Carrara for creating photo-realistic
images from scenes, you can also use it to create anima-
tions. In fact, by creating a few changes, you can transform
your favorite still-image scene into an animation. You have
a choice of three motion methods that you can combine to
create dazzling animations to amaze your friends, your clients,
and even yourself.

Understanding How Animation Works

A computer animation is a compilation of sequenced image
frames. To create action in an animation, one or more of an
object's animatable properties are changed over time. When
played back, as the frames advance, the illusion of action
is displayed on a screen or monitor, in much the same way
that motion pictures first created on-screen motion nearly
a century ago.

Creating the animation involves the careful orchestration
of objects, lights, and cameras. Object motion paths and
trajectories are carefully choreographed. It is the 3D artist's
job to create an intriguing combination of realistic motion and
visual effects. Although it may sound easy in theory, execution
is anything but.

To be a *master* of motion, the 3D artist must first be a *student* of
motion. Careful observations of how things move give the artist
his or her first clues. Newton's First Law of Motion (sometimes
called the Law of Inertia) is still true: Objects in motion tend to
remain in motion, even when acted on by equal but contradic-
tory forces. That's why, when an object stops moving, it almost
never stops abruptly—not even a crash test dummy, tightly
belted into a car seat. The same motion-continuation tendency
is even more noticeable when a baseball player swings a bat.

That smooth follow through, which involves everything that happens in the second half of the swing, could also be called "going with the flow." Once launched, the bat wants to keep on going, and the wise batter doesn't try to stop it in midair.

The same thing goes for acceleration and changing direction. An object doesn't go from a state of rest to a high rate of speed without a period of transition. A plane doesn't change direction without banking. Even the most nimble sports car exhibits some body lean when rounding a corner.

Secondary motion is another trait of realistic-appearing movement. A car hurtling down the highway at sixty miles per hour sways sideways when a truck rockets past in the opposite direction. An animal generally looks towards its intended direction of travel before moving.

To create a successful animation, you must be aware of motion traits and include them in your animation.

Creating an Animation

Carrara animations are created within the Assemble and Storyboard rooms. When objects are added to the animation scene, their presence is recorded on the Universe list in the Sequencer tray. The Universe list contains information about each object's animatable properties.

You have four forms of motion to choose from: Explicit, Physics, Motion Path, or Still. When you choose to animate an object with the Explicit motion method, you use key frames to chart major changes. When you choose to animate an object with the Physics method of motion, an object is made to move by applying one of the laws of physics to it. The Motion Path method of animating an object involves drawing an actual path that the object will follow. The Still method of motion creates an object that cannot be moved during the animation.

Once an animation is set in motion, all group links and hierarchies are frozen. In other words, a sphere can't change into a cube during the animation. But properties can change over time. The sphere can grow, move, or change colors.

To create an animation in Carrara, a key frame (also known to some as a key event) is created where a major change in one or more of an object's animatable properties takes place. Another key frame is added where the next major change occurs. This process is repeated for all objects in the scene that will be animated. When the animation is rendered, the period of transitory motion between key frames is interpolated by Carrara. Each period of transition is controlled by a Tweener. A Tweener controls how the transition from one key frame to the next occurs. Tweeners can be edited to provide smooth, flowing transitions, abrupt transitions, or instant transitions.

Every object in the Universe list has a hierarchy of animatable properties. To view these properties, click the triangle to the left of the object's name and the hierarchy expands. Such properties may also have their own hierarchies. Take motion, for instance. When an object moves upward and across a scene, its X, Y, and Z coordinates change over time. Therefore, its motion property will have separate listings in the hierarchy for the direction change along each axis. Figure 19-1 shows a scene's universe list with one group's hierarchy expanded. Notice how the Transform, XYZ Scaling, and Position properties all have their own hierarchies.

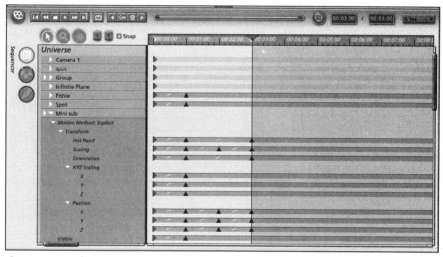

Figure 19-1: The Sequencer tray's Universe list contains information about each scene object's animatable properties.

Using the Carrara timeline

The timeline is used to precisely place key frames within an animation. In Figure 19-1, you see a line extending out from each object and each object's animatable properties. That line is the object or animatable property's timeline. The upright black triangles are key frame markers. Key frames are created automatically when an object is changed at a given point in the animation. Key frames can also be manually created.

At the top of the Sequencer tray is a series of tools and windows that you use to create and preview animations (see Figure 19-2). The first group of tiny blue buttons may remind you of the buttons on your VCR remote control. They function the same way. Use these to preview the animation in the working box. The individual controls are used to play, fast forward, or rewind the animation, or to advance

forward or backward one frame at a time. The solitary button to the right of the VCR controls is used to loop the animation. The next four buttons are used to create, delete, and navigate from one key frame to the next.

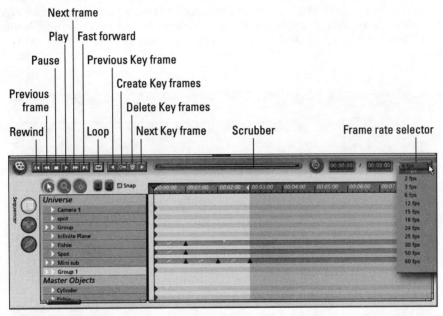

Figure 19-2: These controls are used to preview the animation and adjust frame rate.

The long slider to the right of the key frame buttons is called the Scrubber. Drag the slider to advance to any point in the animation. The round blue button toggles the units of measurement for the animation. Click it to toggle between displaying units of time or individual frames on the Time Ruler. When you choose individual frames as the unit of display on the Time Ruler, each second is designated by a number, which is the number of frames at that point in the animation. For example, if the animation frame rate is 15 frames per second (fps), the first second is designated by the number 15, the next second by the number 30, and so on. Figure 19-3 shows the Time Ruler displayed as frames.

To the right of the time/frame toggle button are the Current Time/Frame and Allocated Time/Frame windows. When the Time Ruler displays units of time, the windows are divided into minutes, seconds, and individual frames. When the Time Ruler displays frames, the windows display the current frame and allocated frames. Enter a figure into the Current Time/Frame window to advance forward in the animation. Enter a value in the Allocated Time/Frame window to increase the length of the animation. The blue button to the right of the Allocated Time/Frame window is the Frame Rate Selector. Click the button to open the menu and click a frame rate to select it.

Allocated Time/Frame window

Current Time/Frame window

Time/Frame toggle switch

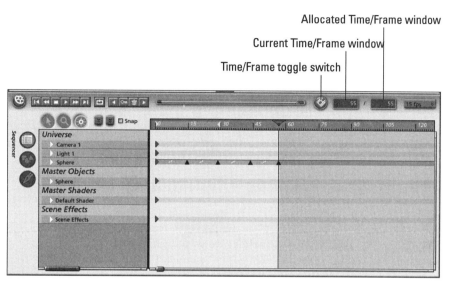

Figure 19-3: Displaying the Time Ruler as frames

Below the Scrubber is a long line with hash marks. This is the Time Ruler. Each hash mark indicates an individual frame in the animation. A large hash mark appears every second. The number of hash marks between each second is determined by the frame rate chosen for the animation. The default frame rate for a Carrara animation is 6 fps. The large downward-facing triangle with a line extending from its peak is the Current Time/Frame bar. Click it and drag to move from one point on the Time Ruler to another.

The render range for the animation is designated by the area of the Time Ruler highlighted in yellow. At each end of the render range are yellow triangles facing each other. These triangles are used to designate the starting and ending points of the rendering. To set the starting point for the rendering, drag the first triangle to a point on the Time Ruler. To set the ending point for the rendering, drag the last triangle to a point on the Time Ruler. In theory, the Time Ruler can extend to one hour minus one frame in length. However, an animation of that size would exceed the capacity of most system hard drives.

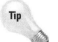 **Tip** To preview a selected part of the animation, drag the Render Range triangles to restrict the Render Range to the portion of the animation you need to preview.

To the left of the Time Ruler are three round icons. The first tool is the Pick tool. Click it and then click anywhere on the Time Ruler to change the current time to that point on the Time Ruler. The tool that looks like a magnifying glass is used to zoom in and out on the Time Ruler. Select the tool and click anywhere below the Time Ruler to zoom in. Alt+click to zoom out. The last icon, the Add Key Frame tool, is used to add key frames. Click it and then click a point along an object's timeline

to add a key frame. Enable the Snap option to have the Current Time bar and key frame markers snap to frame boundaries when you drag them.

Creating key frames

Whenever a key frame is created on an object's timeline, it is designated by a key frame marker. Key frame markers appear as upright black triangles on the timeline.

Key frames can be created in several ways. One method is to drag the Current Time bar to a point in time on the Time Ruler and change an object's animatable properties by directly manipulating the object in one of the rooms.

The second method involves using the Create Key Frame tool.

To create a key frame using the Create Key Frame tool:

1. Select the object whose timeline you want to add a key frame to by clicking its name in the Universe list. The object's name is highlighted in yellow.

2. Drag the Current Time bar to the point on the object's timeline where you want to add the key frame.

3. Click the Create Key Frame tool (the button that looks like a key). A key frame marker appears on the object's timeline at the selected point in time.

A key frame can also be added by using the Add Key Frame tool.

To add a key frame using the Add Key Frame tool:

1. Click the Add Key Frame tool to select it.

2. Click any spot on any object's timeline where you want to add a key frame. A key frame marker appears on the object's timeline at the selected spot.

Once created, key frames may also be deleted. To delete key frames:

1. Select the key frame you want to delete with the Pick tool.

2. Click the Delete Key Frame tool to remove the key frame from the timeline.

 Alternatively, press the Delete key.

Note You can delete multiple key frames. Use the Pick tool to select the first key frame and then Shift+click to add key frames to the selection. You can also use the Pick tool to marquee-select several key frames by dragging the tool around the frames you want to select.

Managing an object's hierarchy

As an animation becomes more complex, the number of timelines multiply accordingly. When you move, rotate, or scale an object, another timeline is added for each animatable property that is transformed. For each behavior or modifier you add to an object, another timeline is created as well. In no time, the object's

hierarchy becomes quite cluttered and complex. Fortunately, there is a way to combat hierarchy clutter.

The small blue button with the downward-facing double arrow to the right of the Add Key Frame tool is used to manage the hierarchies of scene objects. Clicking the button (see Figure 19-4) reveals four options:

✦ **Hide Null Group Tracks:** Excludes any timelines in an object's hierarchy that haven't been applied. For example, if you choose this option and an object has no modifiers applied, the modifiers list won't be displayed when you expand the object's hierarchy.

✦ **Hide Empty Group Tracks:** Excludes any timelines in an object's hierarchy that don't have key frames.

✦ **Hide Non-Transform Tracks:** Excludes any timelines where a particular animatable property of an object hasn't been transformed.

✦ **Hide Non-Animated Tracks:** Excludes any timelines in an object's hierarchy that aren't animated.

Note You can enable as many of these options as you need to manage an object's hierarchy.

Figure 19-4: Managing an object's hierarchy by displaying specific timelines only

Editing the timeline

After mapping the animation, adding objects to the scene, and transforming them to create action, you may need to edit the timeline to fine-tune the sequence of events. Key frames can be moved to different points along the timeline. A selection of key frames can be expanded or contracted to lengthen or decrease the amount of time used for an action sequence.

To move a key frame, select it with the Pick tool and drag it to a new point on the timeline.

Tip When you have overlapping key frames on the timeline, it can become difficult to accurately select the proper one. Select the Zoom tool and click the timeline to zoom in. If necessary, click again to zoom in tighter on the timeline. When you're done editing the timeline, Alt+click the timeline to zoom out.

To speed up or slow down a sequence of events:

1. Drag open the Sequencer tray.

2. Using the Pick tool, select the desired key frames. Select the first key frame in the sequence and then Shift+click to add additional key frames to the selection. Or marquee-select the desired key frames by dragging the Pick tool around them.

3. Press down the Ctrl key and drag right to expand the time sequence. Drag left to compress it.

Duplicating and modifying multiple key frames

Carrara provides a number of features for duplicating and modifying multiple key frames. The second blue button with the downward-facing double arrow to the right of the Add Key Frame tool reveals the Key Frame Action menu. This tool controls how selected key frames are duplicated. The tool is also used to adjust how selected key frames are positioned in reference to the next key frame.

To apply a key frame action to selected frames:

1. Drag open the Sequencer tray.

2. Using the Pick tool, Shift+click to select the desired key frames.

3. Click the button to reveal the Key Frame Actions menu (see Figure 19-5).

4. Click to select the desired option:

 • **Snap:** Adjusts the positioning of selected key frames to coincide with the start of the next frame.

 • **Reverse:** Flips the order of selected key frames so that the last becomes the first and vice-versa.

 • **Repeat:** Duplicates the sequence of selected key frames, placing the duplicates immediately after the selected key frames. You can specify the number of iterations you want the sequence to repeat.

 • **Mirror:** Duplicates the selected key frames, and then reverses their order. The mirrored key frames are placed immediately after the selected key frames. You can specify the number of iterations you want the sequence to mirror.

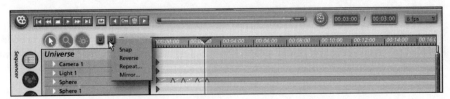

Figure 19-5: The Key Frame Actions menu

Tip You can nudge selected key frames along the timeline. Simply select them, and then use the right arrow key to nudge forward and the left arrow key to nudge backward.

Controlling motion with Tweeners

When one of an object's animatable properties is altered, a key frame is created. The frames in between key frames are interpolated to create action. How the intervening frames are interpolated will depend on the type of action taking place at a key frame. For example, to simulate a light being turned on, you want the action to be immediate. To simulate a sunrise, the scene brightens gradually. To individually edit each intervening frame to create the transition would be tedious work indeed. Fortunately, Carrara provides a device for editing the transition between key frames.

When a new key frame is created, a small symbol appears in the middle of the gap between the new key frame and the previous key frame. This is known as a *Tweener*. Tweeners determine the type of transition between two key frames. There are seven Tweeners to choose from. Each has a unique symbol on the timeline (see Figure 19-6).

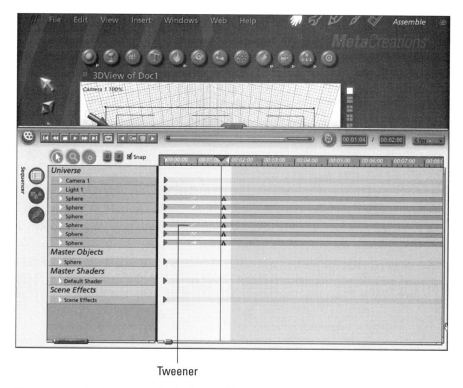

Tweener

Figure 19-6: Each Tweener is designated by a unique symbol on the timeline.

To apply a Tweener to a transition between key frames:

1. Click the gap between two key frames.

2. Drag open the Properties tray. The default Linear Tweener dialog box appears.

3. Click the current Tweener's name, and from the drop-down menu select the desired Tweener for the transition (see Figure 19-7).

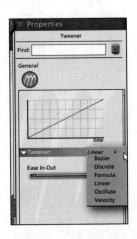

Figure 19-7: Selecting a Tweener

Editing the Linear Tweener

The Linear Tweener is the default Tweener. The Linear Tweener creates a smooth transition from one key frame to the next. At its default setting, the action change takes place at an even rate between key frames. The Linear Tweener can be edited to control how the transition starts and ends.

To edit the Linear Tweener:

1. Drag open the Sequencer tray.

2. Click the gap between the two key frames to which you want to apply the Tweener.

3. Drag open the Properties tray, click the current Tweener's name, and select Linear from the drop-down menu. The Linear Tweener dialog box appears (see Figure 19-8).

Figure 19-8: Editing the Linear Tweener

4. Drag the Ease In-Out sliders to control how action starts and stops. Drag the left (Ease In) slider to the right to start slowly. Drag the right (Ease Out) slider to the left to end slowly.

5. Click the VCR Play control to preview the transition. If it's not to your liking, repeat steps 4 and 5 to fine-tune the Tweener.

Editing the Bezier Tweener

The Bezier Tweener applies a smooth transition from one key frame to the next. The Bezier Tweener is ideally suited for an object with a motion path.

To edit the Bezier Tweener:

1. Drag open the Sequencer tray.

2. Click the gap between the two key frames to which you want to apply the Tweener.

3. Drag open the Properties tray, click the current Tweener's name, and select Bezier from the drop-down menu. The Bezier Tweener dialog box appears (see Figure 19-9).

4. Drag the Ease In-Out sliders to control how action starts and stops. Drag the left (Ease In) slider to the right to start slowly. Drag the right (Ease Out) slider to the left to end slowly.

5. Drag the Tighten In-Out sliders to adjust the path the Ease In-Out values take as they change from start to finish. The default settings apply a smooth, natural transition. Drag the sliders to their extreme settings to create a tight linear trajectory. Drag the sliders closer to the center to create a looser trajectory.

6. Click the VCR Play control to preview the transition. If it's not to your liking, repeat steps 4 and 5 to fine-tune the Tweener.

Figure 19-9: Editing the Bezier Tweener

Editing the Discrete Tweener

When the Discrete Tweener is applied to a transition, the change is immediate. Use the Discrete Tweener when you want an instant change, such as flicking on a light.

To edit the Discrete Tweener:

1. Drag open the Sequencer tray.

2. Click the gap between the two key frames to which you want to apply the Tweener.

3. Drag open the Properties tray, click the current Tweener's name, and select Discrete from the drop-down menu. The Discrete Tweener dialog box appears (see Figure 19-10).

4. Drag the Threshold slider to specify the point in the transition where you want the change to occur. At its default setting (100 percent), the change occurs at the end of the transition period. Drag the slider to the left to have the change occur earlier in the transition period.

5. Click the VCR Play control to preview the transition. If it's not to your liking, repeat step 4 to fine-tune the Tweener.

Figure 19-10: Editing the Discrete Tweener

Editing the Formula Tweener

The Formula Tweener applies a mathematical formula to control the transition between key frames. The basic formula can be edited, or if you're good at math you can apply one of your own.

1. Drag open the Sequencer tray.

2. Click the gap between the two key frames to which you want to apply the Tweener.

3. Drag open the Properties tray, click the current Tweener's name, and select Formula from the drop-down menu. The Formula Tweener dialog box appears (see Figure 19-11).

Figure 19-11: Editing the Formula Tweener

4. Drag the P1 and P2 parameter sliders to increase or decrease the parameter values.

5. Click the Parse button to apply the formula to the Tweener.

6. Click the More button to enter a formula of your own (see Figure 19-12).

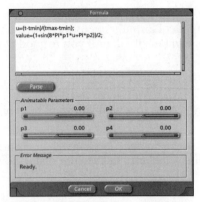

Figure 19-12: Applying your own formula to the Formula Tweener

7. Enter a new formula. Drag the P1, P2, P3, and P4 sliders to increase or decrease the parameter values.

8. Click the Parse button to apply the new formula to the Tweener.

9. Click OK to close the dialog box.

10. Click the VCR Play button to preview the transition. If it's not to your liking, repeat steps 4 through 9 to fine-tune the Tweener.

Cross-Reference

The Formula editor is used throughout Carrara. The editor has its own special protocol. For more information on formulas, refer to the section "Modeling with Formulas" in Chapter 13.

Editing the Oscillate Tweener

The Oscillate Tweener cycles back and forth between the starting and ending values of the transition. You can edit the number of cycles as well as specify the type of loop that's applied to the Tweener. Simulating the flashing beacons on top of a police car would be an excellent use for the Oscillate Tweener.

To edit the Oscillate Tweener:

1. Drag open the Sequencer tray.

2. Click the gap between the two key frames to which you want to apply the Tweener.

3. Drag open the Properties tray, click the current Tweener's name, and select Oscillate from the drop-down menu. The Oscillate Tweener dialog box appears (see Figure 19-13).

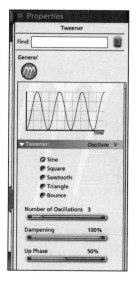

Figure 19-13: Editing the Oscillate Tweener

4. Select the type of wave to apply to the Tweener:

- **Sine:** Uses a mathematical sine curve to cycle between starting and ending values.

- **Square:** Cycles between starting and ending values with abrupt, instantaneous transitions.

- **Sawtooth:** Cycles the transition linearly from start to end and then abruptly snaps back to the beginning value. The Sawtooth wave can be used to loop a movie.

- **Triangle:** Creates a series of linear peaks and valleys, smoothly cycling the transition between starting and ending values.

- **Bounce:** Causes the cycle to begin abruptly at the starting value and smoothly transition back from the ending value of the transition. This simulates the effect of gravity pulling an object downward and then bouncing back as it hits an obstacle.

5. Enter a value for the number of oscillations. This value determines how many times the Tweener will cycle between starting and ending values.

6. Enter a value for Dampening. Dampening lessens the amplitude of each cycle's oscillation by the percentage of the value entered. A bouncing ball exhibits dampening. Each time it hits the ground, it bounces lower until it stops.

7. Enter a value for Up Phase. Drag the slider right to increase the amount of time spent in the up phase and left to decrease the amount of time spent in the up phase.

8. Click the VCR Play button to preview the transition. If it's not to your liking, repeat steps 4 through 7 to fine-tune the Tweener.

Editing the Velocity Tweener

The Velocity Tweener determines the rate at which an object accelerates between the starting and ending values of the transition.

To edit the Velocity Tweener:

1. Drag open the Sequencer tray.

2. Click the gap between the two key frames to which you want to apply the Tweener.

3. Drag open the Properties tray, click the current Tweener's name, and select Velocity from the drop-down menu. The Velocity Tweener dialog box appears. The default transition is linear acceleration (see Figure 19-14).

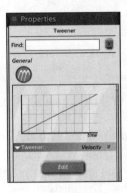

Figure 19-14: The Velocity Tweener dialog box

4. Click the Edit button to edit the Tweener. The Velocity Editor dialog box appears (see Figure 19-15).

5. Click the starting dot in the velocity graph to determine how the object accelerates from rest. Drag the starting dot to reveal a handle that is used to shape the starting curve on the velocity graph.

6. Click the ending dot in the velocity graph to determine how the object slows down. Drag the ending dot to reveal a handle that is used to shape the starting curve on the velocity graph.

7. Enable the Tie End option to tie the end to the last frame. Click OK to apply the changes.

8. The Time graph changes to reflect the object's new velocity characteristics during the transition.

9. Click the VCR Play button to preview the transition. If it's not to your liking, click the Edit button to reopen the Velocity Editor.

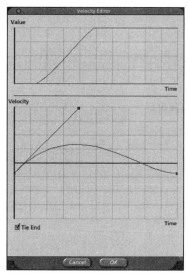

Figure 19-15: Editing the Velocity Tweener

Animating Objects

There are many different ways to animate objects. And virtually all objects in a Carrara scene can be animated. Objects can be animated by changing shader characteristics over time, changing the object's size over time, changing the object's shape over time, and so on.

Virtually every room in Carrara with the exception of the Render room can be used to apply an animation effect. In the Assemble room, objects can be made to move and change physical properties. In the Model room, object's shapes can be modified. In the Texture room, object's shaders can be modified. Modifiers can be used for animation by applying them to an object and then changing their parameters during the course of the animation.

Animating objects with modifiers

Modifiers are used to alter an object's surface into shapes that would be difficult if not impossible to achieve with Carrara's three modelers. By changing a modifier's parameters from one key frame to the next, you can make the object mutate or morph during the course of the animation. Modifiers can be used to make objects bend, twist, explode, stretch, atomize, dissolve, morph, grow spikes, and warp, among other effects. By applying more than one modifier to an object, you can create a complex series of actions that would be difficult to achieve by other

means. Modifiers can be applied to primitive and modeled objects as well as imported objects.

Cross-Reference

For more information on modifiers, refer to Chapter 8.

Working with object behaviors

Behaviors are a special class of modifiers that animate an object. When a behavior is applied to an object, all the instructions needed to make the object act in a certain way are applied. Behaviors create motion that would be difficult to create otherwise. They also help reduce the number of key frames needed to create an animation. More than one behavior can be applied to an object. For example, you can cause an object to bounce and spin by applying both the Bounce and Spin behaviors.

To apply a behavior to an object:

1. Select the object to which you want to apply the behavior.

2. Drag open the Properties tray.

3. Click the Modifiers button.

4. Click the + button, select Behaviors, and then select the behavior you want to apply to the object.

Moving an object with the Bounce behavior

The Bounce behavior causes an object to bounce up and down along the Z axis. You can adjust the number of bounces per second and set upper and lower limits for the bounce.

To apply the Bounce behavior to an object:

1. Select the object you want to bounce.

2. Drag open the Properties tray.

3. Click the Modifiers button.

4. Click the + button and select Behaviors ➪ Bounce. The Bounce dialog box appears (see Figure 19-16).

5. Drag the Bounces per Second slider to set the number of bounces per second.

6. Enter a value for Floor. This value determines the point on the Z axis where downward motion ceases and the object rebounds.

7. Enter a value for Height. The value determines how high the object bounces off the floor.

8. Enter a value for Start. This value determines the point in the animation when the object begins its first drop to the floor.

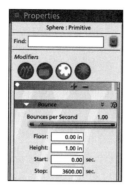

Figure 19-16: Applying the Bounce behavior to an object

9. Enter a value for Stop. This value determines the point in the animation when the object stops bouncing.

Tracking an object with the Point At behavior

When the Point At behavior is applied to an object, its position is oriented towards another object. As the animation progresses, the object the modifier is applied to will point towards the target object as it changes position.

To apply the Point At behavior to an object:

1. Select the object to which you want to apply the behavior.
2. Drag open the Properties tray.
3. Click the Modifiers button.
4. Click the + button and select Behaviors ➪ Point At. The Point At dialog box appears (see Figure 19-17).

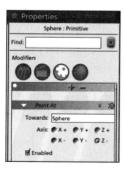

Figure 19-17: Applying the Point At behavior to an object

5. Enter the target object in the Towards box. This field is case sensitive.
6. Select an Axis. Select the axis to correspond to the face of the object you want to point at the target object.

Note When applying the Point At behavior to a camera or light, you want to accept the default axis, the Z axis, because cameras and lights are oriented toward this axis when they enter a scene.

7. Click the Enabled option to toggle the behavior on and off. Each time you turn the behavior on or off, a key frame is created.

Animating an object with the Shake behavior

The Shake behavior causes an object to jump during the course of an animation. You can adjust the number of jumps per second and the amplitude of each jump.

To apply the Shake behavior to an object:

1. Select the object to which you want to apply the behavior.

2. Drag open the Properties tray.

3. Click the Modifiers button.

4. Click the + button and select Behaviors ⇨ Shake (see Figure 19-18).

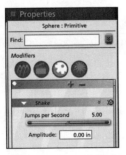

Figure 19-18: Applying the Shake behavior to an object

5. Drag the Jumps per Second slider to specify the number of jumps per second.

6. Enter a value for Amplitude. This value determines the height of the jump.

Tip To simulate the view through an airplane cockpit window going through turbulent air, apply the Shake behavior to the camera rendering the scene.

Rotating an object with the Spin behavior

Applying the Spin behavior to an object causes it to rotate.

To apply the Spin behavior to an object:

1. Select the object to which you want to apply the behavior.

2. Drag open the Properties tray.

3. Click the Modifiers button.

4. Click the + button and select Behaviors ⇨ Spin (see Figure 19-19).

5. Drag the Cycles per Second slider to adjust the number of spins per second. Dragging the slider left (negative values) causes the object to spin in the opposite direction.

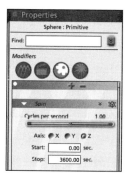

Figure 19-19: Applying the Spin behavior to an object

6. Select the axis of rotation for the behavior.

7. Enter a value for Start. This is the point in the animation when the object begins to spin.

8. Enter a value for Stop. This is the point in the animation when the object stops spinning.

Tracking an object with the Track behavior

The Track behavior instructs an object to shadow the selected target object as it moves throughout the scene.

To apply the Track behavior to an object:

1. Select the object to which you want to apply the behavior.

2. Drag open the Properties tray.

3. Click the Modifiers button.

4. Click the + button and select Behaviors ⇨ Track (see Figure 19-20).

5. Enter the name of the object you want to track in the Towards box. This field is case sensitive.

6. Enable the corresponding checkbox for each axis on which you want the track behavior to occur.

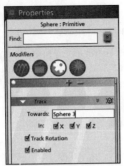

Figure 19-20: Applying the Track behavior to an object

7. Enable Track rotation if you want to track the target object's rotation as well as its position.

8. Click the Enabled option to toggle the behavior on and off. Each time you turn the behavior on or off, a key frame is created.

Linking objects with the Inverse Kinematics modifier

Inverse kinematics is a method of controlling motion. Inverse kinematics transfers motion through linked objects. As an example of inverse kinematics in action, imagine raising your hand in the air to hail a cab; the forearm follows, as does the elbow, upper arm, and shoulder. This is called a *child-to-parent relationship*. The hand is the child to the forearm, and the forearm is the child to the elbow, and so on up the hierarchy to the shoulder.

When a link is established in Carrara, one object is the parent and one object is the child. Where the parent goes the child will follow, but the child can move independently without affecting the parent.

Before an inverse kinematics relationship can be established, a link must first be formed between two objects.

To link two objects:

1. Drag open the Sequencer tray.

2. From the Universe list, locate the object that will be the child.

3. Click the child object's name and drag it on top of the name of the parent object. The link is formed (see Figure 19-21).

Parent object

Child objects

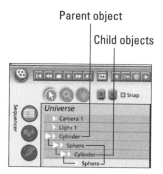

Figure 19-21: A linking hierarchy

To apply the Inverse Kinematics modifier to an object:

1. Select the object.

2. Drag open the Properties tray.

3. Click the Modifiers button.

4. Click the + button and select Inverse Kinematics.

The Inverse Kinematics modifier has no parameters. It merely establishes the relationship. Defining the child's motion relative to the parent requires motion to be constrained.

Constraining an object's motion

After establishing a linking hierarchy, the child's motion must be constrained relative to the parent. Examine the range of motion in your arm. The hand is child to the wrist. It only has a certain range of motion. Furthermore, the forearm is linked to the elbow, and it, too, has a limited range of movement. The motion of each child is constrained relative to the parent.

When you have an inverse kinematics hierarchy established, and constraints are applied to the objects in the hierarchy, moving the parent causes the child to move. However, once an inverse kinematics hierarchy is established and constraints are put on the child's and parent's motion, the child can cause the entire chain to move. For example, if the rotation of the child object was unconstrained, and its position in reference to the three axes was locked, on its own it could rotate freely, but not move. However, once the child is linked to a parent with unconstrained motion along the three axes, selecting the child and dragging it will cause the parent to move. If the first child's parent is child to another parent, the results of the motion are transmitted up the chain.

When you work with inverse kinematics and constraints, the placement of the hot point becomes very important. If you were to establish the hierarchy of an arm from scratch, the hand's hot point would need to be repositioned at the joint where

the hand joins the wrist. Any motion applied to the hand now emanates from the joint. The forearm's hot point would need to be repositioned to the center of the elbow. After repositioning the hot point of the arm's components, you would have to establish a linking hierarchy. The next step would be to apply the Inverse Kinematics modifier, and then to apply the necessary constraints to each object. After creating the links and applying the Inverse Kinematics modifier and constraints, you are ready to pose and animate the arm.

To apply a constraint to an object:

1. Select the object to which you want to apply the constraint.

2. Drag open the Properties tray.

3. Click the Motion/Transform button.

4. Select Constrain, and then select the constraint you want to apply to the object. The default constraint is none. This allows you to place the child anywhere in the scene.

Constraining motion to a specific plane

The 2D Plane constraint restricts an object's motion to a specific plane. The actual plane of constraint is relative to the object's axis and not the global axis references. For example, if you rotate an object and then apply the 2D Plane constraint, the plane of constraint is rotated relative to the object's Yaw, Roll, and Pitch values.

To apply a 2D Plane constraint:

1. Select the object to which you want to apply the constraint.

2. Drag open the Properties tray.

3. Click the Motion/Transform button.

4. Select Constraint ➪ 2D Plane. The 2D Plane constraint dialog box appears (see Figure 19-22).

5. Select the plane along which you want to constrain the object's motion.

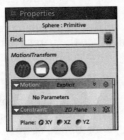

Figure 19-22: Applying the 2D Plane constraint to an object

Constraining rotation to a specific axis

The Axis constraint restricts an object's motion to a specific axis. The object can rotate freely along the axis, rotate within a limited range along the axis, or be locked to a specific point along the axis.

To apply the Axis constraint to an object:

1. Select the object to which you want to apply the constraint.

2. Drag open the Properties tray.

3. Click the Motion/Transform button.

4. Select Constraint ⇨ Axis. The Axis constraint dialog box appears (see Figure 19-23).

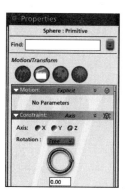

Figure 19-23: The Axis constraint dialog box

5. Select the axis of constraint.

6. Click the Rotation button and choose one of the following:

 • **Free:** Allows the object to rotate freely along the specified axis.

 • **Locked:** Locks the object to a specific radian along a circle whose diameter is equal to the object's size along the specified axis of constraint. To set the angle of constraint, drag the slider (see Figure 19-24).

 • **Limited:** Allows the object to rotate along the specified axis to the degree specified. Rotation can be in a positive and/or negative direction. Drag the end sliders to set the positive and negative limits of rotation.

 These sliders operate independently. If desired, positive and negative settings may differ. The middle slider always indicates the object's current position along the axis of constraint (see Figure 19-25).

Figure 19-24: Applying a Locked Axis constraint to an object

Figure 19-25: Applying a Limited Axis constraint to an object

Creating a Ball Joint constraint

The Ball Joint lets a child object rotate freely 360 degrees around its hot point. An object with the Ball Joint constraint applied is not affected by the parent object except when the parent object moves.

To apply the Ball Joint constraint to an object:

1. Select the object to which you want to apply the constraint.

2. Drag open the Properties tray.

3. Click the Motion/Transform button.

4. Select Constraint ➪ Ball Joint. The Ball Joint constraint dialog box appears. There are no parameters for the Ball Joint constraint nor are there constraints upon any axis.

Creating a custom constraint

A custom constraint restricts an object according to your specifications. By using a combination of sliders and axis rotation controls, you can combine locked, limited, and free motion to have an object behave just as you want it to.

To apply a custom constraint to an object:

1. Select the object to which you want to apply the constraint.
2. Drag open the Properties tray.
3. Click the Motion/Transform button.
4. Select Constraint ⇨ Custom. The Custom constraint dialog box appears (see Figure 19-26).

Figure 19-26: Applying a custom constraint to an object

5. Choose Locked, Limited, or Free for motion in the X position. Depending on the type of motion constraint you selected, drag the sliders to adjust motion parameters.

6. Choose Locked, Limited, or Free for motion in the Y position. Depending on the type of motion constraint you selected, drag the sliders to adjust motion parameters.

7. Choose Locked, Limited, or Free for motion in the Z position. Depending on the type of motion constraint you selected, drag the sliders to adjust motion parameters.

8. For the X rotation constraint, choose Locked, Limited, or Free. Depending on the type of rotation constraint you selected, drag the axis rotation control to adjust motion parameters.

9. For the Y rotation constraint, choose Locked, Limited, or Free. Depending on the type of rotation constraint you selected, drag the axis rotation control to adjust motion parameters.

10. For the Z rotation constraint, choose Locked, Limited, or Free. Depending on the type of rotation constraint you selected, drag the axis rotation control to adjust motion parameters.

11. Click the Rotation Order button to set the order in which the axes rotate.

Creating a Lock constraint

The Lock constraint locks the child object to the parent object. The child object cannot be moved on its own; it will only move when the parent object is moved.

To apply the Lock constraint to an object:

1. Select the object to which you want to apply the constraint.

2. Drag open the Properties tray.

3. Click the Motion/Transform button.

4. Select Constraint ➪ Lock. The Lock constraint dialog box appears. The Lock constraint has no parameters.

Creating a Shaft constraint

A Shaft constraint constrains up-and-down motion and rotational motion within a single axis. A corkscrew pulling the cork out of a bottle of wine is a perfect example of a Shaft constraint in action. The corkscrew rotates along a specified axis and moves down the specified axis as it burrows into the cork.

To apply the Shaft constraint:

1. Select the object to which you want to apply the constraint.

2. Drag open the Properties tray.

3. Click the Motion/Transform button.

4. Select Constraint ➪ Shaft. The Shaft constraint dialog box appears (see Figure 19-27).

Figure 19-27: Applying the Shaft constraint

5. Select the axis of constraint.

6. Click the Slide button and choose Limited, Locked, or Free.

7. Drag the Slide slider to adjust the range of the constraint.

8. Click the Rotation button and choose Limited, Locked, or Free.

9. Drag the axis rotation control to adjust the range of constraint.

Creating a Slider constraint

The Slider constraint restricts motion along the X, Y, and Z axes. A deadbolt is an example of an object with a Slider constraint. It has a limited range of motion along one axis.

To apply the Slider constraint to an object:

1. Select the object to which you want to apply the constraint.

2. Drag open the Properties tray.

3. Click the Motion/Transform button.

4. Select Constraint ➪ Slider. The Slider constraint dialog box appears (see Figure 19-28).

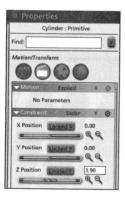

Figure 19-28: Applying the Slider constraint to an object

5. Choose Locked, Limited, or Free for motion along the X position. Depending on the type of motion constraint you selected, drag the sliders to adjust motion parameters.

6. Choose Locked, Limited, or Free for motion along the Y position. Depending on the type of motion constraint you selected, drag the sliders to adjust motion parameters.

7. Choose Locked, Limited, or Free for motion along the Z position. Depending on the type of motion constraint you selected, drag the sliders to adjust motion parameters.

Adjusting constraint controls

Each constraint slider has its own set of controls. Constraint motion sliders constrain motion along a selected axis. Constraint axis rotation controls rotation along a specified axis. Each control uses either Locked, Limited, or Free constraints. Each constraint option has its own set of controls.

A Locked motion slider or axis rotation control has only one control. Drag it to the desired position to lock motion or rotation to that position.

A Limited motion slider or axis rotation control has three controls. One control represents the negative extent of motion. The middle control represents the object's current position along the specified axis. The third control represents the positive extent of motion. Drag the end controls to set the positive and negative extents of travel.

Tip You can fine-tune the adjustment of limited motion sliders and limited axis rotation sliders by moving the object in the working box. Select the axis of constraint you want to fine-tune and then, depending on the type of constraint you're fine-tuning, either move or rotate the object along that axis. When the object reaches the desired extent of motion or rotation, drag the appropriate constraint slider to the middle slider's position.

A Free motion slider or axis motion control has only one control. This represents the object's current position along the specified axis. Drag the control to change the object's position.

Animating objects with physical effects

Physical effects make an object behave in a desired manner by applying the laws of physics to it. Objects can be put into motion and can interact with other objects, all the while obeying the laws of physics.

The Physics method of motion does not use key frames. The desired force is applied to the object and starts at frame one. You cannot move the key frame to apply the physical force at a later point in the animation. You cannot halt a physical force in progress. As in nature, an object in motion tends to remain in motion. You can, however, use the timeline to change any of the object's animatable characteristics that don't fall under the Physics motion method umbrella. For example, you can use a key frame to change an object's shader during the course of the animation.

To apply the Physics motion method to an object:

1. Drag the Scrubber to reset the animation to frame zero.

2. Select the object to which you want to apply the Physics motion method.

3. Click the Motion/Transform button.

4. Select Motion ⇨ Physics. The Convert Animation Method dialog box appears (see Figure 19-29).

5. Accept the default setting if no animation has previously been applied to the object. If animation has been applied to the object, drag the Quality slider to the right to create a more accurate conversion of existing data.

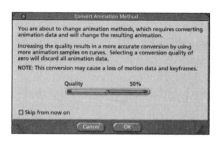

Figure 19-29: The Convert Animation Method dialog box

6. Click OK. The object's method of motion is converted to Physics and a new dialog box appears in the Motion panel (see Figure 19-30).

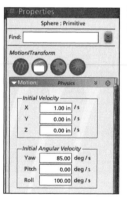

Figure 19-30: Changing an object's motion method to Physics

7. Enter the desired values in the Initial Velocity panel to apply a directional force to the object in frame one. If the object is affected by no other force or object, it will maintain its initial velocity indefinitely. By setting initial velocity in each axis, you set the object's direction of motion. Initial velocity can be a positive or negative value.

8. Enter the desired values in the Initial Angular Velocity panel to apply a spin to an object as it moves. Angular velocity is measured in degrees per second. Initial angular velocity can be used to simulate effects such as the spin of a bullet.

Note When applying initial velocity or initial angular velocity to an object, you're instructing the object to move or rotate along a specified axis. Entering positive numbers will cause the object to accelerate or rotate towards the positive direction of the axis. Entering negative numbers will cause the object to accelerate or rotate towards the negative direction of the axis. For example, if an object is located at Y = 5.00, and an initial velocity of Y = -1.00 in/s is applied to the object, when the animation starts it will accelerate towards the center of the Universe(Y = 0.00) and then continue towards the negative direction of the Y axis.

Applying physical properties to an object

An object's physical properties determine how it will react when it collides with another object. Every object introduced into a scene is given a default set of physical properties. These properties can be altered to cause the object to behave differently when it comes in contact with another scene object. Physical property presets are modeled after natural objects and react differently. A block of wood hitting a wooden table reacts differently than a rubber ball striking the same surface.

To adjust an object's physical properties:

1. Select the object.

2. Drag open the Properties tray.

3. Click the Effects button.

4. Scroll down to the Physical Properties panel (see Figure 19-31).

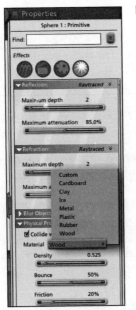

Figure 19-31: Setting an object's physical properties

5. Enable the Collide with other objects option to have the object deflect when it collides with another object. If this option is disabled, the object will pass through objects it encounters.

6. Click the Material button and choose from Cardboard, Clay, Ice, Metal, Plastic, Rubber, or Wood to cause the selected object to adopt the selected material's physical behaviors and characteristics. Choosing one of these material presets changes all the other settings in the Physical Properties panel. Select Custom to enter your own physical properties. If you select Custom, complete steps 7 through 9.

7. Drag the Density slider to determine the density of the object.

8. Drag the Bounce slider to determine how the object bounces after striking another object. This value sets the amount of energy lost when the object rebounds.

9. Drag the Friction slider to determine the surface characteristics of an object. An object with a high friction setting has a lot of drag and comes to rest quicker when sliding along another object.

Adjusting a scene's physics settings

When you choose to animate an object or objects with the Physics method of motion, the scene's physics properties may need to be adjusted.

To adjust a scene's physics properties:

1. Drag open the Properties tray.

2. Click the blue button with the downward-facing double arrow and select Scene.

3. In the Physics panel, select a setting for Effects Fidelity. The default setting of medium works well in most cases. Select the high setting when you have objects interacting at rapid rates. If desired, select lower settings for simple animations.

4. Select a setting for Surface Fidelity. Low settings speed up physics calculations but degrade the surface of the model. High settings produce the best-looking objects but take longer to calculate physics.

5. Enable the Physics option.

6. Enable Save Tweener data to have Tweener data available for objects animated with key frames (see Figure 19-32).

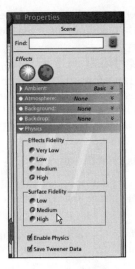

Figure 19-32: Adjusting physical properties for a scene

Working with physical forces

After changing an object's method of motion to Physics and setting the object's physical properties, you must apply an actual force to an object. Carrara gives you five physical force options to work with: Directional Force, Point Force, Damping Force, Torque Force, and Flow Force. You can add physical forces to a scene by using menu commands or by dragging the force into the working box directly from a toolbar. The physical force tools are on the fly-out of the eleventh tool on the toolbar (see Figure 19-33).

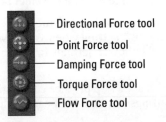

— Directional Force tool

— Point Force tool

— Damping Force tool

— Torque Force tool

— Flow Force tool

Figure 19-33: Use these tools to insert physical forces into a scene.

Animating an object with directional force

Applying directional force to an object causes the object to accelerate in the direction specified. For directional force to have an effect, at least one scene object must have the Physics method of motion applied to it.

To apply directional force to an object:

1. Select Insert ⇨ Directional Force.

 Alternatively, drag the Directional Force tool into the working box.
2. The Directional Force Target Helper Object appears in the working box (see Figure 19-34).

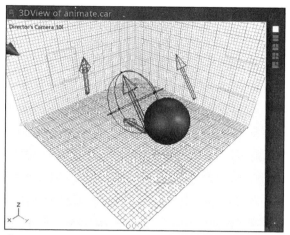

Figure 19-34: Align the Directional Force Target Helper towards the direction you want the object to travel.

3. Using the Move and Rotate tools, align the Directional Force Target Helper towards the direction you want the object to travel.

4. Drag open the Properties tray.

5. Click the Effects button. The Directional Force dialog box appears (see Figure 19-35).

Figure 19-35: Applying a directional force to an object

6. Enter a value for Strength.

7. Enable the Rocket box if you want the object to accelerate as it moves away from the force. This option creates convincing rocket launches.

8. Select the object to which the force is being applied.

9. Drag open the Properties tray.

10. Click the Motion/Transform button and in the Physics panel enter values for Initial Velocity and Initial Angular Velocity.

Animating an object with point force

Point force acts like a beacon, forcing an object with the Physics method of motion to accelerate toward a target object and, if the force is strong enough and the animation proceeds long enough, to eventually collide with the target object. Point force can be used to simulate a metal object being attracted toward a magnet. For point force to have an effect, at least one scene object must have the Physics method of motion applied to it.

To apply point force to an object:

1. Select Insert ⇨ Point Force.

 Alternatively, drag the Point Force tool into the working box.

2. The Point Force Target Helper Object appears in the working box.

3. Align the Point Force Target Helper Object with the target object. The easiest way to do this is to select the target object first and then select the Point Force Target Helper object. Use the Align menu command to align the hot points of all axes (see Figure 19-36).

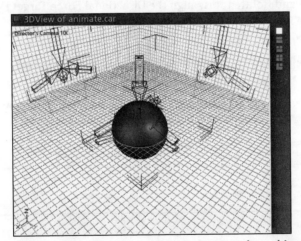

Figure 19-36: Align the Point Force Target Helper object to the target object.

4. With the Point Force Target Helper Object selected, drag open the Properties tray.

5. Click the Effects button. The Point Force dialog box appears.

6. Drag the Strength slider to set the strength of the attraction (see Figure 19-37).

Figure 19-37: Applying a point force to an object

Note Negative values cause an object to be repulsed from the point force.

7. Drag the Field Decay rate to adjust the how the attraction field decays as it moves away from the target object. Higher settings create a field that decays rapidly as it moves away from the center of the point force.

8. Select the object to which the force is being applied.

9. Drag open the Properties tray.

10. Click the Motion/Transform button and in the Physics panel enter values for Initial Velocity and Initial Angular Velocity.

Animating an object with damping force

Damping force acts like a set of brakes, gradually slowing an object down. The force acts like a fluid damper. Regardless of an object's velocity, damping force will slow and eventually cause the object to stop. For damping force to have an effect, at least one scene object must have the Physics method of motion applied to it.

To apply damping force to an object:

1. Select Insert ➪ Damping Force.

 Alternatively, drag the Damping Force tool into the working box.

2. The Damping Force Target Helper Object appears in the working box.

3. Align the Point Force Target Helper object so it is directly in the motion path of the object you want to apply the force to. For example, if you apply an initial velocity to an object that causes it to move towards the X- axis, align the Point Force Target Helper Objects's X Center and Z Center with the object's X Center and Z Center. Make sure the Point Force Target Helper Object's Y Center is downstream from the object's path of motion (see Figure 19-38).

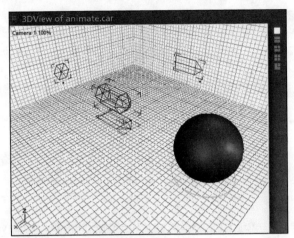

Figure 19-38: Align the Damping Force Target Helper Object to the object's path of motion.

4. With the Damping Force Target Helper Object still selected, drag open the Properties tray.

5. Click the Effects button. The Damping Force dialog box appears.

6. Enter a value for Strength. Higher values cause objects to slow faster (see Figure 19-39).

Figure 19-39: Applying a damping force to an object

7. Select the object to which the force is being applied.

8. Drag open the Properties tray.

9. Click the Motion/Transform button and in the Physics panel enter values for Initial Velocity and Initial Angular Velocity.

Animating an object with torque force

Torque force causes an object to spin. Use it to simulate spinning armatures. For torque force to have an effect, at least one scene object must have the Physics method of motion applied to it.

To apply torque force to an object:

1. Select Insert ⇨ Torque Force.

 Alternatively, drag the Torque Force tool into the working box.

2. The Torque Force Target Helper Object appears in the working box.

3. Use the Rotate tool to align the Torque Force Helper Object to the desired axis of rotation. Figure 19-40 shows the Torque Force Helper Object aligned to rotate an object on the X axis.

4. Drag open the Properties tray.

5. Click the Effects button. The Torque Force dialog box appears.

6. Enter a value for Strength. Higher values produce faster rotations (see Figure 19-41).

Figure 19-40: Align the Torque Force Helper object to the axis of rotation.

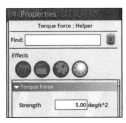

Figure 19-41: Applying torque force to an object

7. Select the object to which the force is being applied.

8. Drag open the Properties tray.

9. Click the Motion/Transform button and, in the Physics panel, enter values for Initial Velocity and Initial Angular Velocity.

Animating an object with flow force

Flow force animates objects by applying randomized directional motion. The motion generated by flow force makes an object look like it's fluttering in a breeze. For flow force to have an effect, at least one scene object must have the Physics method of motion applied to it.

To apply flow force to an object:

1. Select Insert ⇨ Flow Force.

 Alternatively, drag the Flow Force tool into the working box.

2. The Flow Force Target Helper Object appears in the working box (see Figure 19-42).

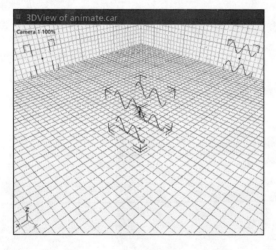

Figure 19-42: The Flow Force Target Helper Object

3. Drag open the Properties tray.

4. Click the Effects button. The Flow Force dialog box appears (see Figure 19-43).

5. In the Strength panel, enter values for X, Y, and Z. These settings determine the effect of each axis on the force.

Note Depending on the type of effect you want to achieve, enter a value of zero in one or more axes.

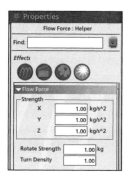

Figure 19-43: Applying Flow Force to an object

6. Enter a value for Rotate Strength.

7. Enter a value for Turn Density.

8. Select the object to which the force is being applied.

9. Drag open the Properties tray.

10. Click the Motion/Transform button and, in the Physics panel, enter values for Initial Velocity and Initial Angular Velocity.

Using target helper objects

Each physical force has a target helper object that is used to set the direction for the force. Target helper objects are null objects that have no properties other than position and rotation. They are invisible to the rendering camera.

In addition to the physical force target helper objects, there is a generic target helper object that can be used for various purposes in a scene. For example, to have a camera track a specific point in a group, insert a target helper object into the group, align it where you want the camera to point, and then use the Point At menu command to have the camera point at the target helper object. Another possible use for a target helper object is to place it in a part of a scene where you need additional lighting. Use the Point At command to have a light point at the target helper object.

To insert a target helper object into a scene:

1. Select Insert ⇨ Target Helper Object.

 Alternatively, drag the Target Helper Object tool into the working box. The Target Helper Object tool is the twelfth tool on the toolbar (see Figure 19-44).

2. Position and align the target helper object as desired.

Figure 19-44: The Target Helper Object tool

Tip

If you use multiple target helper objects in a scene, be sure to give them unique names so they're readily identifiable. To name a target helper object, select it, drag open the Properties tray, and enter a new name.

Animating with motion paths

When the Motion Path method of motion is applied to an object, it moves along a motion path that is drawn in the working box. Individual points along the motion path can be moved and edited. Motion paths are used in conjunction with key frames.

To apply the Motion Path method of motion to an object:

1. Select the object you want to animate along a motion path.

2. Drag open the Properties tray.

3. Click the Motion/Transform button and select Motion ⇨ Motion Path. The Convert Animation Method warning appears.

4. Accept the default setting if no animation has previously been applied to the object. If animation has been applied to the object, drag the Quality slider to the right to create a more accurate conversion of existing data. Click OK. The object's method of motion is changed to motion path and drawing tools appear on the left side of the working box (see Figure 19-45).

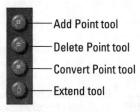
Add Point tool
Delete Point tool
Convert Point tool
Extend tool

Figure 19-45: The motion path drawing tools

The motion path drawing tools are the same tools you used to create shapes and paths in the Spline modeler, except that the Pen tool is now called the Extend tool. The four tools function identically when it comes to creating motion paths:

✦ **Extend tool:** Extends a path from the object. Existing paths can be extended by selecting the object and then using the Extend tool to add additional distance to the path. Drag the Extend tool to create a curve point with handles.

✦ **Add Point tool:** Adds points the path. To add a point to an object's motion path, select the object, and then select the Add Point tool. Click wherever you need to add a point to the path. The Add Point tool cannot be used to create curve points with handles.

✦ **Delete Point tool:** Removes unnecessary points from the motion path. To remove points from a motion path, select the object, and then select the Delete Point tool. Click a point to remove it from the path.

✦ **Convert Point tool:** Converts points along the motion path to curve points with handles. To convert a point on a motion path, select the object, and then select the Convert Point tool. Click a point and drag to convert it to a curve point. Use Alt+drag to convert one side of a point to a curve.

If an object's position has been transformed prior to converting it to the Motion Path method of motion, a path will appear in the working box. Use any of the motion path drawing tools to edit the path. Use the Move/Selection tool to reposition points along the path. Work in one plane at a time. It's best to switch to the Director's Camera's isometric (2D) views when editing a motion path. Remember that when you change the Director's Camera position while editing a motion path, it is not recorded as part of the animation. However, if you were to change the rendering camera's position while editing a motion path, or for that matter editing anything in a scene, the change in the camera's position would be recorded as part of the animation.

To create a motion path from scratch:

1. Select the object you want to animate along a motion path.
2. Drag open the Properties tray.
3. Click the Motion/Transform button, click the name of the current motion method (Explicit by default) and select Motion Path from the drop-down menu.
4. Switch to the Director's Camera Top view.
5. Use the Extend tool to create the path.
6. Use the Convert Point tool as needed to smooth the motion path.
7. Use the Move/Selection tool to move points as needed.
8. Switch to the Director's Camera Front view to align the motion path along the X axis.
9. Use the Move/Selection tool to move points as needed.
10. Use the Convert Point tool to edit points along this plane.
11. Switch the Director's Camera Left view to align the motion path along the Y axis.
12. Repeat steps 9 and 10 to edit points along this plane.
13. If necessary, use the Add Point tool to add additional points to the motion path.

Note Once a point has been converted to a curve point, you can use the Move/Selection tool to edit the point's handles.

Figure 19-46 shows a motion path created with the motion path drawing tools.

Once the motion path has been created, it needs to be applied to the animation. To do this, you create key frames along the timeline where you want major motion changes to occur. After the key frames have been created, you can apply motion changes by selecting a specific key frame and then moving the object to the desired point along the motion path.

Figure 19-46: Creating a motion path with drawing tools

To assign a point on an object's motion path to a key frame:

1. Select an existing key frame or create one.

2. Select the object.

3. Drag open the Properties tray.

4. Click the Motion/Transform button.

5. Drag the Distance Along Motion Path slider to move the object to the desired point on the path (see Figure 19-47).

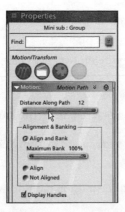

Figure 19-47: Drag the Distance Along Path slider to move the object

Note Depending on the speed of your computer and the complexity of the scene, it may take a few moments to see any visible change in the object's position along the path.

6. In the Alignment and Banking panel, choose from the following options:

- **Align and Bank:** Adjusts the object's Yaw, Pitch, and Roll values to the motion path, and will bank the object where appropriate. If you select this option, drag the Maximum Bank slider to control how much the object banks during a direction change.

- **Align:** Aligns the object's Yaw, Pitch, and Roll values to the motion path with no banking.

- **Not Aligned:** Keeps the object's original axis references at all points along the motion path.

Note The Alignment and Banking settings apply to the object for the extent of the animation. They cannot be changed from one key frame to the next.

7. Enable Display Handles to have each point's handles displayed.

Repeat steps 1 through 5 for each additional key frame assigned to the object.

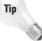

Tip If your working box is set up in four-window mode, switch one window to Top, one window to Front, one window to Left, and one window to Camera 1. Switch from one pane to the next to edit the motion path along all three planes while viewing motion path in 3D through the Camera 1 position.

Mixing motion methods

A single animation can use all three motion methods. For example, you may want an object such as a cannon ball to be animated using the Physics method of motion. In another part of the scene, a ship traveling across the water might be animated by the Explicit (key frame) method of motion. In yet another part of the scene, a bird is flying overhead and is animated using a motion path.

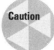

Caution The Physics method of motion requires extensive use of the computer to calculate the laws of physics as they apply to the object you're animating. Applying the Physics method of motion to several objects in your scene will tax your computer's resources and slow down scene editing.

Cloaking objects

Once an object is created, it is what it is for the course of the animation. A cube cannot become a sphere. You can, however, employ a little artistic sleight of hand by making the objects invisible for part of the animation.

To make an object invisible:

1. Drag the Scrubber to reset the animation to frame zero.

2. Select the object you want to make invisible.

3. Drag the Current Time bar to the spot in the animation where you want the object to disappear.

4. Drag open the Properties tray.

5. Click the General button, and disable the Visible option in the General panel. The object disappears and is invisible to the rendering camera. A key frame is created on the object's timeline.

6. Drag the Current Time bar to the spot in the animation where you want the object to reappear.

7. In the Properties tray, enable the Visible option. The object reappears and is visible to the rendering camera. A key frame is created on the object's timeline.

8. Click the transition gap between key frames and apply the appropriate Tweener. For example, if you want the object to suddenly reappear, apply the Discrete Tweener.

Using this method, you can change a cube into a sphere. Simply group the two objects together and cloak one at the start of the animation. Create a key frame where you want the transformation to occur and then cause the cloaked object to appear and the uncloaked object to become invisible. Apply the appropriate Tweener to complete the effect.

Applying motion blur

When you watch objects move, they are not in sharp focus. There's always a slight ghost image apparent behind the object as it moves across your viewing plane. Carrara's rendering engines are accurate to a fault and don't compensate for this natural phenomenon. Carrara has two different methods for applying a post-render blur. You can choose to blur individual scene objects or apply a global blur to all scene objects that move.

To blur an individual object:

1. Select the object to which you want to apply the blur.

2. Drag open the Properties tray.

3. Click the Effects button.

4. Click the Edit button in the Blur Object panel. The Blur Object dialog box opens (see Figure 19-48).

5. Click the Enable box to enable the effect.

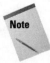

Note Every time you enable the effect, you create a key frame. By turning the effect on and off during the animation, you can create interesting visual effects.

6. Drag the Intensity slider to adjust the amount of blur applied.

7. Click OK to apply.

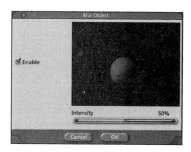

Figure 19-48: Blurring a scene object

To globally blur all moving objects in a scene:

1. Drag the Scrubber to reset the animation to frame zero.

2. Drag open the Properties tray.

3. Click the blue button with the downward-facing double arrow and select Scene.

4. Click the Filters button.

5. Click the + button and select Motion Blur. The Motion Blur dialog box appears (see Figure 19-49).

6. Drag the Intensity slider to 0.

7. Enable Blur to create a halo blur around moving objects.

8. If you enabled blur, enter a value for Blur Radius.

9. Enable Render First Frame to have all frames rendered. If this option is unchecked, the first few frames will render as black while Carrara calculates the proper amount of blur to apply.

10. In the Sequencer tray, drag the Scrubber to the last frame in the animation.

11. In the Properties tray, drag the Intensity slider to 100 percent or more.

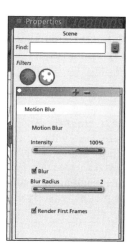

Figure 19-49: Applying a global blur to all scene objects

Animating objects with modelers

In addition to using modifiers, behaviors, and forces to animate scene objects, you can also employ modelers to accomplish this feat. Any object created in the Spline, Vertex, or Metaball modelers can be animated by jumping into the modeler at a desired point in the animation. As soon as you jump into the modeler, a new key frame is created. Apply the desired changes to the object and then jump out of the modeler. Apply a Tweener to the transition gap. When you render the animation, the changes created in the modeler are applied to the object at the desired point in the animation.

Animating objects in modelers can create many interesting effects. Objects can appear to age, mutate, distort, or disintegrate. Each modeler can create its own unique effects.

Objects created in the Spline modeler can be mutated into interesting shapes over time by changing the shape of individual cross sections. Cross sections can also be scaled and rotated during the course of an animation. Flowers created in the Spline modeler can be made to bloom during an animation. Robot's arms can be animated. Cross sections cannot be added or deleted. Cross section shapes can change during the course of an animation, but they cannot be deleted or replaced.

Organic objects created in the Vertex modeler can be morphed with the Sphere of Attraction tool. Faces created in the Vertex modeler can be animated. The Sphere of Attraction tool can be used to make an alien grow spikes during an animation. Vertices and polygons cannot be deleted once they are created. Once created, they remain with the object for the course of the animation.

Objects created in the Metaball modeler can undergo almost fluid changes during an animation. By moving a positive or negative blob element, you can change the entire shape. Positive blob elements can be hidden inside the general shape at frame zero and then extracted during the course of the animation. If you drag the blob elements far enough, the object appears to be disintegrating.

For an interesting Metaball modeler special effect, create one large positive blob and squash it. Create several smaller positive blobs and move them inside the large blob so they're not visible at frame zero. At some point in the animation, jump back into the Metaball modeler and drag them out and away from the large blob. The rendered animation will look like a small ball of liquid mercury breaking apart.

Animating objects with shaders

Modifying a shader during an animation is another way to create some interesting special effects. With a shader, you have eight channels to work with. And if you've created complex shaders with mixers, you have even more components to work with.

The most obvious choice is changing a shader's color during an animation. If the Color channel is a mix, you can create even more complex effects. By changing the characteristics of the blender, the object's surface will change during an animation.

Experiment with changing the settings for the Wires, Checkers, Marble, and Wood functions from one key frame to the next.

The Bump channel can be used to create some wonderful effects during an animation. By simply changing the amplitude setting of the Bump channel, you can raise or lower surface bump. Set the bump amplitude at 0 for the first frame and 100 for the last frame. Apply a waves shader to the Bump channel and change the settings during an animation, and the surface appears to be rippling.

A movie can be used in the Bump channel to create surface motion. Tank treads can be created and animated by using a grayscale bump map to create the bump for the individual treads. Once the bump map is created, a photo-paint program can be used to create a movie. Duplicate the bump map and move it from one frame to the next. When the movie is played back during the course of the animation, the treads will move.

Tip

If a movie you're using in an animation is shorter than the animation, apply the Oscillate Tweener to loop the movie. Use the Sawtooth wave to have the movie loop back to the start immediately after playing. To determine the number of oscillations needed to loop the movie, divide the number of movie frames into the number of frames used in the animation. For example, to loop a five-frame movie in a fifteen-frame animation, you'll need three oscillations.

The Transparency channel can also be used to create interesting effects. Depending on the contents of the shader's other channels, changing transparency over time can make an object appear to materialize out of thin air.

The Glow channel abounds with interesting possibilities. Glow colors can be changed. Value sliders can be used as blenders to change a glow from one color to another. Value sliders can also be used to change how brightly an object glows during an animation. Movies can also be in the Glow channel.

Multi Channel Mixers can create dramatic effects during an animation. Use a Value slider to blend two completely different types of shaders. At frame zero, slide the Value slider to the left and only Source 1 will be visible. Drag the Current Time bar to the last frame and open up the shader document in the Texture room. Drag the Value slider to the right and only Source 2 will be visible. When you render the animation, the object's surface will change from the Source 1 component to the Source 2 component.

The only things that can't be changed during the course of an animation are the components that are used to fill a channel. For example, you can't start out an animation with a Mixer in the Color channel and end the animation with a texture map in the Color channel. If you put a different component in a channel during an animation, the change is applied globally to the entire animation. You can however create two identical objects at the same point and apply the different shaders to each one. Group the objects so they act as one during the animation. Cloak one object at the start of the animation by disabling its Visible option in the Properties tray. Move the animation to the point in time where you want the shader change to

occur, uncloak the cloaked object, and then cloak the uncloaked object. Apply the Tweener of your choice to determine the transition from one key frame to the next to complete the effect.

The Storyboard room

The Storyboard room can be used to create an entire animation. However, it is best used to fine-tune an animation frame by frame. To enter the Storyboard room, click the Storyboard icon (the icon shaped like a pencil). The Storyboard room gives a frame-by-frame representation of your animation (see Figure 19-50). The Storyboard room has the full compliment of tools and menus present in the Assemble room. Anything that can be done in the Assemble room can be accomplished in the Storyboard room, albeit on a slightly smaller basis due to the number of frames presented in the working box.

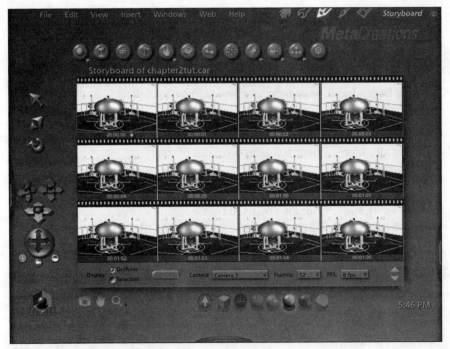

Figure 19-50: The Storyboard room

At the bottom of the Storyboard working box are six controls. They are used to specify the way the Storyboard working box is displayed among other features. The following list describes the controls as they appear from left to right:

✦ **Display:** Choose either Uniform or Selection. Uniform displays all frames at the currently selected frame rate. Selection displays only key frames.

✦ **Update:** Displays key frames added since the last time you displayed the Storyboard room in Selection mode.

✦ **Camera:** Enables you to choose which camera is used to render the frames.

✦ **Frames:** Enables you to select how many frames are displayed in the Storyboard working box. You can choose to display from 8 to 28 frames.

✦ **FPS:** Changes the animation's frame rate.

✦ **Up and down arrows:** Enables you to scroll forward and backward through the frames.

When you first create an animation, the Storyboard has only one key frame, the first frame. Whenever you select an object in another frame and transform it in any way, a new key frame is created. You can edit any object's properties by selecting it and opening the Properties tray. Tweeners can be edited by dragging open the Sequencer tray and selecting the Tweener.

The beauty of the Storyboard room is that you can see all the frames laid out before you. If something isn't to your liking in a particular frame, you can isolate the frame and fine-tune the animation in that frame. All changes made to the frame are carried out from that point in the animation forward.

Summary

Carrara's flexible animation features let the 3D artist create animations in many different ways. By selecting either Explicit, Physics, or Motion Paths as the motion method, the artist has complete control over the outcome of the animation. Virtually every property of a 3D object can be animated to create action.

✦ Key frame animation fills in the blanks from one key frame to the next to create action.

✦ Tweeners are used to control how the transition from one key frame to the next is created.

✦ An object's hierarchy lists all of the object's animatable properties.

✦ The Physics method of motion obeys the laws of physics when assigning motion to an object.

✦ Motion paths can be created from scratch and edited.

✦ Motion methods can be mixed in an animation.

✦ Objects can be animated with modelers.

✦ Shaders can be animated.

✦ The Storyboard room can be used to create or fine-tune an animation.

✦ ✦ ✦

Rendering Your Finished Scene

After spending hours of time creating and shading objects, aligning objects, and manipulating lights and cameras, it all comes down to the final rendering. As with everything else in Carrara, rendering has its own special area, the Render room. Inside the Render room, you specify renderer settings and output settings. You are also able to view scene information, rendering progress, and rendering statistics.

There are three ways to enter the Render room. You can select Windows menu ➪ Render, or simply press Ctrl+5. You can also click the Render button to enter.

Once inside the Render room, you'll notice the familiar Browser, Sequencer, and Properties trays. There's also a large open area, which becomes the document window when you launch a render. Figure 20-1 shows the Render room, ready for action.

The Browser tray serves no purpose in the Render room. However, the Properties tray plays an important part in the rendering process. In the Render room, the Properties tray has three buttons. The Renderer Settings button is used to specify renderers and output settings. The Output Settings button is used to specify image information and the camera used for the rendering. The Progress/Statistics button gives you access to scene information, rendering progress, animation progress, and renderer statistics.

In the Render room, the Sequencer tray becomes the Render tray. The Render tray has two modes: Current Scenes and Batch Queue. Click the Current Scenes button to view a list of the scenes currently open in Carrara. Click the Batch Queue button to view a list of scenes loaded for batch rendering.

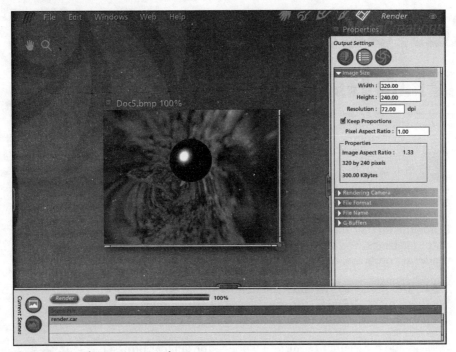

Figure 20-1: The Carrara Render room

Rendering Concepts

Rendering is the process of creating a 2D image or animation from a 3D scene. The beauty of 3D is the flexibility it gives you. You can render one scene from many different angles or even from different cameras if they're included in the scene. This flexibility comes in handy if you're creating a scene for a presentation. Create test renderings from different cameras or viewpoints. Choose the best vantage points and use Carrara's best renderer to create the final images for your presentation.

Ray tracing in action

When a Ray Tracer is launched, the rendering engine shoots imaginary rays into the 3D scene. What is rendered depends on what the ray strikes in the scene. When a ray encounters an object, it bounces off it in search of the source of the object's surface characteristics. The deflected ray may encounter another item, which casts a shadow on the first object. The deflected ray may also encounter a light source. If the first

object the ray bounces off has reflective characteristics, it bounces back a reflection of the next object it encounters. If an object has a degree of transparency, the ray bounces off the transparent object to record information from other scene objects such as color, transparency, and reflectivity, and also passes through the object to record what's behind it.

As you can see, your computer does a lot of computation to render an individual scene. The Ray Tracer records all of an object's surface characteristics to produce the final image. The more objects you have in the scene, the longer it takes to render the finished image. The more complexity you build into an object's shader, the longer it takes to render the finished image.

Consider the lowly sphere shaded in red illuminated by a single spotlight. A Ray Tracer makes short work of producing a 2D image of the scene. Add another sphere to the scene and another light. Now the Ray Tracer has to work harder and generate more rays to faithfully reproduce the scene. Add information in each sphere's Highlight, Shininess, Transparency, Reflection, Bump, Refraction, or Glow channel, or any combination of these channels, and the Ray Tracer has to generate even more rays to produce the image.

Rendering Checklist

As you can see, a complex scene with lots of information can tie up your computer for a considerable amount of time. Before committing to a lengthy rendering, it's important to have everything in order.

Before launching one of Carrara's renderers, review this handy checklist:

1. Are all objects to be included in the rendering visible?
2. Has Ambient Brightness been adjusted to its final setting?
3. Has the scene been properly cropped with a Production Frame?
4. Have background or backdrop images been added to the scene?
5. Have Atmosphere settings been adjusted?
6. Have modifiers and deformers been added to objects in the scene?
7. Have all applicable special effects been applied to the scene?
8. Have all applicable filters been applied to the scene?
9. Have final shaders been applied to all objects?

Choosing the Right Carrara Renderer

Carrara has three rendering engines: ZBuffer, Hybrid Ray Tracer, and Ray Tracer. Each engine produces a different result.

The ZBuffer engine produces an image that can be used to proof a scene before committing to one of the higher quality render engines. The ZBuffer produces an image quickly in one of four modes: WireFrame, Gourad, Textured, or Sketch.

The Hybrid Ray Tracer is a good middle ground renderer. It quickly produces quality images. Settings can be configured for adaptive oversampling and maximum ray depth. The Hybrid Ray Tracer is a good choice for animations.

The Ray Tracer produces the best quality image, but it is also the slowest renderer. Use this renderer when high-quality images or animations are needed. Settings can be configured for adaptive oversampling and maximum ray depth.

Setting Up the Rendering

The rendering engine you choose depends on whether you're doing a test rendering, final rendering, or animation. Once the proper rendering engine is chosen, render options and output settings must be applied.

Using the ZBuffer

To render a scene with the Zbuffer:

1. Drag open the Properties tray.

2. Click the Renderer Settings button.

3. Click the downward-facing double arrow to the right of the currently selected rendering engine. Select ZBuffer from the drop-down menu.

4. Choose a rendering mode:

 - **WireFrame:** The default ZBuffer rendering mode. Use it for test renderings to get an idea of how the objects in your scene interact.

 - **Gourad:** Gives you some shading effects by blending the colors from the corners of the polygon across the object.

 - **Sketch:** Produces a rough rendering similar to a shaded pencil sketch.

5. Choose a lighting mode:

 - **Fast Lighting:** Uses preset lighting and textures. This mode renders quickly but doesn't match the lighting you'll see in the final rendering.

 - **Actual Lighting**: Uses the scene's lighting information and takes longer to draw.

6. Click the Enable SMP option if you have a multiprocessor computer and want to render in multiprocessor mode. This option is disabled if you have a single processor computer.

7. Click the Enable Field Rendering option if you're rendering an animation for video and want to render interlaced fields separately (see Figure 20-2).

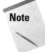

Note If you enable field rendering, choose 60fps (NTSC) for the frame rate.

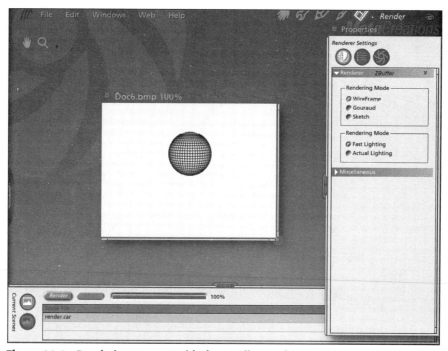

Figure 20-2: Rendering a scene with the ZBuffer renderer

Using the Hybrid Ray Tracer

The Hybrid Ray Tracer is a good compromise. It offers good image quality and fast rendering times. However, the images produced by the Hybrid Ray Tracer usually aren't good enough for printed publication. The Hybrid Ray Tracer is best suited to test renderings and animations.

To render a scene with the Hybrid Ray Tracer:

1. Drag open the Properties tray.

2. Click the Renderer Settings button.

3. Click the downward-facing double arrow to the right of the currently selected rendering engine. Select Hybrid Ray Tracer from the drop-down menu.

4. Select desired rendering options:

- **Shadows:** Renders all scene shadows

- **Reflections:** Renders all scene reflections

- **Bump:** Renders surface bumps

- **Transparency:** Renders transparent objects as transparent

- **Refracted Transparency:** Bends light rays as they pass through objects with information in their Transparency channel

- **Light through Transparency:** Renders lighting effects through transparent objects

5. Select Adaptive Oversampling mode. This option anti-aliases the edges of objects to produce sharper images. Choose None for a quick test rendering and either Fast or Best for a higher quality rendering.

6. Select Maximum Ray Depth. This setting limits the number of interactions allowed for rays that reflect or refract. Higher settings produce better images but take longer to render.

7. Select a sampling option:

- **Light Smart Sampling**: Optimizes lighting calculations. Use this mode to speed up rendering.

- **Smart Sampling**: Provides general optimization. The Hybrid Ray Tracer optimizes light settings based on an educated guess.

To speed up rendering, choose both options.

8. Click the Enable SMP option if you have a multiprocessor computer and want to render in multiprocessor mode. This option is disabled if you have a single processor computer.

9. Click the Enable Field Rendering option if you're rendering an animation for video and want to render interlaced fields separately (see Figure 20-3).

Using the Ray Tracer

To render a scene with the Ray Tracer:

1. Drag open the Properties tray.

2. Click the Renderer Settings button.

3. Click the downward-facing double arrow to the right of the current rendering engine. Select Ray Tracer from the drop-down menu.

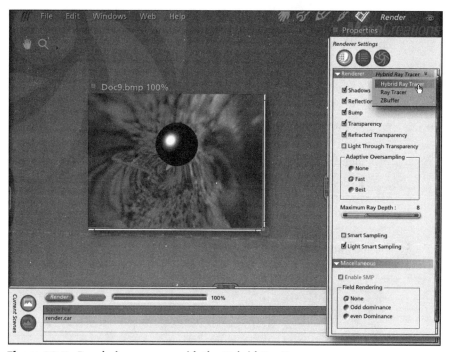

Figure 20-3: Rendering a scene with the Hybrid Ray Tracer

Note

If you enable field rendering, choose 60fps (NTSC) for the frame rate.

4. Select desired rendering options:

- **Shadows:** Renders all scene shadows
- **Reflections:** Renders all scene reflections
- **Bump:** Renders surface bumps
- **Transparency:** Renders transparent objects as transparent
- **Refracted Transparency:** Bends light rays as they pass through objects with information in their Transparency channel
- **Light through Transparency:** Renders lighting effects through transparent objects

5. Select Adaptive Oversampling mode. This option anti-aliases the edges of objects to produce sharper images. Choose None for a quick test rendering and either Fast or Best for a higher quality rendering.

6. Select Maximum Ray Depth. This setting limits the number of interactions allowed for rays that reflect or refract. Higher settings produce better images but take longer to render.

7. Select a sampling option:

- **Light Smart Sampling**: Optimizes lighting calculations. Use this mode to speed up rendering.

- **Smart Sampling**: Provides general optimization. The Ray Tracer optimizes light settings based on an educated guess.

To speed up rendering, choose both options.

8. Click the Enable SMP option if you have a multiprocessor computer and want to render in multiprocessor mode. This option is disabled if you have a single processor computer.

9. Click the Enable Field Rendering option if you're rendering an animation for video and want to render interlaced fields separately (see Figure 20-4).

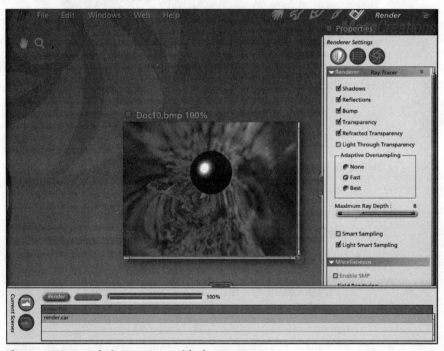

Figure 20-4: Rendering a scene with the Ray Tracer

 Note If you enable field rendering, choose 60fps (NTSC) for the frame rate.

Choosing output settings

Once you've decided on a renderer, you must select image options before rendering. You can adjust the following options: image size and resolution, rendering camera, file format, and filename. You can select G-Buffers before rendering if the renderer and file format support them.

The device that will be used to display the image determines image resolution. The resolution of a device is measured in the number of pixels it can display per inch. Most monitors display images at 72 dpi (dots per inch). Each dot is a pixel. Therefore, an image that measures 72 × 72 pixels would occupy one inch of monitor space.

That's all well and good if you only intend to create images for screen display or Internet Web pages. If you intend to use Carrara to create images for display in printed form, however, the image size and resolution must be adjusted. For example, if the image you're creating is going to be output on a 300 dpi deskjet printer, you must increase both the size and resolution of the image. To create an image that will measure 5 × 3 inches on a 300 dpi deskjet printer, render an image 1,500 pixels (5 inches × 300 dpi) × 900 pixels (3 inches × 300 dpi) at 72 dpi resolution. Resample the image to 5 inches × 3 inches at 300 dpi in a photo-paint program before sending the image to an output device.

Selecting image size and resolution

The current size of the image you've created appears in the Image Size field of the Output Settings dialog box.

To change image size and resolution:

1. Select the Output Settings button in the Property tray.

2. Click the triangle to the left of the Image Size panel to expand it.

3. Enter the desired Width and Height values for the rendered image.

4. Enter the desired Resolution value in dpi (dots per inch).

5. Select the Keep Proportions option to keep the image aspect ratio the same when you change either the width or height.

Note

The Keep Proportions option comes in handy when you've already cropped your image with the Production Frame.

6. Specify a Pixel Aspect Ratio if the intended output device doesn't use square pixels.

7. The panel below Pixel Aspect Ratio gives you information about the selected settings, including the expected file size in megabytes (see Figure 20-5).

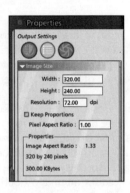

Figure 20-5: Adjusting the size and resolution of the image

Selecting the rendering camera

If you have multiple cameras in a scene, you can create the final rendering from any camera's viewpoint.

To change the rendering camera:

1. Select the Output Settings button in the Property tray.

2. Click the triangle to the left of the Rendering Camera panel to expand it. A button appears listing the currently selected camera.

3. Click the button to open a drop-down menu displaying all cameras in the scene.

4. Click the desired camera to select it (see Figure 20-6).

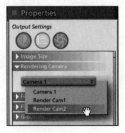

Figure 20-6: Selecting a rendering camera

Selecting file format

Before rendering, you must specify a file format and other related information. If the scene is an animation, you can choose to render either the current frame or a movie.

To select a file format for a still image:

1. Select the Output Settings button in the Property tray.
2. Click the triangle to the left of the File Format panel to expand the panel.
3. To render a single image or single frame from an animation, select Current Frame.
4. Choose from the available file formats:
 - TIFF (.tif)
 - BMP (.bmp)
 - PhotoPaint (.cpt)
 - GIF (.gif)
 - PCX (.pcx)
 - Photoshop 2.5 (.psd)
 - Targa (.tga)
 - JPEG (.jpg)
5. Click the Options button to apply any settings that are applicable to the format you've chosen (see Figure 20-7).

Figure 20-7: Selecting a file format for a still image

If you've got the available disk space and a good photo-paint program, always render the image in a format such as TIFF or BMP. The TIFF and BMP formats don't compress the image when saving it so no information is lost. Use your photo-paint program to do any post-render editing and image compression.

To render a scene as an animation, you'll have to choose a file format and compression settings. Carrara animations can be output as sequenced image files, Windows or Macintosh QuickTime (if you have the player installed) files, Windows AVI files, or animated GIF files for output to the Internet. Each format has its own set of compression settings and options.

Computer animations take up considerable amounts of hard disk space. If you have a limited amount of disk space, select one of the format's compression algorithms (codecs). A compressed movie file saves hard disk space but degrades the image during the process. Depending on the format you choose and the amount of compression you apply, the loss of image quality may be unacceptable. If you have the luxury of a large hard drive, it's always best to render the animation uncompressed. Reopen the animation in Carrara or another video editing program and then apply the desired compression. Be sure to save the file under a different name. If the compression degrades the animation too much, you always have the uncompressed file to fall back on.

Tip If you don't have the luxury of a big hard drive, create a few two-second animations of the same file. Save the files using different codecs with different degrees of compression. Save each file with a name that will readily identify which codec was used to compress it. Compare the image quality for the different codecs and choose the best one for your future animations.

To select a movie file format:

1. Select the Output Settings button in the Property tray (see Figure 20-8).

Figure 20-8: Selecting a file format for an animation

2. Click the triangle to the left of the File Format panel to expand it.

3. To render an animation, select Movie.

4. Choose from the available file formats:

 - Animated GIF (.gif)
 - Window AVI (.avi)
 - QuickTime (.mov)
 - Sequenced BMP (.bmp)
 - Sequenced PhotoPaint (.cpt)
 - Sequenced GIF (.gif)
 - Sequenced JPEG (.jpg)
 - Sequenced PCX (.pcx)
 - Sequenced Photoshop 2.5 (.psd)
 - Sequenced Targa (.tga)
 - Sequenced TIFF (.tif)

5. Click the Options button to apply applicable file options or compressions ratings.

6. The current Start and End points of the animation are listed. To render a partial animation, enter new Start and End settings.

Note

The Start and End points of the animation are noted in minutes, seconds, and frames. For example, 01:05:12 would be 1 minute, 5 seconds, and 12 frames into the animation.

7. The current animation frame rate is listed on the Frame Rate button. Click the button to select a different frame rate.

Selecting a filename

The default name for a rendered file is doc. Carrara gives you the option of choosing a unique name and file location for the rendered image.

To select a filename for the rendered image:

1. Click the triangle to the left of the File Name panel to expand the panel.

2. Select In Named File. The Set File Name dialog box opens, as shown in Figure 20-9.

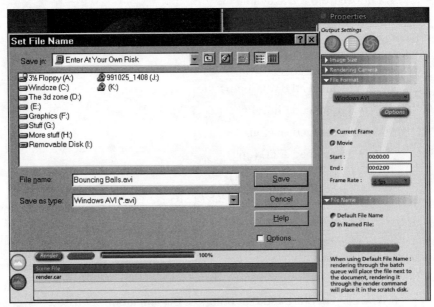

Figure 20-9: Selecting a filename for the rendered file

3. Enter the desired filename and location. Click Save to apply. When the scene or animation is rendered, the resulting rendering will be saved at the specified location with the filename chosen.

4. To reset the filename, click the Set File Name button and enter a new name for the file. Click Save to apply.

Specifying G-Buffers

If the renderer and image file format support them, you can specify G-Buffers. G-Buffers are grayscale channels or masks that are saved with the rendered image. Data stored in G-Buffer channels represent information about specific points in your 3D scene. The information stored in the G-Buffer channels stays with the image when you load it into a photo-paint program. These channels can be used to create masks based on their attributes. G-Buffer channels can be used for post-render editing in photo-paint programs.

For more information about post-render editing, refer to Chapter 21.

The following G-Buffer options are available:

✦ **Pixel Color:** Creates G-Buffer channels based on a pixel's color information. The Pixel Color information occupies Channels #1, #2, and #3, which represent red, green, and blue.

✦ **Mask:** Creates a G-Buffer channel, which describes the boundaries of objects in your scene. This information can be used in a post-render edit to create a mask that selects objects in your scene and allows you to cut and paste them onto another background. Mask data is stored in Channel #4. Refer to the documentation shipped with your photo-paint program for more information about creating objects from masks and compositing images.

✦ **Distance:** Creates a G-Buffer channel that records a pixel's distance from the rendering camera. Use the Distance channel to apply special effects in photo-paint programs that support distance information.

✦ **Object Index:** Creates a G-Buffer channel that relates an individual pixel's point coordinates to the object it belongs to. In photo-paint programs that support this channel, you can use it with a wand-masking tool to select individual objects that aren't overlapping.

✦ **Normal Vector:** Creates three G-Buffer channels that describe the direction each surface of an object faces. The data these channels provide can be used to apply directional lighting effects during a post-render edit in a photo-paint program.

✦ **3D Position:** Creates three G-Buffer channels, one for the scene's X values, one for the scene's Y values, and one for the scene's Z values.

✦ **Surface Coordinates:** Creates G-Buffer channels based on an object's surface coordinates. This is two-dimensional data.

To include G-Buffer channels with your rendered image:

1. Select the Output Settings button in the Property tray.
2. Click the triangle to the left of the File Format panel to expand it.
3. Choose the desired file format.
4. Click the triangle to the left of the G-Buffers panel to expand it (see Figure 20-10).
5. Select the G-Buffer channels you want to save with the rendered image.

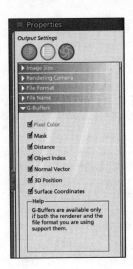

Figure 20-10: Adding G-Buffer channels to an image

Note If a file format doesn't support G-Buffers, the options will be whited out. The GIF (.gif) file format only supports the Mask G-Buffer, which you can use to create a transparent .gif image for a Web site in a photo-paint program.

Rendering an image or animation

After choosing settings for the rendering, it's time to create a finished image or animation of your scene.

To render an image or animation:

1. Drag open the Render tray.
2. Click the Render button to launch the rendering. The Status indicator monitors the progress of the rendering (see Figure 20-11).

Figure 20-11: The Status indicator monitors the progress of the rendering.

3. Click the Abort button or press Esc to abort the rendering (see Figure 20-12).
4. After the scene renders, select File ➪ Save as. The Save As dialog box opens.

5. Choose a name and location for the image, and select one of the available file formats. Click Save to save the image to disk

Figure 20-12: The Render tray starts and monitors a rendering..

Monitoring rendering progress

Carrara also makes it easy to precisely monitor information about your scene or the rendering in progress. Click the Progress/Statistics button to gain information about your scene: rendering progress, animation progress, and renderer statistics.

To gain scene information:

1. Click the Progress/Statistics button.

2. Click the triangle to the left of the Scene Info Panel. Information about your scene is displayed in the panel.

To monitor rendering progress:

1. Click the Progress/Statistics button.

2. Click the triangle to the left of the Rendering Progress panel. Information about the rendering in progress is displayed in the panel.

To monitor animation progress:

1. Click the Progress/Statistics button.

2. Click the triangle to the left of the Animation Progress panel. Information about the animation being rendered is displayed in the panel.

To view renderer statistics:

1. Click the Progress/Statistics button.

2. Click the triangle to the left of the Renderer Statistics panel. Statistics from the rendering engine are displayed as the image is created (see Figure 20-13).

Figure 20-13: Click the Progress Statistics button to gain scene information and rendering statistics.

Rendering Multiple Scenes

Rendering complex scenes or animations can take a long time. If you've only got one computer at your disposal, you can choose to have Carrara render the image or animation in the background while you're using other programs. Or, you can take advantage of Carrara's powerful Batch Queue rendering mode, which enables you to render several scenes or animations while you're doing something more important, like catching up on your sleep.

The Render tray's Batch Queue mode lets you add and remove scene files from the list. After a loaded Batch Queue is launched, Carrara will render the first file, save it to disk, and then repeat the render-and-save process for each file loaded. The Batch Queue lists the status of renders completed and those under way. There's also an option to save a Batch Queue list for future use.

To switch to the Batch Queue rendering mode:

1. Drag open the Render tray.

2. Click the Batch Queue button (see Figure 20-14).

Figure 20-14: The Carrara Batch Queue

The Carrara Batch Queue opens with an empty list and a unique set of buttons. These buttons are used to manage the Batch Queue list and launch a batch render:

✦ **Add:** Opens a dialog box that enables you to add scene files to the Batch Queue.

✦ **Remove:** Drops the selected scene file from the Batch Queue.

✦ **Reset:** Restores the Batch Queue to its initial state after a rendering has been paused or aborted.

✦ **Clear:** Removes all scene files from the Batch Queue.

✦ **Load:** Loads a previously saved Batch Queue list.

✦ **Save:** Saves the currently loaded scene files as a Batch Queue list.

✦ **Launch:** Begins the batch rendering. As the first rendering begins, the Launch button becomes the Pause button.

✦ **Pause:** Pauses the rendering, allowing you to quit Carrara and resume the rendering at another time. After clicking the Pause button, it becomes the Resume button.

✦ **Resume:** Allows you to continue a paused batch rendering.

✦ **Abort:** Halts the batch rendering process.

Scene files loaded in the Batch Queue can have their original render settings overridden.

To override a scene's original settings in the Batch Queue:

1. Click the file's name in the Batch Queue list to select it.

2. Drag open the Properties tray.

3. Click the Renderer Settings button, the Output Settings button, or both.

4. Make the desired changes. A "yes" appears on the Overridden Settings section of the file's line in the queue. The changes will be applied to this rendering only.

If you have a scene with several different cameras, you can use the Batch Queue to render each camera's version of the scene.

To render multiple images of a scene from different cameras:

1. Drag open the Render tray and click the Batch Queue button.

2. Click the Add button to add the scene to the Batch Queue. Add the scene as many times as needed to cover the number of camera views you'll be rendering. For example, if the scene has four cameras, add it to the Batch Queue four times.

3. Click the first instance of the scene in the Batch Queue list.

4. Drag open the Properties tray and click Renderer Settings.

5. Click the triangle to the left of the Rendering Camera panel to expand it.

6. Select the Rendering Camera to use for this rendering.

7. Click the File Name panel to expand it.

8. Enter a name for the image file (for example, myscene_version1).

9. Repeat steps 3 through 8 for each additional instance of the scene in the Batch Queue.

10. Click the Launch button to start the multiple renderings and save the files to disk.

Speeding up the rendering process

As your skill in 3D modeling increases, you'll create complex scenes and animations that take a long time to render. However, there are some techniques you can apply to speed up the rendering process.

If an object lies out of the Production Frame and doesn't show up on another object's surface as a reflection, cloak it by disabling the object's Visible option in the Properties tray. The object still shows up in the Sequencer tray and it still uses computer RAM, but the renderer doesn't know it's there.

When setting up the rendering, take out what you don't need. For example, if you're rendering a scene that has hundreds of objects, but none of them have information in their Bump channels, deselect Bump from the Renderer Settings dialog box.

When you render an animation, choose the Hybrid Ray Tracer and Best Oversampling Quality. Select a maximum ray depth of between 12 and 15. If it's a long animation, render part of it to check image quality. After viewing the partial

animation, adjust the Maximum Ray Depth setting to taste and launch the complete rendering. The difference in image quality between the Hybrid Ray Tracer and the Ray Tracer won't be readily apparent as frames change during an animation.

If you're rendering long animations, use either the Batch Queue rendering mode or render them in sections and splice them together in a video-editing program.

If a modeled object is distant from the rendering camera, reduce its surface fidelity. In the case of a vertex object, decimate the surface. By reducing surface fidelity, you decrease the number of facets the rendering engine has to scan and cut down on the number of rays used to trace the scene.

As you can see, Carrara's renderers have to contend with many different factors and elements to produce a final image or animation. Keep this in mind when you're creating scenes. Be as economical as possible with your use of surface textures. Use transparency and reflection sparingly, especially if you're working with a slower machine. If an object won't be seen in an image or animation and doesn't reflect on another object's surface, don't build it. Before committing to a lengthy rendering, make sure everything in the scene is just the way you want it. Test render scenes with Carrara's fastest renderers at smaller image sizes and lower resolutions.

Summary

Whether you need to do a test rendering, final rendering for a Web site, final rendering for a printed publication, or rendering of an animation, Carrara has a rendering engine for the task at hand. After specifying the proper renderer and output settings, Carrara renders an image or animation suited for the intended application.

✦ The Z-Buffer is ideally suited for test renderings.

✦ The Hybrid Ray Tracer renders quality images quickly.

✦ Animations can be compressed to save disk space.

✦ The Ray Tracer renders high-quality photo-realistic images suitable for high-resolution publication.

✦ G-Buffers include information with rendered images that can be used in post-render editing.

✦ The Batch Queue automates the process of rendering multiple scenes and animations.

✦ Scene settings can be overridden in the Batch Queue for one-off renders.

✦ ✦ ✦

Using Carrara with Other Programs

C arrara is a wonderfully flexible, full-featured 3D program capable of creating 3D scenes that can be rendered as images or animations. Objects created in Carrara can be exported for use in other 3D programs. Carrara scenes can be exported as virtual reality worlds, which can be navigated by using a Web browser with the right plug-in. Carrara images and animations can be exported for use on the Internet. E-commerce sites use Carrara models exported in MetaStream format to display their wares to potential customers. Carrara images and animations can be exported for use in photo-paint and video editing programs.

Exporting 3D Models

Carrara is capable of creating highly detailed 3D models. These models can be exported in a variety of popular formats for use in other 3D programs. Depending on the format selected, models export with textures intact.

Exporting Carrara models in 3D Studio format

The .3ds (3D Studio) file format is the native format for meshes created in 3D Studio MAX. This format is supported by numerous 3D programs. Files exported in 3D Studio format export as mesh objects. Carrara models exported in .3ds format can be saved with textures.

Caution Any time you export an object in a nonnative format, you may lose information. Depending on the quantity of information lost, the exported model may not be usable. It is always a good idea to save an object in native Carrara (.car) format before exporting it in a different format.

To export a model in 3D Studio format:

1. Select File ⇨ Export. The Save As dialog box appears.

2. Select Save as type ⇨ 3Dstudio (*.3ds) (see Figure 21-1).

Figure 21-1: The Save As dialog box

3. Leave the Options box in the lower-right corner of the Save As dialog box enabled. Enter a filename and click Save. The 3D Studio Export dialog box appears, as shown in Figure 21-2.

Figure 21-2: Exporting a model in 3D Studio format

4. Enter a value for Scaling. This option scales the model for the format you are exporting it in. The default value is 1.00. If you choose inches as the unit of measurement from Carrara's Preference menu at the default setting, the model will export one to one. The size of the saved model may differ when imported into another program.

5. Drag the Surface Fidelity slider to increase or decrease the fidelity of the exported model. Increasing surface fidelity adds more polygons to the exported model and results in larger file sizes.

6. Click the Textures Format button and choose a file format from the drop-down menu.

7. Enable the Convert Procedural Shaders to Textures option to convert native Carrara shaders to texture maps, which are saved with the model.

8. If you enabled the Convert Procedural Shaders to Textures option, enter values for Resolution. Higher resolution values create better-looking textures but result in larger file sizes.

9. Click OK to export the model.

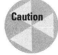
Caution Before exporting spline objects as mesh objects, open the model up in the Modeling room and adjust surface fidelity to its highest settings. Make sure the 3D program you're importing the object has some method of subdividing or smoothing the mesh.

Exporting Carrara models in 3DMF format

The 3DMF (.b3d) file format was developed by Apple and is supported by many popular 3D applications. Objects exported in 3DMF format can be saved with UV mapping information and a texture map.

To export an object in 3DMF format:

1. Select File ⇨ Export. The Save As dialog box appears.

2. Select Save as type ⇨ 3DMF(*.b3d).

3. Leave the Options box in the lower-right corner of the Save As dialog box enabled. Enter a filename and click Save. The 3DMF Export dialog box appears, as shown in Figure 21-3.

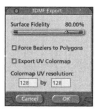

Figure 21-3: Exporting a model in 3DMF format

4. Drag the Surface Fidelity slider to increase or decrease the fidelity of the exported model. Increasing surface fidelity adds more polygons to the exported model and results in larger file sizes.

5. Enable Force Beziers to Polygons to convert Bezier curve points to polygons. This option has the greatest effect on spline objects.

6. Enable Export UV Colormap to export a texture map with the model. The exported map will use the model's UV coordinates as mapping reference points.

7. If you enabled the Export UV Colormap, enter values for resolution. Higher resolution produces higher quality colormaps but results in larger file sizes.

8. Click OK to export the model.

Exporting Carrara models in DXF format

DXF is a text file format that is used by Autodesk and other computer-assisted drafting (CAD) program suppliers. As a DXF file is strictly a text file, shading cannot be saved with the export. Exported DXF models must be textured in the program they are imported into.

To export a model in DXF format:

1. Select File ⇨ Export. The Save As dialog box appears.

2. Select Save as type ⇨ DXF (*.dxf).

3. Leave the Options box in the lower-right corner of the Save As dialog box enabled. Enter a filename and click Save. The DXF Export dialog box appears, as shown in Figure 21-4.

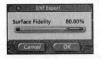

Figure 21-4: Exporting a model in DXF format

4. Drag the Surface Fidelity slider to increase or decrease the fidelity of the exported model.

5. Click OK to export the model.

Exporting Carrara models in WaveFront format

The WaveFront (.obj) format is another popular format for 3D objects. Models exported in .obj format can be saved with external material and texture files.

To export a model in WaveFront format:

1. Select File ⇨ Export. The Save As dialog box appears.

2. Select Save as type ⇨ WaveFront (*.obj).

3. Leave the Options box in the lower-right corner of the Save As dialog box enabled. Enter a filename and click Save. The OBJ Export dialog box appears (see Figure 21-5).

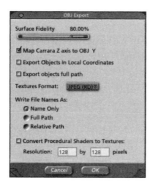

Figure 21-5: Exporting a model in WaveFront format

4. Drag the Surface Fidelity slider to increase or decrease the fidelity of the exported model.

5. Enable Map Carrara Z axis to OBJ Y to have all Carrara Z axis references converted to Y references. Carrara refers to the Z axis as the up-and-down axis. Many other 3D programs use the Y axis as the up-and-down axis.

6. Enable Export Objects In Local Coordinates to export parts of multi-object models with their coordinates intact.

7. Enable Export Object's Full Path to keep the model's hierarchy intact.

8. Click the Textures Format button and choose a format for the texture maps from the drop-down menu.

9. Select an option for Write Names As:

 • **Name Only:** Exports the model with each object named.

 • **Full Path:** Exports the model with each object named and its full path.

 • **Relative Path:** Exports the model with each object named and its relative path.

10. Enable the Convert Procedural Shaders to Textures option to convert native Carrara shaders to texture maps, which are saved with the model.

11. If you enabled the Convert Procedural Shaders to Textures option, enter values for Resolution. Higher resolution values create better-looking textures but result in larger file sizes.

12. Click OK to export the model.

Tip

If you frequently export Carrara models for use in another program, experiment with exporting the same model with different values to arrive at the right scaling size.

Exporting Carrara models for use in 3D paint programs

Carrara's procedural textures create convincing surface textures for scene objects. When you export Carrara objects for use in other 3D programs, the textures don't always import correctly. If you're fortunate enough to have a 3D paint program, save Carrara models in the desired format without textures. Then use the 3D paint program to create a detailed texture map by painting right on the model. When you finish detailing the model, save the texture map in a format that's recognized by the 3D program you plan to use the image in. Follow the program user manual's instructions for importing the model and texture map.

Each 3D paint program has a preferred 3D file format. Refer to the program's user manual for a list of supported formats. WaveFront, 3D Studio, and 3DMF formats are always good bets if you're not sure.

Using Carrara models in other 3D programs

Every 3D program has its specialty or niche in the playing field. Programs like Carrara do many things well, whereas other programs tend to be more specialized. Programs such as Bryce create utterly convincing landscapes, yet fall somewhat short of the mark when it comes to creating 3D objects. Bryce purists have devised workarounds to create impressive 3D models from primitives and terrain objects, but the techniques can be daunting for novice Bryce artists. Another example of a 3D program with a one-track mind is Poser. This program models, poses, and animates the human form (along with animals and robots, depending on the version). Yet 3D props cannot be created within Poser.

Even the most specialized 3D programs support multiple 3D file formats. Once you know the formats a program supports, you can use Carrara to create whatever 3D objects are needed to make up for another program's deficiencies. For example, Poser imports 3D Studio, 3DMF, DXF, and WaveFront OBJ files. If you need a laser pistol for a Poser robot, create it in Carrara, export it in one of Poser's supported file formats, and then import it. Poser also supports images and animations as backgrounds. Create a 3D scene in Carrara, render it, and then import the image or animation into Poser as a background.

It's a two-way street: Objects created in Carrara can be exported into other programs with better capabilities. For example, export a model created in Carrara with an Inverse Kinematics hierarchy that matches the one used in Poser. Once the figure is imported into Poser, use Poser's tools to pose and animate the model. Another excellent example of integrating 3D programs is using a rendered image of a Bryce landscape as a Carrara background.

Carrara and the Internet

With the advent of inexpensive computers and faster modems, the Internet is now a viable source of entertainment and information for the masses. The fact that the Internet is very much a visual medium creates interesting possibilities for 3D artists and illustrators. And if a 3D artist also happens to be conversant in .html, a wonderful world of opportunity awaits.

Exporting Carrara scenes as VRML worlds

3D scenes are actually little virtual worlds. By creating different camera positions, this 3D world can be examined from different vantage points. A consortium of talented 3D artists got together and posed the question, "What if you could actually create a scene that could be navigated in real time?" When they found the answer, Virtual Reality Modeling Language (VRML) was born.

3D scenes that are exported in VRML (.wrl) format can be navigated in a Web browser, provided the user has the proper plug-in. Users can navigate through VRML scenes by using their pointing devices with a combination of keyboard commands. It's possible to zoom in and out, round corners, and turn around in a VRML world.

Carrara scenes can be exported in VRML 1 or VRML 2 format. The amount of detail a viewer sees in a VRML scene is highly dependent on the VRML plug-in loaded in his or her browser. When creating a scene for VRML export, less is more. If you go overboard on the amount of detail and texture included in scene objects, your modeling skill will most likely go unnoticed when the exported scene is loaded in a Web browser. Stick to simple shapes and simple textures. There are some wonderful examples of VRML on the Internet. One site sports a virtual music museum that has rooms filled with interesting exhibits which the visitor can navigate through. The heart of the exhibit shows pictures of instruments on the walls. The pictures are hyperlinked to audio and text files. Objects in Carrara VRML worlds can be hyperlinked to a Universal Resource Locator (URL).

To hyperlink a scene object to an URL:

1. Select the object.
2. Drag open the Properties tray.
3. Click the General button.
4. Enter the desired URL in the space provided (see Figure 21-6).

Figure 21-6: Creating an object link in a VRML scene

5. Choose either the Anchor or Inline option for the object:

- **Anchor:** This type of object ransports the site visitor to another URL or HTML page within the site.

- **Inline:** This type of object is linked to another file that is used to update the object the site visitor is viewing. An inline object updates a VRML file without having to reload the Web page.

Carrara's 3D modeling and texturing capabilities are light years beyond the capabilities of VRML plug-ins. At the risk of being redundant, when creating a Carrara scene for VRML export, keep it simple and subtle.

To save a Carrara scene as a VRML world:

1. Select File ⇨ Save As. The Save As dialog box opens.

2. Select Save As type ⇨ VRML (.wrl). Leave the Options box in the lower-right corner of the Save As dialog box enabled. Choose a name for the file and click Save. The VRML 2.0 Export dialog box appears (see Figure 21-7).

3. Click the Version button and choose VRML 1.0 or VRML 2.0.

Note Older VRML plug-ins may not support VRML 2.0.

Figure 21-7: Exporting a Carrara scene as a VRML file

4. Drag the Surface Fidelity slider to control the fidelity of the export.

5. In the Texture Map panel, select a mode:

 • **External:** Stores the texture maps as external numbered files

 • **Internal:** Stores the texture maps with the file

6. Select a file format:

 • **JPEG:** Creates images with millions of colors

 • **GIF:** Creates images with 256 colors

7. Enable Convert Procedural Shaders to Textures to convert shaders into image maps.

8. If you enable the Convert Procedural Shaders to Textures option, choose a resolution for the image maps.

9. If you're storing the texture maps externally, enter the URL prefix where they can be located.

10. Enter a value for Size Threshold to have smaller objects use a texture map or a lower degree of tessellation.

11. Enter a value for Distance Threshold if you want objects farther from the camera to have a lower resolution. Objects beyond the specified Distance Threshold will have lower resolution. This value is in whatever unit of measure you specified in the Preferences menu.

12. Enter a value for Levels of Detail. For example, if you specify a Distance Threshold of 12 inches and specify three levels of detail, the levels are as follows:

 • Level 1 is from 0 to 12 inches at full resolution.

 • Level 2 is from 12 to 24 inches with reduced resolution.

 • Level 3 is from 24 to 36 inches with further reduced resolution.

13. Enable the Tessellate option for any primitives with which you want better control over the texture mapping process. This option textures the primitives by applying the texture map in a faceted mosaic pattern. Apply this option to scene Cubes and/or Cones and/or Spheres and/or Cylinders.

14. Enable the Remove white space option to remove any extraneous spaces from the VRML file. Choosing this option creates a slightly smaller file size.

15. Click OK to export the VRML file.

Figure 21-8 shows a Carrara scene in the working box.

Figure 21-8: Creating a scene for VRML export

Figure 21-9 shows the same scene as viewed in a Web browser after being exported in VRML format.

Figure 21-9: The scene in Figure 21-8 viewed in a Web browser after being exported in VRML format

Exporting Carrara models for Web sites

When the first e-commerce Web sites appeared, Web designers displayed their customer's products as 2D images. This met with a fair degree of success because purchasing over the Internet offered a certain degree of convenience. Yet at the same time, purchasing over the Internet was missing a key factor in some purchasers' buying decisions: the capability to pick a product up off the shelf and examine it.

Unless a whole new dimension is invented for the Internet, buyers never will have the opportunity to physically pick up an item displayed at a Web site. But they can do the next best thing by latching onto a fully textured 3D representation of a product with their pointing device and examining it from all sides.

3D objects created in Carrara can be exported in the MetaStream (.mts) format. Visitors to a MetaStream site can view the models in their browser after downloading the MetaStream plug-in. MetaStream objects can be scaled, panned, and rotated by latching onto them with a pointing device. Object resolution is user adjustable by right-clicking anywhere in the MetaStream viewing window and selecting commands from the pop-up menu. MetaStream objects load quickly. The viewer sees the first part of the model almost immediately as it streams into the browser.

Any Carrara object or scene can be exported in MetaStream format. Because MetaStream objects stream into a viewer's browser, objects with high levels of detail can be exported. Even viewers with slow modems will see part of the MetaStream model almost immediately because the information streams into the viewer's browser.

To export a Carrara model in MetaStream format:

1. Select File ➪ Export. The Export As dialog box appears.

2. Select Save as type ➪ MetaStream (*.mts). The MetaStream Export dialog box appears, as shown in Figure 21-10.

Figure 21-10: Exporting a model in MetaStream format

3. Enable the Use Native creases wherever possible option to create a MetaStream object that uses the Carrara surface creases.

4. Enter a value for Crease Angle. The Crease Angle determines how the model will be smoothed. Any surface folds greater than the Crease Angle appear as creases. Any surface folds less than the Crease Angle will be smoothed.

5. Drag the Surface Fidelity slider to adjust the surface fidelity of the exported MetaStream object.

6. Enable Export Textures to export the textures with the object.

7. Enter a value for Maximum Texture size. Higher values produce better-looking models with larger file sizes.

8. Click OK to export the MetaStream model.

To save an entire scene as a MetaStream object, select File ➪ Save As, and repeat steps 2 through 8.

Figure 21-11 shows a 3D object in the working box prior to being exported in MetaStream format. Figure 21-12 shows the exported model as viewed in a Web browser.

Figure 21-11: A 3D model in the working box prior to being exported in MetaStream format

Figure 21-12: The exported model as viewed in a Web browser.

Once the file has been exported, you'll want to embed the object in an HTML document for use at a Web site. The following code will embed a MetaStream in an HTML document:

```
<embed src="teapot.mts" type="application/metastream" width="300" height="225"
background= " 255 255 255"
pluginspage="http://www.metacreations.com/metastream/viewer/"></embed>
```

In the preceding example, the MetaStream file teapot.mts is embedded in a Web page. The viewing window measures 300 × 225 pixels and is viewed against a white (255 255 255) background.

Exporting images and animations for the Internet

Images created for use at Internet Web sites are best saved in a lossy format such as JPEG. Images saved as JPEG files are saved with millions of colors. JPEG is known as a lossy format because some of the information contained in the original image is lost. The degree of loss is determined by the options you choose when you save the file. Some photo-paint programs use a numbering system; low numbers mean little loss, whereas high numbers mean significant loss of image information. Other programs let you choose from differing levels of image quality. The trick is to save the JPEG image with the smallest possible file size that still retains enough information for acceptable viewing. Smaller file sizes will load quicker into a Web site visitor's browser.

Resolution is another Internet concern. When an image is saved for use in a publication, the output device that will print the image determines the resolution. If the image is printed on a 600 dpi laser printer, it must be rendered at 600 dpi or better. Computer monitors, however, only require a resolution of 72 dpi. Images saved at higher resolutions can be used, but the only difference the Web site visitor will notice is that it takes the image a lot longer to download. Keep this in mind when preparing rendered images for the Internet.

Carrara gives you four levels of image quality for JPEG files (see Figure 21-13). Render an image and save it with each of the different output qualities and then compare the images to find the degree of loss with which you're comfortable.

Figure 21-13: Carrara's JPEG export options

The GIF format has been a longtime favorite of Web designers. GIF files have a maximum of 256 colors. The quality of the GIF image is largely dependent on the number of colors the Web designer specifies when the image is converted. GIF images with a smaller color palette have smaller file sizes. All images rendered in Carrara are rendered with millions of colors. When millions of colors are converted to 256 colors or less, image degradation is bound to occur. Again, the trick is to balance image quality with file size. Carrara's GIF export converts the rendered image to 256 colors. Figure 21-14 shows the available options when saving a rendered image in GIF format.

Figure 21-14: Carrara's GIF export options

If you have access to a photo-paint program, save your rendered images as BMP or TIFF files. Both of these file formats save the image with no loss of information. Open the saved files in your photo-paint program to perform any post-render editing. Use the photo-paint program's tools to edit the image and apply any third-party filters. When you're done editing the image, export it in JPEG or GIF format under a different name. Always keep the original file in case the edited image is unsatisfactory. Many photo-paint programs won't give you a true idea of what the image looks like until it is opened again.

Post-Render Editing

Carrara's specialty is creating 3D scenes and rendering photo-realistic images. However, there will be times when you'll need to do some post-render editing, such as adding text to an image, compositing a finished rendering with another background, or creating a collage of several renderings.

Editing Carrara images in photo-paint programs

Carrara does an excellent job of creating and rendering 3D scenes. But when it comes to image editing, nothing beats a good photo-paint program. Many photo-paint programs have sophisticated tools such as masks. A mask protects the area of the image to which it is applied. Any editing done to an image will not affect the area protected by the mask.

Masks can be used to cut and then composite (paste) selected areas of an image onto a background photo. If you are creating a Carrara scene with the intention of pasting it onto a background image, render the image against a background color that isn't used in the main part of the scene. When the image is opened in a photo-paint program, use a color mask tool to create a mask from the color background.

Masks are also handy if you want to apply a filter to just part of a rendered scene. Create a mask to protect areas of the image where you don't want the filter applied.

Most photo-paint programs support third-party plug-in filters. These filters can be used to create a wide variety of dazzling effects.

File format options

Carrara can save images in the following formats:

✦ BMP (*.bmp,*.dib,*.rle)

✦ Photo-Paint (*.cpt)

✦ GIF (.gif)

✦ JPEG (.jpg)

✦ Photoshop (*.psd)

✦ Targa (*.tga,*.vda,*.icb,*.vst)

✦ TIFF (*.tif)

If your photo-paint program's native file format is a Carrara export option, by all means use it. If not, save the image as a BMP or TIFF file. Image information is not compressed with either of these formats.

If you intend to edit a rendered image in a photo-paint program, render the image at a higher resolution than you actually need. For example, if you're creating an image for a Web site, the final resolution of the image will be 72 dpi. Render the image at 300 dpi in Carrara. The resulting image will have better definition that will result in a better-looking image after it's resampled. After you're done editing the image in your photo-paint program, resample it to the needed resolution.

Using G-Buffers

If your photo-paint program supports them, G-Buffers can be valuable for post-render editing. G-Buffers are masks or channels that are saved with the rendered image. Each G-Buffer channel records specific information about an area of your rendered image. When an image with G-Buffer channels is opened in a photo-paint program, these channels can be loaded as masks. Depending on the channel loaded, the mask will do one of the following: Define the boundaries of image objects, provide distance information, provide information about coordinates of individual image pixels, provide vector information, provide 3D position information, or provide surface coordinate information. Refer to your photo-paint program's user manual to see how these channels can be used to edit an image. Figure 21-15 shows a rendered image being edited in a photo-paint program. The marching ant boundary in the image is a mask that was created using a G-Buffer channel. Notice the other G-Buffers available from the drop-down menu.

Figure 21-15: Creating a mask by loading a G-Buffer channel

Figure 21-16 shows the image after pasting the masked part onto a background.

G-Buffer channels can also be used to apply special lighting effects, blur selected areas of an image, or apply filters to a selected area of the image. Consult your photo-paint program's user manual for further information.

Figure 21-16: Compositing an image using G-Buffer channels

 For more information on saving rendered images, refer to Chapter 20.

Editing Carrara animations

Animations take a long time to render. To create a high-quality, five-second animation for monitor display involves rendering 75 frames. If you intend to use the animation as part of a video tape, the frame count doubles. It's no wonder most computer animations are fairly short.

There are many powerful video editing programs available to edit your rendered animations. These programs are used to splice animations together, add professional transitions between scenes, add titles to animations, and add soundtracks to animations. The edited animation can be compressed and then saved in one of many popular file formats.

File format options

Rendered Carrara animations can be saved in the following file formats:

✦ Animated GIF (.gif)

✦ Window AVI (.avi)

✦ QuickTime (.mov)

✦ Sequenced BMP (.bmp)

✦ Sequenced PhotoPaint (.cpt)

✦ Sequenced GIF (.gif)

✦ Sequenced JPEG (.jpg)

✦ Sequenced PCX (.pcx)

✦ Sequenced Photoshop 2.5 (.psd)

✦ Sequenced Targa (.tga)

✦ Sequenced TIFF (.tif)

If you have video editing software and intend to edit the rendered animation, save it in a file format that is supported by your program. Save the original animation uncompressed. Use your video editing program to compress the animation after splicing and editing. Another good habit to get into is leaving a few extra frames at the beginning and end of the animation. The extra frames will come in handy when splicing one animation with another. Figure 21-17 shows several animations being spliced together in a video editing program.

Figure 21-17: Splicing animations in a video editing program

If you're editing animations for the Internet, save them in a streaming format or a format that compresses well while still maintaining acceptable image quality. MPEG files compress well and maintain excellent image quality. Apple's QuickTime MOV format can be saved as streaming video and still maintain good image quality. RealPlayer's RM format is also a streaming video format. A visitor to a Web site with streaming video gets to see part of the video almost instantly as it streams into the browser. Visitors to sites with nonstreaming video must wait for the entire video to download before it can be viewed.

There is a fully functional 30-day evaluation version of MGI Software's VideoWave II program on the CD ROM that accompanies this book. VideoWave II can be used to splice your Carrara animations together and add soundtracks to them. The program features special effects and transitions.

Adding audio

Carrara doesn't support audio tracks in animations. Adding audio to a Carrara animation requires a video editing program that supports soundtracks.

Soundtracks add punch to an animation. They can help to establish a mood of drama or comedy. Sound effects can be used to accentuate special visual effects. If the animation is to be part of a professional presentation, appropriate background music and a voice-over can be added to get your message across.

To add music to your animations, insert an audio CD in your system's CD-ROM drive, record the desired song with audio editing software and save it in a format supported by your video editing program. There are also Internet Web sites where you can download music for your animations. If you're going to incorporate the music as part of a commercial video, be sure to get the owner's written permission so you don't violate any copyright laws.

There is an almost unlimited source of sound effects available from Internet Web sites. In addition to sound effects, you can download voice clips from movies and cartoons. A good audio editing program can be used to splice sound clips together to create a soundtrack for your animation. The WAV (.wav) audio format is supported by most audio and video editing programs.

Synching the soundtrack to the video can be a challenge, but the end result is rewarding. To synch an audio with a video, use the audio editing program's timeline to synch specific sound events. If this sounds similar to key frames in an animation, you're right—it's the same principal. In fact, you can use a key frame marker's time from the animation scene file as a reference point for your audio track. If you're splicing animations together in a video editing program, use that program's timeline as reference for key sound events.

On the CD-ROM There is a fully functional shareware version of Goldwave 4.11 on the CD-ROM that accompanies this book. Goldwave is a sound editing program with mixing capabilities. The program has an impressive quantity of sound editing tools that you can use to create soundtracks for your Carrara animations.

Summary

Carrara's flexibility allows you to use objects and scenes with other applications. Objects, scenes, and images can be exported in a wide variety of file formats. This flexibility allows a cross-over with other 3D and 2D applications.

✦ Carrara models can be exported in 3DS, 3DMF, DXF, and WaveFront OBJ formats.

✦ Carrara models can be exported in MetaStream format for use on e-commerce Web sites.

✦ Carrara scenes can be exported as VRML virtual worlds for use on the Internet.

✦ G-Buffers are powerful tools for post-render editing in photo-paint programs.

✦ Carrara does not support soundtracks with animations.

✦ Video editing programs are used to splice animations together and add soundtracks.

✦ Audio editing programs are used to create custom soundtracks for Carrara animations.

✦ Carrara's key frame markers can be used to synch soundtracks to animations.

✦ ✦ ✦

Keyboard Shortcuts

Carrara offers a number of keyboard shortcuts that you can use to streamline and speed up your work. The shortcuts range from general shortcuts that work in all rooms to specific shortcuts that pertain to certain rooms or modelers.

Table A-1		
General Keyboard Shortcuts for the File Menu		
Menu Command	**Action**	**Keyboard Shortcut**
New	Creates a new document	Ctrl+N
Open	Opens a saved file	Ctrl+O
Close	Closes the current document	Ctrl+W
Save	Saves the current document	Ctrl+S
Preferences	Opens the Preferences menu	Ctrl+Shift+P

Table A-2		
General Keyboard Shortcuts for the Windows Menu		
Menu Command	**Action**	**Keyboard Shortcut**
Assemble	Opens the Assemble room	Ctrl+1
Model	Opens the Model room	Ctrl+2
Storyboard	Opens the Storyboard room	Ctrl+3

Continued

Table A-2 *(continued)*

Menu Command	Action	Keyboard Shortcut
Texture	Opens the Texture room	Ctrl+4
Render	Opens the Render room	Ctrl+5
Sequencer	Opens or closes the Sequencer tray	Ctrl+H
Properties	Opens or closes the Properties tray	Ctrl+I
Browser	Opens or closes the Browser tray	Ctrl+B
Render Scene	Renders the current scene	Ctrl+R

Table A-3
Keyboard Shortcuts for the Assemble Room Edit Menu

Menu Command	Action	Keyboard Shortcut
Undo	Undoes the last action	Ctrl+Z
Redo	Redoes the last action	Ctrl+Y
Cut	Cuts the selected object	Ctrl+X
Copy	Copies the selected object to the clipboard	Ctrl+C
Paste	Pastes the contents of the clipboard	Ctrl+V
Duplicate	Creates a duplicate of the selected object	Ctrl+D
Duplicate With Symmetry	Creates a duplicate of the selected object with symmetry	Ctrl+Alt+D
Select All	Selects everything in the scene	Ctrl+A
Select All Primitives	Selects everything except cameras and lights	Ctrl+Alt+A

Menu Command	Action	Keyboard Shortcut
Group	Groups selected objects	Ctrl+G
Ungroup	Ungroups a selected group	Ctrl+U
Align	Aligns selected objects	Ctrl+K
Send to Origin	Sends selected object to scene origin	Ctrl+Shift+O
Center Hot Point	Centers a selected object's hot point	Ctrl+Alt+H
Point At	Causes a selected object to point at a selected target object	Ctrl+M

Table A-4
Keyboard Shortcuts for the Assemble Room View Menu

Menu Command	Action	Keyboard Shortcut
Send Working Box To Object	Aligns the working box to the selected object	Ctrl+Alt+Shift+B
Send Working Box To Origin	Sends the working box to its point of origin	Ctrl+Alt+B
Grid	Opens Grid dialog box	Ctrl+J
Show Production Frame	Makes Production Frame visible	Ctrl+Alt+F

The next set of keyboard shortcuts pertain to the Model room. The Model room is home to the Spline Modeler, Vertex Modeler, and Metaball Modeler. Each modeler has its own set of menu commands and shortcuts.

Table A-5
Keyboard Shortcuts for the Spline Modeler Edit Menu

Menu Command	Action	Keyboard Shortcut
Undo	Undoes the last action	Ctrl+Z
Redo	Redoes the last action	Ctrl+Y
Cut	Cuts the selected shape	Ctrl+X
Copy	Copies the selected shape to the clipboard	Ctrl+C
Paste	Pastes the contents of the clipboard	Ctrl+V
Duplicate	Creates a duplicate of the selected shape	Ctrl+D
Select All	Selects all shapes in the modeler	Ctrl+A
Group	Groups selected shapes	Ctrl+G
Ungroup	Ungroups a selected group	Ctrl+U

Table A-6
Keyboard Shortcuts for the Spline Modeler Sections Menu

Menu Command	Action	Keyboard Shortcut
Center cross section	Centers the selected	Ctrl+Alt+C
Set Shape Number	Opens Shape Number dialog box	Ctrl+Shift+N
Cross Section Options	Opens Cross Section dialog box	Ctrl+Alt+N

Table A-7
Keyboard Shortcuts for the Spline Modeler Arrange Menu

Menu Command	Action	Keyboard Shortcut
Combine As Compound	Combines selected shapes as a compound	Ctrl+Alt+G
Break Apart As Compound	Breaks a compound into its component shapes	Ctrl+Alt+U

Table A-8
Keyboard Shortcuts for the Spline Modeler Geometry Menu

Menu Command	Action	Keyboard Shortcut
Grid	Opens the Grid dialog box	Ctrl+J

Table A-9
Keyboard Shortcuts for the Vertex Modeler Edit Menu

Command	Action	Keyboard Shortcut
Undo	Undoes the last action	Ctrl+Z
Redo	Redoes the last action	Ctrl+Y
Cut	Cuts the selected object	Ctrl+X
Copy	Copies the selected object to the clipboard	Ctrl+C
Paste	Pastes the contents of the clipboard	Ctrl+V
Duplicate	Creates a duplicate of the selected object	Ctrl+D
Duplicate With Symmetry	Duplicates the selected object with symmetry	Ctrl+Alt+D
Select All modeler	Selects all objects in the	Ctrl+A

Table A-10
Keyboard Shortcuts for the Vertex Modeler View Menu

Menu Command	Action	Keyboard Shortcut
Reset	Ctrl+Alt+R	Resets all views to defaults
Grid	Opens Grid dialog box	Ctrl+J

Table A-11
Keyboard Shortcuts for the Vertex Modeler Selection Menu

Menu Command	Action	Keyboard Shortcut
Move dialog box	Opens Move Vertices	Ctrl+Shift+T
Resize	Opens Resize Selection dialog box	Ctrl+Shift+S
Rotate	Opens Rotate Vertices dialog box	Ctrl+Shift+R
Weld	Opens Weld Vertices dialog box	Ctrl+Shift+W
Link	Links selected vertices	Ctrl+Shift+L
Unlink	Unlinks linked vertices	Ctrl+Shift+U
Fill Polygon	Fills an open polygon	Ctrl+F
Empty Polygon	Empties a filled polygon	Ctrl+Shift+F

Table A-12
Keyboard Shortcuts for the Metaball Modeler Edit Menu

Menu Command	Action	Keyboard Shortcut
Undo	Undoes the last action	Ctrl+Z
Redo	Redoes the last action	Ctrl+Y
Cut	Cuts the selected object	Ctrl+X

Menu Command	Action	Keyboard Shortcut
Copy	Copies the selected object to the clipboard	Ctrl+C
Paste	Pastes the contents of the clipboard	Ctrl+V
Duplicate	Creates a duplicate of the selected blob element	Ctrl+D
Select All	Selects all objects in the modeler	Ctrl+A

Table A-13
Keyboard Shortcuts for the Metaball Modeler View Menu

Command	Action	Keyboard Shortcut
Wireframe	Sets preview to wireframe mode	Ctrl+Shift+Y
Shaded	Sets preview to shaded mode	Ctrl+Alt+Shift+Y

Table A-14
Keyboard Shortcuts for the Storyboard Room Edit Menu

Menu Command	Action	Keyboard Shortcut
Undo	Undoes the last action	Ctrl+Z
Redo	Redoes the last action	Ctrl+Y
Cut	Cuts the selected object	Ctrl+X
Copy	Copies the selected object to the clipboard	Ctrl+C
Paste	Pastes the contents of the clipboard	Ctrl+V

Continued

Table A-14 *(continued)*

Menu Command	Action	Keyboard Shortcut
Duplicate	Creates a duplicate of the selected object	Ctrl+D
Duplicate With Symmetry	Creates a duplicate of the selected object with symmetry	Ctrl+Alt+D
Select All	Selects everything in the scene	Ctrl+A
Select All Primitives	Selects everything except cameras and lights	Ctrl+Alt+A
Group	Groups selected objects	Ctrl+G
Ungroup	Ungroups a selected group	Ctrl+U
Align	Aligns selected objects	Ctrl+K
Send to Origin	Sends selected object to scene origin	Ctrl+Shift+O
Center Hot Point	Centers a selected object's hot point	Ctrl+Alt+H
Point At	Causes a selected object to point at a selected target object	Ctrl+M

Table A-15
Keyboard Shortcuts for the Storyboard Room View Menu

Menu Command	Action	Keyboard Shortcut
Send Working Box To Object	Aligns the working box to the selected object	Ctrl+Alt+Shift+B
Send Working Box To Origin	Sends the working box to its point of origin	Ctrl+Alt+B
Grid	Opens Grid dialog box	Ctrl+J

Table A-16
Keyboard Shortcuts for the Render room File menu

Menu Command	Action	Keyboard Shortcut
Print	Prints the rendered image	Ctrl+P

✦ ✦ ✦

Carrara Internet Resources

A number of resources pertaining to Carrara, 3D artwork, and digital art in general exist on the Internet. All of the links listed in this appendix were active at the time of writing.

Internet Web-zines

The Internet Eye (http://the-internet-eye.com/): A Web-zine with useful graphics information. This site features demo programs that can be downloaded and is updated on a regular basis.

I/US Magazine (http://www.i-us.com/): A resource for digital artists and illustrators.

Lightrace (http://www.lightrace.com/): A new Internet resource for both 2D and 3D artists.

PixArt (http://www.ruku.com): This Internet Web-zine is a treasure trove of tutorials for many 3D programs, plus news and reviews about 2D and 3D products. The site is updated on a monthly basis.

Visual Magic Magazine (http://www.visualmagic.awn.com/): An informative Web-zine for the 3D artist and illustrator featuring news and information about 3D applications plus tutorials.

3D Models

Free Stuff (http://www.modmed.com/bmtxw/bmtxw-i4. shtml): Free 3D models and textures.

The Movie Mesh Site (http://www.ozemail.com.au/~dproc/): A must-visit for sci-fi fans. Lots of detailed models available for download.

Starbase C3 (http://www.cube3.com/starbase/c3const/c3const.htm): 3D models for sale — some are free.

The 3D Café (http://www.3dcafe.com/): A resource for 3D models, textures, and tutorials.

ViewPoint Digital (http://www.viewpoint.com): A resource for highly detailed 3D models, textures, 3D software, and plug-ins.

The Zygote Media Group (http://www.zygote.com/): This site features highly detailed 3D models, plus they post a free model every week.

Other Internet Resources for 3D artists

3D Animation Workshop (http://www.webreference.com/3d/): Animation tutorials and information for 3D artists.

3D Artists (http://www.raph.com/3dartists/): A site dedicated to 3D art and artists with links to 3D artist's Internet sites from around the world.

3Dup.com (http://3dup.com/index_eng.shtml): This site has a 3D search engine.

Digital Carvers Guild (http://digitalcarversguild.com/frame.html): This site features plug-ins for Carrara.

Direct Algorithms (http://www.diralg.com/): This site features plug-ins for Carrara.

Ray Dream Studio Hints and Tips (http://www.geocities.com/SiliconValley/Foothills/1451/hats.html): This site is dedicated to Ray Dream tutorials, Carrara's predecessor. There is useful information here.

Maps of the Solar System (http://samadhi.jpl.nasa.gov/maps/stars.html): A NASA site featuring star maps of the solar system along with planetary maps. The star maps make wonderful backgrounds for Carrara space scenes. The planet maps are stitched together as mercator projections. Apply one to a sphere to include your favorite planet in a space scene.

MetaCreations (http://www5.Metacreations.com/) The makers of Carrara and other software.

The Internet RayTracing Competition (http://www.irtc.org/): This site has regularly scheduled competitions that revolve around a selected theme. The competition is broken down into still images and animations.

USGS Download site (http://edcwww.cr.usgs.gov/doc/edchome/ndcdb/7_min_dem/states.html): Download Digital Elevation Models of places throughout the country.

WAVSOUND.COM (http://www.wavsounds.com/): A huge Internet warehouse of sound effects and audio clips.

✦　　✦　　✦

What's on the CD

The CD-ROM that accompanies this book contains companion files for the various tutorials presented in the book. It also contains software and other items of interest to 3D artists.

About the Directories

The CD-ROM is broken down into three directories:

✦ **Content files:** Contains the files used to create the scene tutorials used throughout the book. Contents files are organized by chapters of the book.

✦ **Goodies:** Contains rendered animations, scene files to dissect, and shaders to use.

✦ **Software:** Contains shareware, demo, and trial versions of software.

What's on the Disc

The following is a brief description of some of the items and programs you'll find on the CD-ROM. Refer to the documentation that accompanies the software for installation and other instructions.

✦ **Bryce 4.0:** A 3D program that creates realistic landscape scenes. A demo version is included on the CD-ROM.

✦ **Canoma:** A program that creates 3D models from photographs. A demo version of the program is included on the CD-ROM.

✦ **Goldwave 4.11:** A sound editing program. The program is used to create, mix, and paste sounds. Use it to create soundtracks for your Carrara animations. The version included on this CD-ROM is a fully functional shareware version.

✦ **Headline Studio 1.0:** Used to create animated banners for Web sites. A demo version of the program is included on the CD-ROM.

✦ **MetaStream:** An open graphics format for viewing 3D models on the Internet. The MetaStream plug-in is included on the CD-ROM.

✦ **Quicktime 4.0 Viewer:** This viewer enables you to watch the animations on the CD-ROM.

✦ **Tree Designer 1.0:** A shareware program that creates trees. Modeled trees can be exported in a number of different formats that are supported by Carrara.

✦ **MGI Software's VideoWave ll:** A video editing program that can splice animations together and features professional transition effects. Add a soundtrack and then compile the video for output. The completed video can be saved in most popular formats with compression. Included on the CD-ROM is a fully functional 30-day trial version of VideoWave ll.

✦ **Five 3D models from Viewpoint Digital:** These highly detailed models comprise many objects that are grouped and saved in .obj format. After importing one of the models into Carrara, you can ungroup it and shade the individual parts of the model.

✦ **Ten 3D models from Zygote Inc.:** These models are saved in .rds format, which can be imported directly into Carrara.

✦ ✦ ✦

Index

Continued

Continued

Continued

IDG Books Worldwide, Inc.
End-User License Agreement

4. Restrictions on Use of Individual Programs. You must follow the individual requirements and restrictions detailed for each individual program in Appendix C of this Book. These limitations are also contained in the individual license agreements recorded on the Software Media. These limitations may include a requirement that after using the program for a specified period of time, the user must pay a registration fee or discontinue use. By opening the Software packet(s), you will be agreeing to abide by the licenses and restrictions for these individual programs that are detailed in Appendix C and on the Software Media. None of the material on this Software Media or listed in this Book may ever be redistributed, in original or modified form, for commercial purposes.

5. Limited Warranty.

(a) IDGB warrants that the Software and Software Media are free from defects in materials and workmanship under normal use for a period of sixty (60) days from the date of purchase of this Book. If IDGB receives notification within the warranty period of defects in materials or workmanship, IDGB will replace the defective Software Media.

(b) IDGB AND THE AUTHOR OF THE BOOK DISCLAIM ALL OTHER WARRANTIES, EXPRESS OR IMPLIED, INCLUDING WITHOUT LIMITATION IMPLIED WARRANTIES OF MERCHANTABILITY AND FITNESS FOR A PARTICULAR PURPOSE, WITH RESPECT TO THE SOFTWARE, THE PROGRAMS, THE SOURCE CODE CONTAINED THEREIN, AND/OR THE TECHNIQUES DESCRIBED IN THIS BOOK. IDGB DOES NOT WARRANT THAT THE FUNCTIONS CONTAINED IN THE SOFTWARE WILL MEET YOUR REQUIREMENTS OR THAT THE OPERATION OF THE SOFTWARE WILL BE ERROR FREE.

(c) This limited warranty gives you specific legal rights, and you may have other rights that vary from jurisdiction to jurisdiction.

6. Remedies.

(a) IDGB's entire liability and your exclusive remedy for defects in materials and workmanship shall be limited to replacement of the Software Media, which may be returned to IDGB with a copy of your receipt at the following address: Software Media Fulfillment Department, Attn.: *Carrara 1.0 Bible*, IDG Books Worldwide, Inc., 10475 Crosspoint Blvd., Indianapolis, IN 46256, or call 1-800-762-2974. Please allow three to four weeks for delivery. This Limited Warranty is void if failure of the Software Media has resulted from accident, abuse, or misapplication. Any replacement Software Media will be warranted for the remainder of the original warranty period or thirty (30) days, whichever is longer.

(b) In no event shall IDGB or the author be liable for any damages whatsoever (including without limitation damages for loss of business profits, business interruption, loss of business information, or any other pecuniary loss) arising from the use of or inability to use the Book or the Software, even if IDGB has been advised of the possibility of such damages.

(c) Because some jurisdictions do not allow the exclusion or limitation of liability for consequential or incidental damages, the above limitation or exclusion may not apply to you.

7. **U.S. Government Restricted Rights.** Use, duplication, or disclosure of the Software by the U.S. Government is subject to restrictions stated in paragraph (c)(1)(ii) of the Rights in Technical Data and Computer Software clause of DFARS 252.227-7013, and in subparagraphs (a) through (d) of the Commercial Computer — Restricted Rights clause at FAR 52.227-19, and in similar clauses in the NASA FAR supplement, when applicable.

8. **General.** This Agreement constitutes the entire understanding of the parties and revokes and supersedes all prior agreements, oral or written, between them and may not be modified or amended except in a writing signed by both parties hereto that specifically refers to this Agreement. This Agreement shall take precedence over any other documents that may be in conflict herewith. If any one or more provisions contained in this Agreement are held by any court or tribunal to be invalid, illegal, or otherwise unenforceable, each and every other provision shall remain in full force and effect.

my2cents.idgbooks.com

Register This Book — And Win!

Visit **http://my2cents.idgbooks.com** to register this book and we'll automatically enter you in our fantastic monthly prize giveaway. It's also your opportunity to give us feedback: let us know what you thought of this book and how you would like to see other topics covered.

Discover IDG Books Online!

The IDG Books Online Web site is your online resource for tackling technology — at home and at the office. Frequently updated, the IDG Books Online Web site features exclusive software, insider information, online books, and live events!

10 Productive & Career-Enhancing Things You Can Do at www.idgbooks.com

- Nab source code for your own programming projects.

- Download software.

- Read Web exclusives: special articles and book excerpts by IDG Books Worldwide authors.

- Take advantage of resources to help you advance your career as a Novell or Microsoft professional.

- Buy IDG Books Worldwide titles or find a convenient bookstore that carries them.

- Register your book and win a prize.

- Chat live online with authors.

- Sign up for regular e-mail updates about our latest books.

- Suggest a book you'd like to read or write.

- Give us your 2¢ about our books and about our Web site.

You say you're not on the Web yet? It's easy to get started with IDG Books' *Discover the Internet*, available at local retailers everywhere.

CD-ROM Installation Instructions

The CD-ROM that accompanies this book contains content files, completed scene files, and animations, plus demo and trial versions of commercial software discussed in the book. The CD-ROM is divided into two directories:

+ **Content:** This contains the files used to create the scene tutorials used throughout the book. Content files are organized by chapters of the book.

+ **Goodies:** This contains rendered animations, scene files to dissect, Carrara shaders to use, and fifteen highly detailed models from Viewpoint Digital and Zygote Inc.

+ **Programs:** This contains shareware, demo and trial versions of software.

To install any of these programs, place the disc in your CD-ROM drive and run the .exe file.

Changing the Windows read-only attribute

You can use the scene files and shaders directly from the CD-ROM, but you might get better results by copying them to your hard drive.

To use the software from the CD-ROM, you should copy the files to a folder that you create on your hard disk or another medium (such as a Zip drive). After copying the files, if you get the following error message when you attempt to open a file with its associated application

[Application] is unable to open the [file]

make sure the drive and file are writable. Sometimes when you copy a file from a CD-ROM to another medium, Windows doesn't automatically change the file attribute from read-only to writable. Installation software normally takes care of this chore for you, but in this case, because the files have been manually copied to your disk, you might have to manually change the file attribute yourself. Luckily, this is easy:

1. Click the Start menu button.
2. Choose Programs ⇨ Windows Explorer.
3. Locate the file you want to change and click the file to select it. To add additional files to the selection, press Shift and click the files you want to add. To select all files in a folder, press Ctrl+A.
4. Right-click the selected file name(s) to display a pop-up menu.
5. Select Properties to display the Properties dialog box.
6. Click the Read-only option so that it is no longer checked.
7. Click OK.

You should now be able to use the file(s) with the specific application without getting any annoying error messages.